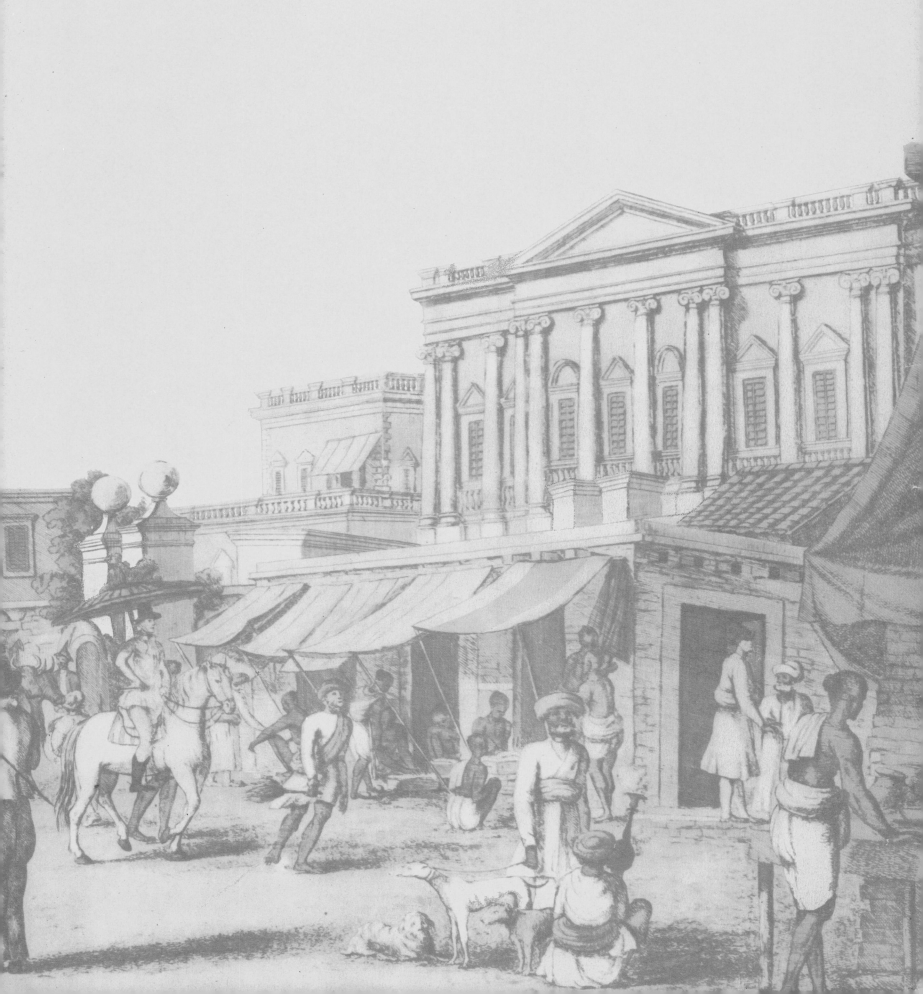

CALCUTTA

GREAT CENTRES OF ART

CALCUTTA

SOUTH BRUNSWICK AND NEW YORK:

A. S. BARNES AND COMPANY

LONDON: THOMAS YOSELOFF LTD

Edited by Heinz Mode, Halle
Revised by Heinz Kucharski, Leipzig

Copyright 1973 by Edition Leipzig
English language edition
© 1973 by A. S. Barnes and Co., Inc.

A. S. Barnes and Co., Inc.
Cranbury, New Jersey 08512

Thomas Yoseloff Ltd.
108 New Bond Street
London W1Y OQX, England

Calcutta. (Great centres of art)
1. Art–Calcutta–Galleries and museums
I. Mode, Heinz Adolph, 1913– ed.
N 3750. C 27 C 34 1973 708'.954'14 72–9852
ISBN 0–498–01305–7

Typography and Design: Horst Erich Wolter

Printed in the German Democratic Republic
by Druckerei Fortschritt Erfurt

This volume is the joint work
of the Directors and the professional staff of the museums dealt with in this book.

Contributions were made as follows:

Indian Museum	Asoke Kumar Bhattacharyya
Asutosh Museum	D.P.Ghosh
Birla Academy of Art and Culture	Laxmi P.Sihare
Gurusaday Museum of Bengal Folk Art	Miss Gitika Guha
Rabindra Bharati Museum	Kanon Mukerji
Indian Institute of Art in Industry	Tarakdev Bharati
Victoria Memorial	A.P. Das Gupta
State Archaeological Gallery of West Bengal	Paresh Chandra Das Gupta
Academy of Fine Arts	Lady Ranu Mookerjee
Photographs	Subodh Chandra, Bombay

CONTENTS

Modern museological studies hardly include the history of museums and collections in countries outside Europe, considering merely the collections in Egyptian and Mesopotamian temples and palaces as forerunners, without, however, admitting for them a specific aesthetic or documentary intent. India was left unmentioned in this connection for the reason, it seems, that this country, during the period of museum formation in Europe, was under the colonial domination of European powers, and had in a later stage slowly been admitted on the invitation of its rulers, adding to and completing the general trend. This view cannot be fully supported, as there have been in India, as in the Near East, forerunners of temple and palace collections as well. Under British rule the nucleus of collections, later placed in museums, was formed, rather on demand of the Indians themselves, assisted by some of the more enlightened foreigners, than by command of the foreign rulers.

Museums as institutions of national validity could not from the beginning harmonize with the intentions of colonial rule, and were only hesitantly permitted under pressure from the newly emancipated national bourgeoisie. Up to the end of the British period the outer prestige was maintained, museum buildings and names symbolizing the imperial aims of the British rulers. They have not, however, succeeded, like for instance in school text books propagating English language, history and literature, in creating museums as institutions of British propaganda for their own purposes. Most of the new museums are in their interior value and contents entirely Indian, documenting in their encyclopaedic phase Man and Nature in India, specializing later on in Indian arts, crafts, archaeology etc., combining documentary, educational and aesthetic neces-

sities, but almost exclusively referring to Indian materials. Thus by demand and out of necessity, foreign materials being scarce in this country, Indian museums can be considered in the main as national museums par excellence.

Like Bombay and Madras, but unlike Delhi, Calcutta is a city of the British period, originating around 1690 and integrating a few older villages in its rapid growth. Even today Calcutta remains the densest populated urban conglomeration in India, having been deprived of its rank as capital and of its leading economic position. Against the growing national movement in Bengal, the British Government after one and a half centuries of rule from Calcutta, centralized their Indian Empire by extending the old Mogul capital Delhi, and in 1947, after being forced to grant political independence to India, with their departure cut the rich province of Bengal into two parts, eastern Bengal then belonging to the newly founded Pakistan, whereas western Bengal remained as part of the Republic of India. Calcutta thus has been preserved for India, but it has lost its rich agricultural hinterland in the east and been deprived of one main source of its wealth. Since the time when East Pakistan, as it was then, gained its independence – supported by India in the last stage of its struggle – and has existed as Bangladesh, the prospects for friedly collaboration concerning both the Indian and Bangladesh areas of Bengal have considerably improved.

Origin and external dependency upon British rule has not made Calcutta an English city, on the contrary, Bengal's metropolis has developed into a centre of national revival and thus favoured, by competition and suppression alike, the growth of national literature and pictorial arts, of social and natural sciences. The Asiatic Society of Bengal, the

Calcutta University and its famous Sanskrit College and the Indian Museum bear witness to this development as well as world-known personalities like Ram Mohan Roy, Sri Aurobindo, Swami Vivekanand, C. V. Raman, Sir J. C. Bose and Rabindranath Tagore, to mention but a few of the multitude of creative geniuses in this eastern province of India. The young intelligentsia of Calcutta enthusiastically hoisted the flag of the French Revolution and at the same time reconsidered and regathered the great heritage of Indian history and culture. Calcutta art collections thus derive from different trends and tendencies in the habitat and feelings of its citizens and rulers.

After a long period of undisguised exploitation of Indian resources it had become the wish of the British to bring together as a sign of their benevolent care for the country a representative collection of Indian art, materials which had already been gathered in older collections like that of the Asiatic Society, to be supplemented by the incoming results of archaeological research all over the vast peninsula. Thus monumental works of art, like some of the Ashoka pillars or the entire rail of Bhārhut were removed to the museum, a rather barbaric action of the earlier period of museology in India, which nevertheless increased the key importance of the Calcutta museum much beyond that of any other museum in India. The early and classical periods of Indian art are thus best represented in Calcutta.

A second trend served more practical purposes. A Calcutta School of Industrial Art was opened in 1854, this act being of a revolutionary nature as against the old Indian tradition of hereditary and cast-embedded crafts, which under British rule were rapidly loosing their old creative power and technical knowledge with the changing social and economic situation. At first European ways of art training, European fashions of art subjects were chosen and foreign teachers employed for the growing number of Indian students. Of these E. B. Havell (1896) is distinguished for his interest and devotion to Indian art, initiating with the help of outstanding Bengal artists like Abanindranath Tagore (nephew of the poet Rabindranath) and Nandalal Bose a new school of painting, the so-called Bengal School, first and foremost in the modern period of Indian art, initially based on the ideals of ancient Ajanta and miniature painting.

Calcutta museums profited from this development in many ways. Collections of traditional handicrafts and miniatures emerged, inspiring a rapidly growing industry of commercial crafts, mainly based on textile, metal and ivory materials. Closely connected with handicrafts, but also a source for new fashions in higher art, Indian folk-art began to be collected, Bengal and the neighbouring provinces of Orissa, Bihār and Assam being particularly rich in such materials. The growing national feeling, at that time predominantly concentrated and active in Calcutta, elevated and even worshipped all objects of the past. Naturally, Bengal art down to the pre-Muslim periods was brought from all parts of the province to public museums and private collections. Parallel to this movement, the British rulers made a last attempt to document and fortify their imperial demands by creating a monument like the Victoria Memorial Museum, a British period art archive, glorifying acts of war and conquest, hardship and endurance, demonstrating supreme power and benevolence towards their Indian subjects.

Finally, as a result of the new art movement, contemporary art was admitted, though to a far lesser degree, and only in more recent years. Large exhibitions and collections of modern art have now found their proper place in the cultural life of the city. Today they are best represented in the Calcutta Academy of Fine Arts and the newly opened Birla Academy of Art and Culture. The great esteem shown for the outstanding genius of Rabindranath Tagore, who was not only a poet, but also a great composer and, in his later years, a highly original painter, is reflected in the collections just named, but more so in the Rabindra Bharati Museum, past of the latest Calcutta University foundation and housed in the renovated and extended town seat of the Tagore family in Calcutta.

Thus Calcutta as a city of art is predestinated to represent India in documents of the ancient periods, in materials of colonial rule and national rebellion against this suppression, in the never ceasing flow of timeless folk-culture and in contemporary reflections of the struggle for national independence and social advance. Non-Indian works of art play an almost insignificant role, as Indian culture at its best has always been able to absorb foreign influences and integrate them to the profit and growth of their own typical and unmistakable Indian creative genius. It

8

is not surprising therefore that foreign art is hardly seen in Calcutta museums, apart from that of regions bordering on India, such as Nepal, Tibet, Burma and Afghanistan, and Indian art alone sufficiently justifies their claim for world-wide appreciation.

Unrivalled in its size, the quality and quantity of its collections, comprising besides art and archaeological materials important zoological, botanical, anthropological and geological exhibits, the Indian Museum of Calcutta has been and still is the most representative museum in the whole country. Large crowds of visitors daily walk through the old-fashioned and spacious halls, in their majority Indian families not only satisfying their curiosity, but considering their visit as a kind of pilgrimage to the sanctified monuments of the past, approaching the exhibits as if in an ancient temple, with shy restraint and almost religious devotion. My own memories reach back to 1934, a time when hardly a single European visitor could be met within the museum halls, yet unforgettable scenes of deepest popular interest, of fearful shuddering or happy satisfaction, could be witnessed according to the changing awe-inspiring or benevolent nature of the images. More recent visits to the museum have revealed a clear development. The museum has now grown into an institution of education, drawing classes of school-boys and girls, individual students and scholars in great numbers, whereas the old type of devotional pilgrims, though not quite extinct, is diminishing in number. Of course tourists and other foreigners now belong to the daily visitors and not always increase the atmosphere of inspiration and cultural elevation.

It has to be remembered that long before modern museums were established in India, their function was maintained by village temples, where arts and crafts were on exhibition to the people, creating or improving the taste for all arts, including music and dance. Ancient Indian literature speaks of Chitrasālās (picture-halls) and Vishvakarma Mandiras (buildings devoted to Vishvakarma, the divine originator of arts and crafts). Large collections of art had been formed by wealthy connoisseurs, mostly kings or petty rulers, thus demonstrating cultural interests. Such collections, however, housed mainly minor works of art, miniature paintings and outstanding creations of traditional crafts in valuable materials, whereas the large architectural monuments and their sculptural work as also some of the paintings in Buddhist rock caves remained as such, and as they vanished or fell to ruins, had to be recovered by archaeological excavation or restored by Government efforts. Not all such materials have found their way to public museums. There has been pillaging and plundering in historical as well as modern times. But all over India numerous monuments still stand to be admired in their original settings. As regards Bengal, the village terracotta temples have suffered a great deal and many of them are partly or even fully deprived of their sculptural decoration. Only small bits of such sculptures are now displayed in the museums and collections of the capital of this province. Foreign invasion and foreign domination, changes in religion and in the social habits of the people have left their traces. Thus Bengal is almost bare of monuments of the oldest periods, apart from those recently dug up, mainly terracotta figures and plaques. In this province terracotta seems to have been preferred to stone, although stone buildings exist as well but on the whole in fewer numbers than in other parts of India. The rich Buddhist culture of Bengal in the middle ages during the Pala and Sena periods, which has been wiped out not so much by Hindu revival but by repeated Muslim invasions, Bengal and Bihār Buddhist art finding its continuation in Nepal and even in Tibet, is now best displayed in museums of the province, where at least some of the sculptures have been preserved. Book covers and manuscript illustrations of the 10th to 12th centuries are valuable documents of the early rise of Indian miniature painting. The fate of the later Hindu art, mainly represented by typical Bengal terracotta temples, has already been mentioned. Muslim art during the Mogul period has left but minor traces in the Bengal province of the Mogul Empire. Their buildings sometimes constructed with materials taken from older non-Islamic structures are now in ruins, and as is well-known, figural art was rejected for religious purposes. But there is a wealth of crafts and miniatures during this period, sponsored by the courts of Mogul governors and independent rulers. They are well documented in Calcutta museums. On the other hand, popular but late art developments, like the Kalighat paintings, devotional and sometimes even socio-critical pictures sold to visitors of Calcutta Kālī temple in the 19th

and early 20th centuries, and appreciated as major links with traditional beliefs now are rare in the Calcutta collections. Too many of these handpainted paper drawings have vanished, victims to the climatic conditions, but also to the curiosity of foreign visitors, disappearing in private collections abroad and forever removed from their Indian home. The nucleus of Calcutta art collections, as has been said, was formed by the Asiatic Society of Bengal and may be dated back to 1784. This ancient seat of Oriental Learning is closely connected with the name of its founder, Sir William Jones. Gandhara sculptures, inscriptions and especially coins, now in the Indian Museum, should be mentioned as proof for this early initiative of enlightened scholars, forming their own association, hardly supported or even disliked by the official colonial government. It is, however, satisfying to notice such scholarly undertakings in the earliest phase of modern museum development in Calcutta, and indeed in the whole of India, the aims being articulated by Sir William Jones as follows: "The bounds of its investigations would be the geographical limits of Asia and that within these limits, its inquiries would be extended to whatever is performed by Man or produced by Nature."

Looking at the budgets of Calcutta museums it is quite easy to understand that, even up to the present time, funds are totally insuffcient and always had to be supplemented by private contributions, thus some of the present museums almost entirely rest on such private donations. The initiative of the Asiatic Society was once taken up by Calcutta University, forming its own museum under the guidance of Sir Asutosh Mukherjee, being named after this outstanding man. Since independence the new Archaeological Department of India, and the provincial Archaeological Departments have enlarged their collections with materials from the latest discoveries. One of the new museums, the State Archaeological Gallery of Bengal, is a result of these recent efforts. Here, as always, the museum work has been associated with profound scholarly research, close links with universities, Government archaeological departments, learned societies and museums leading to a steady and visible advance of science. Thus Calcutta is not only a city of art attracting people from abroad, but also a true home of scholarly and educational institutions, Calcutta museums largely contributing to higher education and popular display of the rich treasures of Indian art, for the benefit of the Indian people.

Heinz Mode

Founded in 1814, the Indian Museum in Calcutta represents not only the earlier phase of museum movement in the East but is recognized as the largest collection of man's artistic and scientific achievements in by-gone ages in this part of the globe. In fact, the preamble to the resolution adopted by the Asiatic Society of Bengal for the establishment of this institution lays down the scope of the museum in the widest possible terms as being an institution 'for the reception of all articles that might be sent to illustrate oriental manners and history, or to elucidate the peculiarities of Art of Nature in the East'. The museum in its six different sections coordinates the results of the scientific activities and artistic expression of the Orient throughout the successive periods of history.

Though a multi-purpose museum, housing under the same roof, in a building of the Victorian style, a vast and varied amount of zoological, geological, anthropological and botanical or industrial economic material as museum specimens, this institution has a reputation for its outstanding collection of art and archaeological objects.

What still forms the most attractive and educative part as the museum's archaeological collection was originally the proud treasure of the Asiatic Society of Bengal transferred to form the nucleus of the Indian Museum. This collection in its separate and individual entity came to be first available in public galleries in the museum in 1878. The archaeological collection from its very inception comprised statues, smaller sculptures, inscriptional records and coins collected by the members of the Society, and presented to it, from all parts of this subcontinent and outside. This collection, small though selective, was transferred to form the Indian Museum, known before as the Imperial Museum. Some time before

1814 a Superintendent was in charge of it. In 1866, the collection, mainly geological, archaeological and zoological, was placed under a Board of Trustees. By 1910, this august body came to include through statutory sanctions, representatives from the three important public bodies, viz., the University of Calcutta, the Bengal Chamber of Commerce, and the British Indian Association. The collection now gradually started to be augmented both by addition to those in the already existing sections, viz., geology, zoology and archaeology, and by founding new sections, one of which was the Economic and Art Section. The collection of this section made its mark at the Great Exhibition held in Calcutta in 1883. The section with its contents of economic, industrial and art products of the country was formally placed under the Trustees on the 1st of April, 1887. In 1891, all collections of the economic products including art and art-ware were transferred to an extension building added to the museum. The art gallery with its nucleus of miniature paintings, glassware, ceramics, cloth-products and other handicrafts was thrown open to the public in September, 1892.

In the Archaeological Section, the collection takes us back as far as the pre- and proto-historic cultures of India. These are represented in the finds of the Palaeolithic, Microlithic and Neolithic ages as well as in the finds from Harappa and Mohenjodaro, Jhukar, Jhangar, Amrī and other places. In a variety of objects like tools, implements and beads, ornaments of semi-precious stones and so on, these cultures are well represented. Indian paleoliths, mostly of quartzite, are chipped implements for cleaning, smiting and digging, and in appearance similar to those found in the Abbevillian and Acheulean periods of Europe. The Palaeolithic, Microlithic and 11

Neolithic implements in all their varieties of functional appearance and manufactorial techniques, are well represented in the large collection of this museum. Comparative material from countries outside India, especially France, is also available here.

Of the paleoliths, a hand-axe, bifacial and ovate in chocolate quartzite from the north of Shevandy, another type in brownish-grey quartzite from Attirampakkam, a cheaver, partly pebble-faced and in reddish-grey quartzite from Dharwar, point in brown-tinted quartzite from the banks of the Malaprabha river, a chopper in yellowish-brown quartzite from Attirampakkam, deserve special notice. Chert and quartz blades and core, as also lunates, from Jabalpur, Pratabganj, Rohri in Sind, and other places, in the group of microliths illustrate the tools in the latter age in the Indian Museum's collections. Of the Neolithic age the typical specimens in the museum consist of polished, celts and adzes, from Bellary.

From the Indus valley, chalcolithic objects of the 3rd millennium B.C. include male and female terracotta figurines, copper bracelets, a bronze lance-head, a terracotta humped bull, a square steatite seal with the figure of a unicorn and pictographic writings, a beaded necklace and a few scored and plain pottery objects representing a beaker, goblet, etc. To this chalcolithic age also belongs a fragment of painted pottery with the peepul leaf, *ficus religiosa*, motif painted in glaze on red slip from Ghaziabad in Sind. Of the copper hoards, a sword with characteristic 'antennae' hilt and an object in crude 'anthropomorphic' shape from Fatehgarh, deserve special mention. From the mother sites, Harappa and Mohenjodaro, this proto-historic Indus Valley culture is represented in the museum, among others by the intaglio seals showing a wide range of animals including the unicorn, early forms of elephants, etc., and a copper tablet, perhaps an amulet bearing the figure probably of a hare in which the outlines are filled with cuprous oxide. A few interesting miniature terracotta animals represent a bull, a buffalo, a dog and a rhinoceros, and the lively head of a camel. One rattle in the shape of a bird yoked to a wheeled car, a typical high-turbaned terracotta figure of the so-called mother-goddess together with a few smaller ones and a couple of interesting figurines seated with legs drawn, are some of the other

specimens of the miniature art of this period preserved in the Indian Museum. The representative art of this period also shows a few bowls and lids of bowls and a group of goblets, and pottery with geometrical patterns or figures of birds, in black-on-red, together with an interesting multi-holed small jar probably used as fire-holder for heating purposes. A couple of burial jars and a big jar probably for storing grains are also some of the antiquities that represent the most interesting and advanced culture of this period.

Mauryan art (322–185 B.C.) forms the starting point for all the successive historical periods represented by architectural fragments, sculptural figures and the earliest forms of coins and coin-systems. Mauryan sculpture of the monumental type influenced by the traditions of Achaemenid Persia is exemplified in pillar capitals ornamented with arabesque decorations in relief, and a few individual figures of Yakshas and Yakshīs, griffins, etc., as preserved in the entrance gallery of this museum. A lion-capital with the characteristic Mauryan polish showing the animal couchant and fully maned, vigorous and majestic in expression, resting on the surface of an abacus disc, is a grand compliment to the royal art that developed in this period. The birds carved into the stone are set up on an inverted closed lotus with petals marked by robust ribs – a typical motif in Mauryan art. A free standing Yaksha figure in soft stone, a headless chauri-bearer with the characteristic polish, a serpent canopy, and a pair of winged lions, probably bracket figures, mark the very different yet very typical art that developed in the 3rd century B.C. under the Mauryas.

From the Sunga period of the following century there are stupendous remains of the carved gateways and railing-pillars from Bhārhut near Nagod, in the province of Madhya Pradesh, India. In flat surface decoration, these reveal the motifs of the fertility dryads, the narrative stories of the previous lives (Jātakas) of the Buddha and decorative medallions, in a style of art which still is of uncontrolled vigour, and which continued largely to be monumental. Typical figures and scenes in these medallions include the scene of the purchase of the Jetavana Vihāra by spreading coins over the land, the Dream of Māyā, Buddha's mother, worship of the Bodhi Tree, Gajalakshmī, a symmetrically placed fan-tailed peacock, a satirical scene of drawing the hair 12

out of the nostril by engaging an elephant, and a host of Jātaka stories, like the Mahākapi, the Ārama-dūsaka, the Mugapakkha, the Kakkuta, the Mahā-ummagga, etc.

From the 2nd century B.C. to about the 2nd century A.D. the prolific school of Gandhāra art in blue schist depicts scenes from the life of the Buddha in detail, revealing an early study in profile and perspective. In the statues of the Buddha and Bodhisattvas, carved in larger proportions, a Hellenistic vigour of the body with its peculiar anatomical precision high-lighted by peculiar Roman dresses, is noticed as a distinctive contribution of this foreign tradition that made itself felt in the wake of political contacts with the West. An attempt is made for the first time in this school to represent the Buddha as a human being. The art of Gandhāra – an expression of Indo-Greek origin, executed in stone and in stucco – opens a new vista in the matter of figuration in detail and with exuberant vigour, peculiar to the West, and is presented in this collection in all its wealth and variety, which include among others a miniature stūpa, with scenes from the life of the Buddha carved in relief around the lower plinth-surface of the dome.

A fairly large collection of the other early school of art bearing considerable influence from outside, viz., Kushāna art of Mathurā, forms an interesting group in this museum. This art originating at Mathurā and places around it, includes railing pillars carved with Yakshinīs in different intimate and homely situations, individual larger figures of the Buddha wearing the transparent Chīvara, a monk's dress, standing or seated in the attitude of offering protection and often attended by worshippers, a few carvings in miniature showing the great Lord, and finally, a group of individual heads wearing typical head-dress. Small Bacchanalian scenes, typical of this period, showing a dishevelled lady, reveal bold delineation on a miniature scale. A small and fragmentary figure of a Nāga king equally typifies the miniature figuration that went hand in hand with the art of a colossal type in this period, especially in standing statues of Buddha and Bodhisattvas preserved in this museum. These constitute the variation and yet exemplify the distinctive expression of art that was more or less localized in the region within about three hundred years from the Christian era.

Imbibing all the traits of the Kushāna is the excellent group of sculptures from Bhumārā, in Uttar Pradesh, where door-jambs and door-lintels with geometrical patterns and florid or leaflike decorative motifs constitute a rare and unique experiment in abstract decorative elements – partly a legacy of the Indo-Greeks and the Indo-Scythians. Yet the emergence of truly Indian expression and themes is also visible here in the depiction of dwarfs with a single-headed necklace (ekavali hāra) and the characteristically curled hair-do, which make them stylistically of Gupta inspiration.

Next in historical chronology, but archaeologically and artistically the finest and most interesting, is the school of sculpture constituted by the Gupta statues and statuettes. They represent not only, though predominantly, the Buddhist faith but are comprehensive enough to include the more important figures with expressive details inspired by both of the other dominating faiths of India, viz., Brahmanism and Jainism. Apart from the standing figures of the Buddha, mostly in the protection pose (abhayamudrā), and the most lovely yet vigorously modelled steles showing the different stages and incidents in the life of the Buddha, starting from his birth and ending with the scene of the Parinirvāna, there are exquisitely carved figures representing Krishna-Līlā and a few of the principal deities of Brahmanism. An isolated figure of the Jaina Tīrthankara Pārshvanātha, in the Sārnāth style, in the scene of his being attacked by Kamatha and protected by Padmāvatī and Dharanendra, serpent deities as Sāsanadevatas, is a rare achievement in scenic representation in the Gupta period. The most finely carved gateways from Buxar, eastern Bihār, with representations of the Gangā and Yamunā, the river goddesses, one on each jamb, mark the typicality of this feature in Gupta art. A most outstanding group of relief-carvings from Chandimau, also in Bihār, depicting a famous episode from a heroic poem, the Mahābhāratā and adopted as a theme in the exclusive Kāvya (lyric poem) of the Kirātārjunīvam: the story of the Pāndava Arjuna and Shiva in the guise of Kirāta, the former engaged in a fight to please and propitiate the latter, illustrates still more characteristically the restrained and proportionate vigour of Gupta art on the one hand, and its wide range of subjects on the other. These and other figures of this school in the museum's collection also represent the different 13

traits in this style, e.g. in a special kind of hair-do and typical ornaments. The delicate modelling speaks only of the excellence to which stone-carving had reached during the period.

During this efflorescent period Indian art developed also in another medium, viz., terracotta, in continuation of the tradition almost extinct since the Indus Valley Civilization. After the early centuries of the Christian era a classical trait came to India through western Asia in the art of terracotta. It mainly comprised the use of double moulds. Several centres grew up during the Gandhāra period like Bhitargaon, Ahichchatrā, Kausāmbī, Pātaliputra, Pāhārpur, and a few others. The Indian Museum possesses a few of the outstanding pieces in this category, revealing the well-known technique that developed during the time of the Guptas. A plaque from Bhitargaon showing Anantashayin Vishnu pertaining to the Gupta period, 5th century A.D., a terracotta medallion showing a village scene from Bhita, assigned generally to the 2nd century B.C., a couple of celestials in armour, richly ornamented in Gupta style, are some of the outstanding pieces in this museum and prove the continuity of the tradition from before the Christian era. A few other plaques showing animal motifs, such as a scratching buffalo from Mainumati, now in Bangladesh, and a few more depicting Bodhisattva Padmapāni from Pāhārpur and a group with the Buddha in different poses, probably used as religious seals, from Bodh-Gayā, all pertaining to a later period, probably from about the 8th to the 10th century A.D., constitute examples of a continued tradition and are some of the extraordinary acquisitions of this museum. The Gupta tradition remains basically unchanged in the successive periods and terracotta continued to be largely the medium of art, especially in eastern regions like Bengal where from about the 15th century terracotta plaques exclusively occupied the place of pride in temple ornamentation. The Indian Museum possesses a few examples of this phase in India's art history and its style in this popular medium.

With the disintegration of the Gupta empire from the end of the 6th century A.D., Indian art of the north gradually fell into comparative decadence in style and manner. The period of interregnum was only filled in sporadically here and there with limited outbursts of art creation which, however, sometimes did outlive time and place. It was only after the grand revival of the decorative carvings in stone enjoyed in the Pāla and Sena periods in the Bihār-Bengal area, and in the Hoysala art with its main centres at Halebīd and Belūr, that anything could attract the notice of connoisseurs. The aesthetic urge of the people, born through the traditions of the Guptas in this part of northern India did, however, channelize itself mainly in the intricately carved decorative elements as could be wrought upon the fine basalt stones of Upper Bengal. Executed by both individuals and guilds under the aegis of a grand revival of culture, especially in the different branches of art and literature, as patronized by the Senas of Bengal, these pieces represent deities of the Brahmanic faith, with almost an equal patronage, extended to Buddhism and Jainism wherever required. The sentiment of Brahmanic revival in this area during the time naturally led to greater attention being paid to the figuration of Brahmanical deities like Sūrya, Vishnu, Ganesha, Kārtikeya, Umā-Maheshvara, the different Avatāras of Vishnu and certain other individual deities and motifs. The art of the Hoysalas of the 12th century A.D. almost strikes a parallel course with the Sena art of Bengal in the 11th to 12th centuries A.D., especially in the exuberance of finely carved ornamentation, though the ornamentation takes the form of lace-work in the former while that in the latter is in low relief. Here in the Museum are Hoysala style individual figures of the Vishnu cult are conspicuous in the forms of Krishna as Flute-player (Venugopāla), Killer of demon Kālīya (Kālīyamardana) or of Sarasvatī, all preserved in the Indian Museum, as are the secular figures representing the dancer in her different poses *in situ* in the Chennakesava temple of Belur or the figures of Sabarī (Huntress) darting arrows, and even figures of Natarāja, though of the Shaiva faith.

Of this period, and perhaps from even a little earlier, examples of Brahmanical deities and Jaina Tīrthankaras from Central India characterized by a limited massiveness are available and are exhibited in the galleries of this museum. These include the Mātrikās or female counterparts (Shaktis) of the well-known deities, as exemplified in the figures of Narasimhī, Vaishnavī, Varāhī, etc. In the Jaina group, a figure of the seated Ādinātha from Sutua is notable.

With unbounded possibilities and patronage, the art of India travelled beyond her immediate borders further into South-east Java (ancient Javadvīpa) 14

and Cambodia (ancient Kamboja). In fact contact between India and Java can be traced back to the early centuries of the Christian era, though from the 11th century onwards monuments in Central Java reveal tangible evidence of Indian influence from the southern regions. The Indian Museum's collection of the specimens representing Brahmanic deities, like the four-armed Shiva, the four-armed Ganesa, the eight-armed Mahishamardinī etc., and figures of the Buddha, of Lokeshvara and of Prajnāpāramitā from Java of about the 9th century and of the mythical bird Garuda, Dvārapāla with staff, etc., from Cambodia, belonging to about the 10th century, is fairly illustrative of this trans-Indian aspect of Indian art.

The Archaeological Section also comprises a very special group of Egyptian specimens including a mummy. This collection has about ten pieces transferred to the museum in 1964 as a gift from the British Museum. These comprise a few Ushabti figurines in blue faience, with an inscribed statuette of Neferibre-sa-neith, along with another interesting specimen of a bronze-head of a cat, both of the XXVI Dynasty, about 600 B.C.

Though the Indian Museum has no gallery of displayed coins, it is in the proud possession of about forty-eight thousand coins in gold, silver, copper, billon and lead, illustrating the different currencies throughout the long history of two thousand five hundred years or more. Since there are hardly any written sources for the chronology of Indian history these coins are an essential help – often the only one – to find out which dynasty was ruling in which area at a certain time of the past. Therefore, the coins are described more detailed than other exhibits. The museum has also a large collection of cameos, intaglios, seals and sealings in precious and semi-precious stones of Greek, Roman, Persian and other origin, which are available on request to scholars and students for study. In two famous collections, the Marshall collection and the Pearse collection, these represent deities and mythological figures including those of some royal and semi-royal personalities. The coin collection includes the earliest issue in circulation in India, the punch-marked coins, from the 6th century B.C. onwards, followed by the Bactrian and Indo-Greek royal issues from the 3rd century B.C. with a solitary issue of Saubhūti (Sophytes), king of Salt Range, assigned to the 4th century B.C., the issues of the Indo-Parthian kings of Taxila, including Maues, the Parthian and first Shaka king, rulers of Drangiana, Arachosia, and finally of western Punjab, from about 120 B.C. to 70 A.D. It also includes the issues of the Imperial Kushānas and their successors, from the 1st to about the middle of the 6th century A.D., trailing up to the Gupta coin-systems, which, drawing upon the Kushānas, emerged to be the first Indian type with its Indian standards, indigenous dresses and accessories, and finally, with its legends in classical Sanskrit. In this last series, a 'King and Queen' type of Chandragupta I, an 'Ashvamedha' and 'Lyrist' type of Samudragupta, a 'portrait' or 'rūpakṛtī' type of Chandragupta II, a 'swordsman' and a 'peacock' type of Kumāragupta I, deserve special mention. The series of early local coins of northern India, from Ayodhyā, Avantī, Kosām and Taxila from about the 2nd century B.C., along with those of the early tribal coins are also represented in the Indian Museum collection. The collection is equally rich in issues of the late medieval North and South Indian types. The latter includes the tiny 'fanams' of the 11th and 12th centuries of the Gangas of Kalinga and the interesting types of the Eastern Chālukyas of the 7th century as well as the later Western Chālukyas of Kalyāna of the 11th and 12th centuries.

The Islamic series is also representative with its numerous varieties of the early Sultans, starting from the bilingual issues of Mahmud of Ghazni to the varied experimentations of Muhammad bin Tughlaq, and some of the early calligraphic types of the Khaljis and the provincial Sultanates, like those of Jaunpur, Gujarāt and the Bahamanis of Gulbarga.

The Mughal issues include early undated silver coins with no mint names, of the time of Bābar, with a copper issue dated 936 H., coined in the 'Fort of Āgra', mentioned as a mint. Early gold coins of Humāyūn that imitate in style and texture the Safavid issues of Persia are represented by a couple of specimens with typical calligraphy. Of the silver and copper issues, a specimen in the Indian Museum's collection of the latter group minted from Āgra as the 'City of the Caliphate' proves the establishment of that city in 937 H. as the capital of the kingdom founded by Humāyūn whose son, Akbar, emerged as the real builder of the Empire. In Akbar's issues, an interesting mint name is the moving mint, the "Victorious Camp", wherefrom two

gold specimens, one dated 984 H. – a unique muhar, and another 'alif', i.e. 1000, are available in the collection, though the system was inaugurated by Bābar much earlier. Almost every denomination of the silver and copper currency is represented, including a few $1/16$ tankas from Delhi and Tattah. In shape and design, Akbar's special liking for ingenuity and his artistic bent of mind is reflected in a lozenge-shaped gold *mihrabi* dated 981 H. At least eight of the Zodiac gold coins issued by Jahāngir are also available in the museum's collections, while as many as five of the Zodiac coins in silver are represented there. There is a mint-less issue of Jahangir's portrait coins showing the bust of the emperor to the left, radiate and holding a goblet in his right hand, with an inscription authenticating the figure as in the sixth year after coronation, and with the reverse revealing a lion to the right, surmounted by a rayed sun and the date 1020 H. Of the silver issues of the emperor, the most interesting group, said to have been issued jointly with the Empress Nurjaban, whose name is also inscribed, is represented by as many as thirteen specimens from widely distributed mints of Āgra, Ahmedābād, Lahore, Patna and Surat. Shāhjahān's issues which are marked by a rare calligraphic and compositional art, are best illustrated in the Indian Museum's varied collections in gold, silver and copper. The inner designs of the lozenge, quatre-foil, eight-foil, square and circle on the reverse of the coins, and the variegated patterns of the flowered field meant to reflect the wide and intensive aesthetic outlook of this emperor, are all available in the large group of gold and silver coins in the museum's collection.

The gold, silver and copper coins of Aurangzeb (1658–1707 A.D.), the son and successor of Shāhjahān, are represented in most of their varieties in the coin cabinets of the Indian Museum. The issues in gold and silver for the limited reign of Alam I Bahādur Shāh, which closely followed the earlier type are also available in the museum's collections. A year's rule by Jahāndār Shāh followed by a short supremacy of Farrukhsiyar for about seven years also saw royal issues in gold and silver that in all their formal style and degenerate execution are a part of this large numismatic collection. Rafiuddarajāt, Shāhjahān II and Ibrāhim, whose reign over one year or a part of it was marked by issues signifying their acknowledged royalty, are repre-sented in their gold and silver issues. Of Muhammad Shāh whose prolific issues in gold, silver and copper only broke the line of quick succession, there are a number of varieties including a few from interesting mints like Akhtārnagar (Awadh), Imtiyāzgadh (Adoni), Muhammadābād (Benaras), Ujjain (Dār-ul-fath), Ajmir (Dār-ul-Khair), Azīmābād (Patna), and so on. The gold and silver coins of Ahmad Shāh, 'Ālamgīr II' (also represented in a few copper ones) and Shāhjahān III, whose short-lived reigns also prove their royal status by issuing coins, have nothing interesting in type and technique. This is once again broken by the advent of Shāh, 'Ālam II whose long reign from 1759 to 1806 A.D. offered a great scope for a revival of the variety in legends and lay-out of the composition. These are all represented in gold, silver and copper in the Indian Museum. Even a pretender in 1788 A.D., Bidar-Bakht, issued a few rare coins, in gold and silver, which have found a place in the museum's collection. Gold became rarer from after Mahammad Akbar II, who followed Shāh, 'Ālam II, in 1806, for about thirty-two years, and whose one gold *muhar* along with a few silver and copper coins, is represented in the collection. The last emperor on Delhi's Imperial throne, Bahādur Shāh II, is represented by a solitary silver issue from Shāhjahānābād (Dār-ul-Khilāfat) dated 1255 H., that is, 1839–40 A.D.

The achievements of India and her southern neighbours, along with a few selected countries beyond her western borders, in the field of applied arts are well-known, especially from about the 16th century A.D. The introduction of Islam into India gave a definite impetus and inspired a great urge for embellishments in all fields – textiles, metal-ware, ivory objects, porcelain, wood-carvings, and the like. The Indian Museum in its Art Galleries has rare and representative specimens of art objects of almost all these categories. This is equally true of miniature paintings, of which some very unique and outstanding specimens are in the proud possession of this great museum.

Among the famous textiles are shawls from Kashmir, the Punjab, Rājasthān and Uttar Pradesh. A few embroidered shawls from Persia, including one with typical English patterns done in Herat, are also noteworthy. A woollen shawl fabric may be sometimes in the form of spreads and blankets. Of the 16

two famous forms known in Kashmir shawl manufacture, namely Tilli Kanikar, and the Amlikar, the museum has specimens done in both. In Kanikar the patterns are elaborated on the loom whereas in Amlikar they are worked out by needles. The usual technique is, however, a combination of both, as is followed in Kashmir, and most of the collections in the Art Galleries of the Indian Museum illustrate this usual combined style of manufacture.

Rare and representative specimens of carpets and woollen *dari* from Kashmir, the Punjab, Rājasthān and South India, with a few special varieties from different parts of West Bengal, like Ranjpur, Tripura, etc., prove that both the pile and the embroidered type of carpet were manufactured in different parts of India. The collection of carpets from Bokhara, Persia, and Tibet also proves that both types were also known equally well abroad.

All the various kinds of cotton sāris, dyed and otherwise embellished, the lace-work and Baluchar Butedars from Bengal, constitute an important group in the textile collections of the museum. Innumerable printed spreads, sometimes used as an inner ceiling cover for the sanctum of temples, stem from different parts of North and South India, like Jaipur, Fatehpur, Bulandshahr, Montgomery and Alwar in the north, and Chingleput, Anantapur, and Arkat in the south, and sometimes they depict interesting scenes from the *Mahābhārata* and the *Rāmāyana*, and from the life of Krishna, and fully reflect the art and technique of Indian cotton-cloth printing. While the Kalamkāri from Āndhra and the Kānthās from Bengal, tinsel prints from Rohtak, Lahore, Jaipur, Indore, Patna and Cuddapah constitute an interesting variety of embellished as well as folk-art in textile manufacture of the last three centuries, a large variety of costumes and cover-pieces *(orhi)*, embroidered or plain, are available from different parts of India, especially Kāthiāwār, where those fitted with glass form a distinctive group. From Bokhara and Tibet, the museum possesses interesting sets of embroidered and brocade dresses.

The Indian Museum collection is very rich in brocades and Kinkhab products of the 18th century from Dacca, Banaras, Lucknow and Aurangābād. Specimens from each of these centres with distinctive patterns and motifs are displayed in the galleries.

In the field of applied arts, enamelled ware, woodcarvings, ivory objects, jade and crystal objects, Bidri work, and Damascened steel-ware, preserved in the Indian Museum, provide an interesting cross-section in the respective fields. The art that flourished through these media for more than three centuries past in different parts of the country gives evidence of the perfection reached in each category and in each style. The museum's collection of woodcarvings illustrates carved wooden fronts of palaces from Kāthiāwār, carved and painted wooden mandapa from Gujārat of the late 17th century, small-scale replicas of the temples of Bengali, and a few trans-Indian specimens which include carved wooden chairs, frames, and copies of templefronts from Burma. A replica of the gateway of Salin monastery (Kyaung) in Mandalay, Burma, done in c. 1895 and another of a teak-wood shrine faced with coloured glass (c. 1895). deserve mention.

The Indian Museum has crystal from Jaipur and other places of India, and from Nepal. The famous cut-glass ware from Lucknow has also found a conspicuous place in this museum's collections.

The commendable collection of old shoes made of cloth, velvet and leather, from places known for their typical styles and manufacture, such as Cuttack, Peshawar, Lahore, Ratnagiri, Nāsik, Ahmedābād, Shillong and Sarone in Bengal, is noteworthy. In the group of caps and turbans, the typical specimens from Kashmir, Darjeeling, Patna, Peshawar, Bombay and Ahmedābād provide interesting examples. A large variety of mats and carpets also form an interesting part of the museum's collections. They represent the wealth and variety of material in this category, coming from Peshawar, Daman, Palghat, Monghyr, Balasore, Patna, Ganjam and Naogaon.

In the matter of printed and dyed cloth, apart from the tie-dyed specimens from Jaipur, the museum's large variety also include a few rare examples of 'wax technique' from Peshawar, Baroda, Kutch and Chanda. Concerning decorative textiles, viz., spreads and screens, the museum also possesses at least two important specimens of Burmese appliqué work, known otherwise as Kalaga, showing mythological scenes, interspersed with decorative patterns, where the designs first drawn are worked out by both embroidery as well as pasted pieces of cut paper or cloth.

A large collection of Tibetan and Nepalese bronzes of the 17th to 19th centuries, with a few Chinese specimens, provide and interesting side-light on the sculptural art in bronze that these neighbours of India developed in the comparative periods. Apart from their iconographic interest they artistically reveal the excellence the art of metal casting had reached in these obscure lands.

Last but not the least, among the fine arts, the miniature paintings in the museum's collection are as commendable in their variety of subject matter as in that of the different styles and manners. The collection consists of the earliest available miniatures on palm-leaf manuscripts of the 12th century and extends to the works of the Bengal revivalists in the persons of Gaganendranath Tagore, Abanindranath Tagore and Nandalal Bose. Almost all the important schools of miniature painting like the Rājasthāni, Mughal, Pāharī and the later Provincial schools are well represented. The Rājasthāni style had flourished in a number of centres like Mewar, Marwar, Bikanir, Jodhpur, Jaipur, Kishengarh, Kotah and Bundi, each of which came to signify a school. A few of the smaller territories within these areas also developed well-known centres of miniature painting and gave rise to distinctive traits. A few styles centered around a cult or a faith. The Indian Museum is well-known for a few of its Mewar paintings, some superb Jodhpur portraits and a few colourful Jaipur paintings including a series depicting Rāgas and Rāginīs, ascribable to Ambar and other places.

In the Mughal series a painting on cloth, probably showing prince Akbar coming out of a fort on horse-back, a hunting scene showing Emperor Jahāngīr hunting a lion, a beautiful turkey-cock by the famous artist Mansūr, a painting depicting a group of Muslim priests and scholars engaged in deep discourse at night, probably of Shāhjahān's period, another showing three ladies visiting a Fakir, and yet a fourth one delineating an episode from the famous love-story of Sohni-Mahiwal, deserve special notice among a host of similar others. Portrait paintings of the Mughal School constitute, however, the main forte of the collection. Emperor Jahāngir standing before his father Akbar holding a hawk, Prince Dārā Shikoh on a prancing horse, Prince Muhammad Murād on an elephant, painted by Ghulām, Emperor Jahāngir and Jodhabai standing

under a tree, a grand profile of Prince Shujà, Emperor Shāhjahān's second son, are some of the outstanding specimens in the most varied collection of the Indian Museum. Court scenes, a distinctive contribution of the Mughal artists are a rare treat, which, in a few examples, is amply testified. The presentation of Todar Mall at the court of Akbar is a typical example in this group, where the famous courtier is ushered in before the emperor who is seated on the octagonal throne of Persian style. The entire composition smacks of the early Persian influence on Mughal painting, which in a way, led to its sturdy foundation. The delicate shading and fineness of the lines, a great calligraphic quality in Mughal painting, stand out pre-eminently. Apart from, and in addition to, portraiture and court scenes, the world of plants and animals was the subject of special study, and the rarer and the more unusual specimens were ordered to be drawn for the emperor in Jahāngir's time. A famous painting of a turkey-cock of the period of Jahāngir from the brush of Ūstād Mansur, the famous court-artist of the time, with an inscription exemplifying such miniatures, as already referred to, adorns the collection of the Indian Museum. Indeed, in some examples preserved here, like the Mughal battle scene, a remarkable feeling for fore-shortening as some of the artists of this period developed and introduced in India, is noticeable in the required grouping and placing of figures. While the Indianization of the form and the environment was complete in Shāhjahān's time, the art started showing perceptible decadence in so far as fineness and sobriety, and the rare amount of simplicity of the preceding epochs, are aconcerned. The art of this decadent Mughal style is preserved in the Indian Museum in a few examples from the time of Aurangzeb onwards into the late 17th and 18th centuries.

The Pāharī style, represented in specimens from Guler, Basohli and Kāngrā in its classical phase and followed up in a number of other centres, such as Punch, Garhwal, Chamba, etc., is also to be seen in some of the best examples preserved in the Indian Museum. A portrait of Rādhā with a rose in her hand, of the Kāngrā school, assignable to the late 18th century A.D., and another painting showing ladies bathing in a tub inside a well-laid garden, in the same style and probably drawn in the same period, provide typical examples. Of the same school 18

is a famous example preserved in the Indian Museum, depicting the Sandhyā Tāndava or the Cosmic Dance of Shiva in the evening. Here Siva dances before Devī, his consort, on the golden floor of Kailasa towering above the peaks of the encircling Himalayas, to a chorus of the different other gods (devas) and semi-gods (gāndharvas). Some of the paintings depicting ordinary scenes of life, especially connected with active love and its preparation, like the toilet of a lady, probably Rādhā, the holy festival, a damsel with a fan in her hand standing before a group of birds and animals, illustrate the lyric character of Indian Pahari paintings in the classical Kāngrā style. Here nature has been brought into the fore-front in order to embellish human feelings and sentiments. Pāharī miniatures are, as it were, the most appropriate plane for a close commingling of nature and man, one supplementing the other. And in this, so far as the drawing itself is concerned, the fineness of the lines was introduced from the Mughal style and technique and continued through the work of the artists who came to the smaller states of the western Himalayas (Pahārī) after having been dispersed from the disintegrating Mughal court.

DESCRIPTION OF ILLUSTRATIONS

3 *Hand-axe*. Attirampakkam. Palaeolithic age. This is a typical massive rock fragment of quartzite chipped into a cleaving or a smiting implement resembling early Stone age implements of N. and S. Africa, Central America and Europe. It is evidently from the palaeolithic locality at Attirampakkam in the Chingleput Dist., Madras, discovered and explored in 1863 by R. B. Foote and W. King jointly.

4 a) *Square steatite seal* with intaglio design of unicorn, with semi-pictographic script. 4.2 cm. ×4.2 cm. Harappa. 3rd to 2nd millennium B.C. The ox-like quadruped animal has apparently one horn which may merely be a convention intended to illustrate one horn behind the other. The unicorn is the commonest representation found on Indus seals and is invariably shown with a short post before the animal. This latter is interpreted to be either a decorative manger or an incense-burner.

4 b) *Terracotta human figure, male*. Height 10.8 cm. Harappa. C. 3rd millennium B.C. These figures with pellet eyes and slit or applied mouths and pinched -up noses are presumably secular and not necessarily religious in conception, and may represent a popular form of art which appears to be a transition from the early bronzes.

Terracotta human figure, female, nude. Height 11.5 cm. Mohenjodaro. C. 3rd millennium B.C. Here in the Indus Valley civilization, in all female figures the pinched-up broad-top head-gear is typical of the terracotta art from Mohenjodaro and Harappa. The ornaments generally consist of three to four rows of hanging *hāras* with pelletted lockets, and a close-fitting necklace. Ear ornaments are also very common, while girdles were also known.

5 a) *Copper bangle*. Diam. 6 cm. Mohenjodaro. 3rd–2nd millennium B.C. Copper objects from the Indus Valley civilization are not unknown and the present bangle shows that these were used as ornaments as far back as the chalcolithic culture.

Beaded necklace. Beads of semi-precious stones in necklace formation. Mohenjodaro. 3rd–2nd millennium B.C. The beads and jewellery from Mohenjodaro and other Indus civilization sites show distinct links with the ancient civilizations of the West such as developed in Syria, Crete, Egypt and Ur, Kish and Tell Asmar. The beads include those in faience, etched Carnelian, etc.

5 b) *Copper object* representing anthropomorphic form with straddled legs and incurved arms. Fategarh, Uttar Pradesh. The Neolithic period was succeeded by a Copper Age culture in India which is represented by implements and weapons found in almost all the regions of North India from Kurram in the former north-western frontier Province, now in Pakistan, to Midnapur in the east and from the foot of the Himalayas to the Kanpur district in Uttar Pradesh. This figure in a crude human form from Fatehgarh in Uttar Pradesh is one of the rarer products of this age.

6 a) *Lance-head of bronze*. Length 18.2 cm. Chalcolithic period. This specimen is a flat, leaf-shaped blade, made of bronze. From the chalcolithic period, large hoards of copper are found in the Gangetic doab though a few bronze implements also formed part of them. The mother-sites of the Indus Valley Culture, Harappa and Mohenjodaro, also produced a few bronze pieces as parts of implements, which are assignable to the chalcolithic periods. The present specimen, a spear- or lance-head from Harappa, is an interesting find in this respect.

6 b) *Bar celt of copper*. Length 55 cm. From Gungariā, Bālāghāt Distr., Madhya Pradesh. Chalcolithic period. Of these collections, flat copper celts formed an important part. The present example is a typical piece with parallel-sided bar from the area.

Copper sword with antennae hilt. Locality unknown. Probably from Fatehgarh, Uttar Pradesh. Post-palaeolithic period. C. 1700–1000 B.C. Within the Gangetic doab there has been found as a result of extensive explorations a large and distinctive series of copper hoards comprising a wide variety of objects which include a few swords usually with the hilt or tang bifurcated like antennae.

Some thirty-four sites have produced implements of these types, mostly in hoards from Uttar Pradesh, Madhya Pradesh, Vindhya Pradesh, Bihār, Andhra Pradesh, West Bengal and Orissa.

7 *Capital of pillar with couchant lion.* Rāmpūrā, Bihār. Maurya style. 3rd century B.C. Of the few capitals of pillars still surviving from the Mauryan era, this one shows a single lion couchant in its majestic glory. Discovered at Rāmpūrā in Bihār, it bears the typical Mauryan polish on the lion as well as its seat composed of a circular *abacus* consisting of a decorative band and an inverted lotus below it. The *abacus* has the typical Mauryan decorative motif with pairs of birds and animals interspersed with floral patterns. The entire composition shows strong influence from the contemporary old Persian art traditions especially in the majestic lion, the *abacus* decoration and the inverted lotus with its banded petals.

8 *Yakshī Sudarshanā.* On rail-pillar, Bhārhut. Sunga. 2nd century B.C. The figure carved in relief bears an inscription in contemporary Brāhmī script which labels it: *Yakhini Sudasanā.* The *stūpa* railings come from Bhārhut, a village in the former Nagod State, Madhya Pradesh, where a *stūpa* originally stood but was not very much in existence in 1873 when the railings were discovered by General Cunningham.

9 *Horseman with a Garuda standard.* On rail-pillar, Bhārhut. Sunga. 2nd century B.C. This is one of the many royal figures, apparently devotees, coming to pay homage to the *stūpa* at Bhārhut, or perhaps representing the royal personages connected with the donation of these carved pillars at the site. This figure holds a Garuda standard in the right hand and the reins of the horse with the left. The composition as usual has a half-circle medallion representing a petalled lotus above, serving as an auspicious and decorative motif. The presence of the Garuda standard clearly indicates that the person was devoted to Vaishnavism and thus suggests the wide reverence in which the Buddhist *stūpa* was held.

10 *Scene of Māyā's dream.* On rail-pillar, Bhārhut. Sunga. 2nd century B.C. Here is illustrated the descent of the Bhagavat, i.e., the Divine Bodhisattva Shākyamuni, from Tushita Heaven, in the form of a White Elephant – a phenomenon which is duly labelled as *Bhagavato ūkramti*, i. e., 'the Descent of the Lord', in contemporary Brāhmī script. The queen is shown as sleeping on a couch, while a pair of female attendants, apparently drowsy seated with their back to the onlocker and another with folded hands attending near her head, are depicted with the rare frontality of early art. A water-pot on the ground and a lamp on a stand with burning flames near her feet add a realistic touch to the composition.

11 *Mahā-ummagga Jātaka.* On rail-pillar, Bhārhut. Sunga. 2nd century B.C. This is one of the many Jātaka stories or legends from the previous births of the Buddha. According to the legend illustrated here, the Bodhisattva was born as Mahosadha, a merchant's son, at a place called Yava-

majjhaka near Mithilā. On hearing of his extraordinary wisdom, the king of Mithilā invited him to the capital where he lived as one of the king's favourites. The king's four ministers gradually grew jealous of Mahosadha and in order to bring the latter to disrepute stole four precious things belonging to the king and keeping them concealed in Mahosadha's house, informed the king. On receiving a timely warning, however, Mahosadha managed to escape from his house in disguise. The four ministers tried to win over Amarā, the wife of Mahosadha, who ultimately entrapped them all and put them each in a basket, and were produced at the royal court, proving their guilt thereby. The relief shows the baskets being uncovered by a man and Amarā pointing at the deceitful persons. The label in contemporary script reads:
Yavamajhakiyam Jātakam, i.e., the Episode of Yavamadhyaka, the place of the incident.

12 *Gajalakshmī.* On rail-pillar. Bhārhut. Sunga. 2nd century B.C. Gajalakshmī is also known as a fertility goddess. She touches her left breast with her right hand pointing to the eternal source of life and sustenance and with the left hand holds the ends of the lower garment which is tied with a heavy knot in front. She stands on a lotus, the stem of the plant issuing out of a vase. A lotus springs from the stem on either side of the figure and an elephant resting on each lotus pours water on her head from a jar held by the trunk.

13 *Scene of Māyā's dream.* Amarāvatī. 2nd century A.D. Amarāvatī in Madras, South India, was a prolific centre of Buddhist art in the 2nd century A.D. Plaques in green schist showing scenes from the life of the Buddha in bas-relief and meant to be set up on the walls and pillars and the lower part of the *stūpa* are typical examples of this art which bears at places influence from the contemporary Roman art with which the neighbouring areas had commercial contact mainly through the sea route.

14 *Yakshī.* Kushāna period, Mathurā. 2nd century A.D. In Mathurā art of the Kushāna period the female form in all its delicacies was one of the main themes of expression. The present figure, conveniently called a Yakshī, in view of its idealistic conception, represents a lady holding a cage in her right hand from where a parrot is apparently let loose to take her seat on her delicate left shoulder. The apparent nudity with the prominent suggestive ornaments is due to the diaphanous apparel that the lady wears and was a deliberate idiom with contemporary artists in their keenness to show the delicacies of the female form in their different twists and bends of the limbs and the poses. A general massiveness pervades the whole style.

15 *Bodhisattva.* Gandhāra. 1st century A.D. Gandhāra art which flourished in the North-western frontier areas of the Indian sub-continent, now included in Pakistan, is marked by a singularly Greek influence with touches of Roman traditions here and there and extends from the 2nd century B.C. to almost the 2nd century A.D. Here figures of the Buddha and of the Bodhisattvas are taken from

20

Greek models characterized by broad shoulders, general muscularity of forms, aquiline noses and Greek styles of dresses. In Bodhisattva figures, ornaments of contemporary Greek origin, especially in the torqué, the single strapped sandals and the moustached faces, emphasize in an unmistakable way the stamp of this foreign influence in the Gandhāra art of India.

16 *Standing Buddha.* Gupta period, Mathurā. 5th century A.D. In both the Kushāna and the Gupta periods, Mathurā continued to be a great centre of art in stone carving. Standing figures of the Buddha in red sandstone were special favourites here in these periods, as Buddhism continued to have the most gripping hold in the region at that time. The figure, remarkable for its exquisite expression of calm compassion, is a typical example of the classical Gupta art of Mathurā. The diaphanous garment of the Lord reveals the superbly delicate form of the limbs underneath, recalling moulded works with delicate and clever modelling.

17 *Standing Buddha.* Gupta style. Sārnāth, Vārānasi. 5th century A.D. One of the important centres for the flowering of the Gupta art was the monastery area of Sārnāth (anc. Sāranganātha – Lords of the deer) in the suburbs of modern Banaras (Vārānasi). Approximately identical with the site of the First Preaching by the Buddha, this area has yielded figures mostly standing, with the typical halo of the period. These exemplify the eastern varieties of the style with half-closed eyes so characteristic of the benign and compassionate attitude of the Lord for the suffering Universe. The protruding lower lip, the long drawn eyebrows, the smooth and delicate forehead, together with the delineation of the 'marks' of the 'Great Men' like the long ear-lobes, the extended cranium, the curls of the hair, the membranous joining of the fingers, the marks of the discus etc. on the palms and the soles, constitute a special feature of in this eastern variety of Gupta art of the 5th century A.D.

18 *Nāga couple.* Gondhawana, Madhya Pradesh, 9th century A.D. Personified Nāgas, i.e., serpents, as individuals or as embracing couples entwined in their tails, are found as temple decorations in Madhya Pradesh, Orissa and Bihār-Bengal during the early medieval and medieval periods in great abundance. These Nāga figures carry, in a large number of instances, bowls of jewels, signifying their association with the nether regions. Both the figures have a five-hooded canopy at the back signifying their serpentine character. The entwining tails reveal a symmetry in composition with a loving expression on their faces while in deep caress.

19 *Padmapāni-Buddha.* Gupta style. Sankissa, Farrukhābād. Padmapāni figures up to the late Gupta period afforded scope for the study of the artistic expression in examples other than the representations of the Buddha which in their wealth of variety were already a speciality. Here in this figure of Padmapāni, the halo is especially noteworthy, which in its expanded lotus form typifies the art

of that time. The figure, fragmentary though it is, bears an expression of smiling compassion on his face, and holds a rosary of beads in the right hand which is still intact, and bears the effigy of a Dhyāni-Buddha on the crest made up of matted hair. The figure comes from Sankissa, Dist. Farrukhābād in Uttar Pradesh – a site noted for the prolific production of icons of Buddhist origin in the Gupta period.

20 *Nāga couple.* Bihār-Bengal. 9th century A.D. Figures of Nāgas and Nāginīs are found in large numbers in sculptures of the early medieval and medieval periods in Madhya Pradesh, Orissa and Bihār-Bengal. This figure, one such from Bihār, in deep caress, shows the male with a five-hooded backpiece and the female with a three-hooded one.

21 *Vishnu with Lakshmī and Prithivī.* Bengal. Pāla or Sena period. In Bengal, especially in the late Pāla and Sena periods, figures of Vishnu with consorts, Lakshmī and Sarasvatī, were very much in favour. In both stone and bronze, such figures showing Vishnu in all the twenty-four varieties of his forms are found in great abundance. Here Vishnu in his Trivikrama incarnation has in his four hands, anti-clockwise, the club *(gadā)*, lotus *(padma)*, blowing conch-shell *(shānkha)* and the disc *(chakra)*. The two figures on the two sides, however, represent here probably Lakshmī and Prithvī, both holding a lotus in their left hands. Vishnu wears the garland of flowers *(vanamālā)*, and stands on a double-petalled lotus. The entire composition has a linear rim set with flames of the cosmic fire, and stands on a *pancha-ratha* pedestal or a recessed stool made up of five rectangles.

22 *Mother and Child.* Sena period. North Bengal. 11th century. These slabs in black basalt are oblong pieces and bear all the usual decorative elements common in the period. The figure of the mother with the highly decorative head-dress and a typical hair-do reclines on a decorative pillow and is supported on her own left hand, the right hand apparently resting on the right hip being broken. The close-fitting torqué, the flowing *hāra*, the *kundalas* in the ear and the rows of bangles and ornaments for the upper arm and the ankles are typical of the style under the Senas. The slab has a row of deities starting with Ganesha followed by the Nine Planets *(Navagrahas)* and ending with the Lingam (the Phallic emblem of Shiva) – all in miniature marking and auspicious presence for a sacred occasion of a mother lying with her baby.

23 *Kārtikeya.* Sena period. North Bengal. 11th century. Kārtikeya, son of Shiva and Pārvatī and the god of the Divine Army, according to Hindu mythology, is here represented, as usual, as riding a fan-tailed peacock and has in his four hands, the arrow and fruit in the right hands, upper and lower respectively, while the lower left rests on the lap and the upper left holds the bow which seems to be broken. In the black basalt of North Bengal, the piece shows the artistic excellence to which Sena icons reached with their neat perfection of forms and developed

ornamentation with a measured and subordinated profusion.

24 a) *Tārā*. Height 9.5 cm. Nālandā. 10th century. Nālandā noted for its bronzes in miniature stone figures, offers almost a complete pantheon of Mahāyāna Buddhism figured during the period from the 9th to about the 11th centuries A.D. The figure in high relief, a skilled miniature, represents the goddess Tārā with her typical coiffure and ornaments, like the *tiara* on the forehead, the *kundalas* in the ears, the wristlet, the necklace, the waistband and the anklet. She has a symbolic fruit in her right hand which is shown in the boon-giving pose *(varadamudrā)*, while her left hand holds the stalk of a lotus. To her right is a miniature *stūpa* characteristic of the figures of Buddhist affiliation. The stele is in the characteristic horseshoe shaped arch which has the symbolic cosmic flames around the borders as typical of the style of the period.

24 b) *Devī*. Chola. 11th century. The Cholas who successfully improved upon the beautifully slender forms in the late Pallava art of the 7th century have left some exquisite pieces in bronzes, unique and unsurpassed. Devī, the consort of Siva, shows here in the right hand the pose of holding a lotus while the left hand dangles down at ease. She wears the typical ornaments of the Chola period with a *karanda-mukuta* on the head. Her full bosom, her high hips, her slender middle and deep navel are meant to indicate the perfect beauty of the female form.

25 a) *Buddha*. Bronze. Chittagong. Bengal. 11th/12th century. Of the few centres of Buddhist art in Bengal, Chittagong, now in Bangladesh, ranked as an important one in the early medieval period. Following the traditions in Nālandā, bronze-casting in this area must have continued down to the 11th–12th centuries of the Christian era. The standing figure of the Buddha holds the monk's frock *(chīvara)* by the left hand and shows the Protection *(abhāyamudrā)* with the right hand. He stands on the *Vishva-padma*, i.e., the cosmis lotus, in the characteristic poised pose.

25 b) *Seated Buddha*. Nāgapattinam. 12th century. The hoard of Nāgapattanam bronzes was discovered in the later half of the last century and revealed a large number of seated and standing Buddha figures, some of which are inscribed. The figure shows the Buddha in *bhūmisparshamudrā*, the earth-touching attitude, with his right hand, while the left as a part of the meditating attitude *(dhyānamudrā)* rests on the lap. The figure is seated on a double-petalled lotus. Bronzes from Nāgapattinam are characterized by a heaviness and a simplicity which distinguish them both from the Chola bronzes and the later creations in more decorative forms of the southern and eastern parts of India.

26 *Sarasvatī*. Black schist. Hoysala art. Belūr. 12th century. Sarasvatī, the goddess of learning and music, is here depicted with the profusion of ornamentation usual in Hoysala art. Halebīd, the ancient Capital city of Darasamudra in Mysore, South India, one of the major centres of this art, is characterized by a massiveness which is replaced by more delicate forms at Belūr. Here Sarasvatī holds in her four hands, anti-clockwise, an elephant-goad *(ankusa)* in the upper right, the manuscript *(pustaka)* in the lower left, the noose *(pāsa)* in the upper left, the right lower hand being broken.

27 *Woman writing a letter*. From Khajurāho. Chandella. C. 11th century. The Chandella art which flourished mainly under the two kings Yashovarman and Dhanga, principally centered round a group of temples standing at the village of Khajuraho. These temples were built during the period from the first quarter of the 10th to the middle of the 11th century.

28 *Devī with Ganesha and Skanda*. Halebīd. 12th century. This is one side of a corner piece showing Devī standing, holding in the three right hands, the elephant-goad *(ankusa)*, the lotus *(padma)* and a rosary of beads *(akshamālā)* respectively, and showing the boon-giving pose *(varadamudrā)* in the lower left while carrying the noose in the upper, with the third hand on this side broken. At her right is four-armed Ganesha holding anti-clockwise, a battle-axe *(parashú)*, a broken tooth *(ekadanta)*, a bowl af sweets *(modaka)* and a noose *(pāsha)*. Skanda's figure to her left is damaged except for his vehicle, the peacock.

29 *Buddhist goddess*. Stone. Height c. 1 m. 11th/12th century. It is characterized by a lotus throne and lotus petals rising at both sides. Two other goddesses are characterized as servants of the main goddess by their smaller size. The rich decoration at the sides and the upper and lower ends of the stele is a feature of both Hindu and Buddhist sculptures of the Pāla-Sena period in Bengal.

30 *Jaina Tīrthankara Ādinātha*. Sutna, Madhya Pradesh. 12th century. This figure reveals the Shrīvatsa mark on the chest. Two elephants, one on each side at the top, decorate the attending figures *(parikara)*, with celestial garland-bearers immediately below them, while two Chāmara-bearers or devotees with fly-whisks, stand as attendants at the two sides. The seat is apparently borne on two lions below, flanked by a Yaksha and a Yakshī, as noted above.

31 *Lion and rider*. Khajurāho. Chandella art. 11th century. A.D. The Chandella art is based on different types of themes some of which are erotic, others decorative and symbolic. The mythical lion figures falling under the last category are characterized by the delicate curvature of bodies with sensitive embellishments. Here the lion with a rider bears marks of Chandella sovereignty on its hips and triumphs over a warrior symbolizing superiority of royal prowess.

32 a) *Brocade*. 93 cm. × 76 cm. Banaras. C. 18th century. Regd. No. A.G. 45.
Banaras is famous for brocades which were essentially silk pieces woven in gold and silver threads, in designs most of which are traditional, like the *Kalgā* in its different varieties and a few well-known flowers, fruits and birds. The present specimen perhaps represents the poppy plant with a peacock on each side, symmetrically placed near the

apex of the tapering top, like two leaves on the sides of the fruit. The peacocks and the upper half of the plant are in gold threads while the lower half is in silver threads. The containing design of the plant is in the form of a flowering bushy tree with flowers placed symmetrically inside. Brocades were greatly patronised by the Mughals and during the 17th and 18th centuries these reached almost a perfection never surpassed thereafter.

32 b) *Sandal-wood box* veneered with tortoise shell and overlaid by fretwork of carved ivory. Breadth 34.5 cm., Length 27.5 cm., Height 15 cm. Visākhapattanam, Southeast India. C. 19th century. In India, the art of veneering has been known and practised since the late 18th century. Jewel boxes or other articles of use are made of sandalwood, and tortoise-shell in either veneered, or, as here, pegged down by nails to the outer surface, on which there is an overlay of carved ivory in delicate fret-work.

33 a) *Bullock cart.* Ivory. Length 16.5 cm. Murshidābād. Late 19th/early 20th century. Murshidābād in lower Central Bengal following a tradition of Mughal patronage from the 17th and 18t hcenturies developed a special love for the art of ivory carving during the time of the Nawabs. Contemporary life in all its commoner phases also provided the most powerful themes of the art and bullock cart with a peasant as its rider wearing a hat woven of bamboo-slices *(tokā)* to keep off sun and rain and holding a hubble-bubble for smoking made of the cocoanut shell *(hookah)* as representing a life-picture of a Bengali peasant, was naturally a favourite theme, being ready at hand all around.

33 b) *Maūyr-Pankhī boat.* Ivory. Length 28 cm. Murshidābād. Late 19th century. The celebration of Naora, a festival when courts were held on decorated boats of different shapes like that of a peacock, fish, etc., floated on the Bhāgirathī (r. Ganges), was started by Nawab Sirāj-ud-daulah, so that these provided a theme for the ivory carvers. Another similar festival, Berah, with illuminated and decorated boats on the river, accompanied by fireworks, also inspired the artisans in making these miniatures. Boats were embellished with rich decorations on the outside, mostly floral patterns, and were endowed with pavilion apparently in Rājasthani style. While the broader front ends of the boats were in the peacocks' body, the thinner rear end was given the form of a *makara*. These boats were meant as mementos commemorating the happy events of the festivals, to be preserved or presented as souvenirs of great artistic value.

34 *Amphora-shaped vase.* Lacquer on cloth. Height 44 cm. Kashmir. 19th century. Lacquer work on various objects of use including painting in lacquer on wood was known in Persia from the early 17th century. The valley of Kashmir drew a great deal from the motifs and designs, and also was influenced largely by the techniques in many fields of Persian arts and crafts. The floral patterns in red, yellow, orange and black in frontal, profile and three quarter profile, in buds and in full bloom, are spread over the

whole area, with two bands, a short one at the bottom and a broader one near the neck.

35 *Natarāja or Shiva as the Cosmic Dancer.* Kerala. C. 14th century. The figure typifies the art style of that region, with its sharp angularity of features reminiscent of wooden figures of the period in the extreme south of India. Here Shiva has, as usual, the Cosmic Drum *(damaru)* in the upper right hand with the lower right showing the pose of offering protection *(abhayamudrā)*, and the lower left pointing to his own feet as the source of salvation, while the upper left holds the Cosmic Fire, the source of ultimate destruction. The figure stands in the 'raised leg pose' *(ūrdhajānu)* with dwarf figure *(apasmāra purusha)* embodying all ignorance, down on the pedestal, as though being crushed by Siva.

36/37 *Gupta coins.* Gold. C. 320–480 A.D. These coins represent the currency of the Guptas who issued them mostly in gold, and sparingly in silver and copper. The period covered by these coins spread from about 320 A.D. to 480 A.D. when Skandagupta ended his reign.

(1) Coin of Chandragupta I. Wt. 7.58 gms. Size 1.93 cm. The *de facto* founder of the dynasty Chandragupta I (or, according to some, his son and successor, Samudragupta) issued this type known as the 'king and queen' type in which on the obverse the haloed figures of the king and his queen of the Lichchhavi clan of Vaishāli are represented as standing, facing each other, with the name *Chandra* written under the left arm of the king in contemporary Gupta script; the reverse is occupied by the figure of a goddess on a lion couchant on a lotus, holding a noose in the right hand and cornucopiae in the left, with the name of the clan of the queen inscribed towards her left: *Lichchhavavah.*

(2) Coin of Kacha or Kācha (Gupta). Wt. 7.52 gms. Size 2.03 cm. On the obverse is the figure of the king, from the inscription below his left arm, *Kacha*, said to be of the same name, whose identity with Samudragupta, the son and successor of Chandragupta I, is suggested, standing in royal majesty with his right hand on an altar and left holding a standard surmounted by a rayed disc, the legends around reading: *Kacho gamavajitya (xarma) bhirutta (mairjayati)* (Kacha having conquered (attained) the heaven by excellent deeds, excels). The reverse has a robed haloed goddess, with a flower held in her right hand and cornucopiae by the left arm, the legend at her left, sideways, reading: *Sarvarājo-chchehetta*, i.e., Exterminator of all kings.

(3) Coin of Samudragupta. Wt. 7.63 gms. Size 2.10 cm. This represents the best-known variety of Samudragupta's coins, the 'Asvamedha', type, in which the sacrificial horse is represented standing to the left, facing an altar with portions of the legend cut away and the letter 'Si' inscribed between the pairs of the legs. The anatomy of the animal is perfectly drawn. The reverse shows a haloed lady carrying a Yak-tail fly-whisk in her right hand, with her left freely stretched down, beyond which from top downwards, inwardly, a legend reads: *Aśvamedha-para-*

krama(h), i.e., 'of prowess (measured by the performance of the Horse-Sacrifice').

(4) Coin of Samudragupta. Wt. 7.26 gms. Size 2.05 cm. Of the other interesting and novel varieties introduced by Samudragupta, the 'Lyrist' type constitutes a unique issue in which the haloed king is shown as seated on a high-backed couch playing on a lyre-type *vīnā* resting in his lap. There is a syllable *Si* only partly visible on the foot-stool below, which is also partly noticed, and a running marginal legend around clock-wise from the back of the head: *Mahārājādhirāja-Shrī (Samudra) guptah* (Shrī Samudragupta, the great king of kings). The reverse shows a seated goddess on a wicker-stool holding a noose in the right hand and a cornucopia in the left. Legend, downward at right, behind the goddess, reads: *Shrī-Samudraguptah*.

(5) Coin of Samudragupta. Wt. 7.50 gms. Size 2.08 cm. The 'Archer' type of king Samudragupta's coins was one of the commoner varieties issued by the king, where the obverse shows the king haloed, standing in majesty holding the end of a bow in the left hand and an arrow in the right, with a Garuda-standard beyond the right, and legends mostly cut away, all around, with the name of the king, *Samudra*, vertically down below the left arm, in the typical Gupta form of Brāhmī script. The reverse shows the throned goddess Lakshmī-Ardochsho with noose and cornucopiae, and a clear legend at left: *Apratirathah* (Invincible).

(6) Coin of Chandragupta II. Wt. 7.66 gms. Size 2.08 cm. The 'couch' type of coins of Chandragupta II, which because of their legend *Rūpākritī* or 'Beauty and Form' on the obverse, are also known by this name, and are one variety of the very personal issues minted by this son and successor of Samudragupta whose 'Lyrist' type is an attempt in this direction. Here on the obverse, the king is seated on a couch, depicted very realistically with its three legs visible, holding a flower in his right hand and the left resting on the couch, with the left leg stretched down and resting on a foot-stool and the right tucked up on the couch. The king, apparently bare-bodied, is haloed and wears ear ornaments. While the legend around, cut away in the middle, gives the name with the titles of the king, the exergue below the seat contains the distinctive legend. The reverse shows a damaged figure of the throned goddess Lakshmī-Ardochsho, with noose and flower in the right and left hands, and the feet resting on a lotus. The legend: *Shrī-Vikramah*, is also not clear.

(7) Coin of Chandragupta II. Wt. 7.80 gms. Size 2.36 cm. Of Chandragupta II's various types, the one showing himself as a 'Lion trampler' is vividly dynamic. Here the king is shown in an energetic attitude trampling on a lion with his left hand drawn to the full, with his right hand drawing the string and holding the end of the arrow near the right ear. This conforms to the traditional shooting posture in which he darts the arrow right into the mouth of the animal. Legends around are almost cut away. The reverse shows the goddess seated on the lion with noose and

a lotus in right and left hands respectively, and a legend at left, reading: *Simhavikramah*, i.e., 'Of the prowess of a lion'.

(8) Coin of Kumāragupta I. Wt. 8.25 gms. Size 2.03 cm. Kumāragupta I, who succeeded Chandragupta II, is perhaps one of the few kings who figured himself in standing and other poses with a most excellent modelling of the form. Here depicted in the act of feeding a fan-tailed peacock, standing and slightly bent to his right with the left hand resting on the hip, the king with his peculiarly curled hair, and his ornaments and his surroundings, truly resembles Kārtikeya, with whom he is actually compared in the legend which reads: *Javati Srī Kumāro* (i.e., Kumāragupta or Kārtikaya, known otherwise as Kumāra, excels). The reverse has a frontal representation of a goddess riding a fan-tailed peacock also frontally depicted, holding a sceptre in her left hand and scattering grains with her right hand which is shown slightly open. The figurization is excellent with her typical ornaments. Legend appears to be damaged.

(9) Coin of Kumāragupta I. Wt. 8.06 gms. Size 1.93 cm. Kumāragupta I in another interesting variety, viz., the 'Elephant rider' type, illustrates the majesty of the king, with the latter shown riding on an elephant which is shown in great movement, with an attendant behind, holding the royal umbrella over him. The king holds an elephant-goad in his right hand, while his left arm rests on his hip, and a legend almost entirely cut away and greatly obliterated, is slightly visible at the margins all around. The reverse with a nimbate goddess standing frontally on a lotus has also marginal legends mostly cut away. The goddess holds a lotus in the right hand and an indistinct object in the left.

(10) Coin of Skandagupta. Wt. 8.53 gms. Size 2.03 cm. Skandagupta of the Imperial Gupta dynasty and son and successor to Kumāragupta I, adopted at least one of the types of his immediate predecessor and also imitated a well-known variety of his forefather, viz., the 'King and Queen' type of Chandragupta I, though with much better modelling and more lively expression of the figures. Here the king and the queen stand facing each other in a bent pose, with a Garuda standard in between. The king at the left has the right hand on his hip, holding the arrow which hangs from his hand, with the left hand grasping the bow. The left leg is placed forward with the left knee slightly bent in a graceful pose and the right leg straight and stiff. The queen raises her right hand, with the left hand holding the stalk of a lotus. The Garuda on the standard is clear in its birdform and is frontally represented. The name *Skanda* in contemporary script is written in bas-relief vertically down near the head of the king. The reverse, partially blurred, shows the nimbate goddess, Lakshmī, seated on a lotus, holding a noose in the right hand and a lotus stalk in the left. At her left the legend reads: *Shrī Skandaguptah*.

38 *Old woman begging for justice from Sultan Sanjar.* Illustration to Khamsa-i-Nizāmi. Persian. C. 15th–16th century. Dur-

ing the 15th and 16th centuries, Shirāz produced a class of these paintings which related to the different legends and stories current in the Persian literature of the time and which was characterized by a colourfulness in which blue, brown and chocolate along with gold predominated. Here in general the human figures are more or less subordinated to the surrounding composition which is rather elaborate in accessories like typical hills, trees, walls of household structures geometrically patterned, but rarely green, open meadows or flowing rivers. In this example, the *hasiya* of floral pattern in gold, the typical headgear of the king and others, the characteristic royal umbrella and the typical Persian willow, make up along with other features what Shirāz developed as a style in the late 15th and early 16th centuries A.D.

39 *Turkey-cock.* Mughal miniature painting. With outer border and *hasiya*, 39 cm × 26.5 cm. Early 17th century. In the period of Jahāngīr, because of the emperor's great predilection for depicting birds and animals, the court-artists took pains to draw and paint each figure with great anatomical precision. As in this example, these paintings had mostly an inner thin border in a contrasting colour, blue as here, and another which contains artistic writing of one or more didactic verses interspersed with flowers in gold. The turkey-cock, in its fantastic natural colours set in very simple surroundings, brings out the individuality of the feathered species to perfection. Though the artist is not known in the absence of any signature on the painting, this must have been the work of one of the master artists who thronged the court of Jahāngīr, maybe Ūstād al-Mansūr, as supposed by some, who is noted for a few other bird figures of the time.

40 *Jahāngīr Hunting.* Mughal miniature. 31 cm × 19 cm. Early 17th century. This miniature showing the emperor in one of his earlier adventures, is generally assigned to c. 1615 and depicts the hunt in all its minutest details and vividness of action. Jahāngīr, after shooting the lioness from an elephant, looks back at his admirers who must have been full of applause, while another royal person, also on elephant, probably Prince Khurram, who accompanied the expedition, approaches him from the front. The Qarāwul or the game-keeper in the foreground near the lioness most realistically depicted in great agony, points to his own right eye suggesting that the animal had been shot in its right eye. The rugged and nude boulders in the background and the general layout and environs without vegetation except for the distant far-ground at the back, with the expressive faces of the figures in the composition, and the typical horses with elongated necks, reminiscent of Persian influence in early Mughal art, testify its date in the early years of Jahāngīr's reign.

41 *Vichitra Vibhramā Nāyikā.* Mewar School, Rājasthāni. 32.5 cm × 22.5 cm. C. mid. 17th century. A large proportion of contemporary North Indian miniatures is devoted to the varied stock of Krishna legends in which the Divine Lover is depicted as 'Hero' *(nāyaka)* illustrating a typical male placed in a domestic or social situation singly or in the company of his beloved, i.e., the Heroine *(nāyikā)*, exemplified in the person of Rādhā. Here is illustrated such a kind of Heroine, known as *vichitra-vibhramā*, described in one of the early Hindi texts, *Rasikapriyā*, composed by the poet Keshavadāsa. The text on the top describes the scene in which Krishna under the tree admires the person of Rādhā who talks to the Divine Lover from the terrace, while Cupid darts his flowery arrow from inside a tree.

42 *A Bathing Scene.* Kāngrā School. With outer border, 27.5 cm. × 19.5 cm. C. 18th century. With the disintegration of the Mughal empire from about the late 17th or early 18th century, the artists of the imperial court dispersed themselves to the various smaller states under local chiefs, especially around the Punjab Hills in the north. From about the beginning of the last quarter of the 18th century, there was available great patronage of the art of miniatures in the court of a hill chief of Kāngrā, Rāja Sansār Chānd, who came to the throne in 1775 A.D. The latter's political exploits in the neighbouring states helped in the spread of the art all around, the art which carried with it the beauty of the lines of the Mughal artists and a resultant study of the individual forms and expressions in the figures. This was coupled with the characteristic lyric layout provided by the luscious vegetation and floral beauty around and a compositional trait in the distant background of structures, trees, undulating dales and green meadows.

43 *Sāranga Rāginī.* Rājasthān. C. 18th century. Sāranga Rāginī here represented illustrated through the theme of the beloved listening to the lover playing music, the musical mode of Sāranga. The naive naturalness of the surroundings with the birds and flowers beside a flowing stream with lotuses and lotus leaves adds to the intimacy of the scene and the intensity of the love not spoken but sung.

44 *Bāluchar Sāri.* Total length: 498 cm. Breadth: 116 cm. Border: 176 cm. Murshidābād. Late 19th century. Silk thread on cotton base dyed in red. From the early 19th century, Bāluchar in Murshidābād developed a distinctive style of weaving and designing, the latter much influenced by contemporary life and custom. European furniture, in the form of chairs and stools with back-supports, European ladies and men in contemporary long-sleeved and flowing gowns and coats respectively, with typical hats worn by Europeans of the times, as exemplified by the dresses of the officers of the East India Company, reveal this influence. The figures are set inside pavilions surmounted by a peacock or similar decorative designs in repeat formations, constituting a band framing at the centre an inner quadrangle which encases through several successive decorative bands a traditionally Indian motif like a central *kalgā* which is intricately delicate in its composite formation. Yet Bāluchar Sāris of a later date are a happy blend of foreign as well as purely Indian styles and motifs. In the inner bands is a repeat figure of a

rider on horseback in a typical Rājasthāni decorative style.

45 *Silk pile carpet.* 100 cm × 94 cm. Thanjavur, South India. Early 19th century. In the 18th and early 19th centuries, Thanfavur (Tanjore) was a great centre for crafts which included brass-ware which followed in the wake of classical bronze art of the area from about the 10th century, and carpets, among other products. Pile carpets are known to have been manufactured in this part of South India with silk piles, though the craft is no longer encouraged now. In the present example and other specimens from the southern areas which have silk piles, a kind of silken twine warp is used. The designs are indigenous. The rectangular piece has a floral band running on all four sides with flowers, each in a different colour and in a different pattern with a studied and effective interspacing. At the four corners there are pairs of beaked birds holding a floral stalk. The entire field outside these has floral patterns symmetrically placed and connected with one another in a stylized way. These silk carpets produce a spectacular effect due to the play of light and shadow when one walks over them, as is produced on corn-fields when summer clouds pass over them.

46 *Enamelled Hookah* (Hubble-bubble). Total height 70.5 cm. Base-plate diam. 50 cm. Lucknow. C. early 18th century. Examples of high quality enamelling on silver have been known in India, at least since the 16th century. Jaipur along with a few other places were the earliest centres, while Lucknow from the 18th century developed this art under Mughal and post-Mughal patronage. The present example of the hookah, i.e., the hubble-bubble, with a silver-wired pipe, highly decorative enamel-work on silver on the chilam and on its lid *(sarposh)*, on the main water-vessel and on the plate on which is set the vessel in a groove – all in their characteristic Mughal technique and Mughal patterns – represent a typical art of that time. The enamelling in its blue, light green, yellow and brown colours representing mainly the trees and floral shrubs as in a typical Mughal *hasiya* interspersed with figures of individual animals like a deer, a leopard and the like, and animals hunting, like a tiger or a lion attacking a deer, duplicates the colourful art of Mughal miniatures in an unusual and different medium. As a decorative element, the *chilam-posh* has three pairs of silver chains ending in mango-formation, hanging at equal distances from one another, together with another such, all from its top knob.

26

ASUTOSH MUSEUM OF INDIAN ART

Named after Sir Asutosh Mookerjee, the great Indian educationist and Vice-Chancellor of the University of Calcutta, the Asutosh Museum, the first University Museum in India was opened in 1937, to collect and preserve representations of different phases of Indian art. As a regional museum it was to envisage the evolution of art in eastern India, ancient 'Prachya', comprising Bengal, Bihār and Orissa, with special emphasis being laid on the Art of Bengal.

The majority of the exhibits record the growth and development of the art of Bengal from the first millennium B.C. to modern times in all its manifold aspects, by examples of outstanding merit. Implements of the Stone age in the shape of microliths and axes from widely scattered areas, carry the cultural history of Bengal to the remotest age. On the other hand, the comprehensive collection of contemporary folk-art of Bengal and Orissa is another distinctive feature of this museum on which special emphasis has been laid to show the unbroken continuity of eastern Indian artistic tradition over three thousand years and more.

It may be recalled that before the establishment of the Asutosh Museum, rarely any art and archaeological museum piece from Bengal was to be found prior to the Gupta period and after the medieval age. Now in about thirty years' time it has been possible to study continually without any gap, the artistic and cultural expressions of Bengal from at least the first millennium B.C. up to modern times, with the help of selective and comprehensive records. This may be regarded as one of the main achievements of the Asutosh Museum besides the building up of a unique Bengal terracotta gallery, the rich collections of which allow the visitor to have a glimpse of the dim past and the living present, age by age, epoch by epoch.

Before proceeding with the story of the gradual development of the Asutosh Museum, it may be worthwhile to shortly recount the vicissitudes it underwent even in its brief history. It was first opened in the rear of the imposing Senate Hall of the University of Calcutta – a very limited space – where its ever increasing collections were housed for a number of years in the first phase. It may be an interesting point to state that during the thirty-five years since its foundation, the Asutosh Museum had to undergo five shiftings, from place to place, resulting in continuous installation and dismantlement of all the exhibits. In 1942, during the Second World War, as a measure of safety, all the portable exhibits of the museum were transported from the Senate Hall to Murshidābād Imambara, and the heavy stone images buried in two layers in a large trench between the Darbhanga Building and the Asutosh Building, within the precincts of the University, as an emergency measure against air raids to which Calcutta then was subjected. After one year they were re-excavated and reinstalled in the Senate Hall – all the paintings, bronzes, terracottas etc. which had returned from Murshidābād in the meantime. When the old Senate Hall was demolished in 1960, the entire museum was again removed to a temporary abode, near the University headquarters. Again with the completion of its new and permanent home at the Centenary Building, adjoining the Central Library, within the University Campus, the whole process of shifting was started afresh taking about seven months. The reorganized museum was opened in February, 1968, curiously on the same site it had occupied in the old Senate Hall.

In the spacious Centenary Building, commanding an area of more than 35,000 sq.ft. in the ground and first floors it has been possible to arrange and display

the identical number of exhibits according to regional, chronological and thematic order. Attempts have been made to present the exhibits now according to modern technique of presentation, so that their importance as educational media combined with aesthetic significance may be fully appreciated.

Divided into ten galleries, the rich and sometimes unique treasures of the Asutosh Museum comprise stone sculptures of the early, classical and medieval periods from different parts of Bengal, Bihār and Orissa including rare and profoundly significant Pāla and Sena images of Brahmanical, Buddhist and Jaina origin; representative bronzes of eastern and western India, Nepal and Tibet, rare coins and seals, dated illuminated manuscripts from Nepal; unique palm-leaf paintings, painted and etched manuscripts from Orissa both old and modern; varieties of wood and ivory works from different regions of India, representative collections of Mughal and Rājasthāni miniatures in addition to Nepalese and Tibetan Thankas; splendid arrays of folk-art and crafts of eastern India including 'Pats', 'Patas', 'Sāris' and 'Kānthās' which comprise the best examples of Kalighat and Orissan paintings and coloured drawings; and lastly a notable and comprehensive collection of Bengal terracottas, which throw fresh light on the unknown corners of art history of India.

Flanking the entrance, the long extensive lobby in the ground floor is lined with heavy architectural pieces as also big monumental stone images of ancient Indian divinities, predominantly from Bengal. Access to the Central Hall is given from here through a glass enclosure centred by a huge 10th-century pillar from a ruined temple in the wilds of Sunderban. It is divided into three galleries – the first devoted to parallel rows of Pāla and Sena sculptures mounted on wooden pedestals with an intermediate line of smaller stone images aligned on stepped pyramidal kiosks, the middle one shows similar arrangement, flanked by showcases, containing representative specimens of early and medieval sculptures from Bihār, Orissa and Central India, while the last one is entirely concerned with illustrating the evolution of terracotta art through the ages besides coins and minor arts, presented in vertical and flat cases. On the first floor the visitor is greeted by an impression of airy spaciousness and pleasing

vistas of colourful scenes. Series of large and faithful copies, by noted contemporary artists, of the famous ancient murals of India and Ceylon are hung up on the wall of a fairly large vestibule in conformity to the horizontal alignment. A corridor leading to the Curatorial offices divides the main hall of paintings and wood from that of bronzes, ivories, etc. Separated by columns, screens and showcases, the galleries of the central hall upstairs, accommodate Mughal and Rājasthāni paintings, Nepalese and Tibetan banners, Orissan, Gujarāti and Nepalese illuminated manuscripts, and painted manuscript covers from eastern India on the right side. The eastern and northern walls are occupied by continuous floor-to-ceiling cases covered with Kalighat drawings, Orissan 'Pats', woven textiles like 'Sāris' and 'Kānthās' and lastly the hanging Bengal scrolls lending an impression of actual murals from a distance. The intermediate spaces are interspersed with vertical showcases full of vivid folk-art objects and dominated in the centre by three-dimensional wood carvings from Bengal and Orissa of monumental size. Lined with masks and folkpaintings from different regions of India and neighbouring countries, the corridor can be crossed to enter the opposite room, exclusively concerned with metal, ivory and wood.

The Asustosh Museum opened in 1937 with 5 exhibits only, rising to 1,228 at the end of the year and to 2,423 in the next year. They jumped to 6,000 by September, 1939. As a result the museum, confined within the strictly limited space at the back of the old Senate Hall, became overcrowded and, consequently, collections had to be curtailed. At the end of 1941, when it was decided to take emergency measures in order to meet the prevailing war situation, the total number of exhibits was 7,000, of which 500 stone sculptures were buried under-ground and the rest were shifted to the interior of Bengal. By the middle of 1956 the total number had rapidly increased to 13,000. The amazing growth of the museum collections in the following period was due to an annual increase of 1,000 pieces over the next eleven years, principally resulting from continued programmes of renewed archaeological excavations. In 1967, at the time of the final shifting, the collection reached the approximate number of 24,200 pieces including 1,440 stone; 3,500 terracotta; 1,125 Pats and paintings; 950 metal; 550 wood; 70 ivory 28

and bone; 2,300 folk-art exhibits; 275 Kānthās and textiles; 240 manuscripts and manuscript covers; 3,370 coins; 1,750 minor antiquities and 76,460 excavated antiquities. About one third of them were on display, the rest being kept in reserve.

One should remember here that the slender financial resources of the Calcutta University as also the absence of any State grant did not allow to enrich the museum collections through large-scale purchases. The phenomenal growth of the museum can rather be attributed to two principal sources, viz., exploration and excavation aided by munificent gifts. It also demonstrates, by and large, the potentialities of Bengal in the field of art – ancient, medieval and modern. Anyway, the museum during the first twenty years, had to rely completely on its own resources to serve the purpose for which it was established, i.e., to encourage field collection and stimulate the study of practical archaeology and appreciation of art through excavation, exploration and exhibition.

A systematic scheme of collection, especially in ten different districts of Bengal, before the partition of India, in which, besides the museum staff, a band of undergraduate and postgraduate students, as well as school-teachers took part at considerable personal risk and sacrifices, yielded results beyond expectation. Mr. D. P. Ghosh, the Curator, also succeeded in the course of his regular exploratory tours in Bengal, Bihār and especially in Orissa in securing unique objects of plastic and visual arts throwing new light on the evolution of Indian art in addition to exploring unknown ancient sites, like Sisupalgarh.

Through intensive field work, again, during the last 14 years, a dozen hitherto unknown ancient sites, revealing remarkable records of a forgotten riverine civilization, have been discovered by the Asutosh Museum, within a radius of fifty miles of Calcutta, forming a sort of garland around it; in addition to five in the district of Midnapur, five in 24-Parganas, two each in Howrah, Bankura and Burdwan, all in West Bengal. Of these the credit of discovering Harinarayanpur on the Ganges goes to a postgraduate student of Ancient Indian History and Culture of the Calcutta University. They bear testimony in ample measure to the fact that about two thousand years ago, besides the great Asiatic seaport of Tamralipta, Gangetic Lower Bengal was bordering on the sea and what is now known as the jungle marsh-es of Sunderban was dotted with numerous cities and ports, temples and monasteries. Also the Bidhyadhari river, once a large and important branch of the Ganges, whose silted-up bed is now being used as an outlet of the sewage and rain-water of the great city of Calcutta, was once a prosperous maritime highway for foreign commerce. It may further be mentioned here that several fragments of carved stones disentangled from the gigantic roots of a banyan tree, from Bhangor, scarcely 12 miles from Calcutta as the crow flies, when pieced together at the museum, produce a remarkable Buddhist image of Hanjueri, one of the masterpieces of the Pala art of Bengal.

The exploration of the three ancient ports of Tamralipta (Tamluk), Chandraketugarh and Harinarayanpur, lining the Ganges and its tributaries, initially carried out by the then Assistant Curator Mr. P. C. Das Gupta in the fifties, was rewarded by unexpected success. He was also responsible for the discovery of a series of other smaller sites in the adjoining area like Atghara etc., while the Curator, Mr. D. P. Ghosh, came upon a veritable mine of antiquities, at Boral, only about five miles south of Calcutta.

Of all the ancient sites explored, Chandraketugarh in Berachampa village (24-Parganas), only 30 miles north-east of Calcutta, has proved to be the most important and by far the most extensive, resulting in the discovery of significant relics which may be ascribed to a period between the pre-Mauryan and medieval ages. In fact, as regards the discovery of countless treasures, of bewildering variety, it can easily vie with Mathurā, Kausāmbī and Ahicchatra and Pātaliputra in northern India. A surface exploration of the area, which was initially visited on behalf of the Asutosh Museum by its first Assistant Curator, Dr. K. K. Ganguli, and his associates in 1948 and scientifically surveyed later in 1950 by the Excavation Officer Mr. K. G. Goswami, confirmed the existence of a city-site of about two square miles, interspersed with rolling mounds, including traces of a rectangular 'Garh' or fortress surrounded by rampart walls, still rising to a height of thirty feet in the same places. Of the thousands of relics found in the course of surface exploration and stratified excavation, objects in the shape of heaps of silver punch marked and cast copper coins – the earliest coins in circulation in India beginning from the 5th and 6th centuries B.C. – include unique ship-type coins, beads 29

of semi-precious stones, terracotta seals inscribed with early Brāhmī characters of the 2nd century B.C. to the 1st century A.D., northern black pottery fragments, portions of rouletted wares and wine vases, probably of Roman origin, ivory objects, terracotta figurines betraying Hellenistic influence, surprisingly large numbers of early terracotta tablets showing erotic scenes, stamped and inscribed sherds of the Kushān period, some Mauryan and innumerable Sunga Kushān terracotta „Yaksha" and "Yakshinī" figurines of surpassing loveliness, besides a host of unique terracotta toy-carts of demons and divinities as well as exquisite Gupta terracotta reliefs and Gupta gold coins of the 4th and 5th centuries A.D. The explorations at Tamluk led to the discovery of prehistoric tools, a large variety of terracotta plaques of intriguing character of the Maurya, Sunga and Kushān liniage, some depicting Buddhist Jātakas, gold coins, inscribed seals of the Pāla period (c. 10th century A.D.) and other cognate finds of fascinating workmanship. Of the four other places in Midnapur district, where archaeological excavations were also conducted on behalf of the museum, laying bare Kushān and Gupta structures, Tilda yielded terracotta seals with inscriptions of controversial character from the beginning of the Christian era and also an attractive panel with a seated Buddha flanked by an inscribed Buddhist formula of the 4th century A.D. An almost life-size terracotta head of a lady of extraordinary beauty and liveliness, apparently of the Gupta era, was recovered from Panna along with other big fragmentary hollow limbs. Further down the sea coast in Midnapur, terracotta objects like toy-carts and archaic mother goddesses, which appear to be very old, have been found in Bahiri. From Pokharna near Susunia hills in Bankura and Mangalkote in Burdwan, in the central part of West Bengal, interesting antiquities belonging to the Sunga, Kushān and Gupta times in addition to early coins and potteries have been similarly acquired for the museum through persistent efforts by members of the museum staff and local people.

The series of explorations, under the auspices of the Asutosh Museum have further resulted in the notable discovery of a new and hitherto unknown archaeological site in West Bengal at Harinarayanpur, four miles south of Diamond Harbour in 24-Parganas. Situated near the estuary of the Ganges, Harinarayanpur was perhaps another important maritime port and emporium. Exposed by relentless river erosion, the finds considerably damaged and defaced by saline action when first brought to the museum were recognized to be of hoary antiquity. They are very akin to the types and styles peculiar to Tamluk and Chandraketugarh finds. A pair of terracotta seals bearing figures of semi-divine beak-headed figures and archaic deer obviously point to their proto-historic origin. Beside hoards of early copper cast coins and heaps of highly polished beads made of semi-precious stones, the antiquities recovered consist of rouletted potsherds of Roman or Romanized origin, fragments of northern black polished pottery, decorated potteries of subsequent ages, terracotta seals and terracotta plaques bearing "Yaksha" and "Yakshinī" figures having a striking resemblance to their Tamluk and Chandraketugarh counterparts. Exploration along the banks of the old and dried-up course of the Ganges (Adiganga), between Calcutta and the Bay of Bengal, have also yielded surprising results in the discovery of several notable mounds, the most important of which was Atghara, 12 miles south of the city. It has unmistakably emphasized the historical antecedents of Sunderban area. The collection of antiquities, secured from there for the museum, is analogous to those of the sites mentioned above.

Further it may be mentioned here that in 1965 and 1966 two successive exploration parties from the Asutosh Museum and the Department of Museology, Calcutta University, headed by Mr. Somnath Bhattacharyya, intensively explored the coastal area of Burartat in Sunderban, bordering the Bay of Bengal. They examined three ancient mounds in the neighbourhood and several Gupta and Pāla structures exposed through erosion, and collected for the museum pre-Christian terracotta figures, human as well as animals, resembling familiar types from Tamluk, Harinarayanpur and Chandraketugarh; Kushān, Gupta and Pāla potteries, early beads and lastly a gold coin of Chandragupta II besides fragments of stone images of about the 11th century. From these valuable acquisitions it is now quite evident that the explored area of the Sunderban supposed to be forlorn and recently reclaimed from dense jungle only a few years ago, was undoubtedly under human occupation from at least the 2nd century B.C. to the 12th century A.D.

Apart from these explorations of archaeological im-

portance, the Asutosh Museum has been greatly enriched by the Rural Culture Survey devised in 1941; one of the most important schemes having a very large bearing on the cultural life of the masses of Bengal and Orissa. It was with the help of this Survey that it was possible to build up the Folk-Art Gallery for which the museum has become famous, mainly through the efforts of Mr. Sudhangsu Kumar Ray and others in Bengal and Mr. D. P. Ghosh in Orissa. The aim of this Survey was to scientifically and critically study the religious, social, literary, and particularly the aesthetic background of the villages and to suggest means and initiate steps for the preservation and renewal of the different aspects of rural culture. An enormous number of folk-art treasures characterized by vivid colour and bold vital composition envisaged in dolls and toys, 'Sāris' and 'Kānthās', 'Pats' and 'Patas' in wood, pith, clay, cloth, and terracotta and diverse other materials were secured. Fortunately the age-old traditions of rural crafts are still being practised in remote corners of Orissa. But Bengal received a death blow after the partition of the country and the resultant large-scale migration of artists and artisans, who still practised the dying traditions and techniques. Fortunately, some of the best examples of handicrafts, acquired before Independence, are now preserved in the museum.

Besides the initiation of the Rural Culture Survey Scheme for the first time in India, the Calcutta University was also the first non-official institution in the country to undertake a comprehensive programme of annual archaeological excavations under the auspices of the Asutosh Museum, which commenced about thirty years ago and has been continued almost without interruption.

The excavations at Bangarh in Dinajpur district, North Bengal, started in 1938 and conducted regularly till 1941 by Mr. K. G. Goswami, Excavation Officer of the museum, have illumined many dark corners of Bengal's past. Five successive strata, reaching to the Sunga level (1st century B.C.) and revealing numerous monuments, buildings, walls of different periods, have been unearthed. In addition to some specimens of the Stone age, the portable antiquities include numerous terracotta figures, potteries and inscribed seals, gold jewellery, punch marked silver coins, copper cast coins and highly polished beads of great variety.

Unfortunately, due to the war situation and internal disturbances in the Dinajpur district it was not possible to continue the field work at Bangarh in the subsequent years. Nevertheless the activities of the museum in this respect did not come to a standstill. Exploratory surveys were carried on at Mainamati in Tipperah district and elsewhere. Trial diggings were carried out in the Chandidas mound in Birbhum district besides Panna and Tilda in Midnapur district where the efforts were rewarded by ample success. The Curator also surveyed the sites of Mahanad in Hooghly district in Bengal and of the ancient city of Sisupalgarh in Orissa pointing out the enormous opportunities of collecting antiquarian and artistic treasures of unique importance for the museum. Two clay medallions embossed with heads of Emperor Augustus, evidently copied from the contemporary Roman coins which poured into India in the wake of brisk maritime trade with Rome along both the western and eastern coastline, were acquired on this occasion. Subsequently, the Archaeological Department of the Government of India took due note of his report and commenced archaeological operations there in cooperation with the State Archaeological Department of Orissa, which led to remarkable results.

Later on in 1957, headed by Mr. Goswami, a party under the auspices of the Asutosh Museum carried on probings in a selected part of the mound of Chandraketugarh. This archaeological excavation, which corroborated the earlier data from surface exploration, was rewarded by finding evidence of several stages of human habitation in different periods beginning with the Maurya-Sunga age down to the post-Gupta period. Even the existence of a pre-Mauryan level was warranted by the find of some potteries of a particular type. According to the Report, "the occupation levels of early periods show the signs of Kachcha houses built of wood, bamboo and tiles and mud walls on mud plinth. Evidences of the destruction of the houses by fire in ancient times have also been brought to light. At a comparatively late period brick houses and portion of a pavement of two layers of brick of such a structure have been exposed in the course of the excavation. One of the earliest occupation levels was associated with a drain of pottery pipes east to west. This drain may plausibly be ascribed to the Maurya period as high class northern black polished sherds with a me-

tallic sound generally found in other ancient sites of northern India of the Maurya and pro-Maurya period, have also been discovered here".

As stated above, excavation on a larger scale has been continuing regularly since then for the last ten years under the supervision of Mr. Goswami and subsequently Mr. C. R. Roychoudhury, the present Assistant Curator of the museum. The excavated materials, which have greatly contributed to the enrichment of the museum, contain hoards of silver punch-marked coins (6th–5th century B.C.), copper cast and punch-marked coins (3rd century to 1st century B.C.) bearing traditional designs and symbols of intriguing character, inscribed seals, a countless number of terracotta plaques, toy-carts of outstanding iconographic as well as aesthetic significance, matching the group of "Yakshas" and "Yakshinīs" of rare elegance recovered from surface exploration, countless numbers of highly polished early beads of semi-precious stones, spouted vases, dishes and pottery of diverse origin used for diverse purposes. In addition to this the excavators came upon what may be called a "bead manufacturing factory" where all kinds of semi-precious stones in various stages of manufacture were found in abundant number. All these bewildering varieties of antiquities and art objects have been unearthed from successive strata from the 2nd century B.C. to the 8th century A.D. Moreover, these series of excavations have definitely put Chandraketugarh, for the first time, on the archaeological map of ancient India. It need not be repeated that the finds constitute some of the most valuable treasures of the Asutosh Museum.

Further, the excavation which continued between 1957 and 1967 have revealed the extent of the cultural progress which Chandraketugarh had made in other directions as well. The most important of the architectural remains are of course the extensive ruins of an early Gupta brick temple covering an area of about 300 ft. by 100 ft., at Khana-Mihirer-Dhipi, resembling the Pārvatī temple of Nachna Kutara in Central India. They are situated almost centrally at the old city site encircled by a huge mud-rampart of about the 1st century B.C. protecting an area of about four square miles. The temple faces the north, flanked on each side by miniature replicas of the temple itself. It was once embellished with decorated brick and stuccoed lotus, string mouldings and shallow niches, some of them exquisitely carved with geometric patterns, now empty. The entire temple complex, which appears to have been vigorously extended and rebuilt in post-Gupta epochs on three occasions, is thus a new architectural discovery in eastern India, recalling remains at Nalandā and Rajgir.

As stated above, the Asutosh Museum has been immeasurably enriched during the last ten or eleven years, by a continuous flow of countless antiquarian treasures, through archaeological excavations, surface exploration, tank digging and agricultural operations, especially from Chandraketugarh and Harinarayanpur. And yet we are not aware as to how much of the treasures remain buried underground. Only a fringe has been touched.

In this connection it should not be forgotten that the rapid growth and development of the museum were greatly promoted by generous gifts on a large scale. Among the valuable gifts, undoubtedly the most noteworthy were those of Bijay Singh representing almost the entire collection of his father, late Furan Chandra Nahar, containing more than 1,000 pieces of sculpture and painting, approximately one lac of rupees worth. The noted scholar Dinesh Chandra Sen also presented part of his important collection of Bengali and Assamese art during his lifetime and the rest were handed over to the museum by Cocola Company. The collections of late A.C. Gupta containing a large number of priceless Rajasthani and Pahārī miniatures were secured through the generosity of his wife Mrs. Syama Devi in 1955. Throughout the years the enrichment of the museum also resulted from the patronage of the Archaeological Survey of India, transferring selected stone sculptures of rare significance from Bihār, Sārnāth and Khajurāho besides a large assortment of ancient terracotta objects from Bengal on permanent loan to the museum. Eminent archaeologists like R. D. Banerjee, D. R. Bhandarkar and K. N. Dikshit also presented their collections of early Indian coins of extraordinary significance to the museum.

Of the acquisitions by purchase, mention may be made of Biren Roy's Museum of Puri comprising 1,500 exhibits of Orissan art in 1939, as also Kalidas Dutt of Mazilpur's Collections which included some of the rarest objects from the reclaimed and unreclaimed dense forest areas of Sunderban fringing the Bay of Bengal, containing some of the singular ex-

amples of Bengal stone sculpture between the 7th and 12th centuries A.D.

After thirty-one years of continuous service, Mr. D. P. Ghosh, the Founder-Curator of the Asutosh Museum retired in 1968. He started from the very scratch with only 5 exhibits in 1937 which gradually rose up to about 25,000 when he left. Moreover, he was responsible for initiating, organizing and directing the Schemes of Exploration and Excavation, Rural Culture Survey, Teachers' Training Course in Art Appreciation, Post-Graduate Diploma Course in Museology, and other activities which have contributed to making the Asutosh Museum of Indian Art an educational institution devoted to academic training, research and community service, apart from being a centre of visual appreciation and aesthetic enjoyment. He has been succeeded as Curator of the Asutosh Museum and Head of the Department of Museology by Dr. K. K. Ganguli, who had been associated with the museum for a long time.

DESCRIPTION OF ILLUSTRATIONS

49 a) *Yakshinī head*. Terracotta. 6.35 × 7.62 cm. Tamluk, Dtt. Midnapur, West Bengal. C. 1st century B.C. A 1st century B.C. work of great beauty and refinement, especially in the exceptionally delicate handling of the richly fashioned coiffure with traces of geometric sandal paste designs on the forehead. This charming head from Tamluk is notable for the summary rendering of the soft warm flesh, missing in the earlier specimens and emphasized by the strings of pearl collar.

49 b) *Two seals*. Terracotta. 2 cm. and 1.69 cm. in diameter. Proto-historic Harinarayanpur, Dtt. 21-Parganas, West Bengal. Not far from the sea, exposed by relentless erosion and considerably damaged and defaced by the saline action of the estuary of the Ganges, a pair of remarkable seals showing an archaic deer delineated in linear abstraction, and equally and completely linear, two human figures beak-headed and crowded with twigs after Post-Harappan Jhukar and Jhangar cultures of the first millennium B.C., represent some of the earliest archaeological finds from Bengal of undoubted historical and artistic significance.

50 *Mould of winged Yaksha*. Terracotta. 7.62 × 13.97 cm. Tamluk, Dtt. Midnapur, West Bengal. C. 1st century A.D. Largest terracotta mould of a standing Yaksha found in India so far, the shallow relief shows a robust figure turbaned, lavishly decorated, but nude.

51 a) *Chhadanta Jātaka*. Terracotta. 8.89 × 7.62 cm. Tamluk, Dtt. Midnapur, West Bengal. C. 1st century A.D. Fragment of a precious terracotta plaque, probably rectangular, represents the story of the Chhadanta Jātaka or the tale of the Buddha's previous birth as a great six-tusked leader of a herd of elephants. Although in bas-relief, the fragment is covered by massive volumes of the sloping backs of ponderous elephants, superimposed in parallel rows to signify depth. A very close observation of nature and intimate study of the animals is amply demonstrated by the way in which the wrinkled skin has been indicated.

51 b) *Female Figure*. Terracotta. 7.62 × 6.35 cm. Chandraketugarh, 24-Parganas, West Bengal. C. 3rd century B.C. Specimens of the art of terracotta of the Maurya period are naturally more voluminous and summarily treated as they are all hand-modelled as opposed to the shallow moulded reliefs of Sunga origin. This female figure, perhaps in a dancing pose, with a hooped skirt, was obviously crowned by a smiling head arrayed with fantastic discs, so familiar from the excavations at Patna and other places. Due to the appliqué technique the figure is full of gaiety and liveliness due to the sharp contrast of light and shade.

52 *Fragment of a Yakshinī*. Terracotta. 9.16 × 8.89 cm. Chandraketugarh, Dtt. 24-Parganas, West Bengal. C. 2nd century B.C. Almost invariably moulded, out of the hundreds of terracotta tablets of early Sunga origin recovered from the walled city of Chandraketugarh, this select fragmentary piece showing the head of a Yakshinī or a dryad nymph is unexcelled for its matchless delicacy and luxurious grandeur of details. "The exquisite precision of carving, the delight in surface decoration and the essentially shallow character of the relief make it appear likely that the sculpture" is a translation in terracotta of the wood carver's or ivory carver's technique. The five weapons *(panchayudha)* in the form of five decorative hair pins of magical significance, consisting of arrow, sword, goad, thunderbolt and trident, denoting the powers of subjugation of the Apsara over the mere male, perhaps served as the prototype of the five arrows *(panchasāra)* of Madana, the god of love, in later ages.

53 a) *Enigmatic Face*. Terracotta. 22.86 × 15.24 cm. Raghunathbari, Dtt. Midnapur, West Bengal. Primitive. A series of such enigmatic heads of mysterious origin have been found in Raghunathbari near Tamluk. Extremely archaic looking with grinning lips, these peculiar heads, covered with red slip, are each capped by a row of serpent hoods. They have close affinity with the Iron age terracottas from South India.

53 b) *Ram toy-cart*. Terracotta. 13.97 × 16.51 cm. Chandraketugarh, 24-Parganas, West Bengal. C. 1st century A.D. Of the many ram toy-carts, excavated from Chandraketugarh, the present example appears to be outstanding because of bold workmanship accompanied by carefully worked minute decorations, sometimes stamped.

33

54 *Sūrya*. Basalt. 45.72 × 35.56 cm. Kasipur, St. 24-Parganas, West Bengal. C. 6th century A.D. Of excellent workmanship, this rare image of the Sun-god of late Gupta origin shows him standing on a chariot with the lower portion concealed, and with bunches of exquisitely carved lotus flowers held in two upraised arms. A severly plain halo brings out the chaste and sober details of the crown, bangle and pearl necklace. Clothed in a fitting tunic, tightly held by a waist band and a floriated knot, the only weapon of the god is hung on one side tied to a diagonal strap across the thighs. Controlling the reins in one hand and a staff in another, the legless charioteer Aruna drives the one-wheeled chariot drawn by seven prancing chargers. Lower corners of the pedestal are marked by two diminutive demons of darkness fleeing before the approaching chariot of the God of Light.

55 *Head of a Nāyikā* (?). Terracotta. 22.86 × 15.24 cm. Panna, District Midnapur, West Bengal. C. 5th century A.D. Of unknown identity, this head of a Nāyikā or an Apsarā is indeed an exciting piece of terracotta art. Almost life size, this glamourous piece is finished by an ochre slip which heightens the total effect of exquisite delicacy. The smooth loveliness of the throbbing flesh is balanced by the elongated *utpalapatra* eyes and a bewitching mysterious smile. Admiring foreign visitors like to call it the 'Venus of Bengal'.

56 *Female head*. Black basalt. 17.78 × 13.97 cm. Agradigun, Dtt. Dinajpur, Bangladesh. C. 10th century. An exciting head of profound significance; it may after all envisage not a goddess but a secular subject. Besides the carefully dressed hair crowned by a *tiara*, proclaiming a princely lineage, which serves as a foil against the supple smoothness of the face, the highly strung arching eyebrows, drooping eyes shaped like *khanjana* bird, bulging cheek and lastly the row of pearly teeth visible between slightly opened lips; all these individual traits combine to lend an indelible impression of great pathos and poignancy, not generally associated with an idealized divine being. Strangely enough there is a current local legend about one Princess Silavati of yore who had a tragic fate. Anyway the total effect of the head is one of unsurpassed loveliness and warmth.

57 *Navagraha*. Black basalt. 99.06 × 38.10 cm. Kankandighi, Sunderban, West Bengal. C. 10th century. Maybe this intact rectangular panel representing Navagraha or the nine planets formerly embellished the entrance doorway of a medieval temple in the Sunderbans. Fringed by a decorative device on three sides, with successive string courses below double lotus petals, scrolls with animals and the respective mounts, the panel shows a horizontal array of the auspicious Ganesa leading the vanguard followed by the standing planets, viz., Sun (Sūrya) with lotus Moon (Soma) with a pot, Mars (Mangala) with a spear, Mercury (Buddha) with a bow and arrow. Bearded and pot-bellied like Jupiter (Ganesha-Brihaspati) holds the jar of ambrosia followed by Venus (Shukra), one of the

hands of both held up in exposition, then Saturn (Sani) with a mace, torso of Rāhu with a vessel and lastly snake-hooded Ketu with a snake tail wielding a sword. In spite of observant modelling and variation of pose through tilted heads and projecting hips a certain sense of metallic hardness is prevalent due to the sharp precision of summarily fashioned limbs of the divinities.

58 *Seated Buddha*. Black basalt. 124.46 × 83.82 cm. Bodh Gayā, Bihār. C. 11th century. Secured from the deserted garden house of Mr. Beglar, the archaeologist who was in charge of restoration of the famous Mahabodhi temple at Bodh Gayā, at Chakdah near Calcutta. This notable image of magnificent proportions was apparently brought down by him from Bodh Gayā to adorn his house where he had settled. If we compare this image with similar seated Buddha images, in situ in the niches of the Bodh Gayā temple, there cannot be any doubt about this. There is remarkable affinity between them in size and style. The Buddha challenged by Māra or Illusion is seen calling the Earth Goddess as witness to his countless deeds of righteousness and virtue in his previous births. Flanked by a pair of hovering Gandharavas, the rounded stela is topped by three branches of the Bodhi tree under which he completed his years of meditation for the attainment of Buddhahood. Surrounded by a halo, the finely chiselled head of the Buddha boldly projects from the background. It is excellently matched by a tapering body, simple and unadorned, whose smooth suppleness has been heightened by contrasting it with figures of Bodhisattvas Avalokitesvara and Maitreya, on either side. Standing in Tribhanga on the right, and crowned by a miniature figure of Amitābha Buddha with matted locks *(jāta mukuta)*.

59 *Saraswatī*. Black basalt. 45.72 × 22.86 cm. Sunderban, Dtt. 21-Parganas, West Bengal. C. 10th century. Originally a side figure of a Vishnu image, the aesthetic qualities of this lovely fragment can be better enjoyed in the broken condition. Carved in prominent relief, it depicts the Goddess of learning almost in the *ābhanga* pose, without the undulating triple flexion, apparently playing on the lyre. The pose gains additional emphasis from the diaphanous drapery marked with conventional ridges, clinging to sensuous limbs adorned with appropriate jewellery and supporting a piquant head ennobled by an attractive coiffure. The rhythmic outline of the slender body, emphasised by flowing scarfs, enhances the lightness of form which appears as if floating in air.

60 *Shiva-Lokeshvara*. Bronze. 58.42 × 21.59 cm. Habibpur, Dtt. Barisal, Bangladesh. C. 11th century. Besides the great decorative beauty of this bronze sculpture, achieved by tightly modelled attenuated limbs of Shiva, his attendants and his trident echoing the structural design of the aureole *(prabhāvalī)*, this image is of extraordinary iconographic significance. Flanked by a small seated Ganesha to the right, Shiva stands majestically crowned by the tiny figure of a Dhyāni Buddha. There is no doubt that this syncretic image of Tantrik origin definitely served as the prototype

34

of the Shiva-Buddha cult of Indonesia – hence its unique importance.

61 *Bodhisattva stele.* Pāla. Height c. 80 cm. Bengal. The five small Buddha figures in the upper part of the representation make evident that it belongs to the Buddhist cult. They were similar to statues – put in high relief before the stone background; they show several attitudes typical of Buddha statues.

62 *Vishnu Chakra.* Black basalt. 55.88×48.26 cm. Sarisadha, Dtt. 24-Parganas, West Bengal. C. 10th century. A unique piece, the perforated double-sided lotus wheel shows in the inset medallion a remarkably carved dancing figure of Vishnu supported by his flying winged eagle mount *(vāhana)* Garuda. Forms of dancing Siva as the Lord of dance (Natarāja) are very familiar and numerous. But this characteristic figure of Vishnu Natarāja is without any parallel in Indian art. Bordered by a floriated rim, the ecstasy of the dance is perfectly expressed by the clapping hands above the head, the other two clasping the usual emblems, mace and wheel *(gada and chakra)*, tilted head, arching garlanded torso and bent legs. To conform to the circular outline of the disc, the artist has deftly spread the pliant limbs of the god in a charming manner. According to some scholars, instead of representing the god himself this is an example of Sudarsana Chakra envisaging the very personification of the wheel itself and as such installed as a standard or *Dhvaja* in front of a Vishnu temple, now lost.

63 *Tārā.* Bronze. 34.29×25.40 cm. Nepal. C. 18th century. One of the feet placed horizontally on the lotus pedestal and the other dangling at an angle, the seated figure of Tārā in *Lalitāsana* pose, as usual gilded and richly decorated with stones as characteristic of Nepalese art, presents a visually exciting appearance. Although the *tiara* is missing, the round face topped by an elongated hair-do in *usnīsa* fashion, the boldly modelled hands, in *varada* and *abhāya mudrā*, the heavily breasted image clad in a Sārī with a decorated border, leave a lasting impression on the mind of the visitor.

64 *Copper plate engraving.* 22.86×27.94 cm. Rakshaskhali, Sunderban, West Bengal. 1196 A.D. An extremely rare document with the obverse containing a long inscription by a local Pāla chieftain, himself a devout worshipper of Vishnu, the reverse side is naturally engraved with a remarkable figure of easily poised Vishnu seated in *lalitāsana* on a chariot with a royal standard behind and confronted by a kneeling devotee with a staff, in a pose of adoration. Executed on the eve of the Muslim invasion of Bengal and one of the treasures of the Asutosh Museum, the copper plate is undoubtedly a record of profound historical and aesthetic significance. Representing the formal linear style of medieval eastern India, somewhat different from the characteristic western India norms of Gujarāt, in this unique engraving discovered from the wilds of Sunderbans, the angularity and crispness of the emotionally surcharged figures accentuate the tendency towards an abstract linearism which visibly influenced the contemporary pictorial style of the Pagan murals, the later paintings of Thailand, and remotely perhaps the Wayang mannerism of Indonesia.

65 *Avalokiteshvara.* Bronze. 30.40×9.16 cm. Nepal. C. 12th century. The lower part of the feet unfortunately broken, the gilt image of Bodhisattva Avalokiteshvara, represented in a triple bend pose *(tribhanga)*, is one of the earliest and very aesthetically satisfying products of the metal art of Nepal. The pleasing movement of the elongated body is matched by the smooth gliding curves of the hands, especially the one holding the long lotus stalk and the rhythmic chain *(hāra)*. Crown and jewellery, studded with semiprecious stones, further add to the glitter of this striking figure.

66 *Hunting scene.* Ivory. 35.56×8.89 cm. Orissa. C. 16th century. A dramatic work of amazing dexterity, the throne post carved in the round, here is a royal hunting scene, depicting a fully caparisoned charger of the turbaned king, who has already speared a fawn, rearing upon a strikingly visualized forest scene with the mother deer herself menaced by dogs and soldiers, casting a last lingering look at another fawn clinging closely to its heels. The technical mastery with which the complicated details have been brought out through perforation and carving, retaining the shape of the tusk, testifies to the excellence of the ivory carvers' art in India from time immemorial.

67 *Fragment of a female Figure.* Chlorite. 21.59×16.51 cm. Purī, Orissa, C. 14th century. Originally a Nāyikā or a Rādhā, this voluptuous sculpture, completely modelled in the round, is unequalled in the masterly handling of vibrant flesh in spite of the loss of the head. The figure is surcharged with intense animation – the heaving outline of the surging volume, has amply balanced with utmost effect, the upthrust of the voluptuous breast and projecting hip, with indications of a slightly tilted head.

68 *Nandi pedestal.* Bronze. 40.91×30.48 cm. Murshidābād (?) West Bengal. C. 18th century. In Bengal, Shiva and Vishnu used to be worshipped through symbols like the *linga* and the *nārāyanashila* respectively, instead of anthropomorphic forms. Representations of the mounts, viz., the bull and Garuda respectively, as also the rampart lion, were used with great skill and fancy by the artist of the day. Composed of a three tiered lotus base, the present example envisages a dynamically conceived jumping bull – Shiva's mount –, with upturned head and tail, embellished on the harness with the peculiar insignias of Shiva, horn and a drum (Bamaru), in their turns supporting the stand itself.

69 *Venu-Gopala.* Wood. 139.70×35.56 cm. Kansat, Dtt. Malda, West Bengal. C. 15th century. Completely in the round, unadorned and naked, unlike its counterpart from Orissa cited above, this almost life size statue of young Krishna playing on a flute in the characteristic *tribhanga* pose, is another precious possession of the Asutosh Museum, of international repute. Relying on typical late

35

medieval technique of juxtaposing swelling planes with forward thrusts of angular limbs, the master artist has happily conceived a work of singular beauty. Carved out of a single log, the grains of the wood, echoing the flowing undulating contour of the form, at the same time emphasize the summary modelling of the anatomical structure in a surprisingly modernistic way. We find here significant evidence of India having anticipated, five hundred years ago, the contemporary sculptural technique of Epstein and Henry Moore.

70 *Elephant Chariot.* Bronze. 67.61 × 17.78 cm. Bankura, West Bengal. C. 18th century. Cast by the *cire perdue* process, this magnificent four-wheeled elephant chariot carrying figures of Lakshmī-Saraswatī within a tasselled pavilion, is one of the best specimens of the Dhokra artist of eastern India where the abstract images in the upper portion are skilfully integrated with the massive animal of great power and vitality.

71 a) *Ascetic.* Wood. 27.94 × 9.16 cm. Jessore, Bangladesh. C. 17th century. Bearded and with matted locks hanging down on both shoulders, hollow stomach framed by bare ribs, hands clasped above the head and one leg doubled, revealing an intimate knowledge of human anatomy contrary to the usual practice in Indian art, here is an unusual representation of an ascetic or Yogi, from a chariot, in an attitude of penance, and strangely reminiscent of Gothic sculpture. A slightly smiling face, calm repose and utmost spiritual serenity is expressed in a masterly way through a weightless body full of sap of life.

71 b) *Nāyikā.* Wood. 43.18 × 15.24 cm. Purī, Orissa. C. 18th century. Represented in the pose of wearing an anklet, the Nāyikā or temple dancer *(devadāsī)* is indeed a creation of enchanting beauty. Indigo painted flowered Sārī clinging to the soft flesh gracefully complements the Indian red blouse, yellow limbs and jet black coiffure of the saucily tilted head.

72 *Krishna and Rādhā.* Bronze. 30.48 × 9.16 cm. and 26.67 × 9.16 cm. Purī, Orissa. C. 17th–18th century. Vibrant and vigorous, the animation and liveliness of the pair is the result of judicious combination of robust modelling and fluent lines. Rādhā appears to be enraptured by the sweet melody of the flute, played by Krishna in *tribhanga* pose wearing a peaked cap finished with great delicacy and charm and wooden sandals of the *sakshifopala* variety.

73 *Hunting scene.* Terracotta. 19.05 × 15.24 cm. Naldanga, Dtt. Jessore, Bangladesh. C. 16th century. Echoing the similar mode of presentation of the Orissan ivory hunting scene, a prince, also similarly attired in Mughal costume is leading a deer hunt in a forest on a galloping horse, diagonally represented across the surface covering a speeding hound underneath.

74 *Kānthā.* Cotton. 88.90 × 88.90 cm. Bongaon, formerly in Dtt. Jessore, Bangladesh. 19th century. A unique and distinctive phase of the folk art of Bengal is represented by the peculiar textiles known as Kānthās. These beautiful fabrics are prepared by village women with the help of dis-

used worn-out clothes. Coloured threads from borders of Sāris and Dhoties are skilfully employed to produce charming designs of great symbolical import, on a quilted ground. Almost invariably a large lotus with concentric circles of petals occupies the centre, surrounded by successive panels containing incidents from the Epics, local legends and flowering Kadamba trees or *kalkas.*

75 *Manasā.* Shola. 72.50 × 55.88 cm. Goalpara, Assam. 20th century. This mask, a fine example of Assam's folk art, represents Manasa, the goddess of snakes. The present example, predominantly treated in black and red, is weird and fascinating.

76 *Toilet scene.* Paper. 45.72 × 27.94 cm. Kalighat, Calcutta. 19th century. An attractive specimen of Kalighat Pat where a Bengali lady at her toilet is effectively presented with the help of bold colour masses bordered by elastic curves, dexterous and sweeping.

77 a) *Jatayu and Rāvana.* Handmade paper. 43.18 × 26.67 cm. Kalighat, Calcutta. 19th century A.D. Distinguished for the amazing mastery of the brush, the Kalighat line drawings are well known for their exquisite freshness and spontaneity of conception. Here is a striking example from the Rāmāyana where Jatayu, the friend of Rāma, is trying to swallow the chariot of Rāvana sloping with Sītā, within the majestic sweep of its extended beaks. The great bird has been endowed with a volume and monumentality, surprisingly expressed with the minimum economy of lines.

77 b) *Horse.* Terracotta. 96.52 × 30.48 cm. Dtt. Bankura, West Bengal. 20th century. Hollow within, a powerful and spirited animal, rendered in terms of swelling volume, whose massive limbs are outlined by sharp elastic curves.

78 *Bāluchar Sāri.* Silk. 110.49 × 405.40 cm. Murshidābād, West Bengal. 18th century. Catering to the needs of the court of Murshidābād and the aristocracy, Bengal was famous for the Butidar Sāris woven in Bāluchar, one of the suburbs of Calcutta, in post-Mughal days. Woven in local silk, this beautiful fabric, the only one of its kind so far as colour scheme and composition are concerned, is designed in yellow with repeated patterns of a seated Nawab holding a flower in the hand, after typical Mughal miniatures against a crimson background.

79 *Gopīs in arbour,* Paper. 39.37 × 30.48 cm. Ranpur, Orissa. C. 17th century. An illustrated page from a *Gīta Gevinda* manuscript, it represents a rare and eclectic example of the Eastern Indian variety of medieval Hindu painting, betraying organic fusion of Mughal, Deccani, Vijayanagar and indigenous Orissan traits. Lightly touched with colour and envisaging willowy stately Gopīs, transparently draped, roaming in search of Krishna in an arbour on the banks of the Yamunā, this unfinished drawing has been hailed by connoisseurs as a masterpiece of Oriental art.

80/81 a) *Swoon of Chaitanya.* Painted wooden cover. 13.97 × 39.37 cm. Bankura, West Bengal. C. 17th century. Char-

acterized by an unerring sense of draughtsmanship, combining bright luminous colours with careful arrangement of balancing figures, the earliest and most important manuscript covers of Bengal, painted after the typical medieval Eastern Indian School of Painting, is provided by the *Pata*, describing the historic scene of the first meeting of King Prataparudradeva of Orissa with Srī Chaitanya, the great Vaishnava Saint of the 15th century whose ardent disciple he was. Attended by his retinue, the king is shown massaging the feet of the saint who has fallen in a swoon.

80/81 b) *Vishnu with Nārada and ascetics*. Painted wooden book cover. Corresponding to the Bengali *Pata*, above, this oblong painted manuscript cover depicting Vishnu riding on his mount being greeted by Nārada and other ascetic devotees is also in the typical eastern Indian style of medieval Orissa. The brilliant Indian red background serving to bring into prominence the sharply outlined figures in yellow and green, is deftly punctuated by the vertical accent of the standing figures, balanced by the horizontal alignment of the spreading features of the divine group.

82 *Manasā Ghat*. Painted terracotta. 45.72 × 21.59 cm. Faridpur, Bangladesh. 20th century. An object of worship, this shapely terracotta vase from Faridpur is remarkable for its vibrant colours and exciting delineation of Manasā, the Goddess herself, fearful and benign at the same time.

BIRLA ACADEMY OF ART AND CULTURE

One of the latest efforts to set up a Public Charitable Trust comprising an Academy which would include the cultivation and preservation of art and specimens of ancient culture and provide for training in music as well, culminated in the establishment of the Birla Academy of Art and Culture in 1962. It was essentially organized to promote the visual and the performing arts, different branches of literature with comprehensive and interrelated studies of these subjects.

Accordingly, an eleven-storey building with a suitable auditorium was designed. It was completed in 1966 and the formal inauguration of the academy in its new building was celebrated on January 9, 1967. With the establishment of this academy, which includes a museum, Calcutta came to possess one of the newest galleries of art with an adjunct for its allied activities in encouraging the art of painting and the art of music.

From the ground up to the fifth floor there are galleries, the sixth is the Reserve and the seventh occupies the Trustees' office and the library while the eighth and ninth floors are utilized by the music and dance unit known as SWAR SANGAM.

The Museum of the Birla Academy, with its total exhibition space of 20,000 sq. feet, has on the ground floor examples of ancient Indian sculptures from the first century B.C. to the 16th century A.D. And while the first floor houses a part of the sculpture collection in stone and bronze, wood-carvings and terracottas together with a few textiles, the next floor contains contemporary Indian paintings of the poet Rabindranath Tagore, and artists Nandalal Bose and Gaganendranath Tagore. The third floor houses some of the finest examples of Indian miniatures of Mughal, Rājasthāni, and Pahārī schools from the 15th to the 19th centuries.

There are Jain and Orissan palm leaf manuscripts, painted book covers, Tibetan and Nepali Thankas, illustrated Persian books, Bengali manuscripts and some letters written by eminent Indians like Rabindranath Tagore, Sarat Chandra Chatterjee, etc.

The fourth floor is an International Gallery of Modern Art which includes paintings, drawings, sculptures, wood arts, serigraphs etc., donated mostly by the artists themselves.

The fifth floor is a fully equipped gallery for temporary exhibitions including exhibitions of the contemporary art of India.

Mention may be made of the exhibitions of Rabindranath Tagore's letters he exchanged with eminent Indians, and literary manuscripts of fourteen major Indian languages to mark our National Poet Rabindranath Tagore's 107th birthday.

This gallery is divided into two wings. They are let to artists at a weekly charge. Exhibitions of artists from almost every part of India as well as a few international exhibitions have already taken place in this gallery.

Internationally reputed antiquarians and art historians deliver lectures in the academy's auditorium.

The Academy has opened also practical classes for painting and sculpture which have become very popular within a few months.

The museum has an exploration unit which discovers and collects antiquities from various sites of India. In 1967, the academy was credited with the discovery of the earliest pre-historic site in eastern India. The site situated in the village of Maluti, District Santhal Parganas, has yielded 150,000-year-old pre-historic artifacts.

The museum has a valuable library of selected books 38

and journals. Its collection has been enriched by the entire personal collection of the illustrious artist Abanindranath Tagore and a few notable presents, like one from the Museum of Modern Art, New York.

The above mentioned 'Swar Sangam' is a school for music, painting and dancing. In the vocal music section, are taught Dhrupad, Dhamar, and folk music and in the instrumental section lessons are given on Sitar, Sarode, Violin, Guitar and other percussion instruments as well as in Tabla.

In the dance unit are taught Kathakali, Kathak, Manipuri and Bhārata Natyam dances and both in music and dance units lessons are imparted by the best available teachers.

An institution like this cannot grow overnight and the academy has only completed a few years of its existence. A lot of things have yet to be done towards the realization of its aims and objectives. The Trustees of this academy as well as the staff members feel that their efforts would be amply rewarded if the Academy aids the visitors towards a better understanding of India's heritage and the message of mutual tolerance and brotherhood which is the keynote of Indian culture.

DESCRIPTION OF ILLUSTRATIONS

85 a) *Buddha in dhyānamudrā.* 54×33.5 cm. Gandhāra. C. 1st century B. C. The sculpture represents the Buddha seated in the meditation pose *(dhyānamudrā)*. His nose, eyes and facial features have been chiselled in depth and his coiffure exhibits a top knot. He carries a heavy drapery and shows well proportioned muscular gait. His wide opened eyes with scooped portions for the eye-balls speak of his Rhodian association and in style it is much akin to the earliest Gandhāran examples found at Mardan or Loriyān Tangai.

85 b) *Bodhisattva Maitreya.* 42.5×32 cm. Gandhāra. C. 1st century A.D. The sculpture represents Maitreya seated on the diamond throne *(vajrāsana)* in meditation pose *(dhyanamudrā)* with *mangala kalasha* hanging beneath his right palm. He is profusely ornamented with bangles, armlets, necklaces, ear ornaments, etc. His coiffure is also plaited with strings of pearls. Heavy drapery wraps the upper portion of his left arm and he sits on a throne resting on two lions. On the pedestal, three devotees on either side are shown worshipping an alms-bowl.

85 c) *Scenes from the life of Buddha.* Red Sandstone. 51×21 cm. Early Kushān. Mathurā. C. 1st century A.D. The panel depicts three scenes from the life of the Buddha. In the first scene from the left, he is shown in the earth touching attitude *(bhumisparshamudrā)*. The second scene shows the Buddha seated in the protection pose *(abhāyamudrā)*, in a style much akin to its ilk in Aniwar and Katra. In between the scenes, seven devotees are shown, arranged in three rows (3+3+1) in peculiar Bhārhut style, standing one above the other. They are certainly the first seven converts to the faith at Sārnāth (Mrigadava). The third scene shows the Buddha lying beneath the Sal tree with weeping Ānanda and others while Vajrapāni with his characteristic attribute is shown standing at the extreme end. The scenes have been arranged side by side in a shallow frieze, in characteristic Bhārhut style. The spotted red sandstone speaks of its origin at Mathurā and the

frieze was also found there. Hence there is hardly any doubt that it is an early Kushāna piece. The most remarkable thing in the composition of Buddha figures is their hair styles, well proportioned eyes, muscular contours, heavy drapery, etc., in which we find a pronounced Gandhāran impact. Thus, this piece of sculpture represents a peculiar synthesis of early Indian art forms of Bhārhut, Mathurā and Gandhāra.

86 *Yakshī.* 81.5×17 cm. Mathurā. C. 2nd century A.D. The scene represents a Yakshī, standing on a human being, clasping the twig of a tree with her left hand. The sculpture has been depicted on a 'Crossbar' *(thaba)* of a Kushāna stone railing. The grooves for fixing are still visible and there are three lotuses carved in relief on the back of the pillar (not visible). The Yakshī has been depicted nude except for her ornaments like anklets, waist-band, bangles, necklaces, etc. According to primitive faith these Yakshīs caused efflorescence and fruition and as such, they were shown in association with a tree and their fertility aspects were depicted prominently. This Yakshī represents a further development from the Bhārhut and Sānchī phase and in appeal and voluptuous gait, imitates her ilk from the Bhūteswar pillar railings in the Indian Museum.

87 *Front view of a bullock cart.* Terracotta. 9×8.5 cm. Kausāmbī. C. 1st century A.D. The terracotta plaque represents the frontal portion of a bullock cart. Above it, there is a stylized arch. The terracotta is very interesting as a good example of transitioned terracotta pieces from Sunga to Kushāna idioms.

88 *Head of Buddha.* 67.75×25.5 cm. Gupta. Sārnāth. C. 5th century A.D. The schematic curls of the head are wider and the *usnīsa* more elevated than usual in Sārnāth. The eyelids have been separated from the eyeballs deeply at both ends. All this speaks of the contemporary Central Indian tradition and it is possible that some Central Indian master carved it in Sārnāth with locally available

materials. Its nose, lips and a portion of left chin are missing.

89 *Hari-Hara.* Grey sandstone. 107 × 61 × 18 cm. Gupta, Sārnāth. C. 7th century A.D. The left half represents Vishnu, who wears the crown *(kirīta mukuta),* earrings *(kundala)* and *dhatī* and holds the disc (chakra) and couch (shankha), in his upper and lower left arms. He is attended by Chakra purusha at his left. His right portion represents Hara or Shiva as can be envisaged from the Jāta Mukuta and elephant hide. On this side, he holds the trident *(trishūla)* in his upper and the rosary *(mālā)* in his lower right hands. The sculpture is a notable example of Gupta workmanship from Sārnāth and the delicate modelling of the body, fullness of the lips, the hair style and the suggestion of introspection speak of its later Gupta origin. On stylistic grounds it can be ascribed to c. 7th century A.D.

90 *Vishnu.* 108 × 60 cm. Pallava. C. 9th century A.D. The sculpture represents a standing image of Vishnu against a stone background in relief. Of his four hands, the upper right holds the disc, the upper left Sankha, the lower left resting on his hip on which in identical specimens, the Lord holds the mace *(gada).* The lower right seems to be missing in which he generally holds the lotus *(padma).* This is a Samapāda Sthanaka type of icon – with blessing pose – and he wears a crown *(kirīta mukuta)* on his head, flower rings *(pushpa kundalas)* in his ears and armlets and bangles on his arms. His schematic cloth shows two characteristic knots on either side.

91 *Tīrthankara.* Reddish sandstone. Post-Gupta. 27 × 28 cm. Bodh-Gayā. C. 7th century A.D. The mentor is shown seated in the meditation pose on a throne supported by a pair of lions. The Srīvatsa mark on his chest speaks of his Jain association. The fullness of his face, his thick lips, drooping eye-lids speak of its Gupta origin. Yet, in the treatment of his body there is a marked slenderness that shows a tendency to depart from the aesthetic idioms.

92 *Ādinātha.* 80 × 68 cm. Rājasthān, C. 9th century A.D. The sculpture is hewed in black sheist and represents the Jain deity Ādināth seated in the meditation pose. In the centre of his chest, a Shrīvatsa symbol is exhibited as he represents perfect concentration and poise. He is placed over a nicely carved pedestal which exhibits stylized Shrīvatsa symbols. This is one of the finest examples of sculpture from the Asmer-Bekanir region.

93 *Manjushrī.* Gilded Brass. 48 × 22 cm. Nepal. C. 15th century. The icon from Nepal represents Manjusrī seated on the diamond throne on a lotus capital. He is profusely ornamented in head, neck, ears, arms and wrists as he exhibits *(dharmachakrapravarthanamudrā).* Either side of his arms are adorned with lotuses on the tops of which there is a manuscript in the left and a sword in the right.

94 *Call of spring.* Miniature painting. 34 × 26 cm. Pahārī, Kāngrā, C. middle of 18th century. The painting represents an illustration from the Gīta Govinda. A grove in spring has been depicted on the bank of the Yamunā. The trees and shrubs are shown to be loaded with flowers.

Krishna in a yellow robe seems to be waiting at the extreme left. His 'duti' or female messenger approaches Rādhā who stands in the middle in a fit of pique. Rādhā is draped in a pink robe and her identity is written above her head, in Devnāgri script. The entire scene has been labelled as Vasant, i.e., Spring, in another inscription above Krishna. This is one of the finest products of the Kāngrā School of painting.

95 *Gopī.* Jamini Ray. 76.5 × 61 cm. About 1940. Jamini Ray is the most celebrated among the living artists in India. In the first quarter of this century, Abanindranath Tagore and his young associates of the Bengal School made a deep probe into the rich artistic heritage of India's past. In such attempts while Nandalal and Asit Haldar were influenced by Ajantā murals, Jamini Ray took up Bengal's homogeneous artistic tradition of Kalighat Pats as his ideal. In the course of time, he could fully exploit all aesthetic possibilities and linear qualities of the Bazar painting and added in his works the delicate flavour of his own genius. Gopīs are the mythical lady loves of Lord Krishna and here she is shown in the dancing attitude. Her heavy bust and thighs have been peculiarly balanced by her light and lithe abdomen, and her gait is at once so soothing and impressive. Bold flat outline contrasts her frame from the dark brown background and the subtle nuances in the treatment of outline as well as the schematisation of the facial features, etc., show Jamini Ray's individual characteristics.

96 *Chamba Rumal.* 134 × 64 cm. Chamba. C. 19th century. Chamba, a former hill state in the Gharwal region, is not too far from Kashmir. In Kashmir also we come across Rumals, but if Kashmiri Rumals are redolent of sophisticated taste and temperament, in Chamba this is purely a folk art. They are thus akin to the Kānthās of Bengal, though their purpose is different. This Rumal depicts Rāma and Sītā seated on a throne in the centre. Rāmā carries a bow in his left hand and an arrow in the right. Before him, Lakshmana holds the Chamara in his right hand and sweets in the left. The god Hanumān stands behind Lakshmana with folded hands. Some celestial figure, probably Brahmā with definite aureola round his head stands with palms joined together and a rosary in his hands. Behind the couple, Bhārata holds the Royal umbrella *(rāja chhatra),* Satrughna follows Bhārata with a Chamara in his left hand and sweets in the right. The last person in the back is Indra who is distinguished by the aureola round his head as he carries a pair of lotuses in his folded palms. Over the heads of Rāma and Sītā two Vidyādharas are depicted as pouring flowers. A horse, an elephant, a goat and a deer have been depicted on the top. Below them a rhinoceros and flying parrots can be seen. The last frieze shows a tiger, a peacock, a crane, a goat, a pair of white and coloured peacocks, etc. Stylized acanthus leaves serve as the frame for the entire composition.

97 *Rādhā and Krishna in a Grove.* Miniature painting on paper. 19 × 12 cm. Kishangarh. C. middle 18th century.

The painting depicts Rādhā and Krishna standing beneath a pair of Tamala trees that have formed a grove. With his right hand Krishna holds a twig. His left hand is stretched over the neck of Rādhā in which he holds his flute. Rādhā has been depicted as clasping Krishna by her right hand. Krishna is shown here in his usual deep blue colour and Rādhā in ivory white. The divine nature of the couple is suggested by the aureola round their heads. The colours used in this painting are yellow, green, dark-brown, blue, orange, white, gold and black and other combinations of shades. Slightly carved eyes, sharp facial features, slender treatment of the bodies, all this speaks of the mature Kishangarh style in the middle of the 18th century.

98 a) *Bhūdevī*. Grey sandstone. 183×61 cm. Chola. C. 10th century. A.D. The sculpture represents a life-size figure of Bhūdevī, hewed in grey sandstone. She stands with her left knee tilted forward, and her left hand, holding a lotus, is broken. She wears an elaborate Karanda Mukuta on the head and flower rings in the ears. She exhibits a delicate and sensitive modelling of the mass and volume and her rhythmical gait perfectly balances with her sensitive smile. Her nose is broken. She wears strings of necklaces and the lowest one makes its way in between her breasts. A strip of cloth covers her delicate bosom. Round her waist, she wears waist bands and other ornaments while armlets and wristlets embellish her right arm. The cloth covering her up to the ankles suggests wet drapery and on her feet, she wears bells *(nūpuras)*. This is one of the finest specimens of the 10th century. Chola sculpture and its possible provenance is near Thanfaner (Tanjore) in South India.

98 b) *Shiva as Vīnādhara Dakshina-mūrtī*. Bronze. 95×34 cm. Tanjore. C. 15th century. The four-armed Siva, standing on a lotus pedestal, wears a Jāta Mukuta on his head, a Patra Kundala in his left ear and a Makarakundala in the right. He has Ajina as his Upavīta and a bell has been tied below his right knee. In his two upper arms, he holds *(parashu)* and Deer *(mriga)* and his two lower arms have been depicted in a posture that represents playing on the Vīnā. Shiva is shown here as the universal Lord of Music and his visage represents the rapture of joy and ecstasy.

99 *Gajāsura. Samhāra Mūrti of Shiva*. 80×62 cm. Chandella. C. 11th century. The sculpture represents the Gajāsura Samhāra aspect of Shiva. The Lord is here represented in his eighteen-armed form and the entire composition depicts energy and vigour. The Gajāsura whose belly has been torn apart is shown over the head lifted by two top arms. The next to the right picks up an arrow and trident. The sixth hand is broken. The seventh carries Gada, the eighth Pustaka, and the ninth Musala. In his lower left hands, he carries a snake, the next one exhibits the pose of teaching *(pradarshanamudrā)* which he points at the carcass of Gajāsura. The lower one holds a shield, the fifth, seventh, eighth and ninth arms in this direction are broken. The Lord wears a garland of human skulls and bones. On the top, two Gandharvas are shown and a Vidyādhara has been depicted floating on the air before his eyes. Three retainers of Gajāsura have been depicted in the lower part of the panel. One has been upturned with his head hanging below at the right. The Lord places his left foot on the head of another who carries a sword in his right hand. The third one in the extreme corner is shown lying on the ground with his head resting on his left arm. In the foreground to the left, Mahākālī has been depicted in her four-armed form. She carries the drum *(damaru)* in her upper right arm while the lower right is broken from the waist. She has a human skull *(kāpala)* on her left arm from which she is shown drinking the blood of Gajāsura. Her lower right arm carries *khatvānga*, a weapon made of a skull on a human bone. She wears a necklace of snakes. Behind her Vīrabhadra has been depicted with a sword in his right and a shield in his left. The bull Nandi, the Lord's mount, occupies the lower portion of the background. The sculpture is undoubtedly an outstanding product of the 11th century Chandella sculpture from Central India.

100 *Vaishnavī*. Coloured wooden panel. Kerala. C. 16th century. The sculpture represents Vaishnavī, the female counterpart of Vishnu, standing over the head of the Buffalo demon Mahishāsura. According to some of the Purānas, it was Vaishnavī and not Durgā who killed Mahishāsura. She is four-armed and has the deep green complexion with which her lord is characterized. In her upper two arms, she holds the disc and couch, the common attributes of Vishnu, but in her lower two arms, she carries a bow and an arrow. There are two stylized Makaras on either side of the panel. The colours used here are deep green, white, dark brown, yellow and blue. This plaque comprised the decorative panel of some temple.

GURUSADAY MUSEUM OF BENGAL FOLK-ART

Gurusaday Museum is a specialized museum only containing folk-art objects collected from different corners of Bengal, which reflect the aesthetic mind of the rural people of Bengal. Though the history of this collection began in the early thirties, it is a house of a very rich and rare collection of Bengali traditional arts and crafts, most of which are now disappearing hurriedly. This museum has a character of its own. Though the objects displayed here were collected by one great personality, it is not a personalia museum, but an art museum devoted to a particular region: 'Bengal' before its partition.

This museum was originally known as Bratachari Museum, as its founder, the late Gurusaday Dutt planned to establish this folk-art and craft museum as an essential part of his scheme of the Rural University, as part and parcel of his Bratchari movement for the revival of the past glories of Bengali folk-culture.

The late Gurusaday Dutt, the original founder of this collection, was a member of the Indian Civil Service and took great personal interest in collecting and reviving the traditional art object, as well as in folk-dance, folk-song, folk-lyric and literature, which are still alive and interlaced with each other and also inseparable from the native rural life itself.

With the aim of revitalizing the dying art tradition of Bengal, Gurusaday Dutt started collecting folk-art objects in 1929.

He began to write on these neglected treasures of Bengal in different journals and magazines. He was able to link up a particular object with the whole life of the people and place. He knew what sort of life and tradition, philosophy and economic activity each object represented and put his finger straight on the heart of the matter and tried to rouse sympathy of the masses towards these neglected art treasures. He went to the people themselves, their villages and tried to unravel thesources of their creative activity.

In 1932 he arranged an exhibition with his collected objects of folk-art under the patronage of the Society of Oriental Art at the Society's building, which attracted the minds of the art lovers and connoisseurs towards these 'trifles' and dying art treasures of Bengal.

In 1940, he established Bratacharigram, his ideal village to house his planned University of folk-culture.

In 1941, this collection was shifted to Sri Dutt's newly built house at Store Road, now Gurusaday Road; six months later he passed away prematurely in the month of June.

In 1945, the present permanent building of the museum was built under the supervision of the Bengal Bratachari Society, the present supervisory authority of the museum. But due to unavoidable circumstances, it took a long time to shift the collection to its new home. In the meantime, two exhibitions were arranged at Government House which drew great attention from art lovers as well as the general public to this collection.

Finally, in 1959, this collection was shifted to the present museum building placed in a natural sylvan atmosphere in the southern suburbs of Calcutta, on the Diamond Harbour Road. An honorary Curator was also appointed by the Society to look after the collection.

In 1961, the museum building was opened by the then Chief Minister of West Bengal, Dr. B.C.Roy, but very few people could see this collection as there were no regular opening hours due to lack of staff.

In August 1962, a full-time, paid Curator was appointed by the Society for the museum and after

that regular opening hours were introduced enabling the visitors to view the collection.

On February 8th, 1963, Prof. Humayun Kabir, the then Union Minister for Scientific Research and Cultural Affairs, opened the Lower Exhibition Galleries to the public permanently.

In May 1968, on the Birthday Festival of the founder, the late Sri G. S. Dutt, the Upper Gallery for folk-paintings was opened to the public.

The museum is owned and supervised by the Bengal Bratachari Society. Both the Union Government and the Government of West Bengal support this museum with development and maintenance grants.

Exhibits are being changed every four months, making the whole museum collection accessible to the public, which is an attempt to widen the visitor's outlook and interest.

Gurusaday Museum is fully devoted to the folk-art objects of Bengal and mainly contains folk-paintings (including scroll-paintings, square paintings, painted potteries, painted cards, painted manuscript covers, Chalchitra, etc.), decorated Kānthās (embroidered quilts etc.), wood carvings, terracotta plaques, dolls and toys, potteries (ancient and modern) and a few stone, bronze and brass sculptures, etc. The aesthetic minds of the village people reflected in these trivial objects are of superb order though the materials used are very cheap and mostly made of rejected articles.

DESCRIPTION OF ILLUSTRATIONS

103 *Eyosara*. Painted pottery. Terracotta. Rangpore district, Bangladesh. 20th century. Is was used as an auspicious pottery in Bengali wedding ceremonies.

104 a) *Temple plaque*. Terracotta. 10.43×15.24 cm. 9.16× 15.24 cm; 15.24×15.24 cm. From a temple in Jessore district, now Bangladesh. Early 18th century. The relief shows Krishna dancing with Rādhā and her friends.

104 b) *Temple plaque*. Terracotta. 17.78×17.78 cm. From a temple in Mathurapore village, Faridpore district, Bangladesh. 17th century. The representation shows a typical hunting bandparty on the back of a camel or a stylized horse.

104 c) *Toy cart*. Terracotta. 19.05×15.24×13.97 cm. Faridpore district, Bangladesh. Early 20th century.

105 a) *Vase*. Terracotta. Height 39.64 cm. and 20.32 cm. in diameter. Tamluk, Midnapore district, West Bengal. 1st century B.C. or 1st century A.D. It shows affinity with Cretan pottery in shape and stamped creeper – like design on the neck.

105 b) *Black stone sculpture*. 27.94×12.70×13.97 cm. Burdwan district, West Bengal. 18th century. It shows crawling baby Krishna lifting his right hand as if holding something, i.e., Naru, a type of sweet.

106 *Kānthā*. An embroidered quilt. 182.88×152.40 cm. Faridpore district, Bangladesh. 19th century. It depicts a central lotus being surrounded by four corner Kalkas, mango trees, mirror, comb, lamb-stand, kajal-lata, pair of scissors, umbrella, nut-cutter moon and star, etc. within the rectangular field bordered by a floral creeper. This Kānthā having some Muslim influences in the designing and colour scheme was collected from a Muslim family.

107 *Painted dolls*. Burnt clay. 12.70 and 7.62 cm. Bengal. Early 20th century. Clay dolls like these have been preserved from different parts of Bengal.

108 *Wooden bull*. Height 39.37 cm. Comilla, Bangladesh. Early 20th century. Part of a Barisakstha, a wooden auspicious object connected with Bengali after-death religious ceremonies *(sradh)*.

109 a) *Mother-and-child doll*. Terracotta. Height 10.43 cm. Mymensingh district, Bangladesh. Early 20th century. Here the mother is engaged in work with a winnowing fan and the child is clinging to her shoulder.

109 b) *Mother-and-child doll*. Terracotta. Height 17.78 cm. Mymensingh district, Bangladesh. Early 20th century.

110 a) *Part of a decorated wooden supporting beam*. 86.36×25.40 cm. Village Balijuri, Birbhum district, West Bengal. 19th century. It stems from a wooden structure for a thatched hut used as a place of worshipping Goddess Durgā *(chandīmandapa)*. The left side panel shows a village barber engaged in shaving an old Bengali village teacher and a little page boy holding a hukka for his master, the teacher, being placed behind the barber. The right side panel depicts the barber's wife colouring the feet of the teacher's wife.

110 b) *Decorative wooden panel*. 66.04×16.51 cm. Khulna district, Bangladesh. 17th century. Depicting the inner apartment of a Bengali landlord's family with the landlord's mistress being seated on a stool in the centre, enjoying the company of her friends and attendants, each holding a musical instrument or peacock, etc.

110 c) *Decorative wooden panel*. 66.04×13.97 cm. Khulna district. 17th century. Showing a Bengali landlord being seated on a chair under an umbrella before his house, and two archers (probably his attendants) standing before him with an elephant, perhaps being ready for hunting.

111 a) *Wooden sculpture of a Bengali lady* in European dress. 30.48×13.97 cm. Birbhum district, West Bengal. 19th century.

43

111 b) *Wooden sculpture of a Bengali lady* pasting betel leaf. Height 30.48 cm. Jessore district, Bangladesh. Early 18th century.

112 a) *Lakshmī sara*. Terracotta. Diameter 25.40 cm. Faridpore district, Bangladesh. Early 20th century. Lakshmī sara is a circular convexed disc (painted) which is worshipped in lieu of the image of Lakshmī, the Goddess of Prosperity, during the full moon day after the Durgā pūjā.

112 b) *Small magical painting*. 60.96 × 22.86 cm. Midnapore district, West Bengal. 19th century. The painting is connected with some after-death ritual, known as Paralaukik, pat, having two panels showing a man and a woman engaged in eating betel leaf.

RABINDRA BHARATI MUSEUM

Rabindra Bharati Museum, which is one of the newer museums in Calcutta, has a character of its own. It was founded on May 8, 1961. This was the centenary birthday of the poet Rabindranath Tagore, who was the first in Asia to have received the Nobel Prize for literature in 1913.

Tagore was a genius, a man of multifaceted personality. His creative activities covered almost every phase of human feeling, thought and action. He was a poet and philosopher; a novelist and short-story writer, a dramatist and an actor, who appeared successfully in some of the leading roles of his own dramas; an essayist and for some time even a leader of India's political movement for independence; a visionary and a worker with a keen sense of reality devoted to the cause of the socio-economic development of his country's under-privileged community; a staunch nationalist and an indomitable prophet of internationalism; an educational thinker with revolutionary ideas who built up the first international University in India and an aristocrat with sincere feeling against the philistines of his age. He was a musician who composed nearly two thousand songs and gave tunes to most of them. Lastly, he started painting when he had already reached the advanced age of sixty-seven and produced in twelve years more than two thousand pieces of drawings and paintings, which are mostly datable between 1928 and 1940.

In memory of this great son of India the local State Government acquired the poet's ancestral house, situated in the heart of old Calcutta and established a University and the Rabindra Bharati Museum there.

The house of the Tagore family has been of great historical importance for generations. It was the earliest centre in India where the cultures from the East and the West met in modern times. It is also associated with the memory of a number of talented members of the Tagore family, who played leading roles in different spheres of the cultural renaissance of Bengal throughout the nineteenth century. Lastly, it was here that the poet was born and brought up and died. The first forty years of his long life were spent in this house. And during the last forty years, he used to reside here whenever he visited the city.

Rabindra Bharati Museum is therefore a museum different from many others. It is mainly interested in the collection of rare objects, books and records and works of art and craftsmanship concerning the life and creative activities of Rabindranath Tagore, the achievements of the distinguished members of the Tagore family other than Rabindranath, and the nineteenth-century renaissance of Bengal and its leaders. The most remarkable works of art collected at Rabindra Bharati Museum are the forty-two original pieces of drawings and paintings done by Rabindranath Tagore. Of these, forty-one pieces were purchased and one was received as a gift. For a lover of international art, these alone would make a visit to the house of the Tagore family in Calcutta worthwhile.

The story of Rabindranath's creative activities in the realm of pictorial art has a special interest of its own. It began with corrections of his literary manuscripts. The poet had no training in academic painting. His love for neatness often made him develop casual corrections into rhythmical creations in lines sometimes taking strange shapes. At the earliest stage, he used pen and ink as the media of artistic representation.

In 1928 the poet became more serious and took to coloured inks and a little later pencils, crayons and gouache. But the great bulk of his work is in ink as

he continued to use that medium throughout his artistic career. Twice or thrice only he tried his hand at oils, but in vain.

The subjects of his treatment are diverse. In the beginning he discarded representation of natural objects and drew fantastic figures and imaginary shapes, stored up either in memory or dreams. Later on he covered a vastly wider range. The results were pictorial representations of strange birds, fanciful trees, fantastic monsters, grotesque shapes, landscapes, and human faces and figures. There were also some attractive abstract designs and calligraphic representations.

Tagore's creations are remarkable for their rhythmic vitality. In fact, they were born out of a sense of rhythm which was rather instinctive in the creator. "One thing which is common to all arts is the principle of rhythm which transforms inert materials into living creations. My instinct for it and my training in its use led me to know that lines and colours in art are no carriers of information; they seek their rhythmic incarnation in pictures. Their ultimate purpose is not to illustrate or to copy some outer fact or inner vision, but to evolve a harmonious wholeness which finds its passage through our eyesight into imagination." These are the words of the poet himself. The same sense of rhythm made his verse, prose and music peerless.

It was in 1930 that his drawings and paintings were exhibited publicly for the first time. They were shown in Paris, London, Berlin, Copenhagen, Moscow, and New York. Everywhere they received wide acclaim. The poet at once became an international artist.

From 1930 till his death in 1941 Tagore continued to paint regularly. Perhaps his best creations belong to this period. In this period we find many portrait studies and landscapes with a real human feeling, often uncanny and at times haunting in their expressions. The colour is vibrant, luminous and evocative. His landscapes, particularly in colour, have a feeling of nostalgia of a distant scene of the past. They appear before our eyes as something very intimately known.

The novel medium of coloured ink has some kind of inherent luminosity and energy which makes his landscapes as well as his portrait studies glow from within. "His compositions, though less in number, are highly interesting because of their unorthodox and original manner of juxtaposition." This is the appraisal of Tagore's later stage of art creations by a Director of the National Gallery of Modern Art in New Delhi.

There is another point of international interest about Tagore as an artist. He was strongly opposed to the idea of appellation for his creations for the purpose of reference. "It is absolutely impossible," he wrote, "to give a name to my pictures, the reason being that I never make a picture of any preconceived subject. Accidentally some form, whose geneology I am totally unaware of, takes shape out of the tip of my moving pen and stands out as an individual." Tagore also disliked any attempt to find meaning in his pictures. To him, they were but to express and not to explain. "They have nothing ulterior behind their own appearance for the thoughts to explore and words to describe." (Rabindranath Tagore) Tagore had ideas quite clear and definite about the function of an artists. True art gives us things to see. We see them and enjoy. They should neither convey a philosophic message nor impose any moral lesson. If they do, it is something over and above – a surplus. Tagore in his characteristic way explained his position to a contemporary Indian artist thus: "When I had not yet taken to painting, out of this phenomenal world melodies would enter my ears and give rise to feelings and emotions which would make their aural impact on my mind. But when I turned to painting, I at once found my place in the grand cavalcade of the visual world. Trees and plants, men and beasts, everything became vividly real in their own distinct forms. Then lines and colours began revealing to me the spirit of the concrete objects in nature. There was no more need for further elucidation of their *raison d'être* once the artist discovered his role of a beholder – pure and simple. Only the true artist can comprehend the secret of this visible world and the joy of revealing it. Others who seek to read senseless meaning into the pictures, are bound to get lost in a maze of futility."

Though a nonconformist throughout his life, Rabindranath Tagore was indeed a great expressionist painter.

The second gallery of this museum has a corner exclusively devoted to Abanindranath Tagore. He was a nephew of the poet and an artist of international fame. He was the leader of the revival movement in Indian art.

His elder brother Gaganendranath Tagore was also a powerful and versatile artist. A number of his paintings have been collected. Gaganendranath was the first in India to try cubism and cartoons. Few pieces, however, is copied. He developed his own style in every field.

Sunayani Devi, a sister of Abanindranath and Gaganendranath, is represented by her "Lady with a Lotus". She was self-trained and belonged to no school.

Rathindranath Tagore, the poet's eldest son, was also an artist. He painted 'portraits of flowers' and carved wood work, either painted or inlaid. A self-taught artist as he was, he developed a style of his own in both painting and craft. There are a number of his representative works in the collections of the museum.

The portrait of Rabindranath, who was one of the most handsome persons of his time, has been tried by a large number of artists, Indian and foreign. Various media were used. Some are painted, some sketched. The art collections of the Rabindra Bharati Museum have been enriched with original copies of a number of these portraits.

An exhibit of particular interest is a box with a sculpture in bas-relief on the front side used as panels. This box was the personal property of Abanindranath Tagore in which he used to keep his painting equipment, etc. The three pieces illustrate the incidents of the Krishna legend by three distinguished artists of Bengal.

DESCRIPTION OF ILLUSTRATIONS

115 Gaganendranath Tagore, born in 1867 in Calcutta, died in 1938 in Calcutta. 'Composition'. Chinese black on hand-made paper, 33 × 24.5 cm. A woman sitting in a room. Signed.

116 Abanindranath Tagore, born in 1871 in Calcutta, died in 1951 in Calcutta. 'Jyotirindranath'. Portrait, on thick drawing paper. Water colour, 24 × 17 cm. Signed.

117 Rabindranath Tagore, born in 1861 in Calcutta, died in 1941 in Calcutta. 'Self-portrait'. On hand-made paper. Sepia and Chinese black, 34 × 23 cm. Signed and dated Asar 3, 1342 B. S. Chandernagar.

118 Rabindranath Tagore. "The Bird". On writing pad paper. A decorative bird in colour on black background. 17 × 24 cm. Signed.

119 Manishi Dey. One of the exponents of the Bengal School founded by Abanindranath Tagore. 'Poet Rabindranath' On hand-made paper in tempera colour. General tone yellowish red, 23.5 × 15.5 cm. Signed and dated 1961.

120 a) Rabindranath Tagore. 'A Mask'. On thin board paper. Black dry point print. Tendency calligraphic. 11.5 × 17.5 cm.

120 b) Rabindranath Tagore. 'A Face'. On writing pad paper Pen and ink drawing, 28 × 21 cm. A grotesque figure with terrific expression. Signed and dated 29-3-36, Delhi.

120 c) Rabindranath Tagore. 'A Study'. On hand-made paper. A female bust in colour, general tone sepia, 37 × 25.5 cm. Signed and dated Agrahayan 3, 1341 B.S.

121 Sunayani Devi, born in 1875 in Calcutta, died in 1962 in Calcutta. 'Lady with a Lotus'. One of her masterpieces done on Kent paper in black lines and wash. 31.5 × 24.5 cm.

122 Hironmay Roy Chadhury. Bronze plaque from 'Radha' series. 44 × 62 cm. It forms the central piece of the front side of a box representing – together with the left and right plaques by Asit Kumar Haldar and Nandalal Bose respectively – scenes of the Krishna Legends. The casting of all three plaques was done by H.R. Chandhury.

INDIAN INSTITUTE OF ART IN INDUSTRY AND CRAFT MUSEUM

The Indian Institute of Art in Industry was established in 1947 by artists and industrialists of Bengal. Although the collection of craft objects had started almost from the inception of the institute, the collection could be suitably displayed only in 1957 when the Craft Museum came into being.

The basic aims of the Indian Institute of Art in Industry are to serve as a link between artists and industry and also to strive by all practical means to raise the standard of commercial and industrial design throughout India.

The Indian Institute of Art in Industry had originally been formed to give essential design services to industry. It was firmly supported by some of the industrial concerns. These concerns are in constant need of good designs for their goods, their packaging, their advertising and printing. Throughout its existence the institute has striven to improve the general standard of industrial and graphic design by arranging exhibitions, symposiums, lectures, seminars, conferences, etc., to encourage talented designers and artists to work in this field and to make the public aware of better designs.

While working for general improvement of industrial and graphic design, the institute has also been conscious of millions of traditional craftsmen of India who are still making a living from the crafts manufactured on cottage industry basis.

The institute has done extensive surveys on various craft pockets of the country with a view to focussing popular interest as well as specialized attention to their beautiful products and also to their problems. In the course of these surveys many beautiful specimens of crafts have been acquired by the institute and preserved in the Craft Museum where the institute has collected and is still collecting masterpieces of craft objects, old and new, from all over the country.

The collection is meant to be an inspiration to the present and future generations of designers and manufacturers to produce goods of Indian character and spirit.

The institute firmly believes that the rich heritage of our crafts preserved in its Craft Museum will be of immense value to future generations.

The Craft Museum and the library of the institute are paid more and more attention by artists, designers, architects and interested scholars and have now become a place for serious study of crafts and applied art.

The institute publishes a quarterly illustrated journal *Art in Industry* with articles of general and informatory nature upon various aspects of applied art, crafts and designs, contributed by eminent authorities from all over the world. Apart from this journal, the institute has a number of other publications to its credit.

While holding the Annual Exhibition of Applied Arts, the institute awards the institute's plaques to the best exhibits in different branches of production and Certificates of Merit to deserving entries. The Annual Exhibition encourages young designers to produce new designs for competition.

The institute and the Craft Museum were taken over from private management by the Government of India in March, 1970, and have been placed under the management of the Regional Design Centre with similar aims and objects.

DESCRIPTION OF ILLUSTRATIONS

125 *Drummer.* Sandstone. Height 53.4 cm. Orissa. 12th century. Here is the sculpture of a celestial damsel *(apsara)* in a very lively dramatic pose. She is depicted with an exquisitely carved drum *(mridanga)* strapped round her waist and kept in place with the support of her right thigh. She is holding the right side of the mridanga with her left hand and her right hand is raised above her head ready to strike the mridanga at the precise moment, to keep the beat of the music. The ornaments and jewellery in her hair, tied in a bun at the nape of her neck, enhance the beauty of her figure. Women playing on instruments, as in Rāsa Dance, is a Vaishnava tradition according to later texts.

126 *Caress.* Khondolite stone. Height 43.2 cm. Konārak, Orissa. C. 13th century. This is a masterly presentation of a loving couple. Rarely has the caress of a lover been rendered with such infinite tenderness, concentration and grace. The caressing fingers of the man speak a sensitive language of their own. Equally expressive are the fingers of the lady resting on her lover's shoulder. The right leg of the lady is on the left thigh of the lover and her right hand is responding with the same abandon as the man's left hand, which is lovingly caressing his beloved's cheek. Here, the man is also wearing the same type of jewellery as the woman.

127 a) *Measuring bowl.* Brass on wood. Height 21.6 cm. Lokepur, Birbhum, West Bengal. C. late 19th century. Generally used in the rice-producing states of India, this typical Kunke (regional name) is stylistically probably one of the best. Based on the idea of wicker-made measures, the ornamented brass plate reinforces the wooden structure with the design of a pair of pigeons at regular intervals.

127 b) *Nut-cracker in the Shape of a couple.* Brass. 17.8 cm. These betel-nut-cutters were made of brass. When the blades are held together, the actual figure comes out. These are fine specimens of utilitarian objects designed with beauty.

128 a) *Horse on Wheels.* Brass. Height 26.7 cm. Rājasthān. This horse on wheels with a man on its back is meant to be a toy. It can be easily pulled about on flat surfaces with the help of a string. The holes in the face and the reins of the horse are specifically meant for this purpose.

128 b) *Elephant on Wheels.* Brass. Height 25.5 cm. Rājasthān. This elephant on wheels with one man on the seat *(hawda)* and the driver *(mahout)* is also meant to be a toy. It can be pulled about on flat surfaces with the help of a string passed through the ring on the trunk. The mahut is seen with two elephant-goads *(ankushas)* in each hand.

129 *Miniature temple.* Brass. Height 33 cm. Rājasthān. This miniature brass temple is modelled on the thatched house of rural India. It is used to enshrine the household deities. The lattice decoration is probably imitated from Jali-work (stone screen) of Mughal tradition.

130 *Goddess Kālī.* Painted clay. Height 22.8 cm. The cult of Goddess Kālī (the Black) is one form of Sakti worship in the Hindu pantheon. This image is one of the manifestations of Pārvatī, consort of Shiva, the God of Destruction. Here we find a nine-inch Goddess Kālī which is still being made by only one family in Krishnagar, Nadia.

131 *Technique of Orissa Pata paintings.* 20.3×20.3 cm. The technique of painting Varāha (boar) Avatāra, one of the ten incarnations of Vishnu, is shown here, stage by stage, in ten patas. This modern pata from Orissa has been painted on cloth by Karuna Shau.

132 *Jewellery.*
a) Massive anklet made of zinc and other alloys in two pieces for use of Rājasthāni (?) farmer girls. Diameter up to outer circumference 18 cm.
b) Silver necklace from Sind (?) with a stone set in the middle. Length 25.5 cm.
c) Enormous ear-ring made of silver and other alloys found in Madhya Pradesh. Length 11 cm.
d) Hollow silver bangle *(bandriya)* from Orissa with pointed cones with delicate designs. Diameter up to outer circumference 9.5 cm.
e) Bangle *(kankan)* made of silver and other alloys beautifully designed with bead works from Orissa. Diameter 7.6 cm.

133 a) *Spear.* Length 238.5 cm. Udaipur, Rājasthān. C. 18th century. This is a very valuable spear probably made at the instance of a Rajput king. With pointed head of steel and detachable staff engraved with ivory, this spear is notable for its size and symmetrical design on wood.

133 b) *Dagger with scabbard.* Length 35.5 cm. Udaipur, Rājasthān. C. 18th–19th century. Beautifully shaped and sheathed in a decorated silver scabbard with a silver sling, this dagger has a traditional design.

133 c) *Gun powder box.* Height 16.5 cm. Udaipur, Rājasthān. C. 18th century. This gun powder box is made from the horns of a buffalo. Retaining the natural shape of the horn, the gun powder box is engraved with geometrical patterns in ivory. Two rings are fixed on one side of the horn to carry it at the waist. The lid and the base are made of ivory.

134 *Temple plaque.* Terracotta. 17.8×17.8 cm. Birbhum, West Bengal, C. 18th century. This is a typical temple brick depicting the Rāsalīlā scene from Krishna's life. The circle in the centre is a lotus around which Gopas (male) and Gopīs (female) are shown in a dancing pose, joining hands to form a ring. Designed with floral and geometric patterns, this type of brick was especially used to decorate the outer walls of the temple in order to attract the people.

135 a) *Bowls and plates.* Bowl. Height 15.2 cm., diameter 18.8 cm.; Bowl. Height 6.4 cm., diameter 10.8 cm; Plates, diameter 7.5 cm. Late 18th century. Jaipur white marble household ware (or articles for domestic use) with golden floral motifs around the rim are still being made in Jaipur, Rājasthān.

135 b) *Utensils.* Plate, diameter 18.7 cm. Scent bottle, height 28 cm. Powder Box, height 10.8 cm. Bidar, Hyderabad or Uttar Pradesh. C. 17th–18th century. Here are a few specimens of silver-inlay bidri-ware with floral and fish motifs inside the powder box. It is interesting to note that bidri-work in Bidar (Hyderabad, South India) is confined to the Mohammedan community there. This art has been handed over from father to son for generations.

136 *Bow and arrows.* Bow length 99.2 cm. Arrows 66 to 76 cm. Udaipur, Rājasthān. The bow is made of tempered steel. The lines are simple but elegant. Height measurement: – 3′ –3″ or 99.2 cm for bow. A few specimens of Indian arrows noted for their typical steel heads. Sometimes poison was smeared on the steel heads of the arrows. The arrow with a blunt head is generally employed for hunting birds as this type is always retrieved and can be used again. The arrow with a pointed head is used for shooting at animals.

On the death of Queen Victoria in January 1901, Lord Curzon, who was then the Viceroy of India, placed before the public the question of setting up a fitting memorial to the Queen. He suggested that the most suitable memorial would be a 'stately' spacious, monumental and grand building surrounded by an exquisite garden. This building was to be used for a "Historical Museum, a National Gallery and that alone, and that it should exist not for the advertisement of the present, but for the commemoration of that which is honourable and glorious in the past ... the art, the science, the literature, the history, the men, the events which are therein commemorated must be those of India and of Great Britain in India alone".

The people of India responded generously to his appeal for funds and the total cost of construction of this monument amounting to one crore and five lakha of rupees was derived entirely from their subscriptions. Sir William Emmerson, President of the British Institute of Architects, designed and drew up the plan of this building; King George V, then Prince of Wales, laid the foundation stone on 4th January 1906, and it was formally opened to the public in 1921.

The building, which is chiefly Italian Renaissance in character, is in the form of a capital H, the ends being joined by curved colonnades. Its exterior is of marble quarried at Makrana in the district of Nagaur, Rājasthān, the same quarries which supplied the marble for the Taj Mahal at Āgra. The group of statues over the entrance porches on the north and south and the statues surrounding the dome were executed in Italy.

The exhibits of the Victoria Memorial unfold a panorama of Indian history from the Mughal period to recent times. There are in the halls of this memorial rare Mughal miniatures, Persian and Indian manuscripts, paintings in oil and water colour of Indian scenery and life by European artists, statues, portraits of persons, European and Indian, who have played a prominent part in the history of India in the 18th, 19th and 20th centuries, arms and armours used in late medieval and comparatively modern warfare and important historical documents relating to the British period of Indian history.

The Victoria Memorial has a valuable collection of Indian and Persian manuscripts most of which are beautifully illustrated and are fine examples of calligraphic art. Special mention has to be made of *Anwari-i-Soheilli* which is the Persian version of stories from the *Panchatantra* and the *Hitopadesha*, well-known books of Indian fables. Written in Persian in 1518, it is believed to have been once in the library of the Mughal emperors of Delhi and might have been consulted by the artists of the royal atelier in preparing the famous royal copy of the *Anwar-i-Soheilli*. Another interesting work is the copy of the Persian translation of the Indian classic *Nala Damayantī*, which contains some full page illustrations of the Murshidābād School of Painting which flourished under the patronage of the Nawabs of Bengal in the 18th century. The text of this is written by an expert calligraphist. Dahpund-i-Hakim Arustu (ten counsels of Aristotle), Diwan Hafiz, and the collection of Persian poems calligraphed by Mir Emad for the Emperor Jahāngīr, are some other manuscripts bearing testimony to the excellence reached by calligraphic art. The *Gulistan* and *Bostan*, *Maznavi* of Maulana Rumi, *Haft Pand* of Loqman, Firdausi's *Shahnamah*, *Khamsa-i-Nisami* and *Kullivat-i-Sadi* are some of the beautifully illustrated manuscripts which need special mention.

The Victoria Memorial has about 200 oriental min- **51**

iatures. Mughal miniatures of the early period as well as of the peak period and of the different local schools which sprang up in the 18th and 19th centuries, will be found among them.

Special mention may be made of the miniatures of 'Jahāngīr distributing alms at the shrine of Salim Chisti', 'Akbar listening to a wise dwarf', 'Akbar with Jahangir and courtiers', 'Akbar on a hunting expedition', 'Jodha Bai', 'Shāh Jehān and his commander-in-chief', 'Prince Pateh Khan', 'Moktub Shāh, Jahāngīr's Munshi', 'Ibrāhim Adil Shāh II', 'Kabir', 'Birth of Christ', 'Akbar's elephant going mad'. From the miniatures displayed in the gallery of the Victoria Memorial the visitors may have a peep into the Mughal way of life: their sports and pastimes, their courts and courtiers and scenes of historic events of the period.

Among the paintings of the different sub-schools, the painting, 'Nawab of Lucknow giving a dinner party to Europeans' is a very interesting one. Scholars will find some new trends in the manner of composition and technique of painting, imported possibly from the European school of art.

It is well known that a number of European artists visited India in the second half of the 18th century and the early years of the 19th century and have left their impression of Indian scenery, Indian personages and historical events on oil paintings, water colours, sketches and prints. The Victoria Memorial exhibits works by the most well-known of these artists. Of those done in oil, paintings of Indian scenery by Thomas and William Daniell and the paintings of historical personages and events by John Zoffany deserve special mention. Of all museums in India, the Victoria Memorial possesses the richest collection of the paintings by the Daniells. The 'Fall of Pappanassum' by Thomas Daniell and 'A Choultry at Ramisaram with the approach of the n. e. monsoon' by his nephew William Daniell, show their mastery in depicting the forces of nature and the two paintings of the Taj Mahal their skill in portraying architectural edifices.

Zoffany's paintings of historical events are characterized by dynamic vigour and dramatic effect. 'Embassy of Haider Beg', 'Claude Martin and his friends' and the 'Death of a tiger' are instances in point. Zoffany was equally a master in delineating portraits. 'Warren Hastings and his wife' and 'Mrs. Hastings' where these personalities are faithfully re-

presented, are evidence of his skill in that direction. The composition and the depth of the paintings are noteworthy; the details are meticulously done to produce a very realistic look. The Victoria Memorial has also in its collection paintings by Joshua Reynolds, William Hodges, George Chinnery, Robert Home, Thomas Hickey and Tilly Kettle. Of the water colours, those by Miss Emily Eden and Samuel Davis should attract the attention of the visitors.

The principal events in the life of Queen Victoria have been depicted in the murals in the circular hall under the dome and in several oil paintings in the Royal Gallery. The painting of the Russian artist Verestchagin – the 'State Entry of Edward VII as Prince of Wales into the city of Jaipur in 1876', is a remarkable work of art which is generally admired. Measuring 274 by 196 inches, this masterpiece is known to be the largest canvas in oils in India.

The museum displays a good number of statuary in marble and bronze. There are statues of governors general and army commanders who figured prominently in Indian history, as well as of eminent persons in different spheres.

There are also portraits in oil and prints of several personages, European and Indian, who have played an important part in India's history in the 18th, 19th and 20th centuries. A special gallery exhibits portraits by eminent artists of the great sons of India who paved the way for their country's freedom.

The Victoria Memorial has a fairly good collection of documents comprising treaties, sanads, minutes, despatches, official and semiofficial letters, etc., connected with the British period of modern Indian history. This gallery shows to visitors through these documents how a trading company gradually acquired dominion in India. The adjoining National Leaders' Gallery displays documents relating to some episodes in the Indian struggle for freedom against British rule.

There is a separate room in this museum to give the visitors a glimpse of the changing face of the city of Calcutta in the years between the middle of the eighteenth and the beginning of the twentieth century through prints, paintings and photographs.

No account of the contents of the Victoria Memorial can be closed without reference to its collection of arms and armours which consists mostly of specimens used in India in the Mughal and late Mughal

period. They are fine examples of the workmanship of armour-smiths and decorative craftsmen of India. The form, shape, design and ornamentations in many of these are fascinating. The swords and daggers are fairly representative of the different types used in India. Most of them were manufactured in India or in Persia. Some European blades with Indian hilts and mountings can also be seen. Fine specimens of enamel work, gold damascening and filigree work, embossing, inlay and carving on metal, stone and ivory can be seen in this collection. The blades of many of these weapons are beautifully chiselled or engraved, portraying jungle or war-scenes, floral, foliage and creeper motifs, human and animal figures and many other compositions. Some of the swords are inscribed with verses from the holy books of the Muslims.

The museum has a rich collection of 'muzzle loaders', antique matchlocks, flintlocks and percussion type guns of Indian, Turkish and European manufacture. The Indian matchlocks have attractive decorations.

Housed in a palatial marble building of great architectural beauty these objects annually draw about four hundred thousand visitors to the galleries, among them students with their teachers, research workers in social and political history of India in the British period and art historians.

DESCRIPTION OF ILLUSTRATIONS

139 *Sword of Hyder Ali* (1722–1782). The hilt of the sword and the scabbard are gilt. While the hilt is decorated with red, white and light green imitation stones, inlaid on an exquisite floral design, the scabbard is embossed on both sides with a beautiful pattern composed of flowers and animals, such as deer, lion and elephant introduced at alternate positions. This sword is known to have originally belonged to Hyder Ali, the ruler of Mysore, a district in the southern part of India. His great aim was to dislodge the English from their possessions in South India.

140 '*The Old Fort and River Bank at Calcutta*'. By Thomas Daniell. Oil on canvas. 228.60 × 130.81 cm. This is identical with No. 8 of the set of twelve issues of Calcutta brought out by the Daniells in 1786–88. On the river bank are the houses of well-to-do Indians. A Hindu temple is seen. The old fort and the Armenian Church can be seen in the distance. There are country boats of different kinds on the river, a boat flying the East India Company's flag and a pleasure boat with the front portion of a winged horse as the prow *(pankhiraj)*, rowed by sixteen men. The whole presents a busy scene of activity on the river.

141 '*Rāja Rammohan Roy*'. By Atul Bose born 1774 in West Bengal died 1833 in Bristol). Oil on canvas. 233.68 × 142.24 cm. One of the masterpieces of the renowned Indian portrait painter Atul Bose. This is a full-length standing portrait of the Rāja. He is wearing the official dress of the time. Rammohan Roy may be correctly called the prophet of the New Age which dawned in Bengal in the nineteenth century. He strove to free the people of his country from superstition and ignorance and to arouse in them a love of freedom. His reforming activities, also directed against the social abuses in Hindu society, above all the rigours of the caste system, led him to publish Bengali translations of ancient Hindu scriptures and to bring out Bengali tracts. This helped the development of Bengali prose literature and Bengali journalism. The pro-gress of English education in Bengal also owes a great deal to Rammohan Roy. He had the vision of an educated India approximating to European standards of culture which could claim political rights enjoyed by the people of the West. This led him to be in the forefront of every progressive movement in the country.

142 *Chait Singh*. Miniature on ivory. 7.08 × 8.89 cm. Oudh. These two miniatures on ivory are good examples of late eighteenth/early nineteenth century miniatures of the Oudh School. Chait Singh. Rāja of Menares, contemporary with Asaf-ud-Dowiah, is shown here seated on a sofa with the pipe of a hubble bubble in his left hand. The ornaments on the turban, the earring and the long necklace are all made of pearls. The Rāja wears a bangle on both wrists.

143 a) *Asaf-ud-Daula*. Miniature on ivory. Diameter 3.51 cm. Asaf-ud-Daula was Nawab Visier of Oudh from 1775 to 1797. The head and shoulder of the Nawab are shown with fine details. The artist has succeeded in bringing out a most expressive face in all its details. The Nawab is shown wearing pearl ornaments on his turban and round his neck and a long one over his shoulder down the body.

143 b) '*The Palace of the Nawab Nazim at Murshidābād*'. By George Chinnary (1766–1852). Water colour on paper. 53.34 × 35.56 cm. George Chinnary was one of the numerous English artists who visited India in the first quarter of the 19th century and painted portraits and landscapes. The palace of the Nawab of Bengal at Murshidābād, the capital, is shown in the distant background on the opposite bank with other buildings as it was in the second quarter of the 19th century. The palace is hazy and the picture mainly represents a river scene with country boats. The principal object in the foreground is a big boat with six oars, three on each side. One of the boatmen is standing on the top holding the rudder. Of the

two others, one is smoking a hooka (hubble bubble) and the other is lying on the deck.

144 '*The Village School Master*'. By Thomas Daniell (1749 to 1840). Oil on canvas. 107.95 × 78.74 cm. The painting bears the name of T. Daniell and is dated 1812. The painting shows a typical village school master teaching his little pupils the three Rs. The scene is laid outside a temple wall. The school master and his wife are seated under a tree and are shielded from the sun by a bamboo mat. One pupil is drawing figures on the sand while another looks on. Two other pupils are reading. The inevitable rod of the school master is lying on the ground beside him. The scene is South Indian as is shown by the temple in the left background and by the appearance of the pupils. The colour of the painting is the same as with most other works of the Daniells, viz., umber mixed with yellow.

THE STATE ARCHAEOLOGICAL GALLERY
OF WEST BENGAL

Though partly composed of new alluvium mainly deposited by the river Ganges (Ganga) and her tributaries the archaeology of West Bengal stretches as far back as the Pleistocene particularly within the purlieus of the western uplands and rocky terrains of the State. Apart from the ruins and monuments of Darjeeling Himalaya covering the magnificent slopes and thrusts along the meandering courses of streams like the Tista, the Railly and the Great Rangit, the archaeology of West Bengal reveals an unbroken continuity of civilization across prehistoric and historic times, art being ever resuscitated even in the dark ages of political uncertainty.

In view of the importance of art and archaeology in the State, an Act was passed in 1957, regulating The West Bengal Preservation of Historical Monuments and Objects and Excavation of Archaeological Monuments and Objects and Excavation of Archaeological Sites, and became effective on 7th March, 1958. In order to implement this West Bengal Act XXXI of 1957 the Directorate of Archaeology of the State Government was created with effect of 1st August, 1958, having a few members of the staff working under the Chief Engineer of the Public Works Department actually to study the question of conservation of monuments preparatory to such considerations by archaeologists whose appointments were awaited at that time. In 1960 this Directorate really began its activities with the appointment of the Director and the Superintendents which was gradually followed by engagement of services of a technical staff. Being encouraged by Dr. B. C. Roy, the then Chief Minister, within two years, between 1960 and 1962, the Directorate of Archaeology acquired an appreciable number of objects of art and antiquity mainly by explorations and excavations. These included a number of significant examples which could throw a new light on Indian culture and civilization from chalcolithic epochs down to historical times recognizable by northern black polished ware, Sunga terracottas as also sculptures, paintings and other materials of Gupta, Pāla and medieval times. Besides, the repertoire was enriched by examples of lithic industries typologically and stratigraphically appertaining to the earlier part of the Neothermal times and the Pleistocene. In view of such an accumulation of materials including rare examples of antiquity as also a number of sculptures and paintings of artistic value and significance in some of the crowded chambers of the Old Secretariat in Calcutta, the necessity for opening a museum was felt and consequently the State Archaeological Gallery was inaugurated on 15th June, 1962, on the first floor of a large building at 33, Chittaranjan Avenue, in Calcutta. While inaugurating the Gallery Sri K. N. Das Gupta, the then Minister of the Public Works Department of West Bengal, conveyed his cherished hope that this gallery would one day develop into a large treasure-house of antiquities and relics eloquent of past achievements of human cultures and art. Thus, the gallery was created with expectations and hope both on behalf of the Government and the people.

On the date of inauguration the Gallery contained among others chalcolithic pottery ware and other antiquities unearthed from the mound of Pandu Rajar Dhibi in the valley of the river Ajay in Burdwan district, the first of its kind so far discovered in the entire eastern India. Here excavations were conducted in successive seasons by the writer, being assisted by Superintendents Sri D. K. Chakravarty and Dr. S. C. Mukherji and the staff. Apart from terracotta figurines and plaques envisaging *apsarās*, divinities and mythical subjects in Sunga-Kushān

55

style from Chandraketugarh in 24-Parganas district, there was an attractive array of images of Brahmanical, Buddhist and Jaina iconography, mainly carved in black basalt, besides a few examples in chlorite and sandstone. These sculptures being recovered from various regions of West Bengal have their usual emphasis on frontality achieved by high relief which indeed visualizes the supple grace, elegance and sensitive beauty of Pāla style and convention, characterized by an intimate appreciation of beauty and tenderness in the art of Varendra in North Bengal where the Rajmahal trap could be conveniently available to the sculptor. Apart from an important numismatic collection including a hoard of silver punch-marked coins from Lohapur, Birbhum district, embellished with a repertoire of symbolic motifs indicative of early Indian cults and rituals often affiliated as it appears with Vedic or protohistoric traditions, the wealth of materials in the gallery contained a number of fascinating sculptures in stucco and terracotta which delineated an uncommon grace and sensitivity both inspiring and contemplative according to the language of Gupta art. The latter mainly consisted of the stucco head of a *devata* stylistically appertaining to the Gupta period from Karnasuvarna in Murshidābād district and a set of terracottas from Panna in the valley of the river Silavati in Midnapur district, envisaged in the idiom of a slightly later convention which might have prevailed in plaques as referred to can sometimes be pleasantly decorative by visualizing foliated scrolls, arabesques or other floral motifs in a world of divine miracles, combat, love and redemption where peacocks and parrots can perhaps symbolize the celestial sphere like the half-bird *kinnaras* of early medieval compositions. As the wars between the gods, giants, centaurs and amazons on the pediments of Parthenon and Homeric combats are depicted on Greek pottery, the war of the Rāmāyana appears on terracotta temples of Bengal though of recent date as an eternal *tableau*, where a European battle-ship with full sail or riding at anchor or a file of infantrymen moving on in an attack may be introduced to heighten the effect of fray. Whoever might be the foreign troops, the grenadiers, marines, or guards, the artist has succeeded in visualizing the moments of war.

The repertoire of sculptures displayed in the new section opened in 1966 included some of the beautiful examples of stone stylistically appertaining to Bengal in post-Gupta and Pāla times. Such images usually carved in greenish chlorite discovered amidst ruins of ancient Jaina temples at Pakbira close to the source of the Silavait-river in Purulia district in West Bengal consist of a number of heads carved in the vocabulary of Gupta tradition visualizing an assured tranquility where the inner soul is more sought for than the external world. A torso of a female figure recovered from Pakbira on the other hand envisages a graceful modulation of the lower part seductively enclosed by a delicate fabric furnished with fine folds and yielding to movement. Similarly, among other sculptures displayed in this section a fragmentary large stele of Vishnu carved in black basalt from Bhagavanpur in Malda district is flanked by what may be regarded as one of the most graceful and elegant images of Sarasvatī, the goddess of Learning, Music, Speech, c. 7th century A.D., not only indicating a pleasing freedom in clay but also an affiliation with comparable terracottas from Ushkar in Kashmir and Padmavati in Central India. The wealth of collections in the State Archaeological Gallery steadily increased since its inauguration in 1962 and consequently a new wing to be known as the Historical Art Section was opened on 5th October, 1963. At this time the Gallery was enriched by a repertoire of old paintings and drawings belonging to Mughal, Rājasthāni, Pahāri and Deccani schools besides a number of masterpieces from Bengal inspired by classic and folk traditions in the 19th and beginning of the 20th centuries. Among these a special mention may be made of a 19th century panel of wood painted with the subject of *Shiva-Vivāha* or *Kalyanasundaram* (Shiva's marriage) from a ritual car *(ratha)* at Kalna, Burdwan district, where the general composition and figuration reveal a charming balance and dignity by stimulating lines and luminous pigments emphasizing the seductive beauty of a goddess coyly standing in the foreground before a perspective occupied by a glorious congregation of Puranic divinities.

After the inauguration of the new Section, the gallery still expanded mainly due to the conduct of field-work all over West Bengal by the explorer of the Directorate of Archaeology, though paintings, bronzes, wood-carvings, ivories, coins, gems, textiles and other examples of minor arts were often acquired by purchase or in a few instances as gifts 56

from private collectors. Thus, the excavations at the chalcolithic site of Pandu Rajar Dhibi in the valley of the river Ajay in Burdwan district brought to light a large number of proto-historic ceramics including various examples of Black-and-Red Ware and lustrous Red Ware, often enbellished with painted designs besides black-burnished pottery and handmade vessels occasionally bearing incised or scratched patterns and motifs. While the assemblage of excavated Black-and-Red Ware from the site included knife-edged or channel-spouted bowls, vase-stands and basins of graceful forms often resembling a flower-pot or an inverted helmet, the examples of lustrous Red Ware represented bowls with slightly incurved bevelled rim globular vases, saucers and others.

Besides, there were fragments of Chocolate Ware painted in whitish pigment and a single fragment of burnished Black Ware embellished in primrose. The excavation at Pandu Rajar Dhibi conducted in 1963, like those of the previous and succeeding years, brought to light as usual numerous specimens of Black-and-Red Ware often painted with conventional designs in whitish pigments. On the other hand, the excavated lustrous and smooth Red Ware was frequently painted in black the decorations including solid triangles, stopped chevrons, trellis, wavy and radiating lines, hatched diamonds and others. Such pottery ware from Pandu Bajar Dhibi indeed bears evidence of a material culture belonging to proto-history as classified within three successive periods from the natural level of this site composed of mottled sandy silt mixed with laterite. In this connection it may be observed that while Periods I and II of the site witnessed the growth and development of a chalcolithic civilization which once dawned in the forested uplands of West Bengal, topographically associated with the Chotanagpur plateau in the west and extending as far east as the floodplains of the Bhagirathi, Period III of Pandu Bajar Dhibi is characterized by the introduction of iron and polished neolithic celts besides a kind of dish-on-stands of glossy Black Ware. Apart from stratigraphic evidence correlated after obtaining sections of the rolling mound, a C14 examination of excavated charcoal remains from the level of Period II has indicated that the full efflorescence of culture at Pandu Rajar Dhibi appertains to the end of the 2nd millennium B.C.

Apart from successive floor-levels, human cemeteries and rows of ovens, the microlithic blades and copper objects and a plethoric occurrence of channel-spouted bowls are obviously of real importance for their comparable horizons in central and western India.

Excavations at Pandu Rajar Dhibi, the first chalcolithic site discovered in West Bengal, have brought to light a number of terracotta figurines representing as it appears mothergoddesses with accentuated breasts or splayed hips and pin-hole decorations and male figures with formalized and sharply designed features suggestive of considerable strength, vigour and an established convention in art. While these figures belong to Period III, characterized by the intrusion of short swords and celts besides polished neolithic axes within an otherwise chalcolithic assemblage, a terracotta torso of a male gymnast or dancer enigmatically belongs to Period II. The archaeological diggings at Pandu Rajar Dhibi and explorations conducted in a much wider area have established that a civilization dawned in Bengal somewhere in the second half of the 2nd millennium B.C. when unknown communities studded the valley of the river Ajay and its neighbourhood with villages. The habitational levels at Pandu Rajar Dhibi reveal that the site was occupied by a large village or town in the Copper age, being predominantly composed of round, oblong or square huts with orange-red floors of pellety laterite and wooden or bamboo posts. The walls of such huts were composed of wooden or bamboo screens plastered with rammed clay. Evidences have been found to prove that the proto-historic inhabitants of Pandu Rajar Dhibi practised stock-breeding, hunting and fishing besides practising the art of weaving delicate fabrics of silk-cotton and regular cultivation of domesticated rice. They also smelted iron when they still used painted Black-and-Red and lustrous Red Ware and microlithic blades, thereby recalling the comparable sequence at Luristan and at Sialk, Necropolis B, in Iran.

Due to the continuous efforts of the Directorate of Archaeology of the State Government, the gallery was steadily enriched by objects of art and antiquity in the years 1964 and 1965 for which the necessity for opening a new section was felt again. Thus, the Prehistoric and Early Antiquities Section was inaugurated on 26th January, 1966. The section being

accommodated in a hall with considerable floor-space not only contained tools of the Early Middle and Late Stone ages mainly discovered in West Bengal but also excavated pottery-ware from Pandu Rajar Dhibi including a complete channel-spouted bowl of Black-and-Red Ware (Period III) and a dish-on-stand of burnished Black Ware (Period III), besides stone sculptures of post-Gupta and early medieval periods and terracotta plaques once embellishing a class of brick-temples in Bengal in the 18th and 19th centuries. While such terracotta panels, covering the exterior surfaces of shrines often dedicated to Shiva or Rādhā-Krishna, generally relate the central theme of the *Rāmāyana* and other Puranic subjects and holy myths as sung in the Bengali *Mangal-Kāvyas*, the stone sculptures mirror a refined and sensitive taste regarding manifestation of divine beauty in relaxed poise or with symbolic verve. The terracotta plaques as referred to can sometimes be pleasantly decorative by visualizing foliated scrolls, arabesques or other floral motifs in a world of divine miracles, combats, love and redemption where peacocks and parrots can perhaps symbolize the celestial sphere like the half-bird *Kinnaras* of Early Medieval compositions. Like the wars between the gods, giants, centaurs and amazons on the pedimenta of Parthenon and Homeric combats depicted on Greek pottery the war of the *Rāmāyana* also appears on terracotta temples of Bengal though of recent date as an eternal *tableau* where a European battle-ship with full sail or riding at anchor or a file of infantrymen moving on in an attack may be introduced to heighten the effect of fray. Whoever might be the foreign troops, the grenadiers, marines, or guards, the artist has succeeded in visualizing the moments of war.

The repertoire of sculptures displayed in the new section opened in 1966 included some of the beautiful examples of stone stylistically appertaining to Bengal in Post-Gupta and Pāla times. Such images usually carved in greenish clorite discovered amidst ruins of ancient Jaina temples at Pakbira close to the source of the Silavati river in Purulia district in West Bengal consist of a number of heads carved in the Gupta tradition visualizing an assured tranquility where the inner soul is more sought for than the external world. A torso of a female figure recovered from Pakbira on the other hand envisages a graceful modulation of the lower part seductively enclosed by a delicate fabric striated with fine folds and yielding to movement. Similarly, among other sculptures displayed in this section a fragmentary large stele of Vishnu carved in black basalt from Bhagavanpur in Malda district is flanked by what may be regarded as one of the most graceful and elegant images of Sarasvatī, the goddess of Learning, Music, Speech and Wisdom conceived as milk-white in appearance. Being a healer she was originally a consort of Brahma and then of Vishnu, one of the *ādityas* of the Rigveda. Her worship as a rivergoddess may by traced as far back as the Rigvedic *Samhitās*. The elaborate coif of her masses of hair and her affectionate in holding the *Vīnā* delicately pressed on her supple front illustrate they lyrical and romantic approach of the Pāla sculptor in the style of circa 10th century A.D.

After opening the Prehistoric and Early Antiquities Section in January, 1966, the Directorate of Archaeology continued explorations as before, the activities being responsible for discovering implementiferous beds and conglomerates around the sandstone hill of Susunia in Bankura district of West Bengal. Within an area of about 8 square miles around this sprawling monadnock about 2,000 tools of the Early Stone age were discovered, mainly consisting of fully developed and symmetrical Acheulian hand-axes of quartz, quartzite and lava. Such a density of occurrence along with fossils of Pleistocene fauna associated with different beds is indeed very important in the prehistoric archaeology of India, *vis-à-vis* such comparable horizons in other parts of Asia as also in Europe and Africa. In view of the limited space in the gallery only a number of representative examples of palaeolithic hand-axes and cleavers have been displayed. These along with fossils have drawn attention of visitors during periodic exhibitions held in the gallery.

In recent times the Directorate of Archaeology of West Bengal has acquired valuable and rare examples of stone sculpture, terracottas, wood-carvings, works of bronze, brass, silver and octo-alloy, ancient coins of gold, silver and copper, gems, paintings, ivories and other objects of minor art which have again added to the collection of the gallery, now grown into a centre of education and research. At present the entire array of stone sculptures in the gallery consists of images of Brahmanical, Buddhist and Jaina iconography, mainly belonging to post- 58

Gupta and Pāla times, while the terracotta plaques and figures stylistically belong to a series of epochs from proto-history down to the age of European contact. Besides a number of beautiful wood-carvings from the 17th and 18th centuries the metal sculptures include a number of graceful images from Bengal, Orissa, Nepal and western India. Among the latter an image of Rādhā in octo-alloy does indeed visualize a romantic mood, the figuration with long braided hair representing a charming elegance. The metal works also include Pala bronzes as also primitive brasses of the 17th to 19th centuries from Bankura, West Bengal. *Bidris* spangled with silver foils in the style and convention of late Mughal date also belong to the collections.

At present the numismatic collection of the State Archaeological Gallery is also appreciably rich and does not only contain among others a hoard of silver punch-marked coins obviously of Mauryan and pre-Mauryan origin from Lohapur, Birbhum district, but also a good number of uninscribed copper cast coins belonging to early historic phases from archaeological sites of Chandraketugarh, Deulpota and Harinarayanpur in the lower ganges valley and a set of gold coins struck during the reigns of Kanishka I, Samudra Gupta and Chandra Gupta II. While the provenance of the Gupta gold coins has been traced in Jessore and Hugli districts of undivided Bengal, the coin of Kanishka was discovered mixed with humus close to the toe of the famous mound of Pandu Rajar Dhibi in Burdwan District. The obverse of the Gupta and Kushān gold coins illuminate idealized portraits of emperors in the context of their achievements or leadership. The reverses, on the other hand, often visualize deities or icons. While the Gupta gold coins will illustrate a strong faith in Puranic religion and commendations in respect of an ideal monarch, the Kushān coins will depict a medley, as is so well-known, of Hindu, Mithraic, Hellenic and other Central Asian gods and goddesses.

Though the metrology and presentation of Gupta gold coins were inspired as it appears by Roman standards the aims and ideals of monarchy and civilization returned to their own roots of tradition and faith in India during this age of revival.

Apart from the hoard of silver punch-marked coins from Lohapur, Birbhum district, which occasionally bear abstract human figures among various other symbols like those from Purnea (Bihār) and Taxila (Pakistan), a few silver punch-marked coins from Chandraketugarh in 24-Parganas also reveal motifs of sea-going vessels having sterns resembling a fish tail. Such ships are in all examples flanked by a spoked wheel recalling the *dharmachakra* or any other solar symbol suggestions of an early aniconic cult.

The entire collection of the gallery now also contains a valuable repertoire of beads of semi-precious stones ascribable to various epochs from the proto-historic down to the medieval times besides beautiful objects of minor art often inlaid with colourful gems and glasses in the style and convention of the Rājput-Mughal period. Though local in craftsmanship, to the latter epoch belongs a set of rings from Murshidābād inlaid with finely cut and inscribed cornelian, chalcedony, turquoise and tourmaline.

The repertoire of old paintings now preserved or displayed in the gallery includes a number of masterpieces of unaccountable beauty and significance often communicating a tender emotion to suggest a lyrical mood and individual dignity. Among these may be mentioned a large group of Rājput and popular Mughal paintings besides fine examples of oil and tempera produced in the ateliers of different schools of West Bengal flourishing in the 17th, 18th and 19th centuries. Among the latter the most attractive are a number of paintings done on canvas, paper or wooden panels from Murshidābād, Nashipur, Kalna, Chandernagore, Halisahar and Kalighat. The gallery also contains a number of prayer banners *(thankas)* and other scrolls and paintings from Tibet.

Among other objects of art belonging to the gallery a special mention may be made of a set of ivory chessmen belonging to the 19th century, envisaged as European and Indian soldiers, old wood-carvings with scenes from the *Krishnalila* and the *Ramayana*, illuminated manuscripts from Nepal, a set of playing cards painted with Dasavatāra of Vishnu from Bankura, an inscribed votive bell dedicated to Jalpeshvara Shiva in Jalpaiguri district by a Bhutenese invader about 200 years ago, and a collection of Bāluchar Sāris, a kind of old silk brocade from Murshidābād besides *Chamba rumals, Gujarati Phulkaris* and Bengali *Kanthas*, visualizing delicate needle work.

Apart from regular acquisitions by explorations and 59

purchase the treasures in the gallery have been greatly enhanced by generous gifts from individual collectors and antiquarians. Among such gifts it is indeed a grateful obligation to recall the recent acquisition of a large array of early and medieval terracottas, seals, pottery-ware, stone sculptures, bronzes, paintings, coins, wood-carvings as also valuable and rare books on art and archaeology collected by the late Kalidas Datta of Jaynagar-Mazilpur, a pioneer archaeologist working on the lower Ganges valley by his efforts over many years and bequeathed along with a set of dioramas to the gallery sometime before his demise. These valuable materials brought to Calcutta after the passing away of the veteran archaeologist are now being arranged for proper preservation and display within the limited space of the gallery.

Apart from conducting recurrent exhibitions and lectures on art and archaeology, the Directorate of Archaeology of the State Government is now continuously performing field-surveys and research within obscure valleys, river-sides, forests and hills of West Bengal extending from the Himalayan cliffs in the north down to the shore confronting the Bay of Bengal in the south. Such activities are now being conducted to bring to light one of the most prolific industries of polished neolithic implements on the terraced slopes folding above the meandering streams of the Tista and the Great Rangit at Kalimpong towards the frontiers of Sikkim in Darjeeling Himalaya. These neoliths include very characteristic perforated and faceted celts and adzes which have comparable horizons in China beyond Tibet and the K'un Lun.

DESCRIPTION OF ILLUSTRATIONS

147 Head of a goddess. Greenish chlorite. Height 17.5 cm. Pakbira, district Purulia, West Bengal. The eyes of the divinity are half-closed and the strands of hair are sensitively arranged on the forehead. Apart from the delineation of the eyes, ears and the delicately modelled chin, the tranquility of expression tenderly heightened by the lower lip will assign this beautiful sculpture to the post-Gupta period about the 9th century A.D.

148 a) *Yakshinī*. Moulded terracotta with red lips. Height 17.5 cm. Chandraketugarh, district 24-Parganas, West Bengal. Figure of a Yakshinī or Apsarās standing in *ābhanga* attitude. She is wearing a diaphanous skirt held by a heavy girdle of beads and other draperies besides an elaborate coiffure tied with jewelled bands and conventional hair-pins, parts of which are still recognizable. While she is adorned with disc-like ornaments, necklaces and anklets, a lotus-medallion adorns her front above the navel as a buckle. The Apsara as a celestial nymph of Indian art is shown standing with the usual elegance of terracotta Yakshinīs of Sunga-Kushān period revealing the mythical grace and sensitivity of the art of Bhārhut, Bhājā, Sānchī and Mathurā. Besides the consideration in respect of treatment of drapery consisting of a skirt and a scarf as also the kind of jewellery and the nature of idealization of celestial beauty, the higher relief evolving from the two-dimensional modelling of post-Mauryan tradition belongs to the stylistic idiom of c. the 2nd century A.D.

148 b) *Standing lady*. Moulded gray terracotta. Height 18.5 cm. Panna, district Midnapur. C. 7th century A.D. Figure of a standing lady wearing a skirt attached to the waist by a girdle of round medallions besides necklaces, including one with a spherical pendant, ear-rings and an elaborate coiffure studded with gems and gracefully rolled like a turban *sirastraka*. The lady is standing in a slight *abhanga* pose holding an ornament resembling an anklet of twisted pattern in her right hand. Though the sculpture is delineated according to the language of Gupta art, there is a recognizable trace of folk tradition. Though the skirt displays the convention of opaque and closely clinging costume *(magnamsuka)* and the accentuated bosom is balanced by the smooth shoulders visualized according to the Gupta idiom of divine beauty suffused with the life-force *(prāna)*, the emotional dignity as expressed by the sculpture seems to be the achievement of an unknown artist who preferred freedom of folk inspiration to classic formalities.

148 c) *Mother goddess*. Terracotta coated with chocolate slip. Height 15 cm. Mutilated. Bangarh, West Dinajpur. Figure of a mother goddess with applied and scratched decoration. She is squatting with spread-out legs, one of which she holds by her right hand. Besides her tresses, partly plaited with a small bun above her forehead her face is surrounded with motifs obviously representing symbols or jewelleries of magical significance. Her necklace with a large circular pendant and girdle shown in *appliqué* enhances the feminity of the image having massive breasts and a deep navel, as symbolic of fecundity. The sophisticated grace of the divinity in spite of the primitive vigour and other stylistic considerations will ascribe this figurine to the Kushān period.

148 d) *Kubera*. Terracotta. Height 13.5 cm. Chandraketugarh, district 24 Parganas, West Bengal. A terracotta rattle envisaging the corpulent and bejewelled figure of

Kubera. This figure holds a round object in his right hand and wears a jewelled coiffure, necklace, bangles, earrings and a diaphanous costume including what appears to be a *muslin* scarf. Though a figure of votive and magical significance this was obviously used as a toy which would presumably signify the jingle of wealth whose over-lord is Kubera, the guardian deity of the northern quarter. The god, also known as Vaishravana, is frequently referred to in post-Vedic Brahmanical literature, while he is known as Jambhala in ancient Buddhist texts. The present rattle envisages Kubera seated in *bhadrāsana* on a low stool and he is represented as holding his symbolic attribute, a citron. This image will recall the relaxed poise of the well-known portrait of Huvishka belonging to Mathurā. The increased eminence of form in spite of the modeller's faith in bas-relief which was evidently stronger in Sunga times and other considerations will attribute this small sculpture to circa the 2nd century A.D.

149 *Four gold coins* belonging to Kanishka I, Samudra Gupta and Chandra Gupta II.

a) *Gold coin of Kanishka I.* Diameter 1.95 cm. Weight 8.09 gr. Pandu Rajar Dhibi, district Burdwan. Obverse: The king, standing on the left, wearing trousers, an over-coat and a cloak. He is holding a spear in his left hand and is sacrificing on an altar with his right hand. The bearded king is also wearing a helmet and is armed with a sword which is attached to the waist. Flames are issuing out from his right shoulder. The circular legend in Greek runs 'Shaonano Shao Kaneshki Koshano' (Kanishka, the Kushāna, the King of Kings). Reverse: Four-armed Shiva, nimbate, standing as looking to left. He is holding a hand-drum *(vajra)* and a water-vessel by his upper and lower right hands respectively, while he similarly holds in his left hands a trident and a goad. The coin has a dotted border and a four-pronged monogram or symbol on the left side. The small inscription on the right side can be read as 'OESHO' generally equated with Umesa or Bhavesa.

b) *Gold coin of Samudra Gupta.* Diameter 2.05 cm. Weight: 6.45 gr. Bangladesh. Exact provenance unknown. Obverse: King standing on left, nimbate, holding a standard with a fillet with his left hand and offering incense on an altar with his right hand. He is wearing a close-fitting cap, trousers and a tail-coat. The king is flanked by his imperial standard surmounted by Garuda and tied with a fillet. The legend or inscription in Brāhmī below his left arm can be read as 'Samudra' while the short legend in the field before the Eagle-capital runs 'Gupta'. Similar coins generally bear the following circular legend in Upagiti metre on the margin: 'Samara-Sata Vitala – Vijayo Jita – ripurajito divam jayati.' (The invincible (King) who had won victories on a hundred battle-fields and conquered the enemies, wins the heaven.) The legend is missing here evidently being off the flan, Reverse: Goddess Lakshmī or Ardochsho seated on a throne holding a *cornucopiae* in the left hand and a fillet in the right hand. She is wearing a flowing skirt and a scarf besides ornaments and anklets.

She is nimbate and is flanked on the left by a monogram or symbol and on the right by the legend 'Parakramah'. The feet of the divinity rest on a circular mat.

c) *The gold coin of Chandra Gupta (II).* Diameter 1.8 cm. Weight: 6.06 gr. Mahanad, district Hughli, West Bengal. Obverse: The king nimbate standing in *dvibhanga* pose holding a bow in his left hand and an arrow (now blurred) in his right hand. He is flanked by a pillar or staff *(garudadhvaja)* surmounted by a Garuda, the Eagle, as an emblem of Vishnu. While the upper part of the king is bare he is wearing trousers, coat, a tight-fitting cap, earrings and armlets. Besides laying stress on the physical vigour of the royal archer, the king is visualized as having flowing curls of hair *(alakavali)*. Below his left arm the short vertical legend can be read as *Chandra*, an abbreviation of Chandra Gupta. The usual marginal legend is either out of flan or has eroded away. The legend when complete generally runs as 'Deva-Sri-Maharaja-dhiraja-Sri-Chandragupta'. Reverse: Goddess Lakshmī or Ardochsho seated on throne holding *cornucopiae*. She is giving gems or coins with her right hand. Her head is adorned with a semi-circular string of pearls or beads. The goddess is wearing a flowing skirt, a bodice and a scarf. Her feet rest on a circular object which is generally identified with a mat or a lotus. The metrology of this coin is interesting since its weight is less than the usual Dinara or Suvarna standard of Gupta coins. It is possible that the metrology here is related to a ratio of the Dinara standard of about 122 grains since the half Dinara was also current in the Gupta empire.

d) *The gold coin of Chandra Gupta (II).* Diameter 1.8 cm. Weight: 7.35 gr. Jessore, East Bengal, Bangladesh. Obverse: The king, nimbate, standing to left in *dvibhanga* pose holding a bow with his left hand and an arrow in his right hand. He is wearing trousers and a coat besides earrings and armlets. He has also the usual curly hair *(alakavali)*. The king is flanked by a Garudadhvaja on the left while there is the vertical legend *'Chandra'* in *Brāhmī* below his left arm. The usual circular legend occurring on the obverse of the Archer type of coins of Chandra Gupta already quoted while describing the preceding coin is out of flan. Reverse: Goddess Shrī or Lakshmī seated cross-legged with a lotus in the left hand and a noose in the right hand. Her head is adorned with a beaded string or surrounded by a halo of pearls. She is wearing a necklace, armlets and other ornaments. Circular legend at right and monogram at left are blurred together. The coin has a golden loop evidently for suspension as a locket or for preparation for a necklace.

150 *'Portrait of a Lady'.* Tempera. Height 55 cm. Width 45 cm. Hazarduari. Palace of Nawab Hazim. Murshidābād. West Bengal. 19th century. The youthful lady, seated before a table with a porcelain flower-vase, is wearing a skirt of emerald green colour besides wearing a tight blouse of golden brocade and an embroidered shawl of deep purple hue. Her tresses are softly rolling on her

shoulders in natural curls. She is shown in reposeful contemplation as if lost in a reverie while posing before the painter. Amongst all the conventional settings of the picture such an idealization of a woman vividly envisaged recalls the creations of European masters like Ingres and Bacciarelli besides echoing the style of Lucknow and Patna. Even the original framing of the portrait is European.

151 '*Rāmā and Sītā on the Throne*'. Miniature. 57 × 48 cm. Chandernagore, Bengal. The miniature shows Prince Rāmā, hero of the Indian national epos *Rāmāyana*, who is considered to be one of Vishnu's embodiments, with his consort Sītā on the throne. At his side his brave brother Lakshmana holding an umbrella as sign of his royal dignity. In the foreground *Hanumān*, the holy ape that – according to the legend – supported Prince Rāmā in his justified struggle against despotic Rāvana and helped him to free his wife who had been abducted by Rāvana. By using yellow, scarlet, purple, white, green, blue and rose the soft quality of the composition is stressed. Whereas clothes and jewels are reminiscent of the excellent taste of the Bengal people in the 19th century, style and way of painting clearly show European influence.

152 a) *Head of a goddess*. Stucco. Height 16 cm. Karnasuvarna, district Murshidābād, West Bengal. Head of a goddess with characteristic features of the Gupta age as visualized in the treatment of elongated eyes resembling leaves of blue lotus *(nīlotpālapatra)*, the serene expression suggestive of contemplation and the protuberant lower lip which has symbolically heightened a tender and delicate beauty. The beautiful masses of curly hair though eroded will depict the ideal of *alakavali* sensitively balanced with *patrakundala*. The right side of the sculpture is damaged. It is difficult to identify the image with a particular god or goddess.

152 b) *Male head*. Terracotta. Height 10 cm. Pandu Rajar Dhibi, West Bengal. Period III (proto-historic). Characteristic are the long and straight nose, large ears, protuberant chin, thick lips and eyes shown *in appliqué*. The terracotta reveals certain foreign traits both in features as well as in style.

152 c) *Channel-spouted bowl*. Black-and-red ware. Length 23.7 cm. Height 9.3 cm. Pandu Rajar Dhibi, district Burdwan, West Bengal. This bowl has a sagger base, steep sides like those of a calabash and slightly incurved beaded rim, while the channel-spout is broad and splayed at the end. Besides a single groove obviously effected by wheel-turning, the black and smooth surface of the interior is painted with radiating strokes in creamish-white pigments. Apart from the resemblance of such a painted bowl to those of Chalcolithic Navda-Toli, Maheswar, Eran Daimabad in Central and western India such channel-spouts are comparable with bridge-spouts or tea-pot spouts of proto-historic Iran, Egypt and the Aegaean World. The present channel-spouted bowl of Black-and-Red Ware belongs to Period III of Pandu Rajar Dhibi obviously appertaining to a chronological horizon close to the age

of the human cemetery of the mound dated at 1012 B.C. ± 120 according to a run of C^{14} examination done by Prof. Dr. Shyamadas Chatterji, Head of the Department of Physics in Jadavpur University of Calcutta. Since the entire thickness of habitational layers of the Chalcolithic and proto-historic phases at Pandu Rajar Dhibi is about 2 metres on the average the culture covering Periods I, II and III through evolution might have a duration of approximately 400 years without seriously considering one question of unconformity between Periods I and II.

153 *Agni*. Black basalt. Height 44 cm. Patharpunja, district West-Dinajpur, West Bengal. C. 10th century. Agni, the god of fire, seated in *lalitāsana* placing his right leg on his goat *(vāhana)*. Originally mentioned in the Vedic literature, the deity was later on associated with the Sun being identified with Pingala, one of his associates, mainly found in the sculptural compositions of Sūrya belonging to early medieval times. In the Vedic literature he has a number of theriomorphic representations. From the Shatapatha Brahmana it is known that the goat was also sacred to the Ashvins, the divine Gemini twins, repeatedly invoked in the Vedas. The carved stele visualizing flames surrounding the divinity as also the supple and vigorous style by which the bearded deity is envisaged indicate that the sculpture was carved in about the 10th century A.D. Agni as a divine protector has been repeatedly invoked in the Rigveda.

154 *Rādhā*. Eight-metal cast. Height 22 cm. C. 17th century. Rādhā standing in *ābhanga* pose with a sensitive modulation of the upper part of her body as if dancing to the music of Krishna's flute, full of mystic communication of divine love and yearning. She is wearing a very closefitting skirt with a frill delicately flowing from her waist where it is tied with a precious girdle embellished with small bells. The slim and graceful figure with sensitively taut lines as also the appreciation of physical charm with a candour envisaging eternal love and symbolism, besides the braided hair painted as black as collyrium will suggest that the statuary belongs to Western India.

155 '*Two Women and a Rose*'. Oil on canvas. 50 × 35 cm. Calcutta. 19th century. The supple plane visualized in contrast to the raven hair and the marginal black band of the diaphanous *Sāri* envisage the grace and sensitivity of the Kalighat style of 19th century A.D. Here the beauty of women is expressed with intimacy and love for pleasant conventions enumerated by the traditional ideals of feminine form. Whereas the graceful elegance is heightened by coyness and the romance of mutual confidence, the tresses being separated in the middle and tied in a bun appear as black as a bee *(bhramar-krishna* in Bengali language) and the eyes touched by kohl have the innocent look of a doe besides the lips stained red as a pomegranate. The dark complexion of the ladies has indeed achieved the rare flesh-colour exuberant behind the flimsy cover of muslin. The poignant taste and beauty of the painting

62

reveal as if in an Eastern setting some of the ideals of beauty of the Victorian era.

156 *Two soldiers*. Relief. Terracotta. 22 × 14 cm. West Bengal. C. 18th century. Terracotta temple plaque visualizing two European *(feringhee)* soldiers holding muskets. While it is often difficult to ascertain the exact nationality of such warriors, they may often appear as belonging to the world of Puranic Wars and strife though anachronistically. The soldiers of this plaque have wigs and whiskers and they are represented as wearing boots, tight breeches, frilled coats and hats with upturned brims.

157 *Sarasvatī*. Height 50 cm. Bhagavanpur, Malda district. C. 10th century. Sarasvatī gracefully standing in *dvibhanga* pose and playing the *vīnā*. The goddess is wearing a skirt, opaque and delicately clinging to her waist. She is bedecked with precious jewellery including ear-rings, a necklace, armlets, anklets and a decorative girdle. Her masses of hair are knotted in a large bun tied with beaded strings. An end of her skirt is shown delicately rolling down over her girdle on the left side of her waist. The upper part of her divine form is bare while the *vīnā* is sensitively pressed over her navel and on the supple undulation of her left bosom. Though an accessory figure of a larger image of Vishnu envisaged in high relief, the elegant pose achieved by softly smooth lines, besides the general convention of style envisage the presiding goddess of knowledge in the vocabulary of Pāla art.

158 *Peacock*. Terracotta temple-plaque. Length 24 cm. Height 25 cm. West Bengal. C. 18th century. This moulded plaque is not only sophisticated and vivaciously decorative in its impulse but it may also unconsciously represent the iconography of Kārttikeya whose vehicle *(vāhana)* is often a peacock *(mayūra* or *sikhi)*. Such representations of birds and animal life besides vegetal motifs and formalised foliages on shrines and *stūpas* since the days of Bhārhut have obviously brought about an atmosphere of sylvan environment where a heaven of gods could be envisaged.

ACADEMY OF FINE ARTS

The Academy of Fine Arts, Calcutta, was founded in 1933 for the cause of art, artists and art-lovers in the city. At the initial stage the academy was housed in the Indian Museum and its activity was restricted mainly to holding an annual art exhibition in which painters and sculptors from all over India used to participate. It was not until 1959 that the academy could move into its own permanent home built on a plot of land in one of the most picturesque localities of Calcutta, given by the Government of West Bengal and built through the munificence and tireless efforts of the present President of the academy, Lady Ranu Mookerjee. From a modest beginning the Academy of Fine Arts building has now become a landmark in the metropolis.

The activities of the academy, besides holding the Annual All India Fine Arts Exhibition, comprise guiding and encouraging the development of art, organizing one-man and group art shows, arranging lectures and seminars on art subjects, providing well equipped studies, publishing bulletins, catalogues and booklets on art matters and housing a number of permanent galleries. At present there are seven galleries for temporary exhibitions and five permanent galleries displaying Rabindranath Tagore's Paintings and Manuscripts, Contemporary Paintings and Sculptures of India, Old Miniature Paintings, Old Textiles, and Antique Carpets. In addition to these there is a well equipped auditorium with 700 seats where public lectures, cultural performances and cinema shows sponsored by various cine clubs and societies are regularly arranged.

The academy has been running a studio-cum-sketching club for artists since 1957. A similar studio for sculptors was added in 1967. Art classes for children in the 4–12 age-group and 12–18 age-group are being regularly organized by the academy since 1962. These studios and courses have provided young and enthusiastic artists with excellent facilities and have become very popular. There is also a well-stocked library of art books for the convenience of artists. Deserving working artists are given a few scholarships under the aegis of the academy.

In spite of the diverse activities of the academy the focus of attention has always been to render service to young contemporaries in every possible form. The location of the academy amidst lush green trees and lawns, colourful gardens and reflecting pools mirroring the spires of St. Paul's Cathedral – a symbol of Old Calcutta – the snow-white marble dome of the Victoria Memorial, and the modern box-like architecture of the Rabindra Sadana, adds dimension to the infinite quest of the artist for life and variety. Calcutta's responsive public from all walks of life stream into the academy which pulsates with movement and activity.

In the gardens encircling the Academy, a large number of modern Indian sculptures are exhibited in a surrounding of green trees, exotic plants and colourful flowers, an atmosphere in which sculptures can be viewed in the proper perspective. Of all the permanent galleries, the Contemporary Art Gallery has become very popular since its inauguration in 1966. The idea, at the time of its inception, was to provide a wide survey of Indian art from the works of the pioneers of the Indian Renaissance movement to those of contemporary young artists through an exposition in which practically all phases and schools will be represented. The gallery contains works of all the leading painters of the Indian Renaissance movement: Abanindranath Tagore, Gaganendranath Tagore, Nandalal Bose, Kahitindranath Mazumdar, Asit Kumar Haldar, Samarendranath Gupta, Sarada Ukil as well as

those of Jamini Ray, Debiprasad Roychowdhury, Ramendranath Chakravarty, Benode Bihari Mukhopadhyay, etc. The academy is particularly rich in having a number of important works of Abanindranath, Gaganendranath, Nandalal and Jamini Ray. Representative works of the painters of the Calcutta Group, of Atul Bose, Mukul Day, Ramendranath Chakravarty, Gopal Ghose, Rathin Maitra, Niroda Mazumdar, Sunil Madhav Sen, Paritosh Sen, etc., who have contributed immensely to the development of modern Indian Art, are included in the academy's collection. The academy has a comprehensive collection of works of other outstanding modern Indian painters including those of Husain, Bendre, Hobbar, Chavda, Paniker, Laxman Pai, Kanwal Krishna and of eminent sculptors such as Rankinker, Pradosh Dasguptam Sunil Pal, Dhanraj Bhagat, etc. The academy also possesses a unique piece of sculpture done by Nandalal Bose. The collection is being enlarged constantly by the addition of works of up-and-coming young painters and sculptors from all over the country.

DESCRIPTION OF ILLUSTRATIONS

161 *'Self-portrait'*. By Jamini Ray. Oil. 33.65 × 35.02 cm. Jamini Ray is universally well-known as the painter who found, in the simple imagery of folk-tradition prevalent in Bengal, his universal form. Fantastic yet simple form expressed through bold yet suave lines and flat, pure and bright colours make Jamini Ray's works rhythmic and sensuous. This was not achieved by the painter without striving. Jamini Ray started his career by painting orthodox works, portraits, classical nudes and other academic studies. The 'Self-Portrait', probably done between 1920 and 1924, depicts the initial phase of his career, when he was painting in the conventional style. This phase did not last long as Jamini Ray started looking for the basic simplicity and universalism found in the works of uninhibited folk painters.

162 *'The Honey Bee'*. By Kahitindranath Mazumdar. Tempera. 29.94 × 23.49 cm. The work of Kahitindranath Mazumdar shows signs of deep emotion and classical discipline achieved through long and patient exercise in the traditional paintings of ancient India. A careful balance of delicate colours and rhythmic lines distinguished by structural simplification and sublime depth is noticed here.

163 *'Flute Player'*. By Asit Kumar Haldar (1890–1964). 9.80 × 8.26 cm. Asit Kumar Haldar, a grand nephew of the poet Rabindranath Tagore, was a close collaborator and one of the first disciples of Abanindranath. With his fascination for the history and mythology of ancient India, Asit Kumar became easily inspired by the frescoes of Ajantā, Ellora, Bāgh and Jogimara. His works frankly exhibit the depth of traditionalism intermixed with romantic sensibility expressed through delicate forms and subtle colours.

164 *'Sat Bhai Champa'*. By Gaganendranath Tagore (1867 to 1938). Water colour. 50.26 × 35.02 cm. Gaganendranath Tagore occupies a unique place in the modern art movement of India. Though four years older than Abanindranath, Gaganendranath took up the brush years later and remained almost free from any influence of his highly talented brother. A man of refined taste, of deep emotion, of versatile interest, Gaganendranath experimented with various media and styles with a daring courage. His works amply express the bewildering variety of styles and techniques that he adopted from time to time. This remarkable work is an example of the semi-cubist experimentations made in the mid-twenties. It was painted at the time of the marriage of Manjushri, daughter of Surendranath Tagore and was presented to her. It vividly depicts a fairy-tale atmosphere in a sharply contrasted light percolated through prison-like contraptions and shades of deep blue hues.

165 *Painting'*. By Laxman Pai (born 1926). Oil. 81.28 × 60.96 cm. Laxman Pai, also belonging to the progressive Artists' Group, developed a highly independent style by arranging moving lines and contrasted colours with mannerized forms and designs.

166 a) *'Airavat'*. By M. F. Husain (born 1916). Oil. 90.17 × 128.27 cm. 'Airavat' is a recent example of this greatly talented painter whose deeply sensitive and introspective interpretation of ideas has given him a unique position amongst modern Indian painters. His picturesque figures owe their origins to the voluptuous Yakshinīs of Sānchī, Mathurā, Khajurāho or Konārak where women are depicted as eternal objects of passion and longing, provocative yet beautiful. Husain's interpretation of Hindu mythology is authentic as well as impressionistic. Airavat, the great elephant which became the mount of Lord Indra, was raised from the depth of the fathomless ocean.

166 b) *'Rhythm of Life'*. By Rathin Maitra (born 1913). Pastel and water colour. 61.23 × 74.93 cm. An important member of the Calcutta Group, Rathin Maitra is a versatile painter whose works pulsate with life in vigorous motion and breathtaking sensuality. His expression sometimes takes the shape of decorative patterns of balancing forms and contrasting colours to depict the poignant mood of the subject. 'Rhythm of Life' represents the constantly moving cycle of the life-force with its ascents and descents regulated through rhythmic motion.

167 a) *'Boats'*. By Gopal Ghosh (born 1913). Water colour. 30.80 × 46.99 cm. Gopal Ghosh is a distinctive painter with a highly individual style. His works portray with a minimum of detail a most graceful and rhythmic description of Nature. His lines are vital and sure, his interpretation of Nature and the animal world is lyrical, where ecstasy and joy catch the quality of breathless motion. His flower studies are brilliant and the birds commonly seen all around the countryside acquire an uncommon grace through his amazingly lively studies. In this example the conglomeration of country boats on the placid waters of the wide river form a fantastic pattern and convey an idyllic picture of Nature.

167 b) *'Words and Symbols'*. By K.C.S. Paniker (born 1911). Oil. 86.36 × 2121.92 cm. Paniker has been called "a living painter, who is evolving from moment to moment, fearless in following his creative impulse". In this example, executed in 1965, his experimentation in abstract symbolism, executed in a restricted and distinctive colour scheme, is presented in full glory.

168 *'Bharat Natyam Dancer'*. By Shiavax Chavda (born 1914). Oil. 60.96 × 81.28 cm. Line is Shiavax Chavda's greatest asset. Powerful, fluid and dynamic lines sweeping with breathless motion inevitably form Chavda's characteristic pose and expression. They are rhythmic and harmonious – as in the present example where the difficult 'mudrā' of the Bhārata Natyam dance has been easily rendered with perfect poise and wonderful vigour. A widely travelled man, Chavda intimately studied the widely different fold and classical dances practised all over India and abroak and sketched numerous studies from them. This work was painted in 1966.

INDIAN MUSEUM

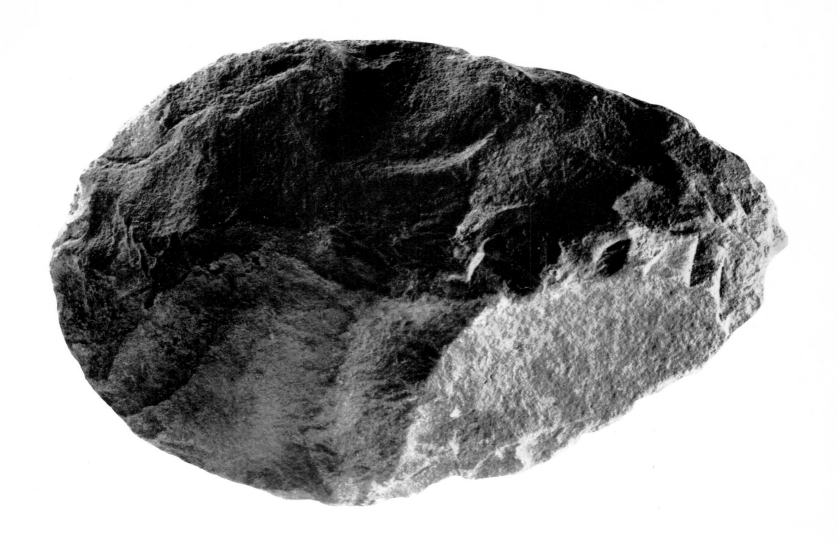

3

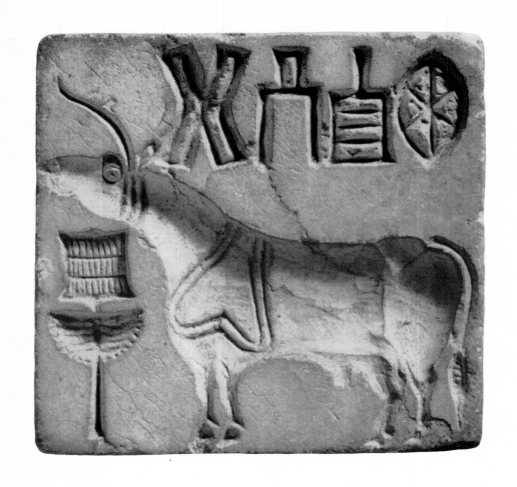

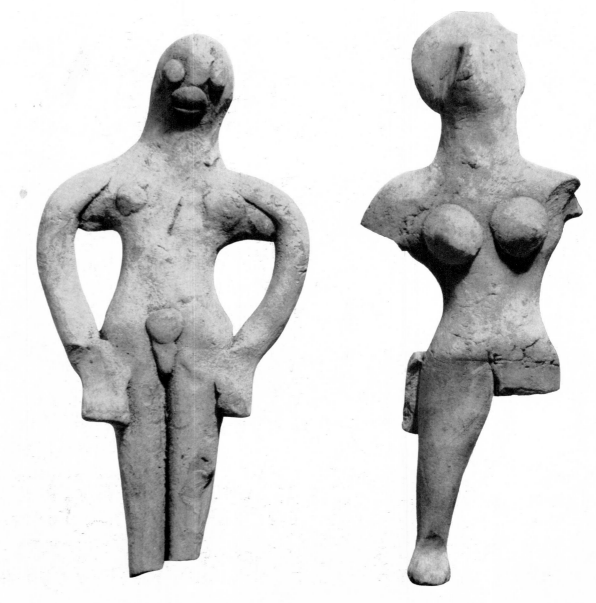

4

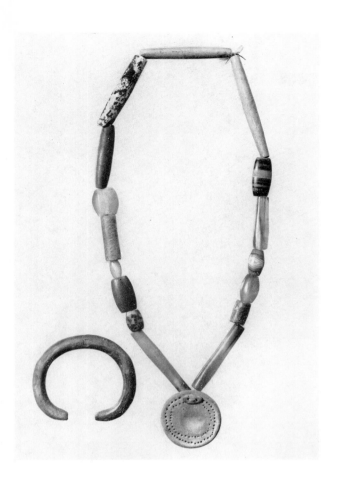

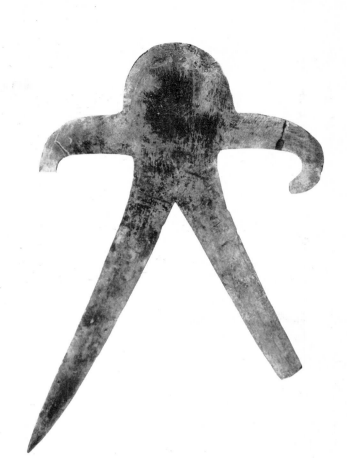

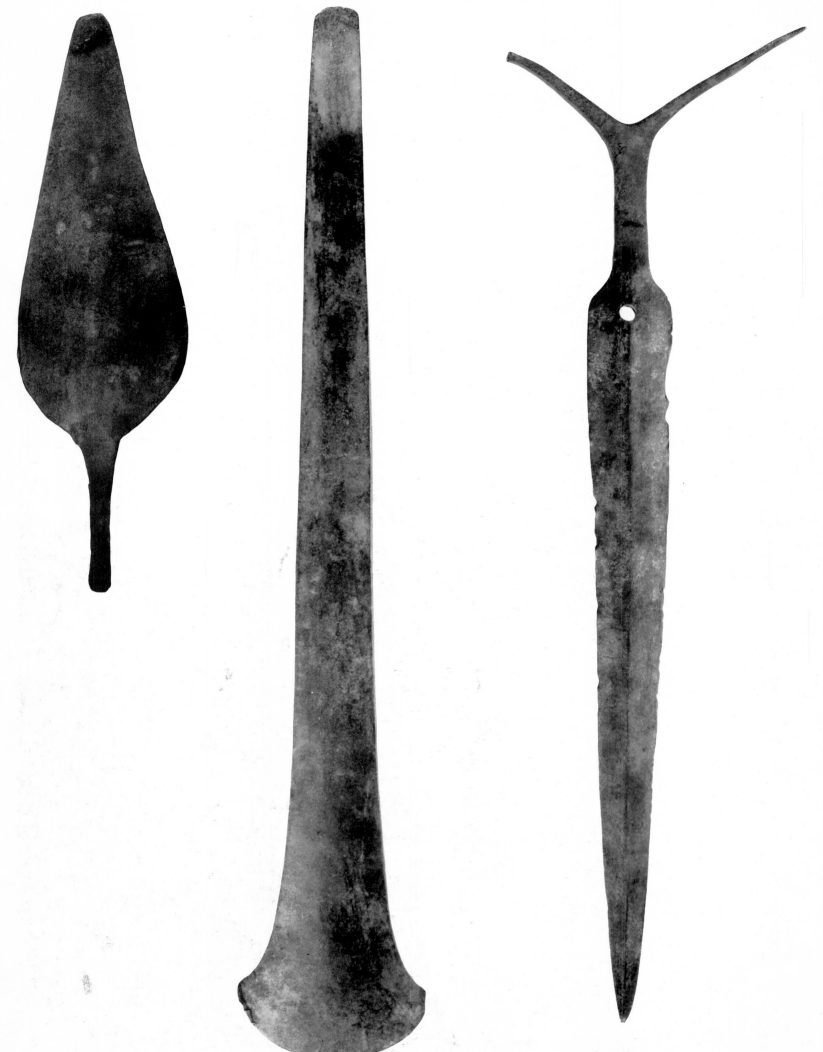

6

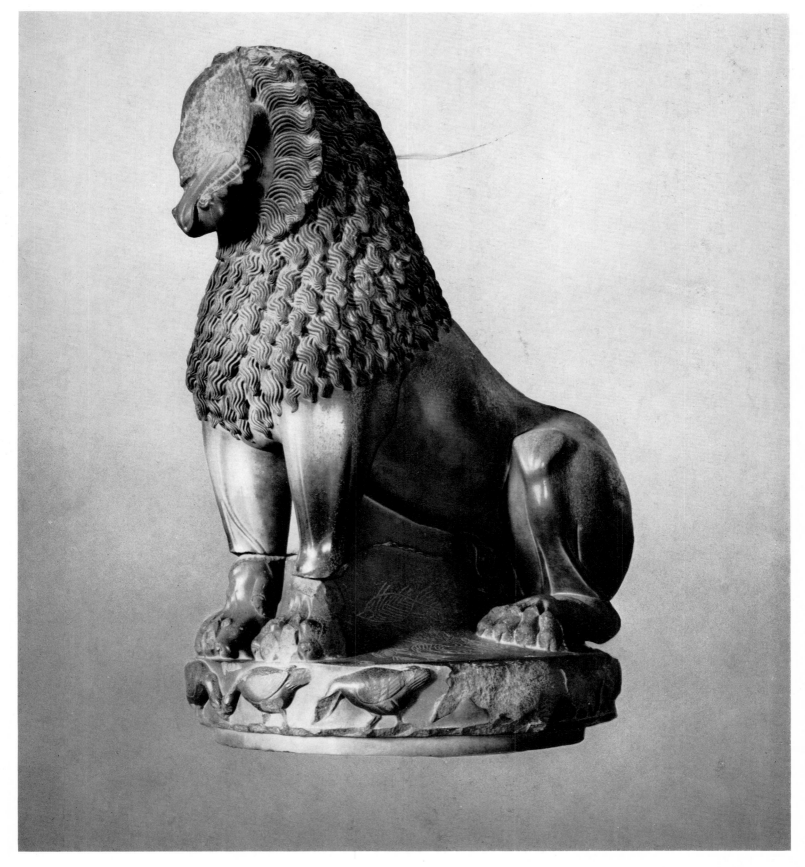

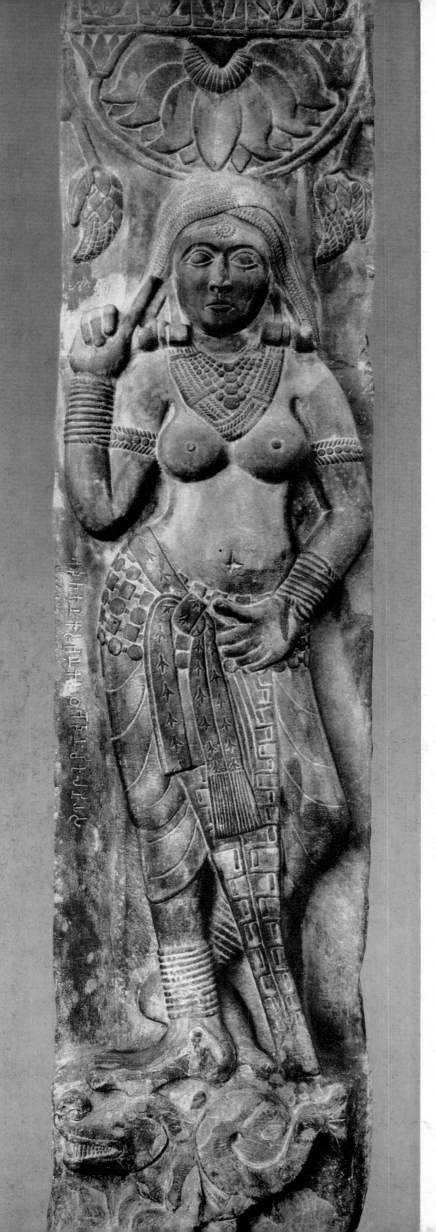

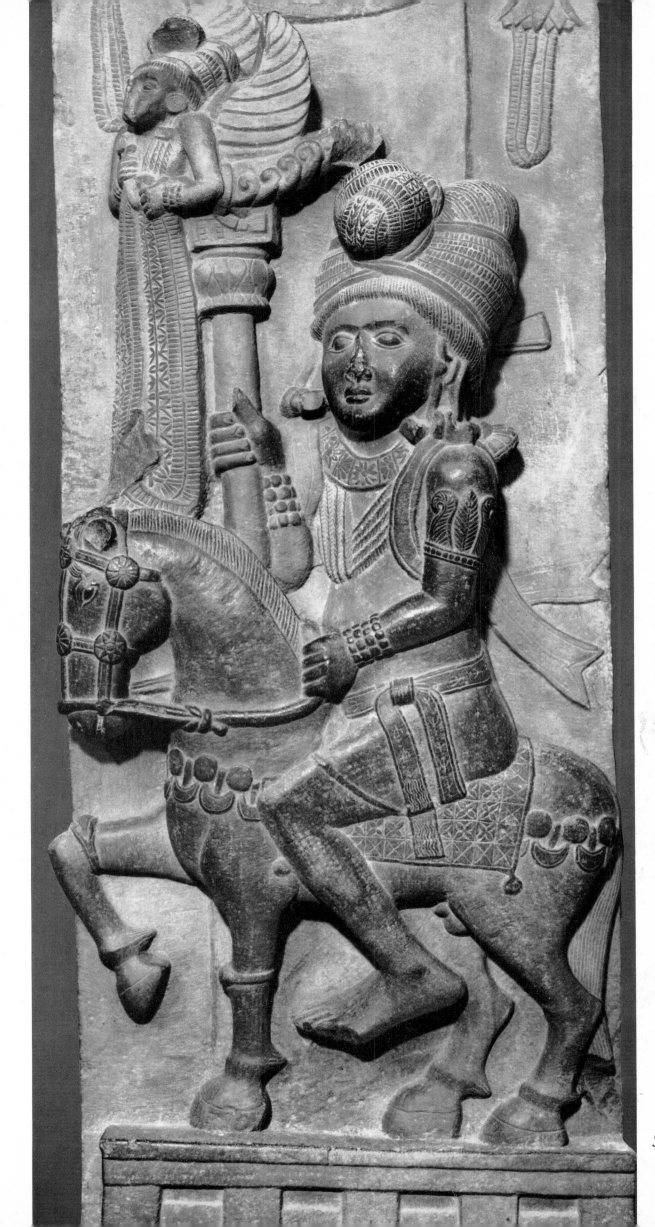

9

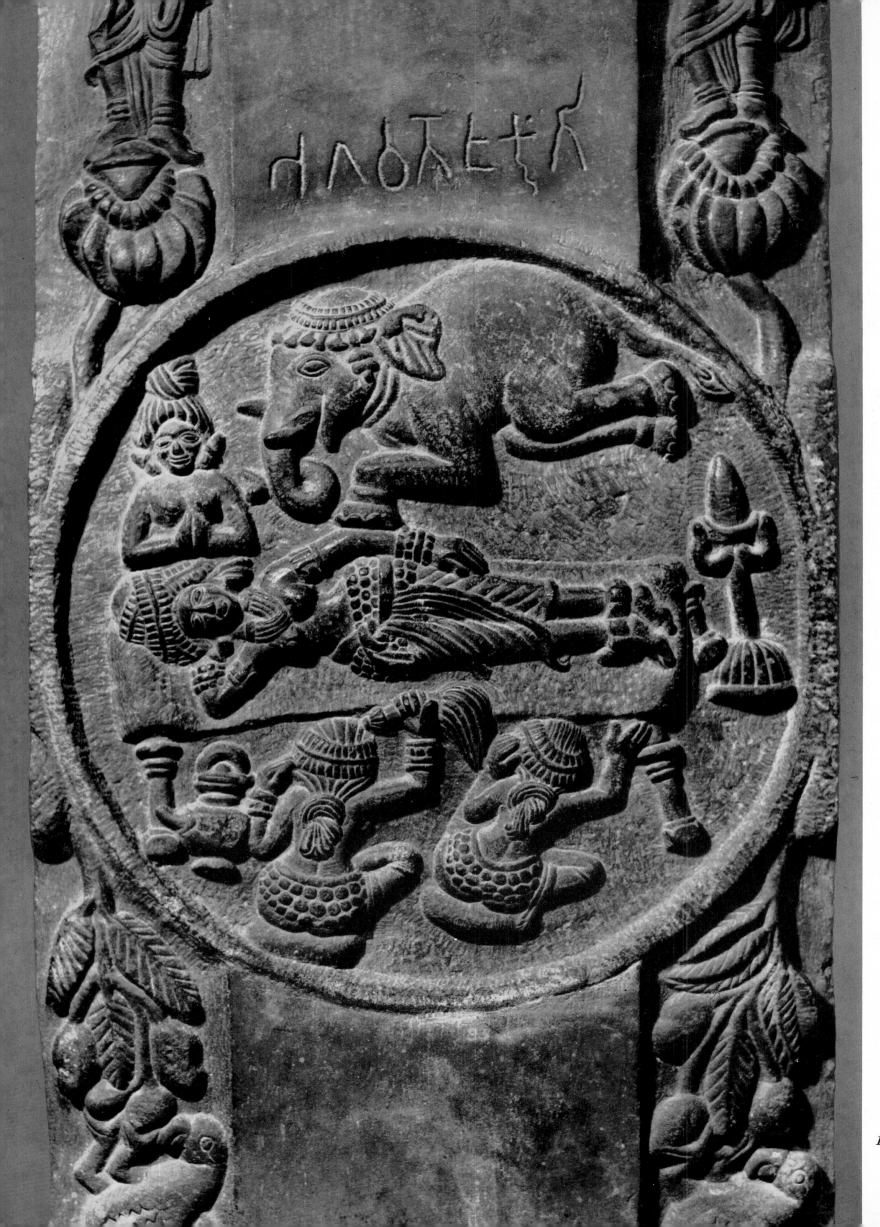

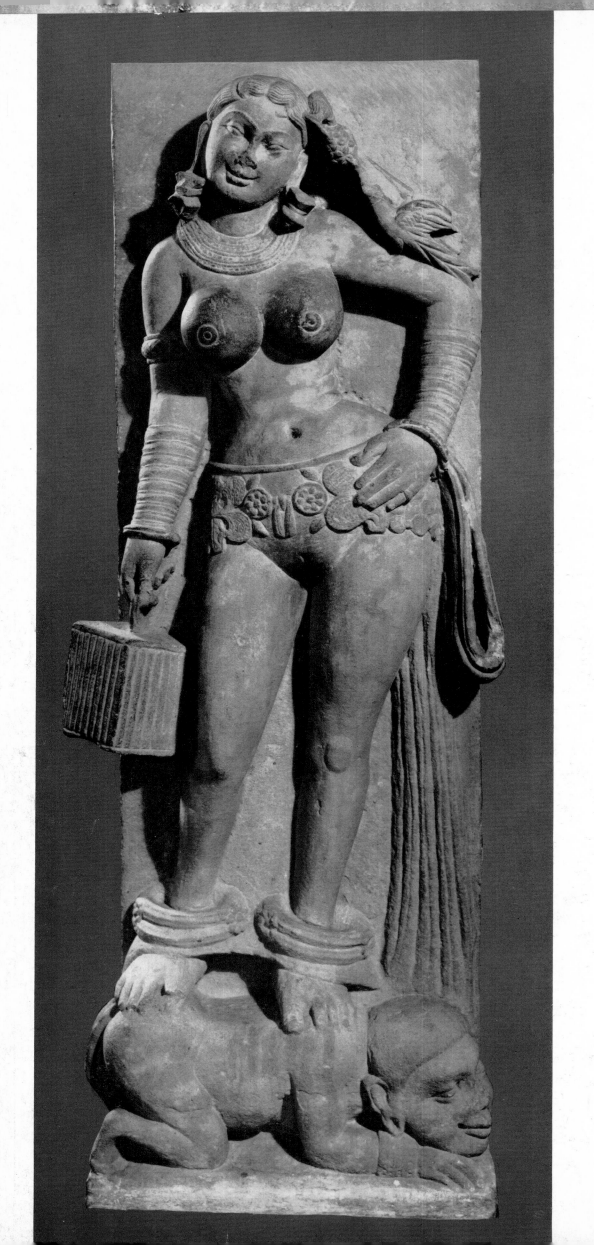

14

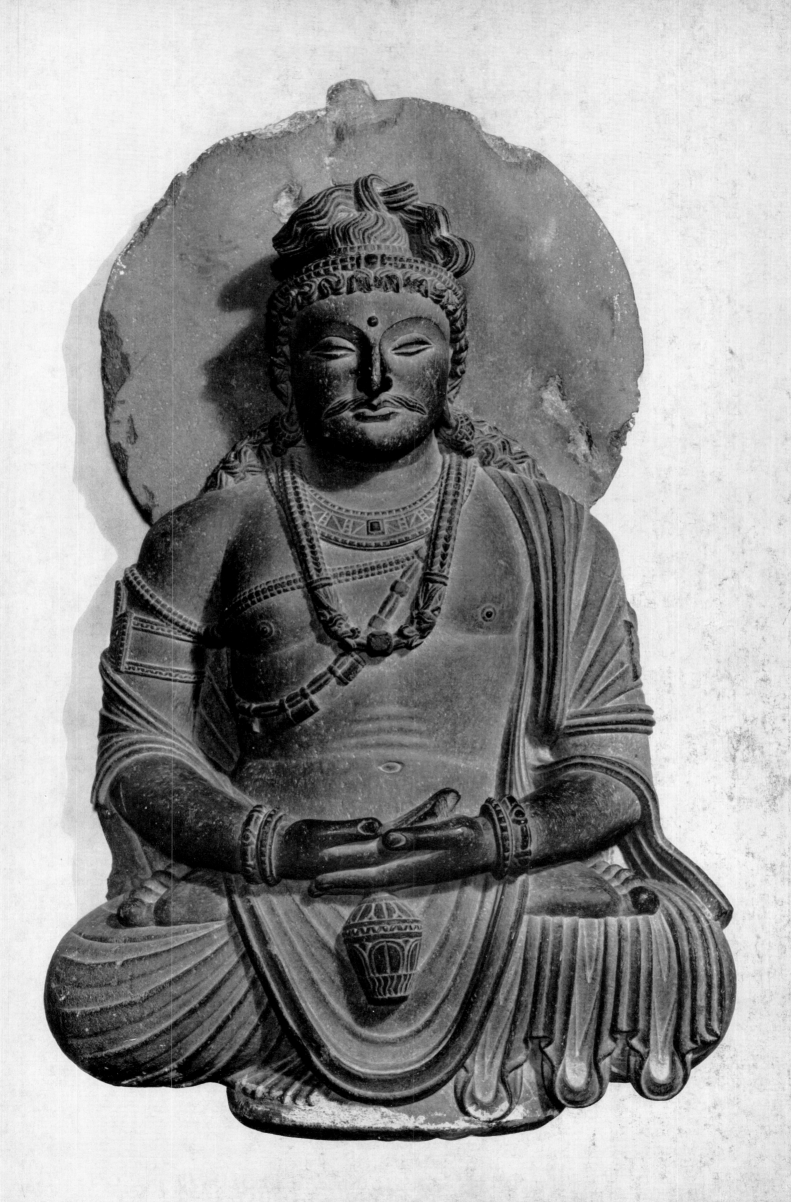

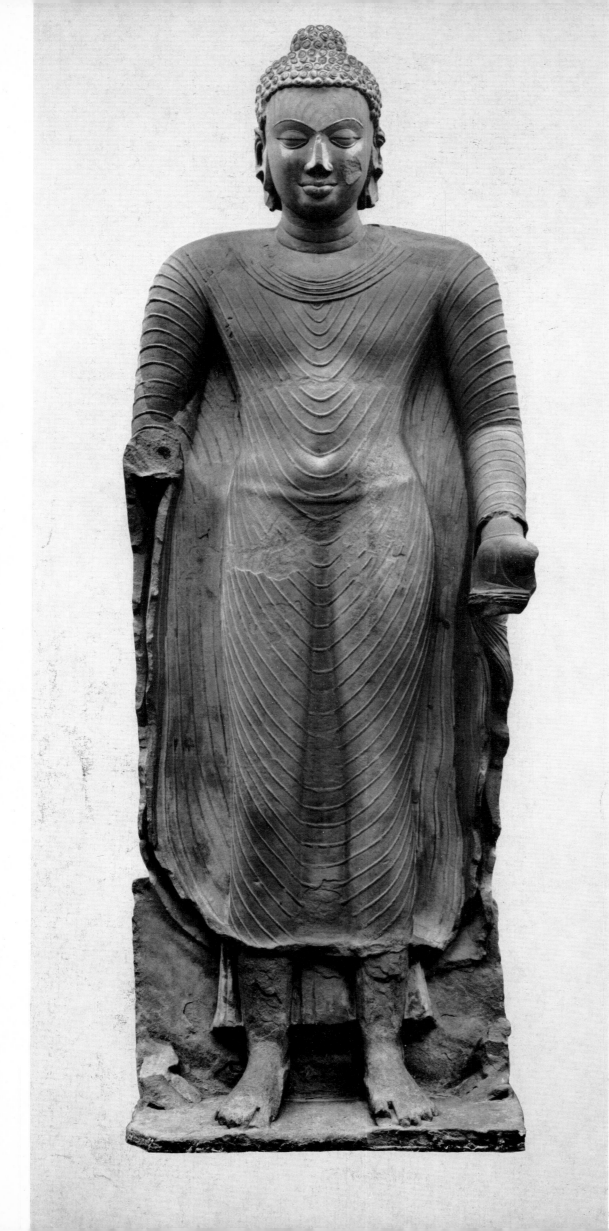

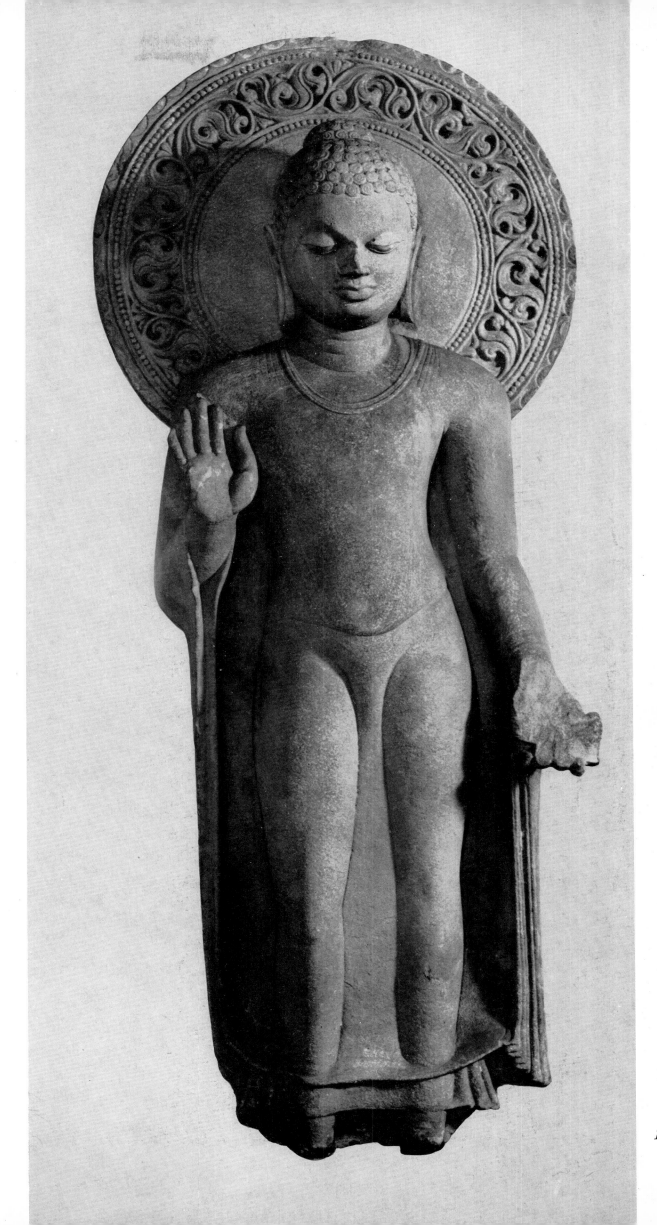

17

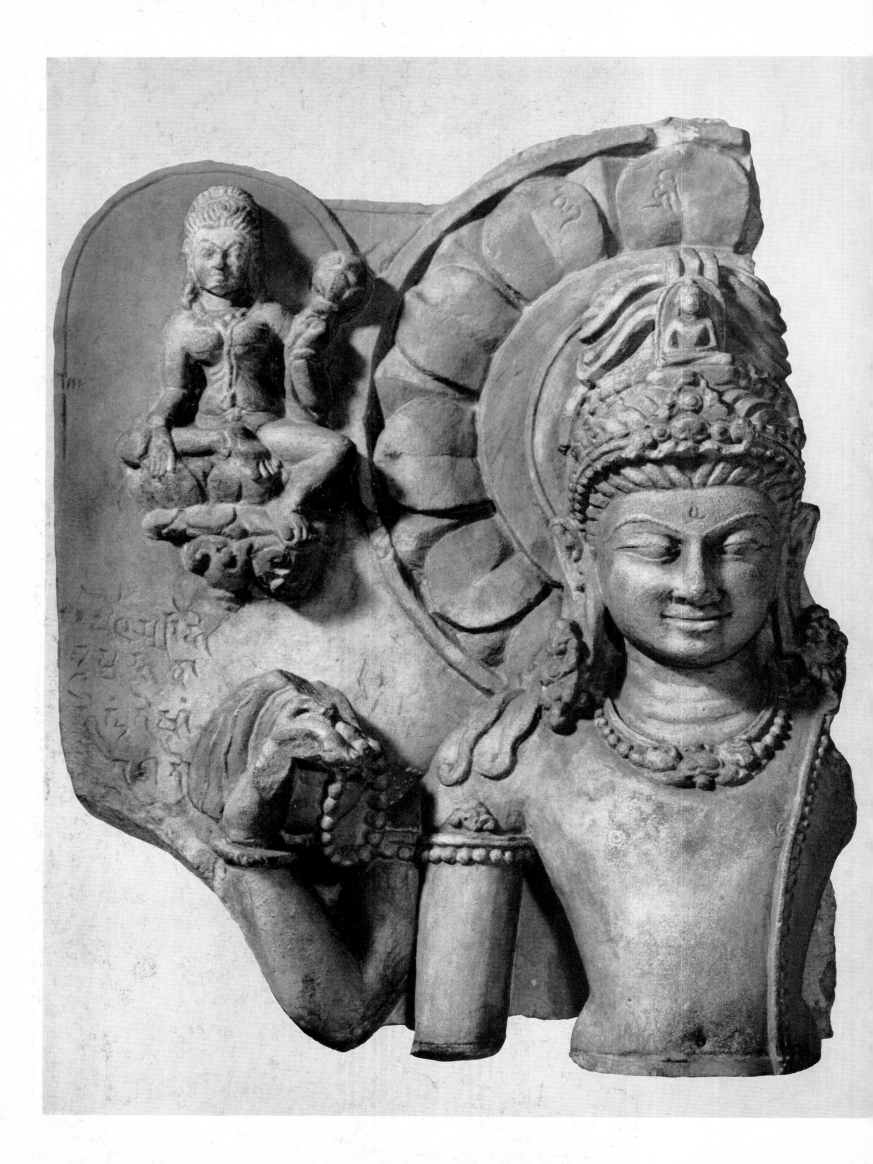

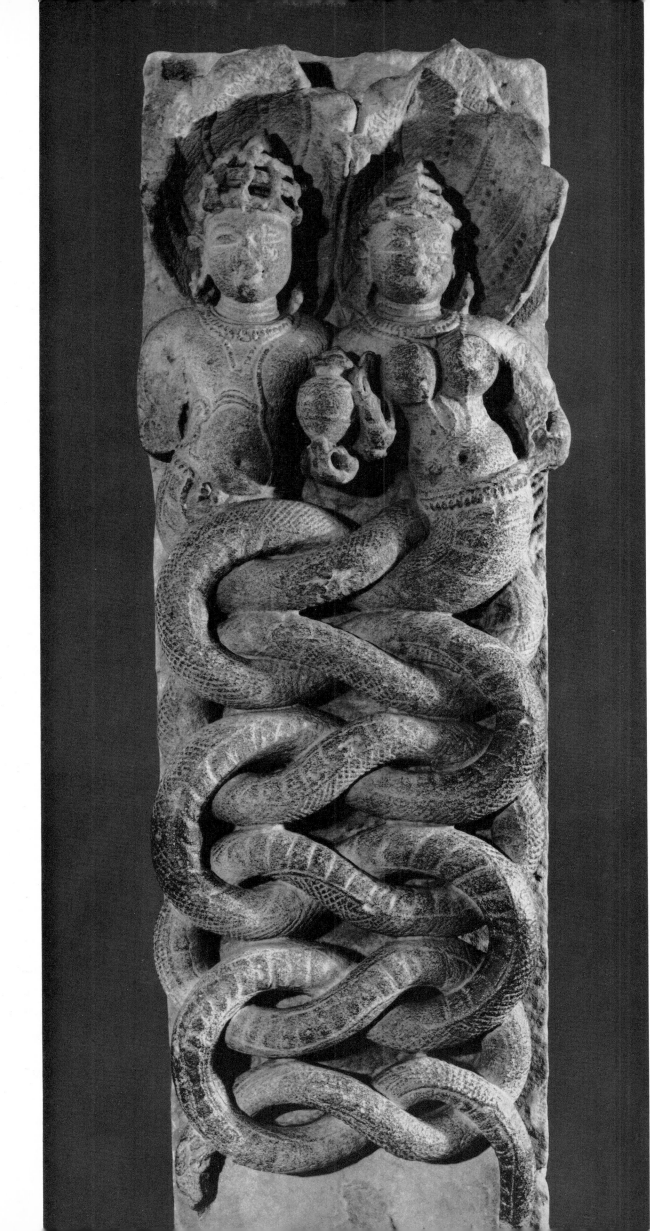

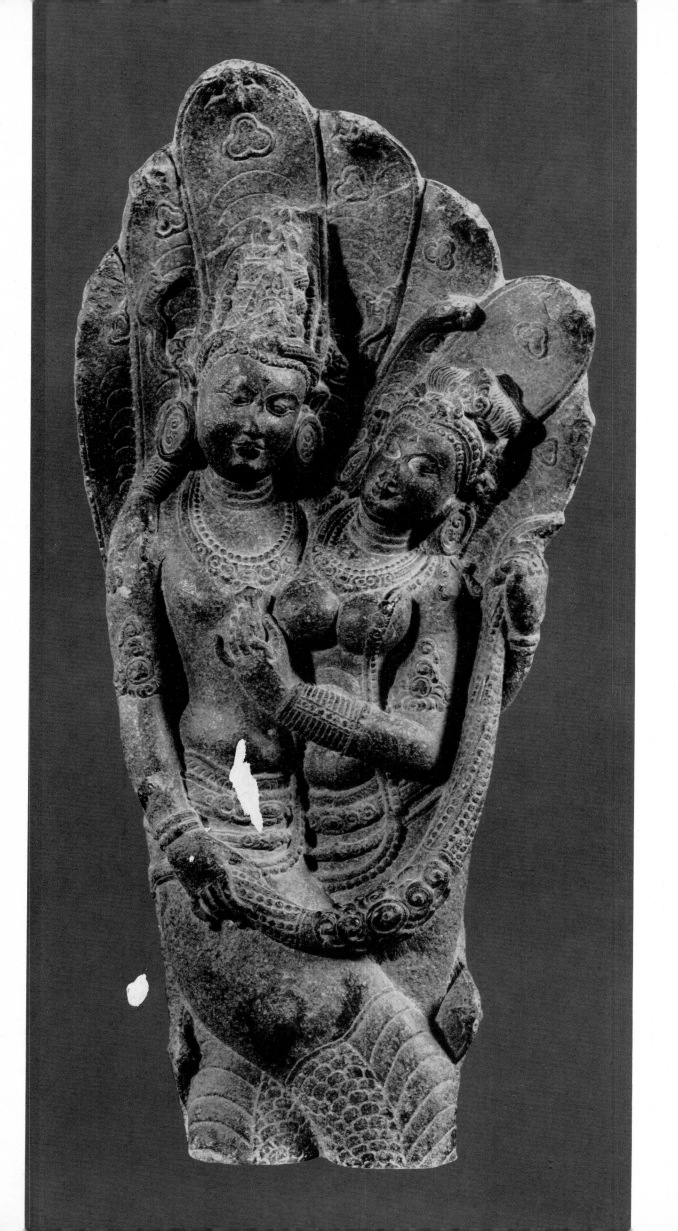

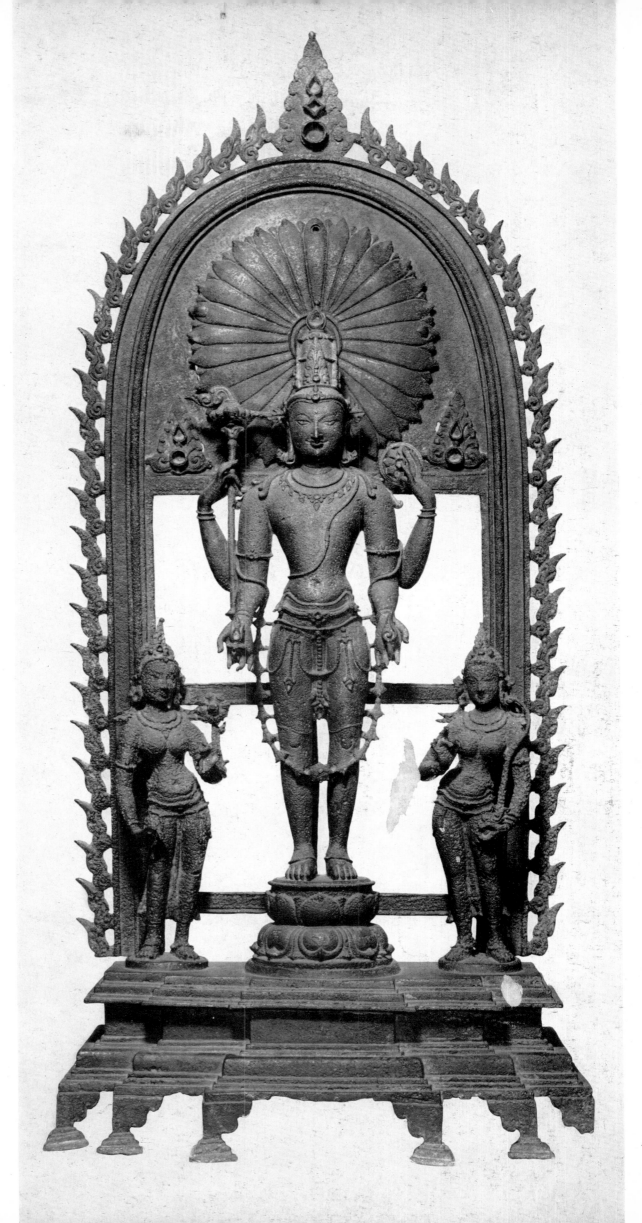

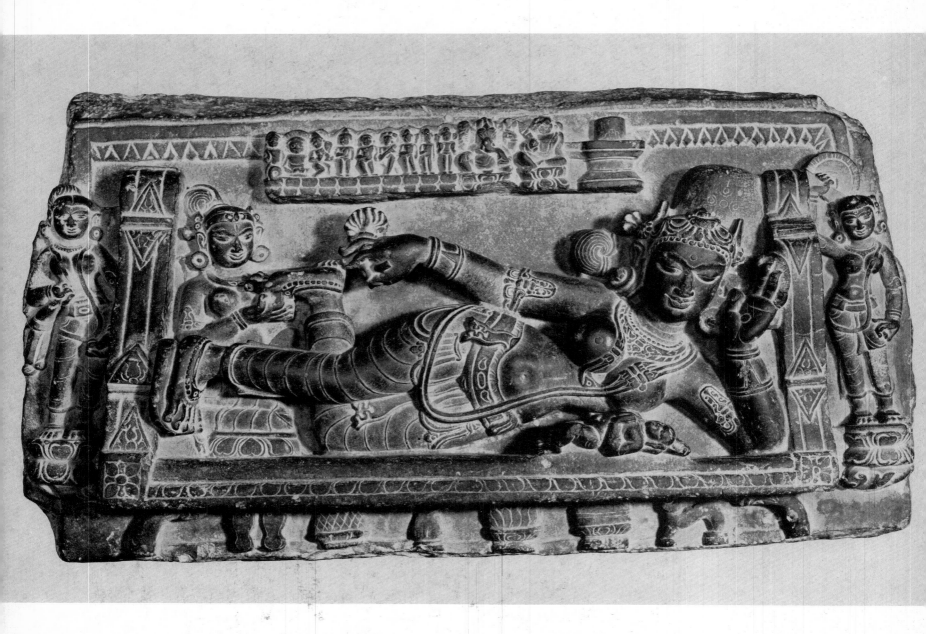

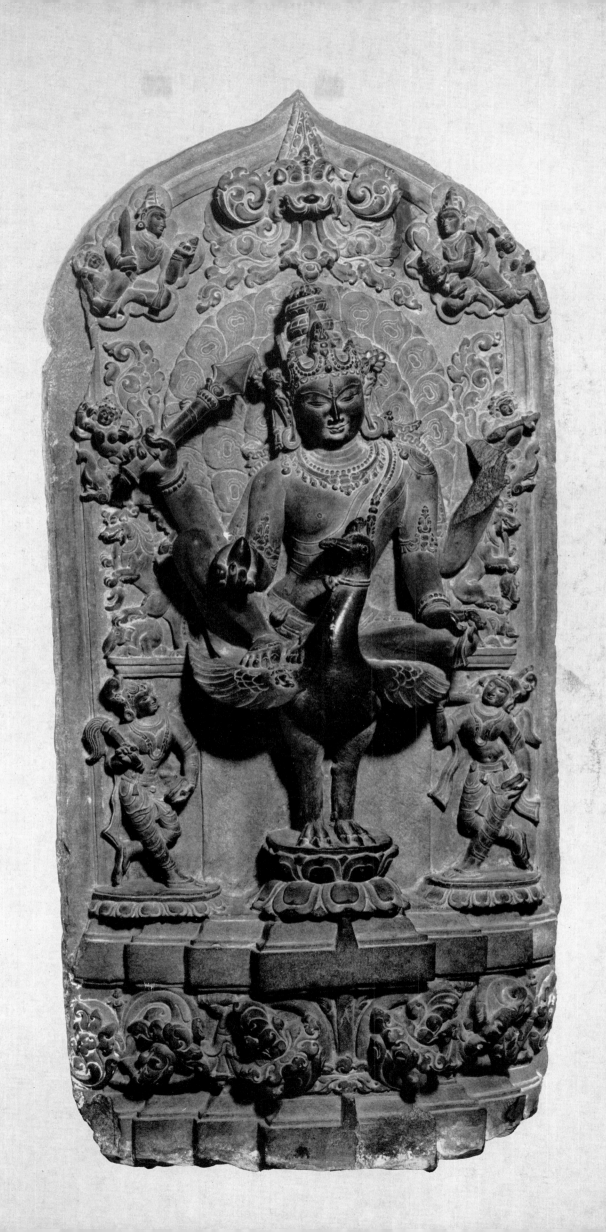

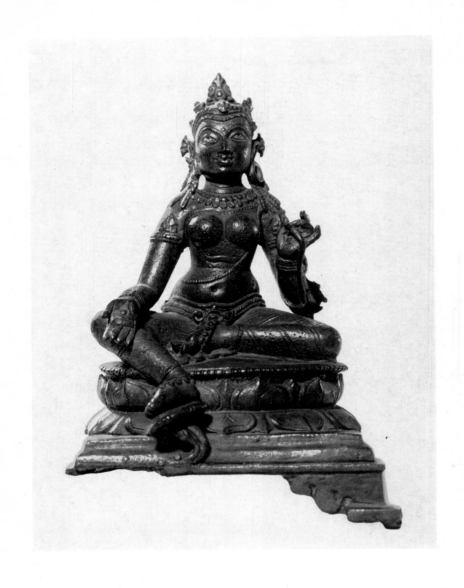

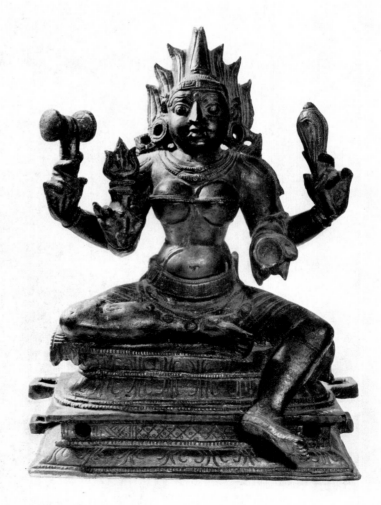

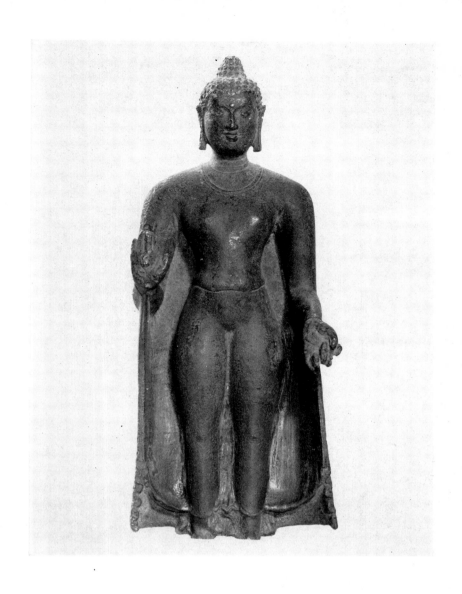

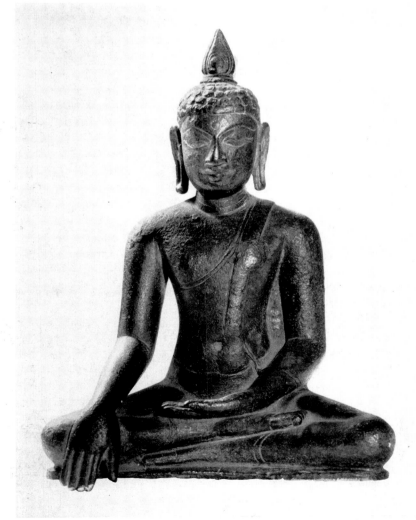

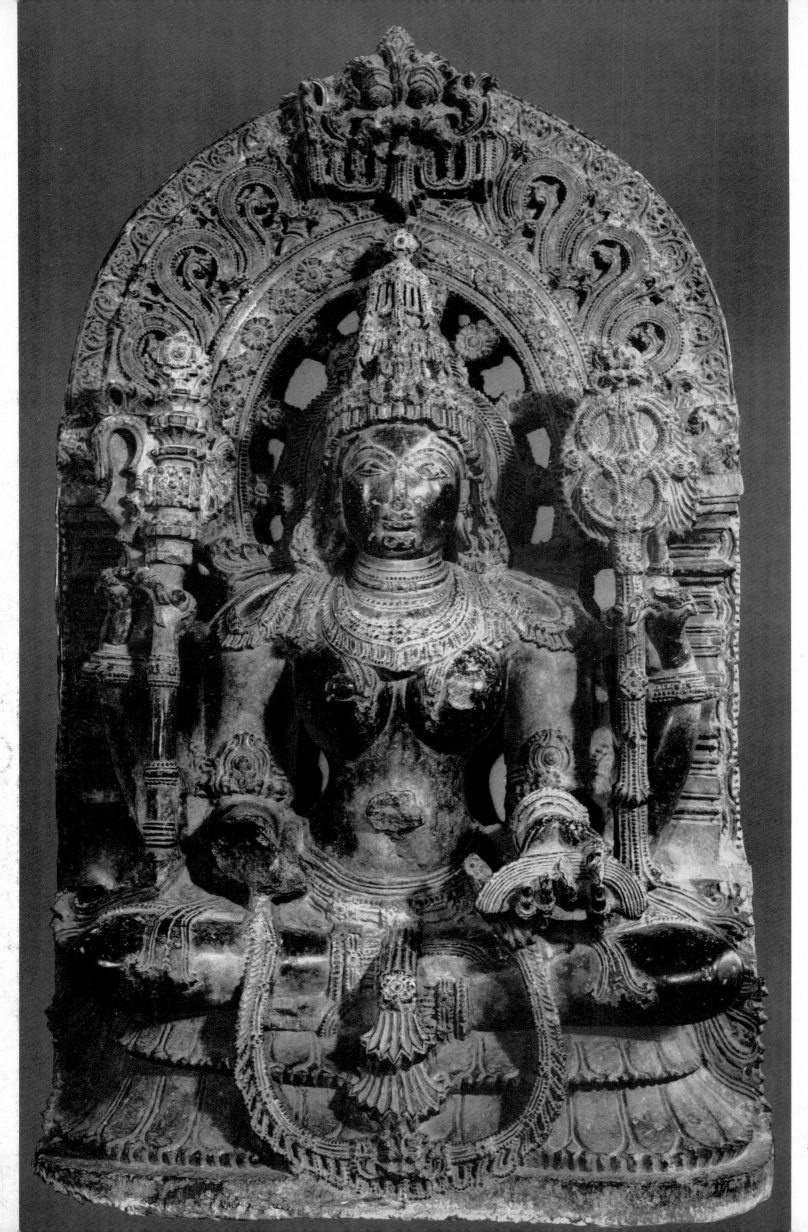

26

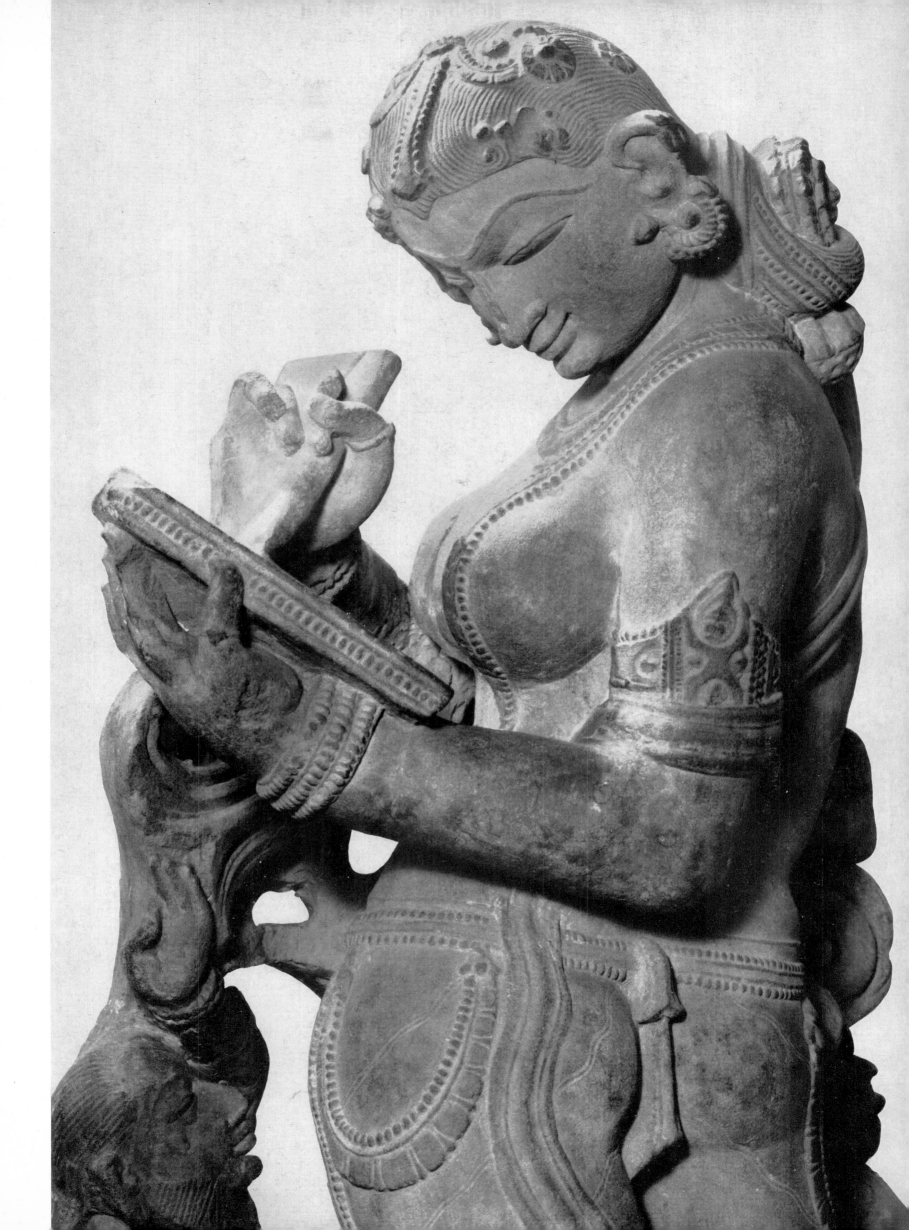

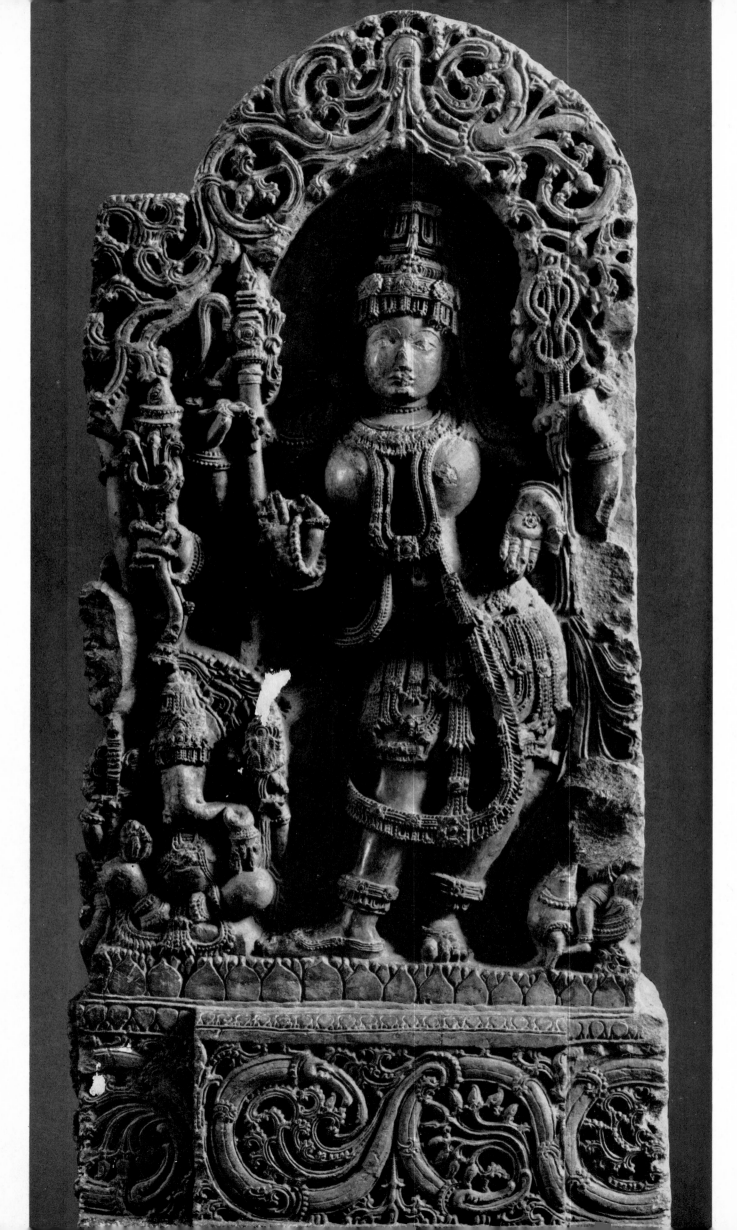

28

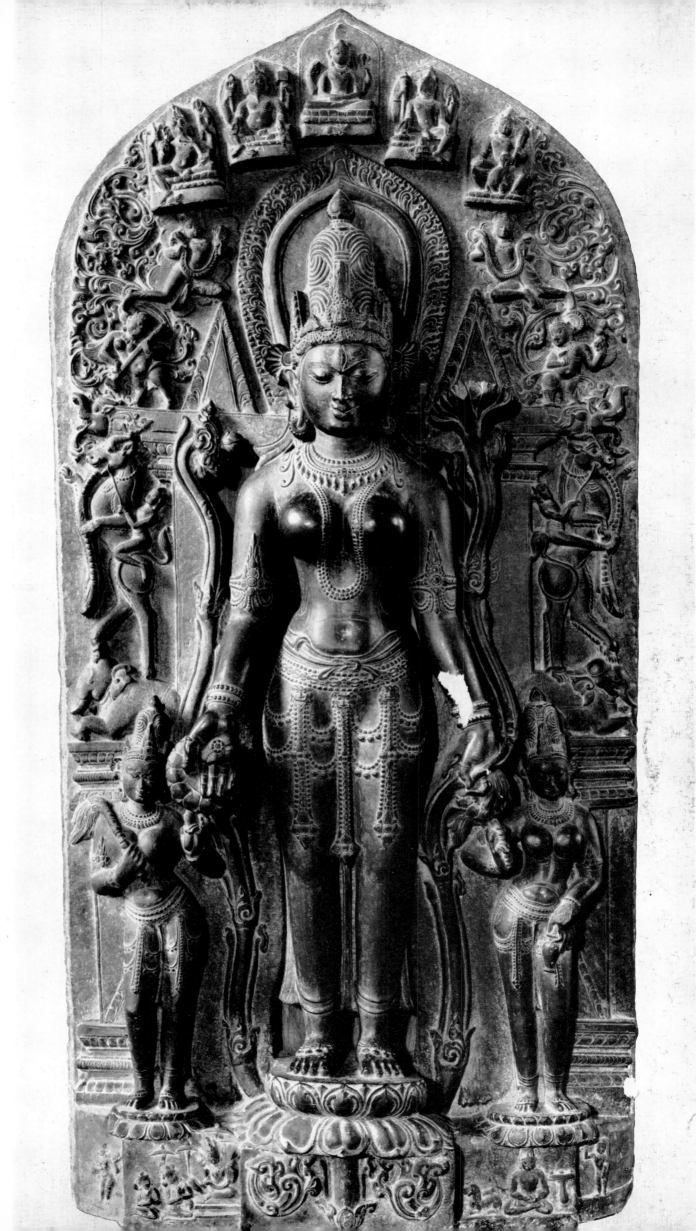

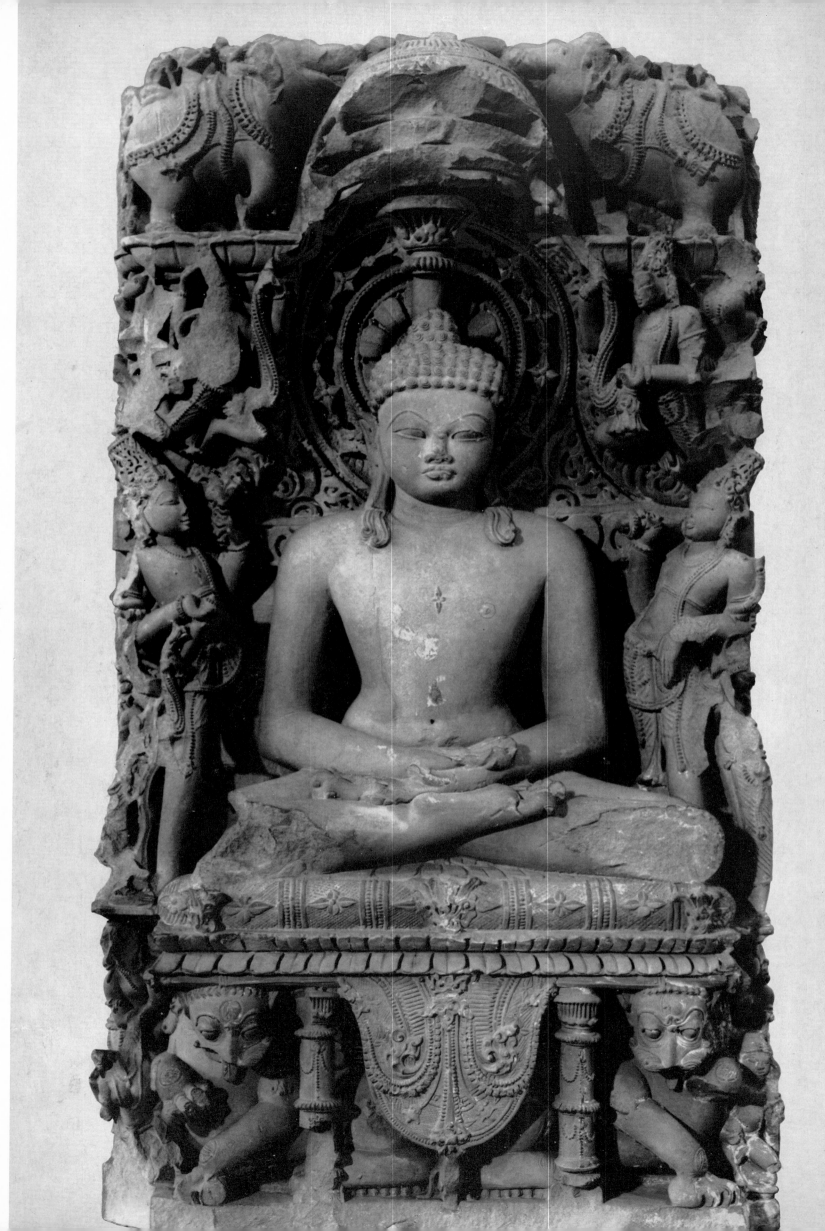

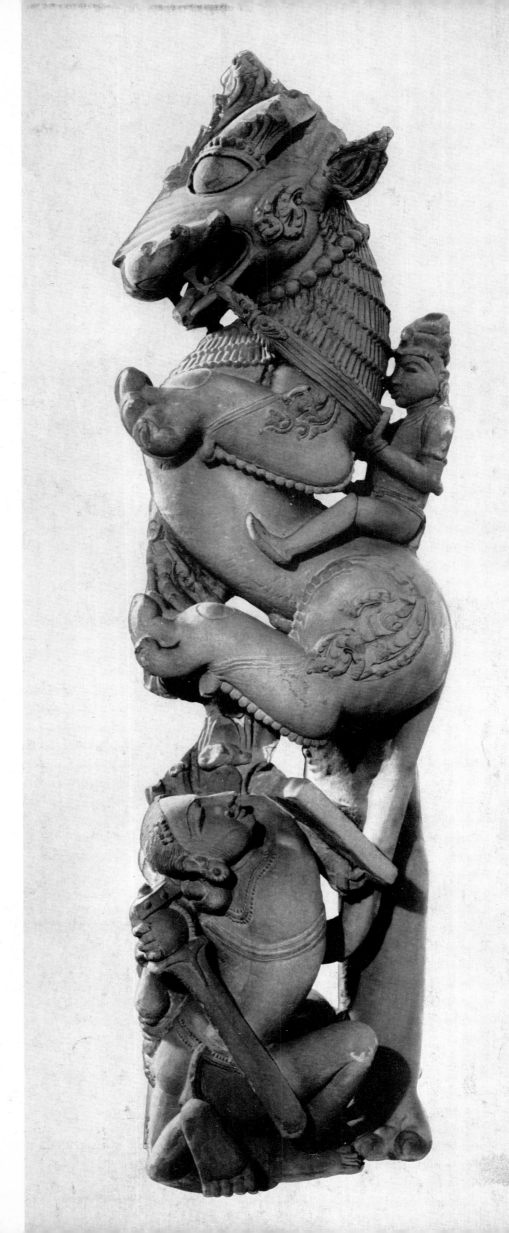

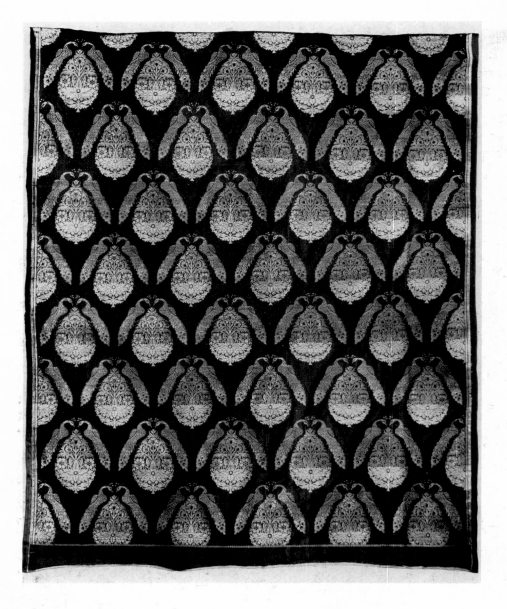

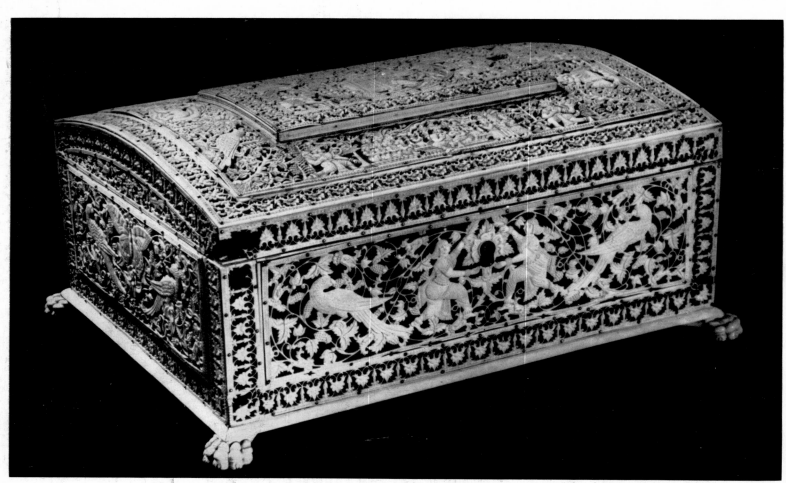

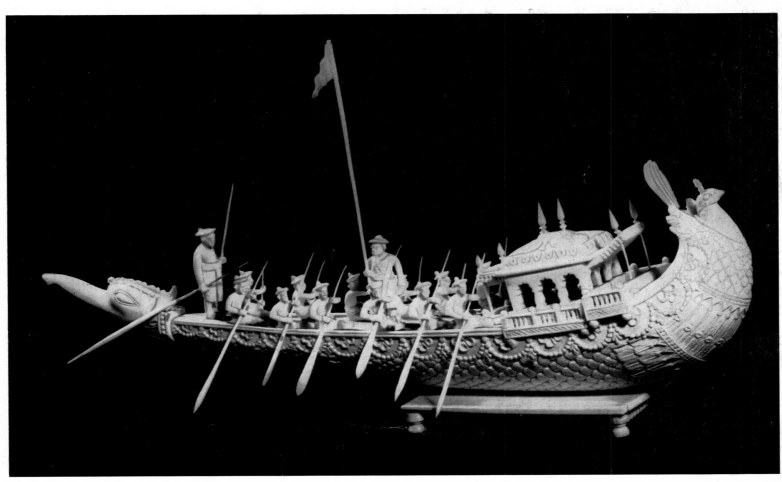

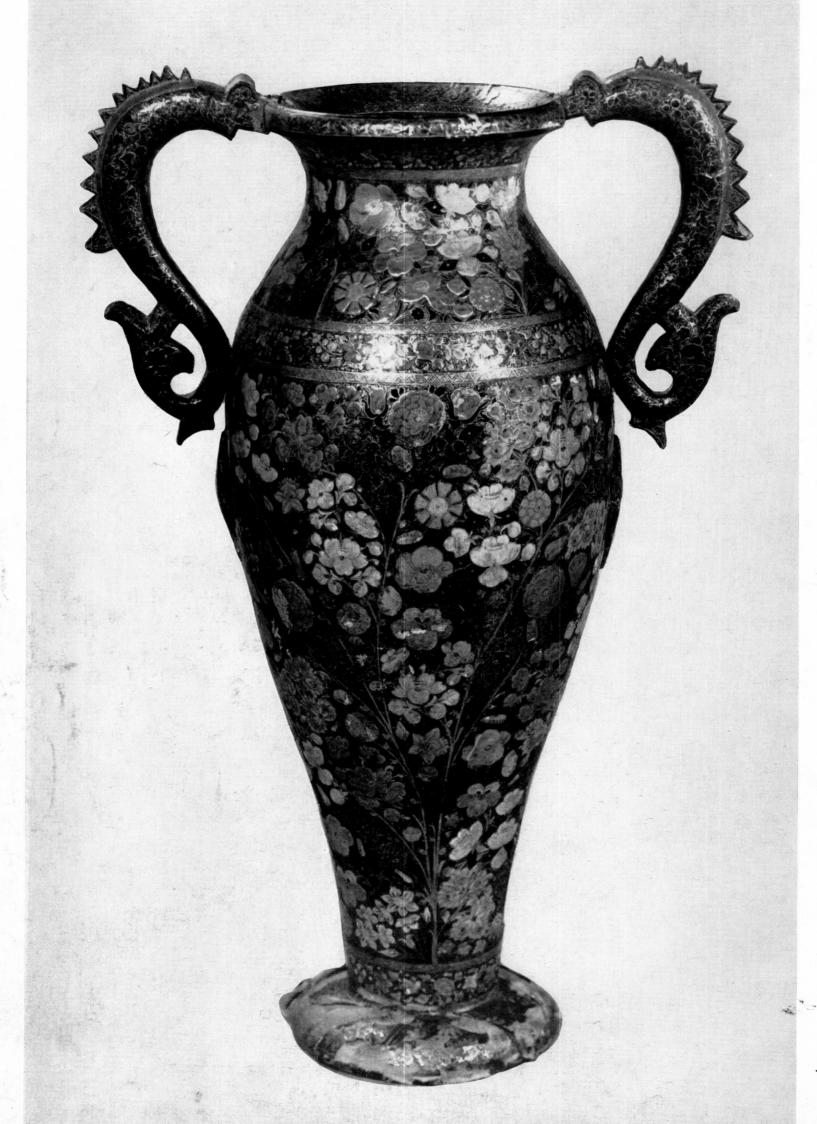

34

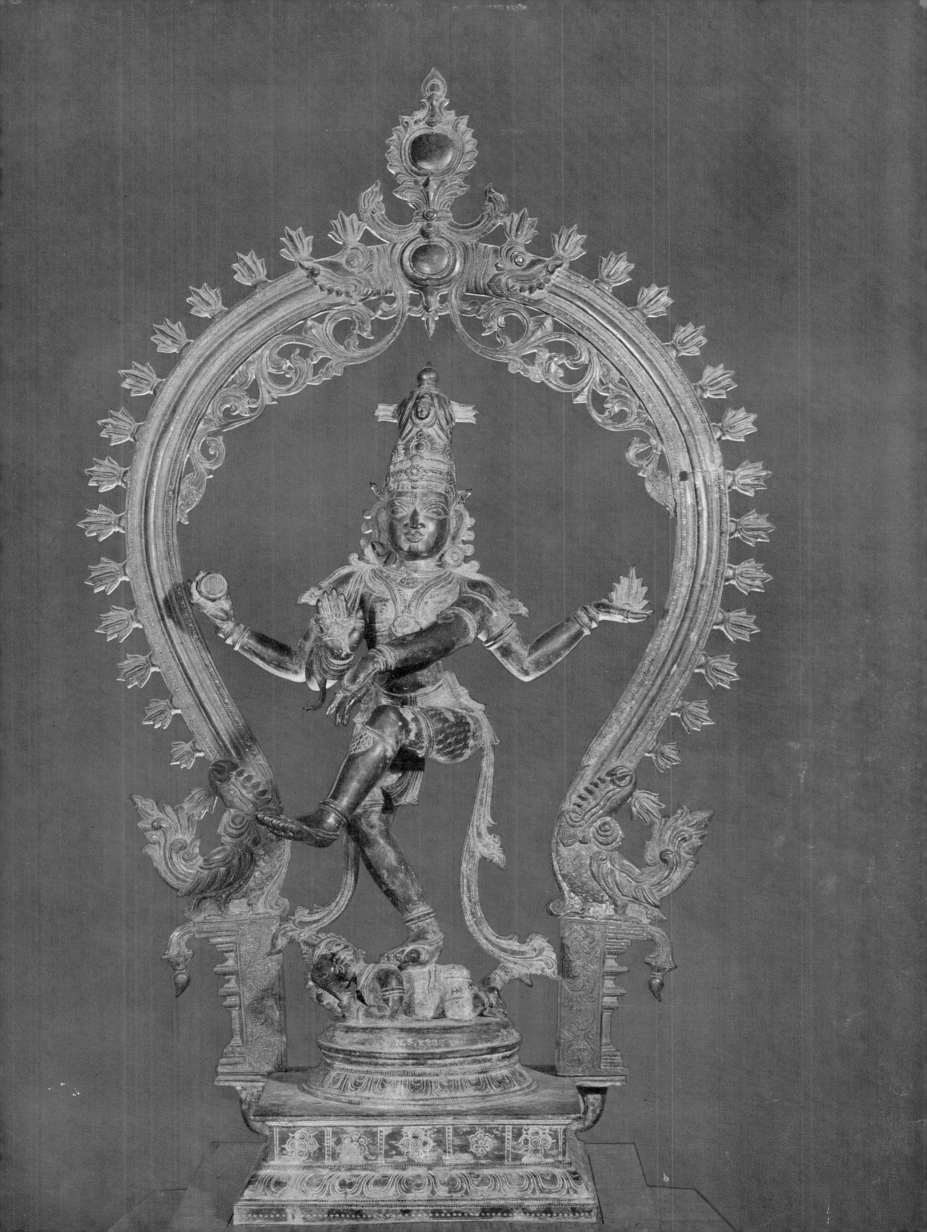

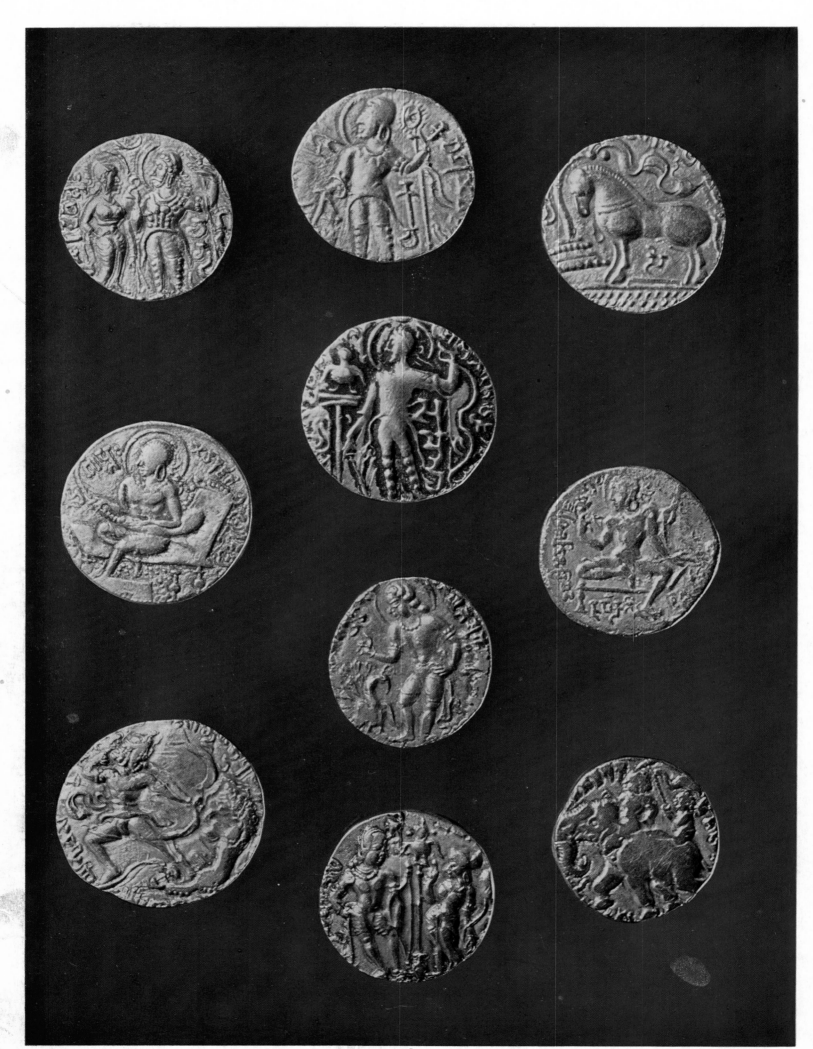

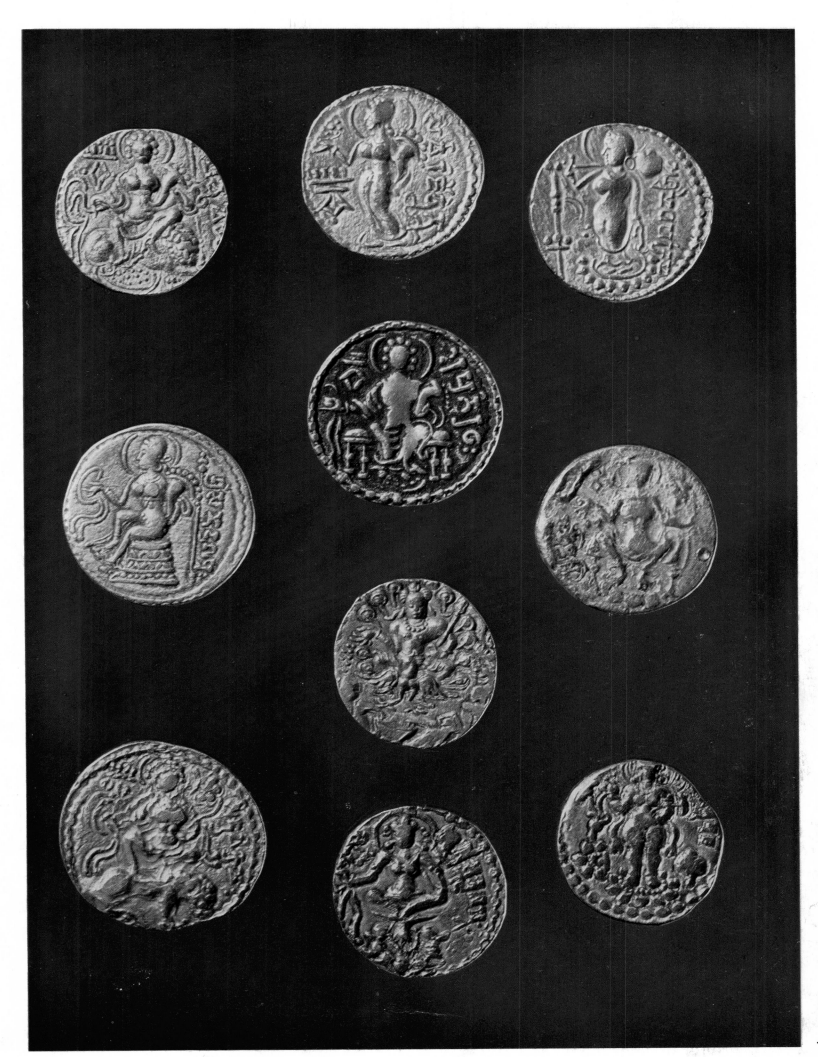

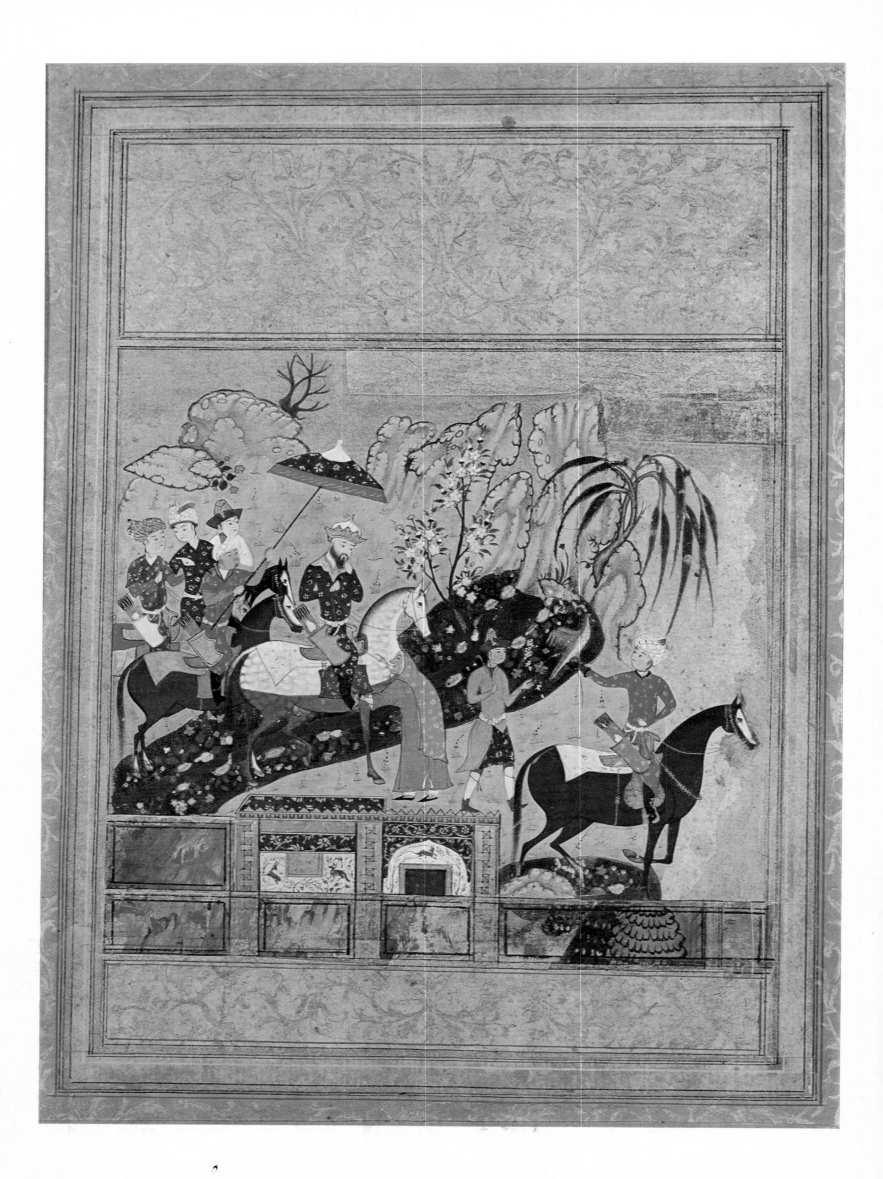

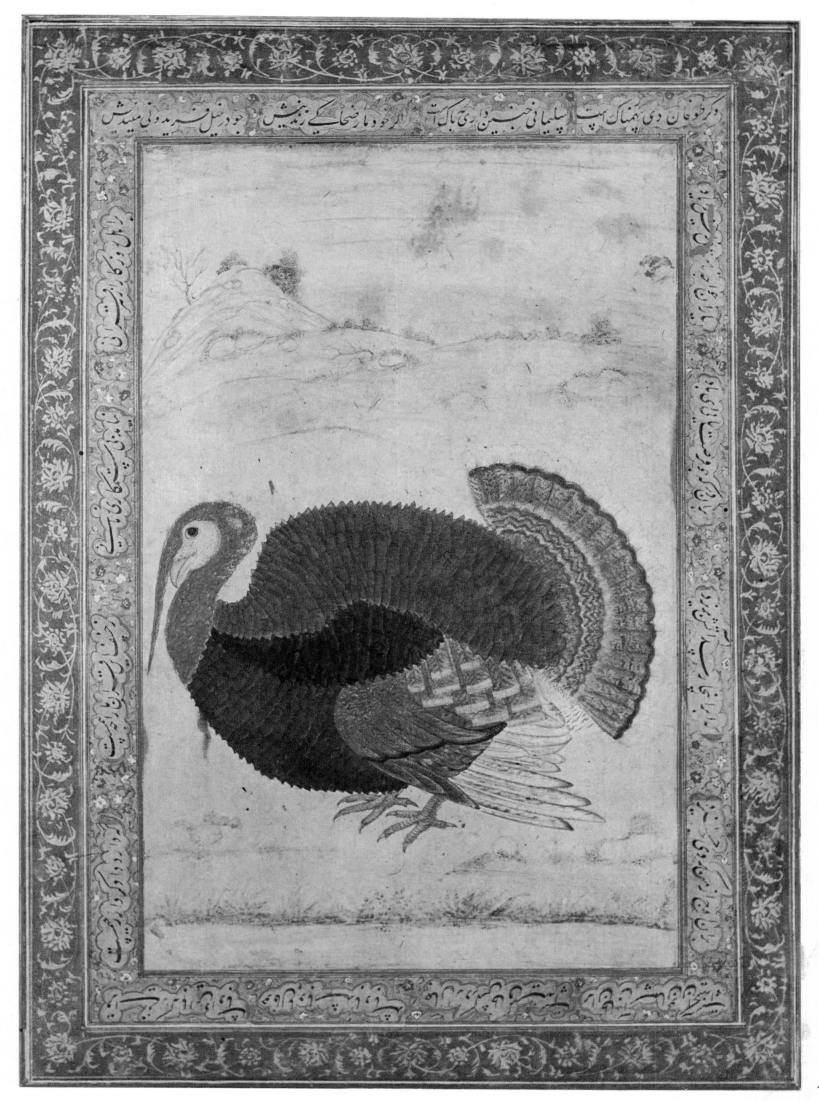

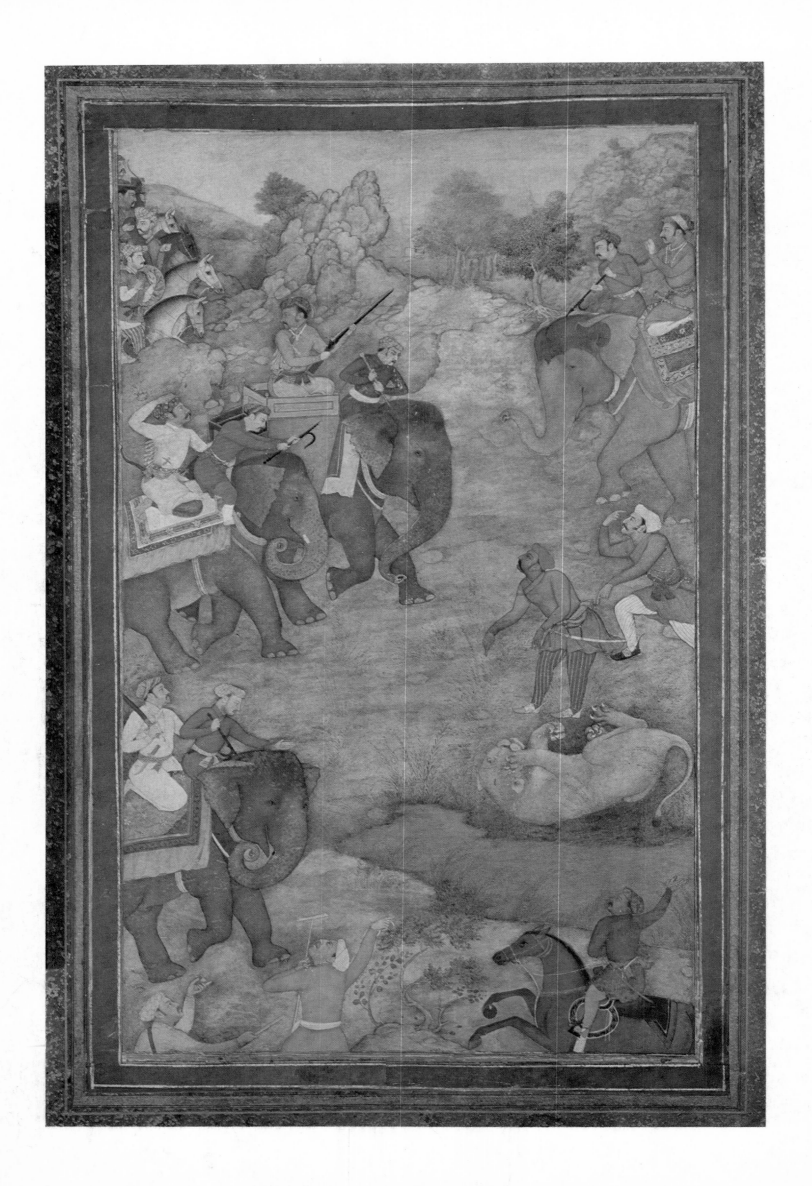

॥अथविचित्रविभ्रमाः॥ हेगतिमंदृसमनोहरकेमृ्व्रखानंदृकंदृहिएउलहेहे: चूंहविलायनिकोमलहासनिश्रंगज्वासनिगाढेगहेहैं बंकविलो कंनकौच्यवलोकसुमारदेनंदुकुमोरदहेहे: एमृनौकोमकेबांनकेहावतेफलनिकेविधिनौलेकहेहें॥१६०॥

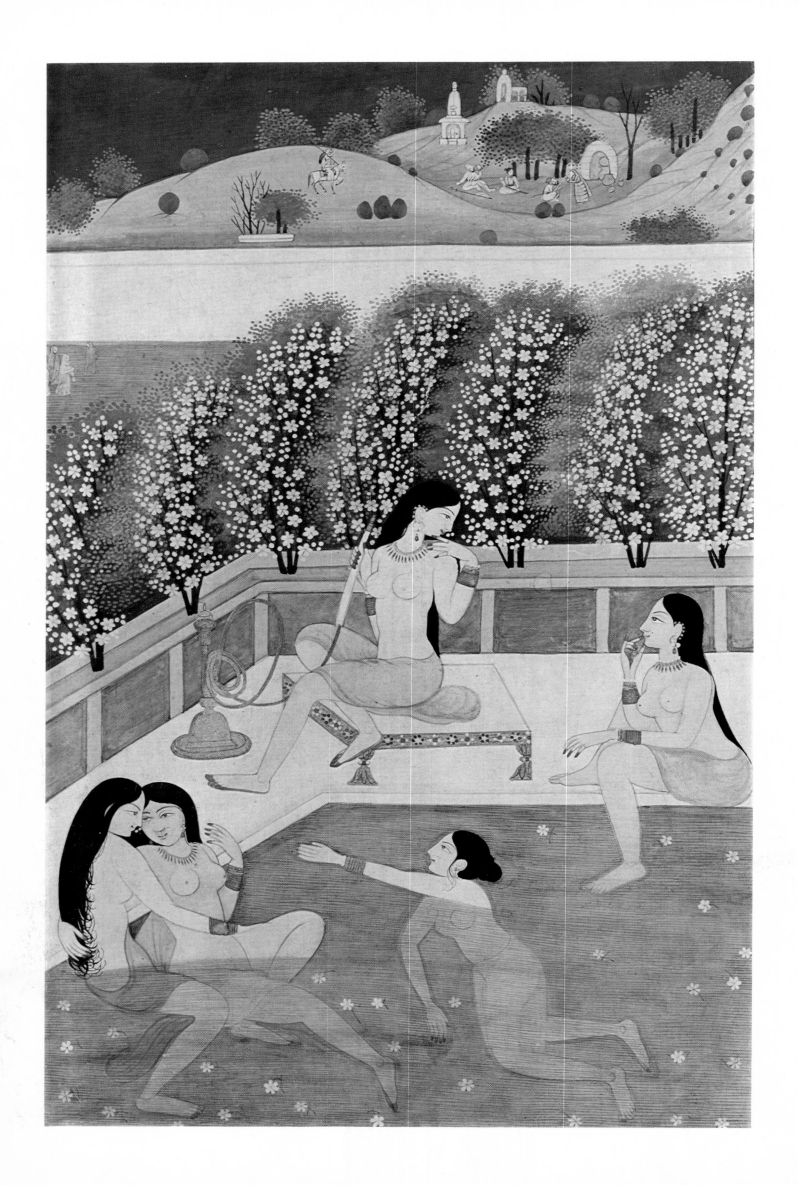

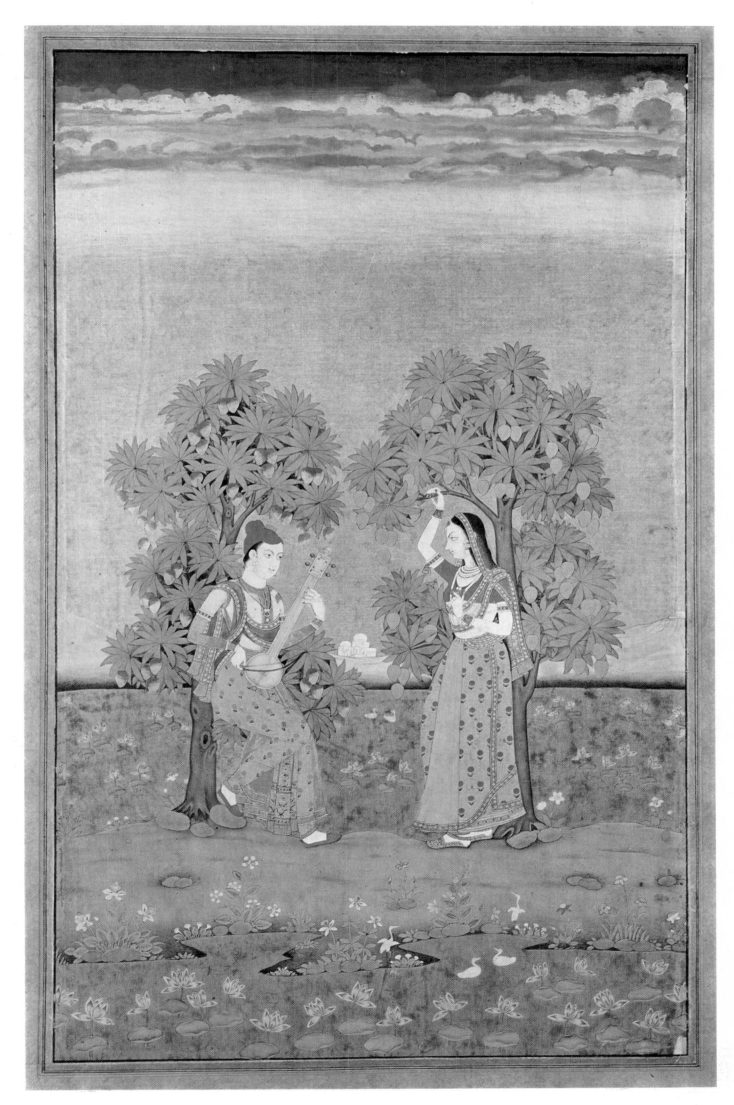

43

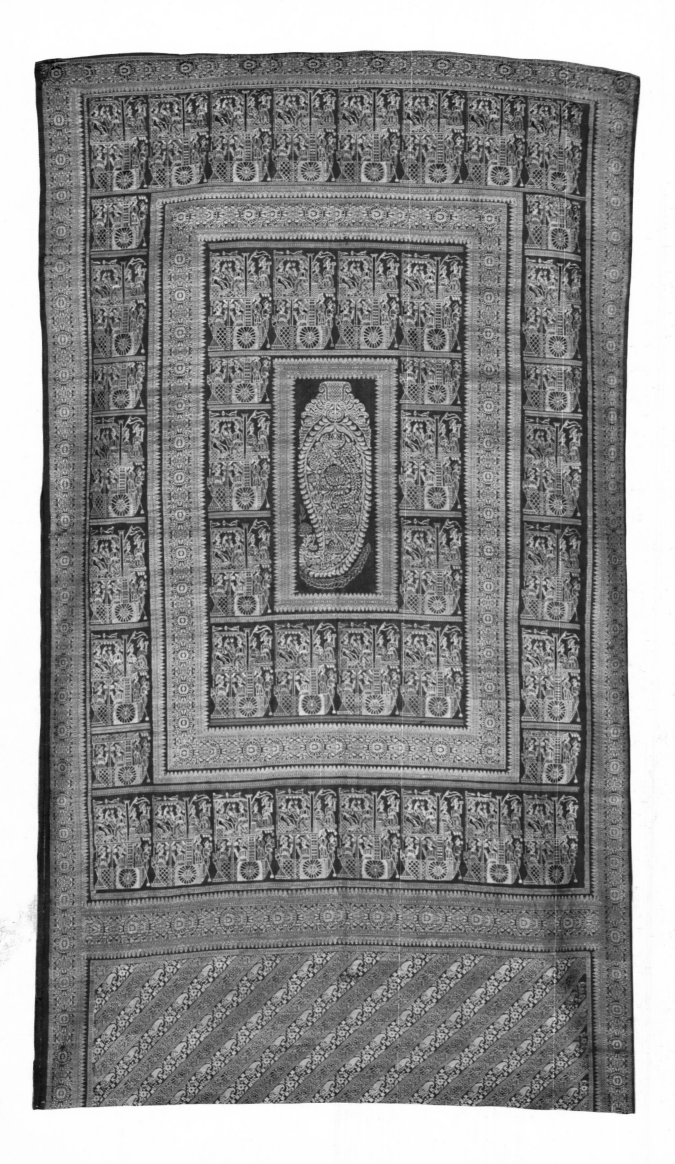

44

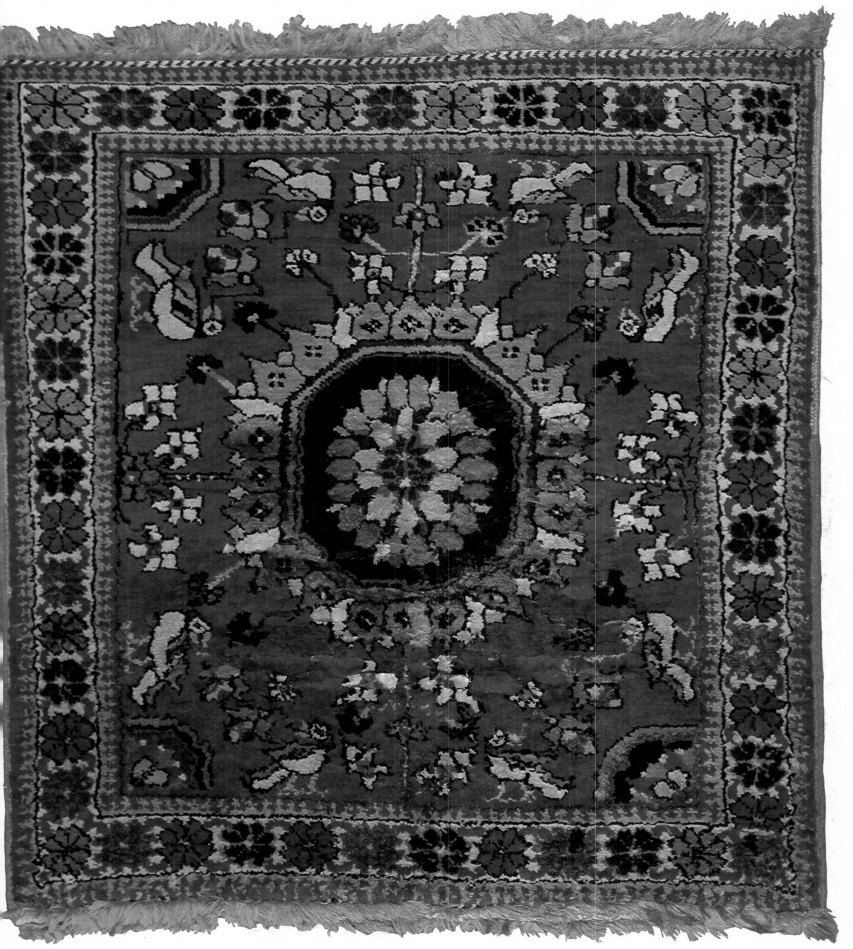

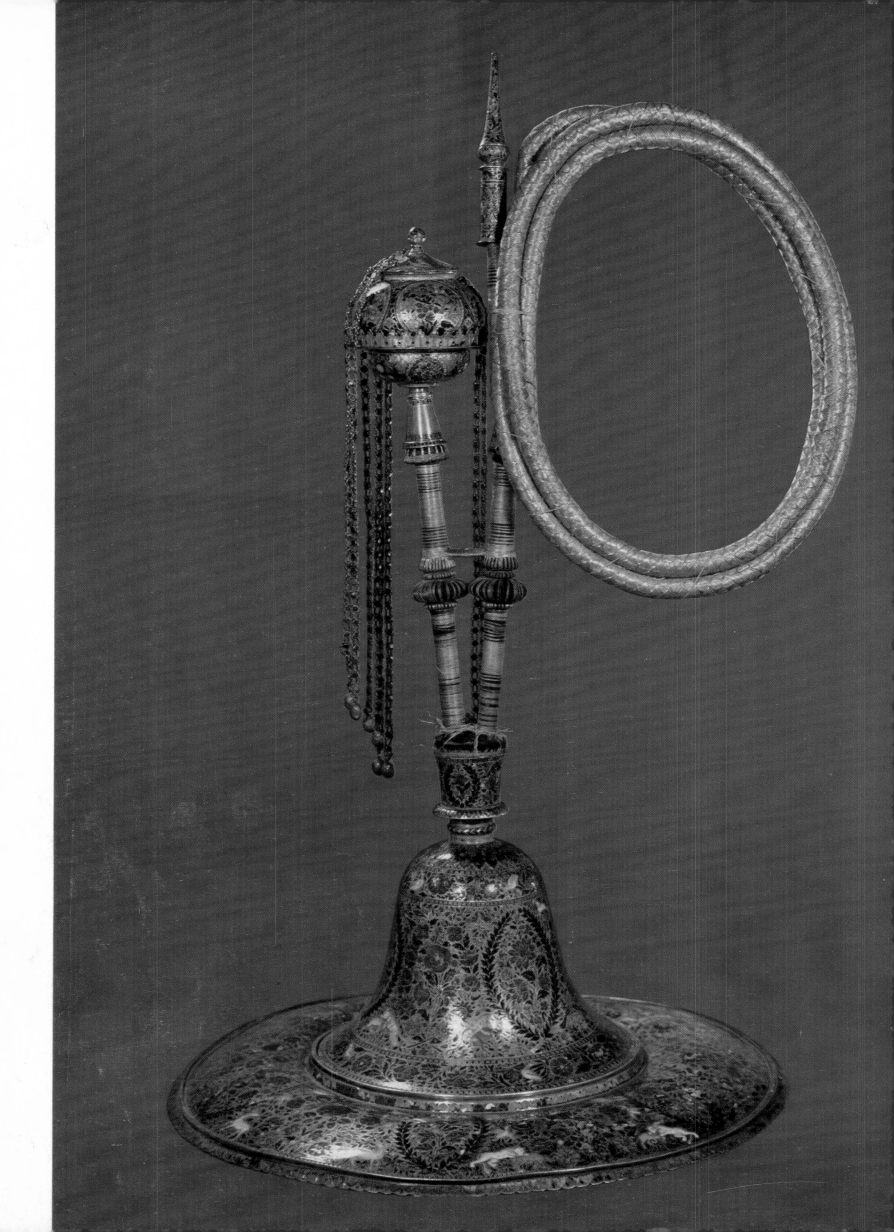

ASUTOSH MUSEUM

49 a) Yakshinī head. Terracotta. Tamluk. 1st century B.C.

49 b) Two seals. Terracotta. Harinarayanpur, West Bengal. 1st millennium B.C.

50 Mould of winged Yaksha. Terracotta. Tamluk. 1st century B.C.

51 a) Fragment of a precious terracotta plaque. Shaddanta-Jātaka. Tamluk. 1st century A.D.

51 b) Female figure. Terracotta. Chandraketugarh. C. 3rd century B.C.

52 Fragment of a Yakshinī head. Terracotta. Chandraketugarh. C. 2nd century B.C.

53 a) Enigmatic face. Terracotta. Raghunathbari, West Bengal.

53 b) Ram toy-cart. Terracotta. Chandraketugarh. C. 1st century A.D.

54 God Sūrya. Basalt. C. 6th century A.D.

55 Head of a Nāyikā. Panna, West Bengal. C. 5th century A.D.

56 Female head. Agradigun. C. 10th century

57 Relief panel representing the nine planets. Kankandighi, West Bengal. 10th century

58 Seated Buddha. Bodh-Gayā, Bihār. C. 11th century

59 Sarasvatī. Sunderban, West Bengal. C. 10th century

60 Shiva-Lokeshvara. Habibpur. C. 11th century A.D.

61 Bodhisattva stele. Pāla. Bengal

62 Vishnu-Chakra. Sarisadha, West Bengal. C. 10th century

63 Tāra. Nepal. 18th century

64 Copper plate engraving. Rakshaskhali, West Bengal. Dated 1196

65 Avalokiteshvara. Nepal. C. 12th century

66 Hunting scene. Ivory. Orissa. C. 16th century

67 Fragment of a female. Purī, Orissa. C. 14th century

68 Nandi pedestal. Murshidābād. C. 18th century

69 Venu-Gopala. Wood. Kansat, West Bengal. C. 15th century

70 Elephant chariot. Bronze. Bankura, West Bengal. C. 18th century

71 a) Ascetic. Wood. Jessore. C. 17th century

71 b) Nāyikā. Wood. Purī, Orissa. C. 18th century

72 Krishna and Rādhā. Bronze. Purī, Orissa. C. 17th or 18th century

73 Hunting scene. Terracotta. Naldanga, Jessore. C. 16th century

74 Kānthā. Bongoan, Jessore. 19th century

75 Manasā. Shola, Assam. 20th century

76 Toilet scene. Paper. Kalighat. 19th century

77 a) Jatayu and Rāvana. Handmade paper. Kalighat. 19th century

77 b) Horse. Terracotta. Rājasthān, West Bengal. 20th century

78 Bāluchar Sāri. Murshidābād. 18th century

79 Gopīs in arbour. Paper. Ranpur, Orissa. C. 17th century

80/81 a) Swoon of Chaitanya. Painted wooden cover. Bankura, West Bengal. 17th century

80/81 b) Vishnu with Nārada and ascetics. Painted cover

82 Manasā. Ghat. Painted terracotta. Faridpur, Bangladesh. 20th century

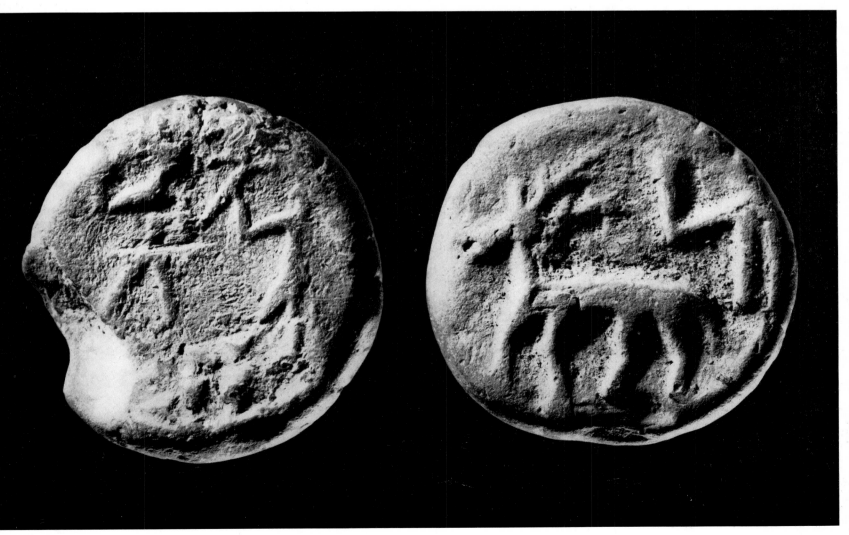

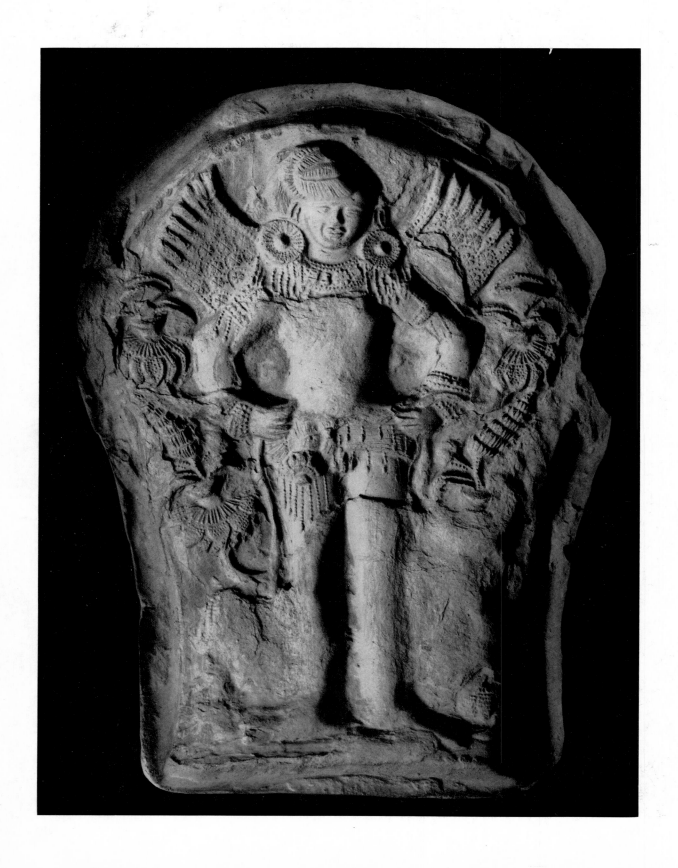

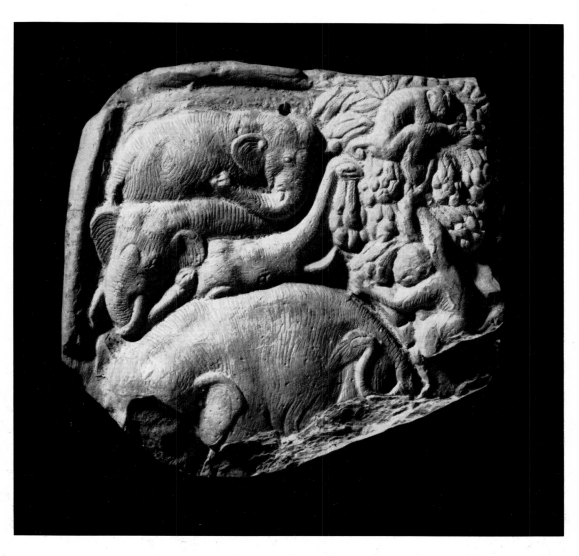

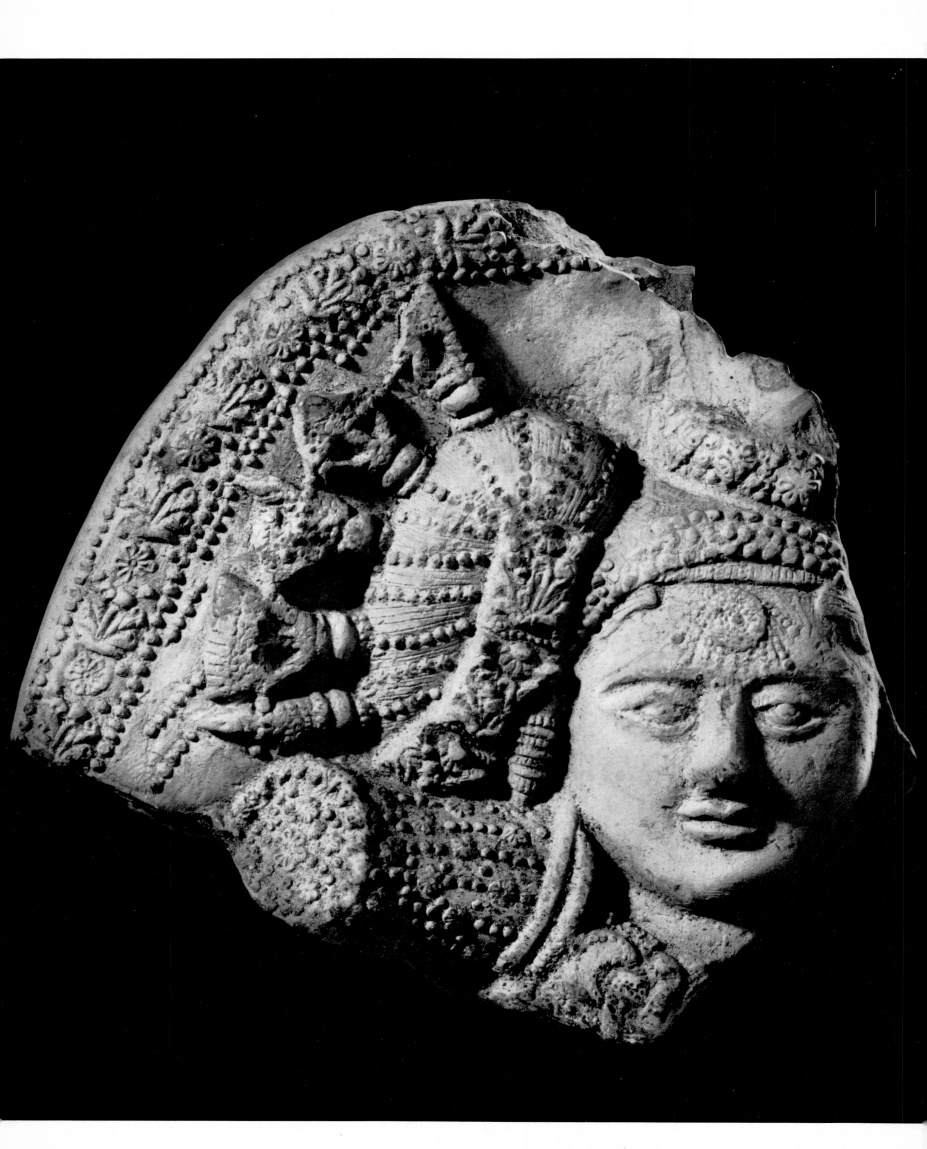

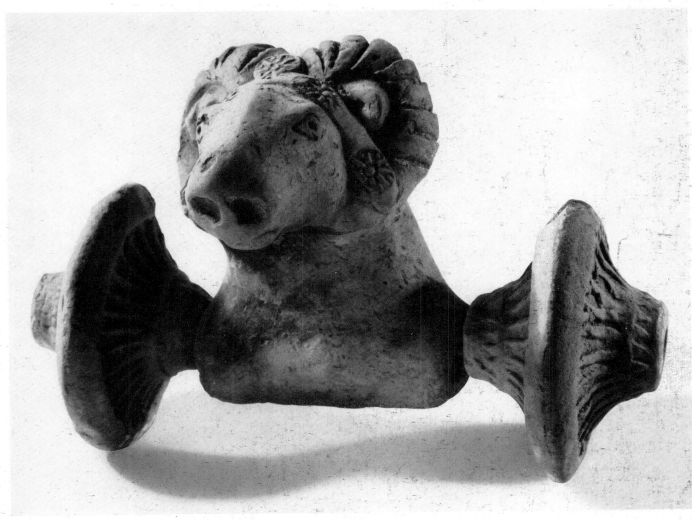

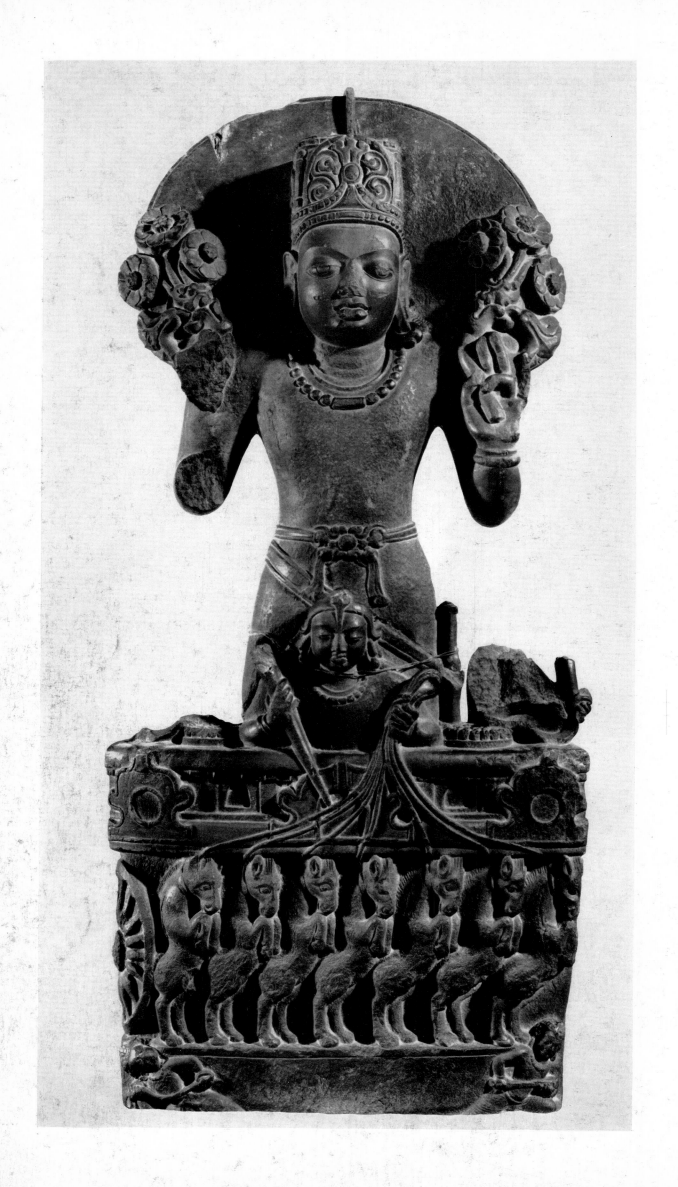

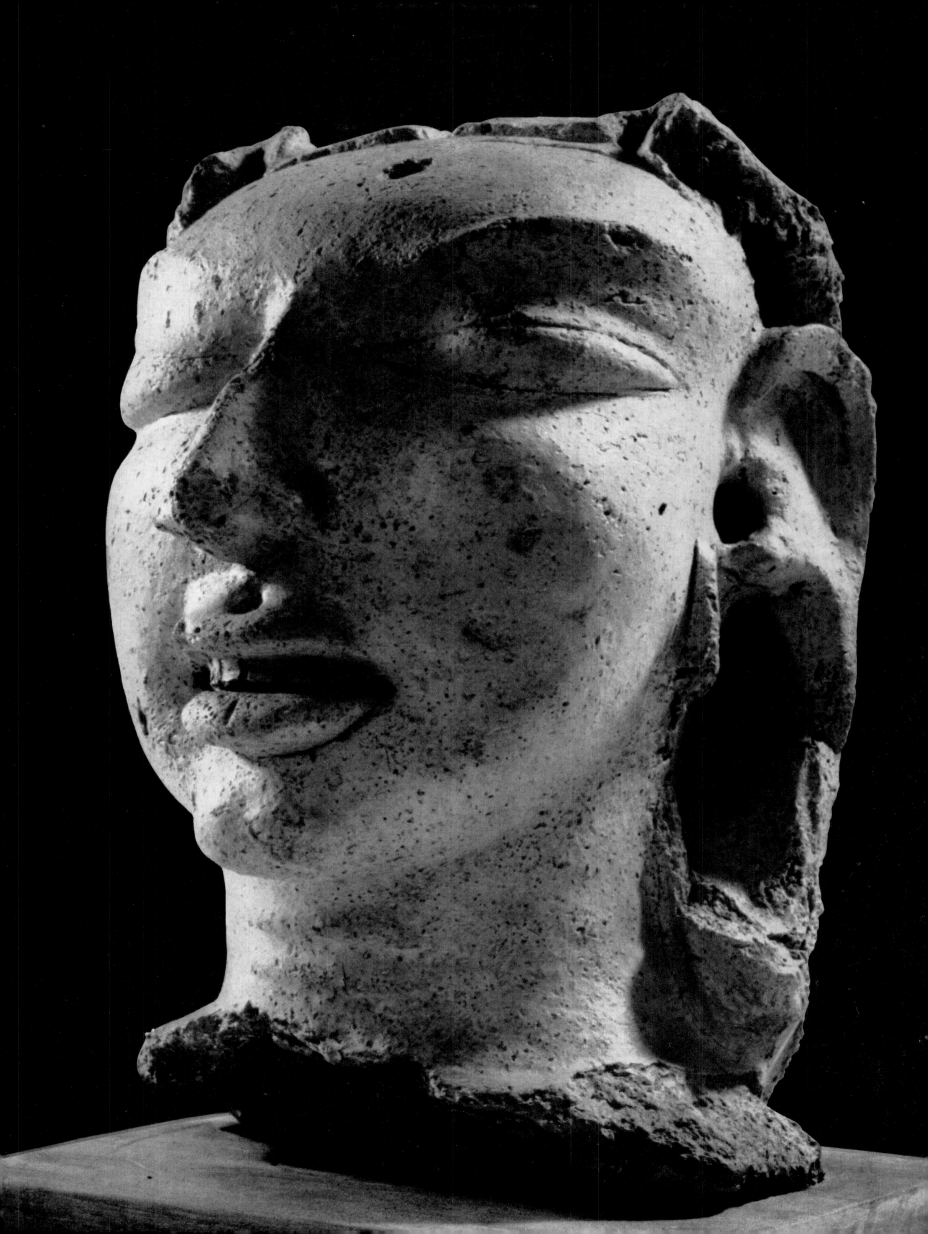

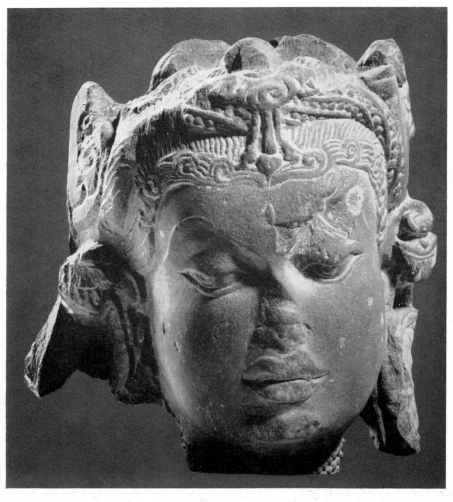

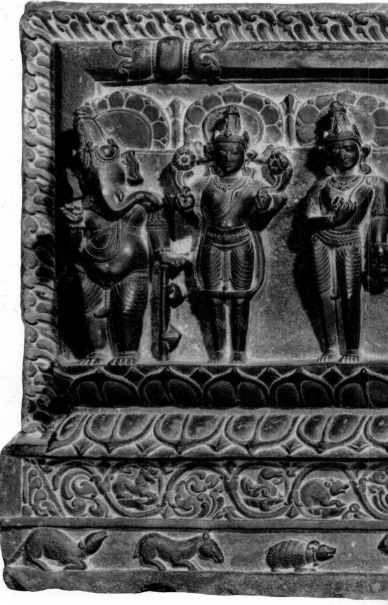

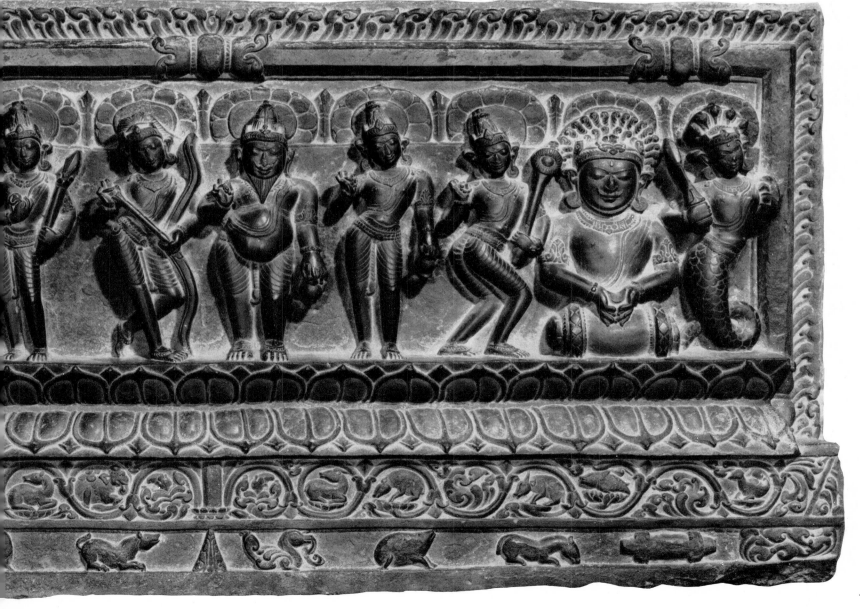

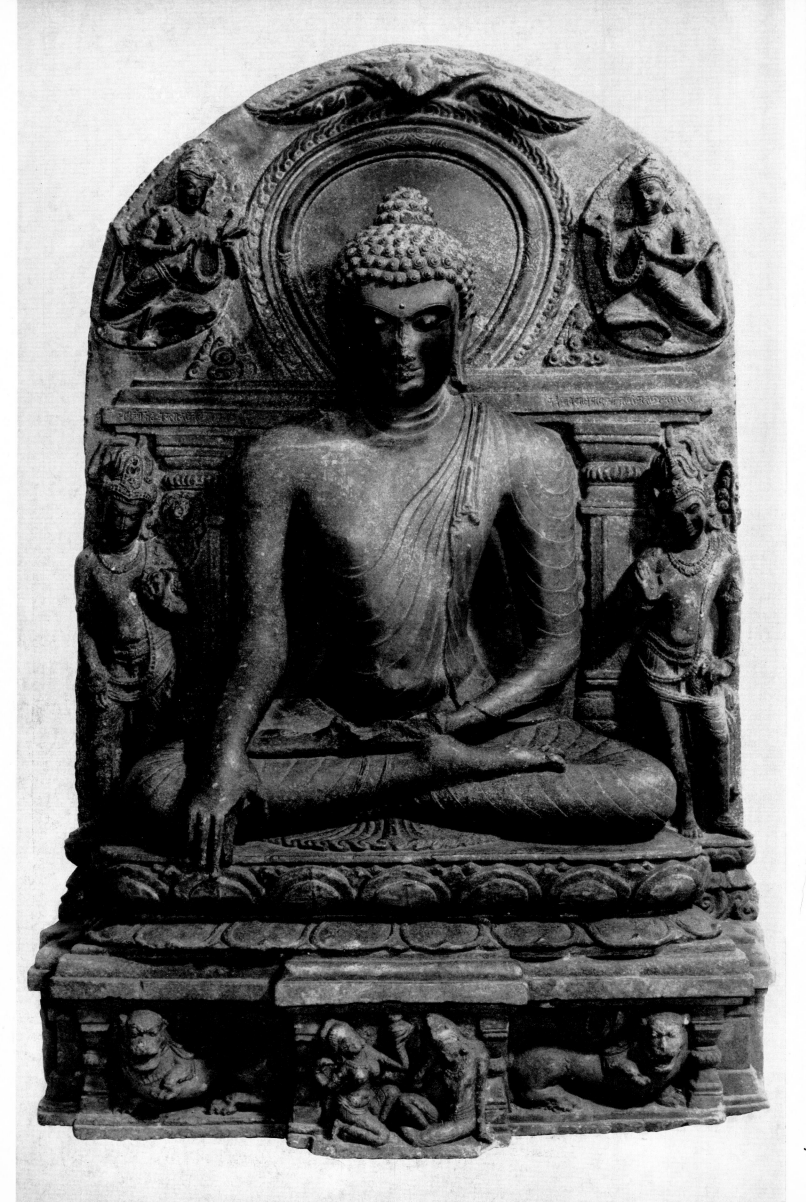

58

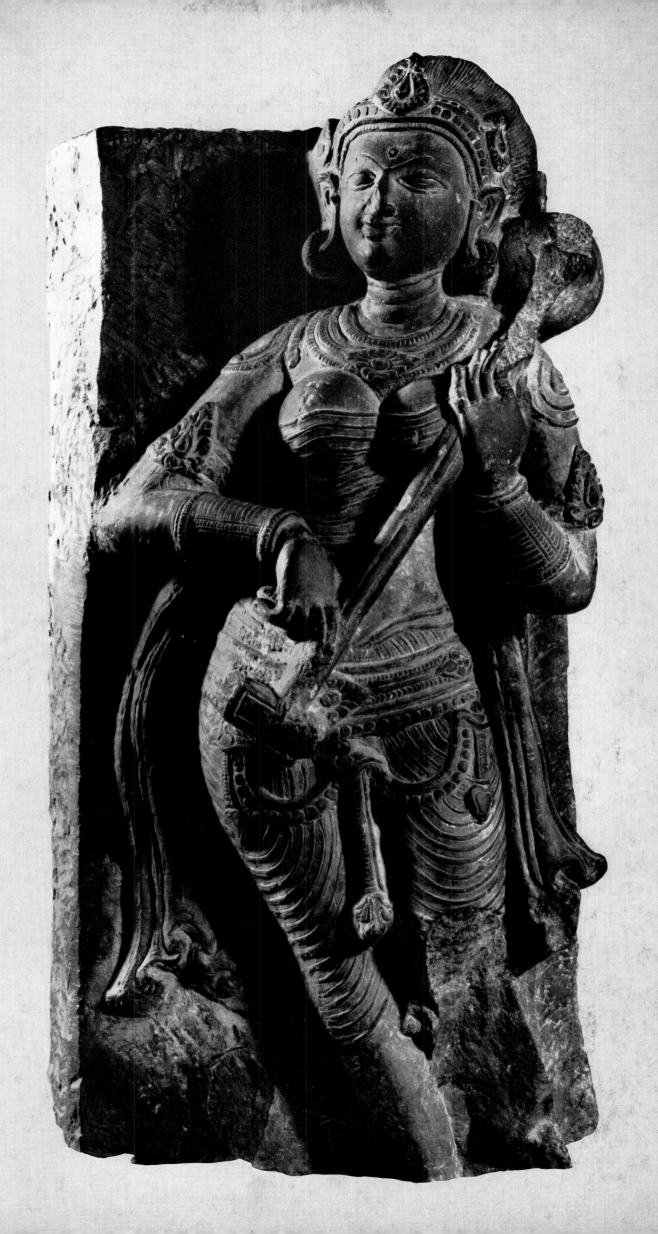

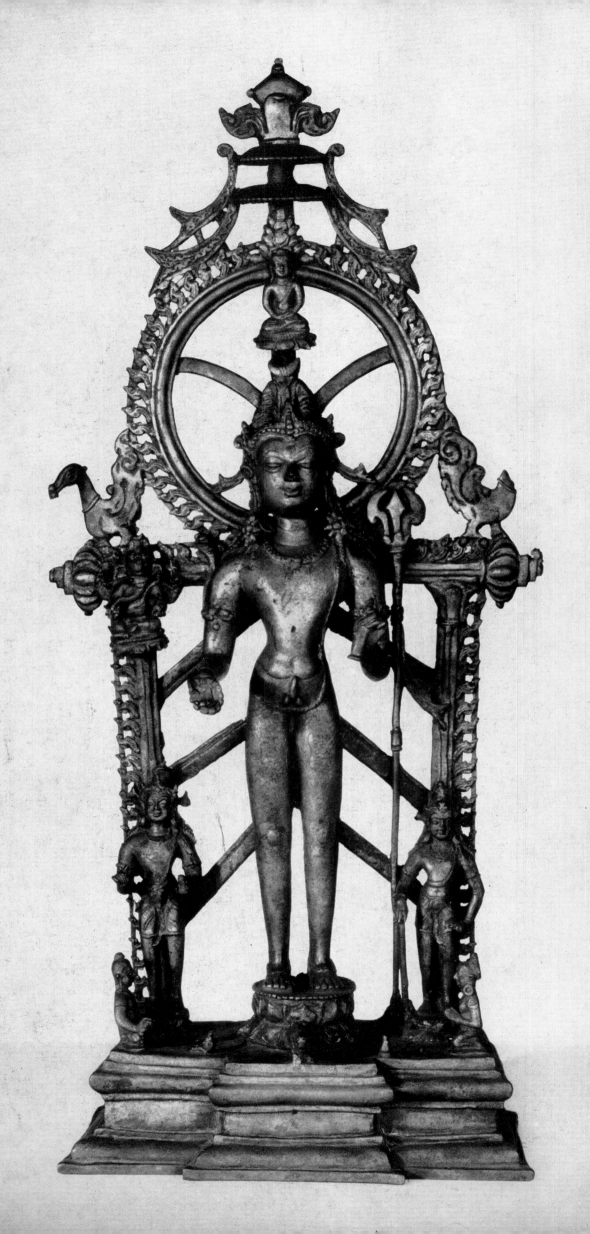

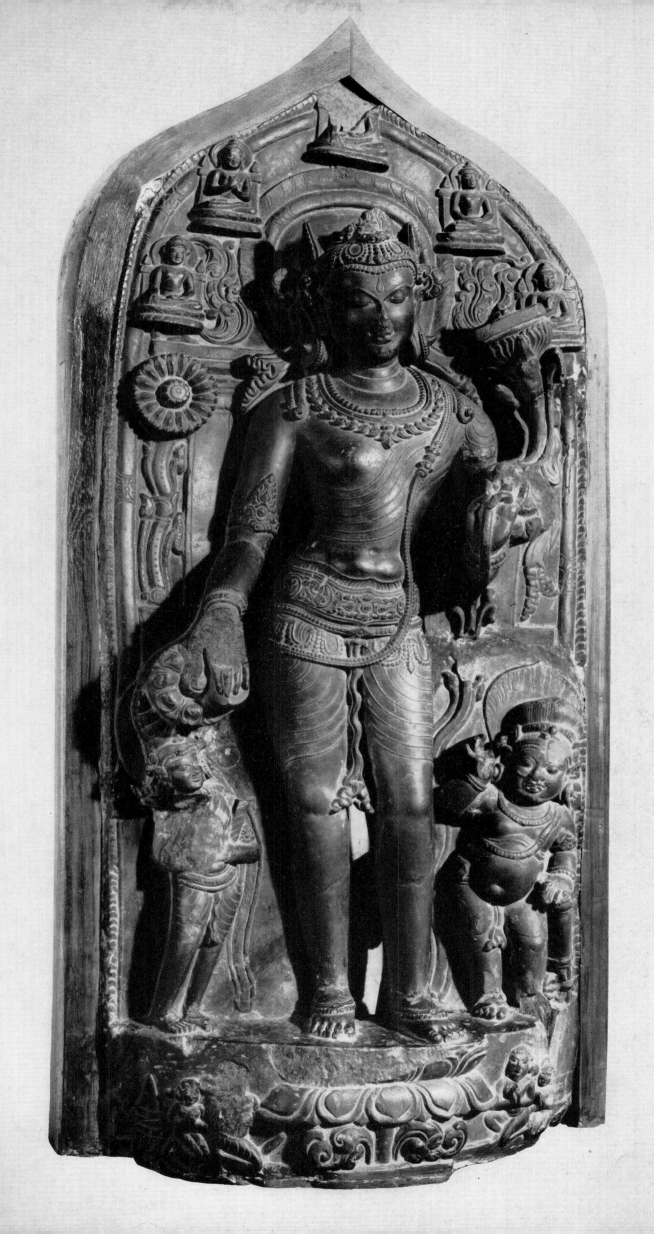

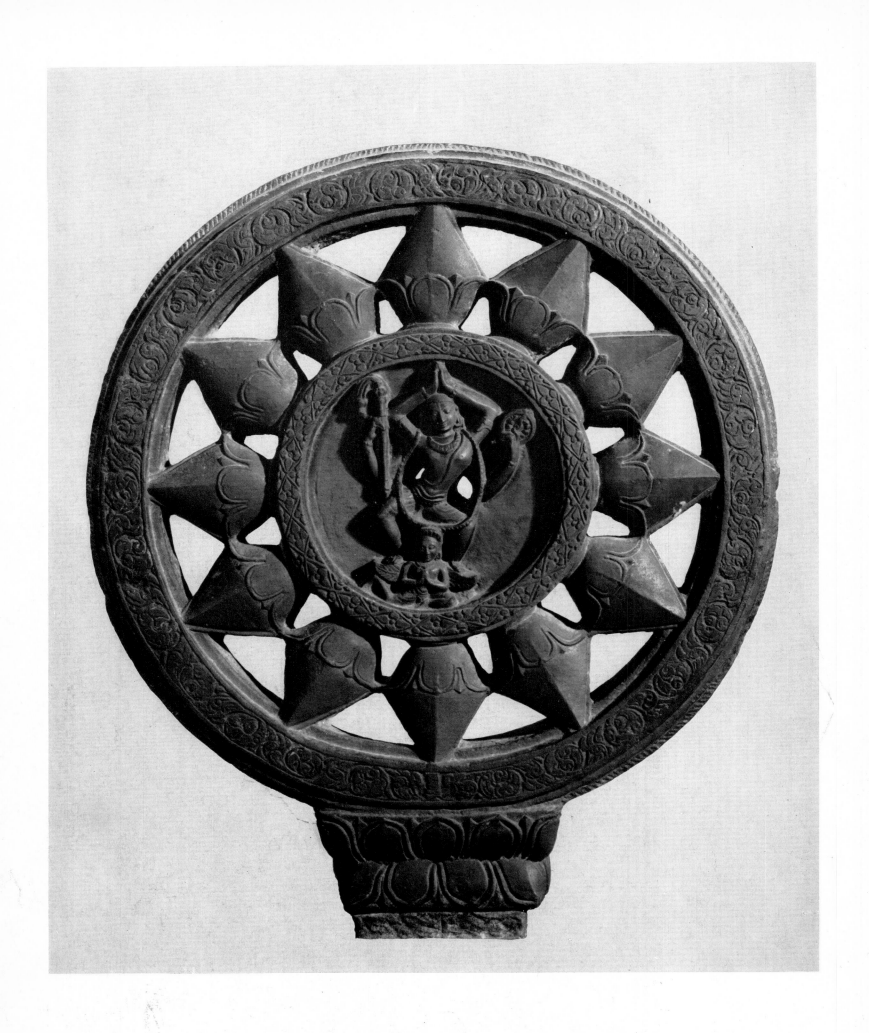

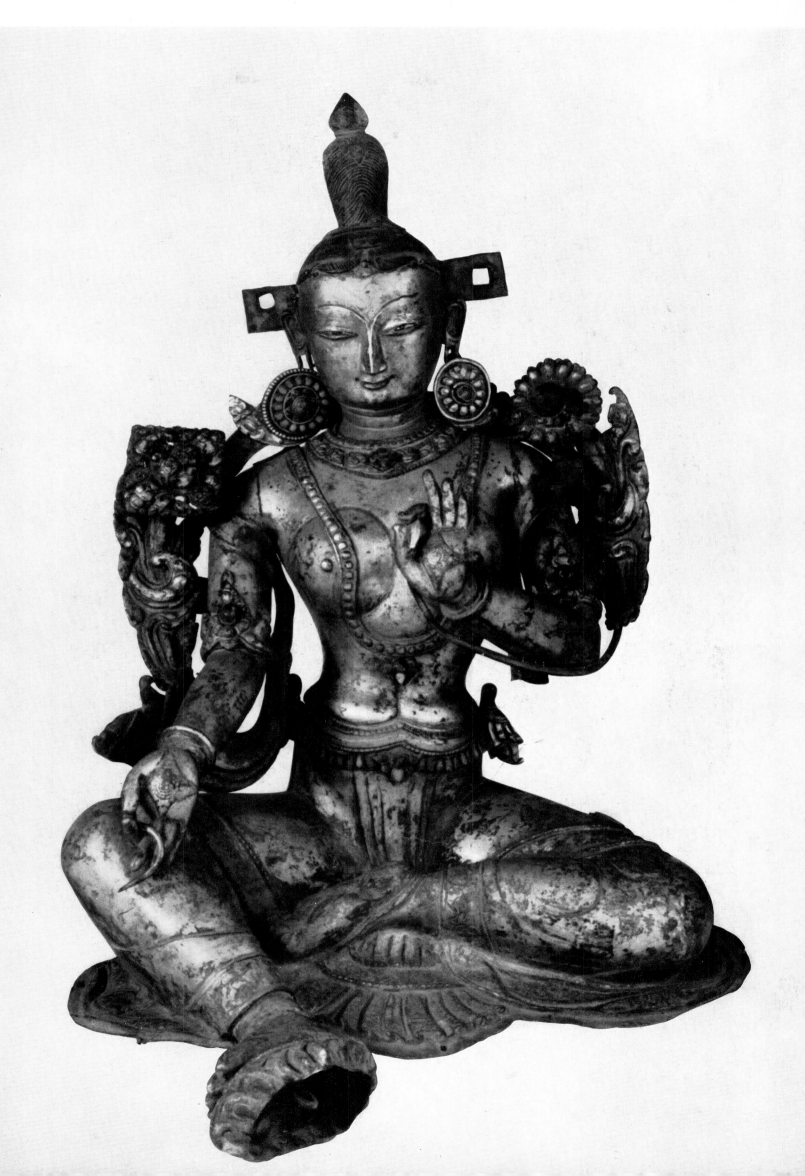

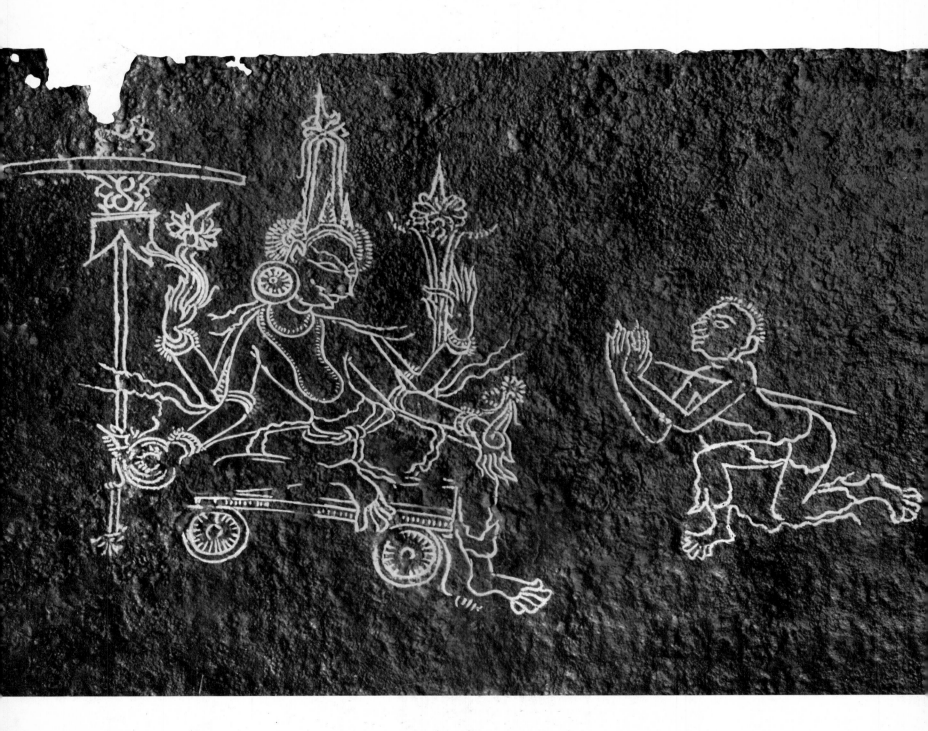

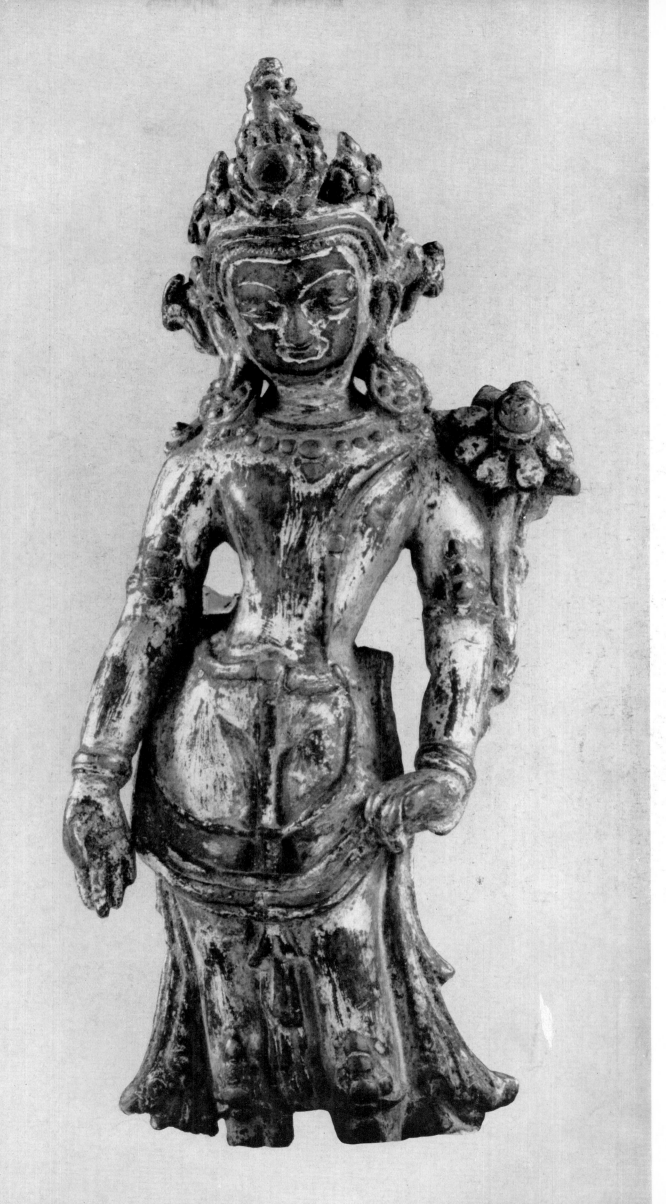

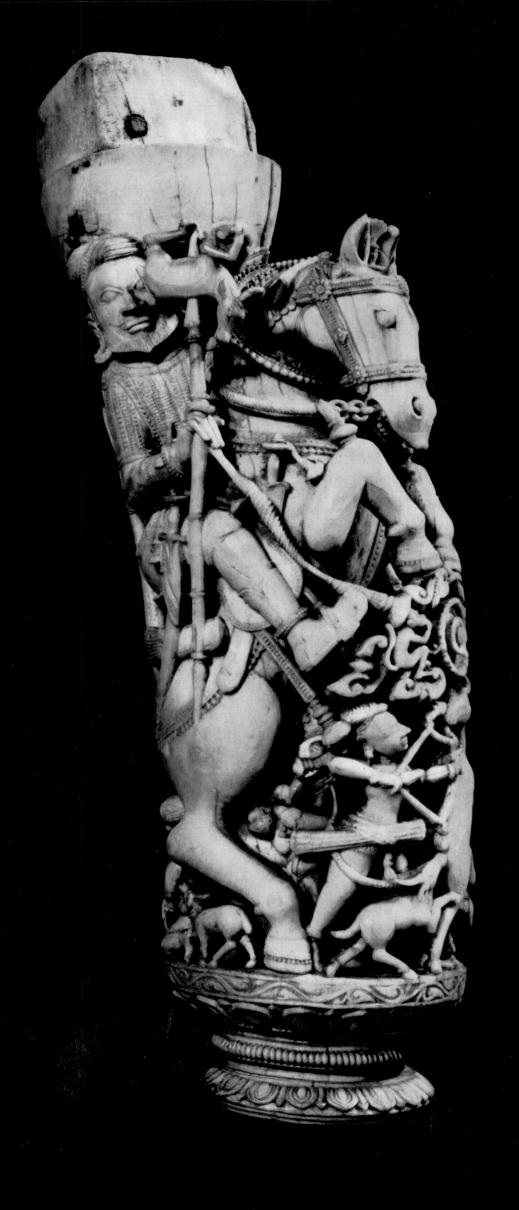

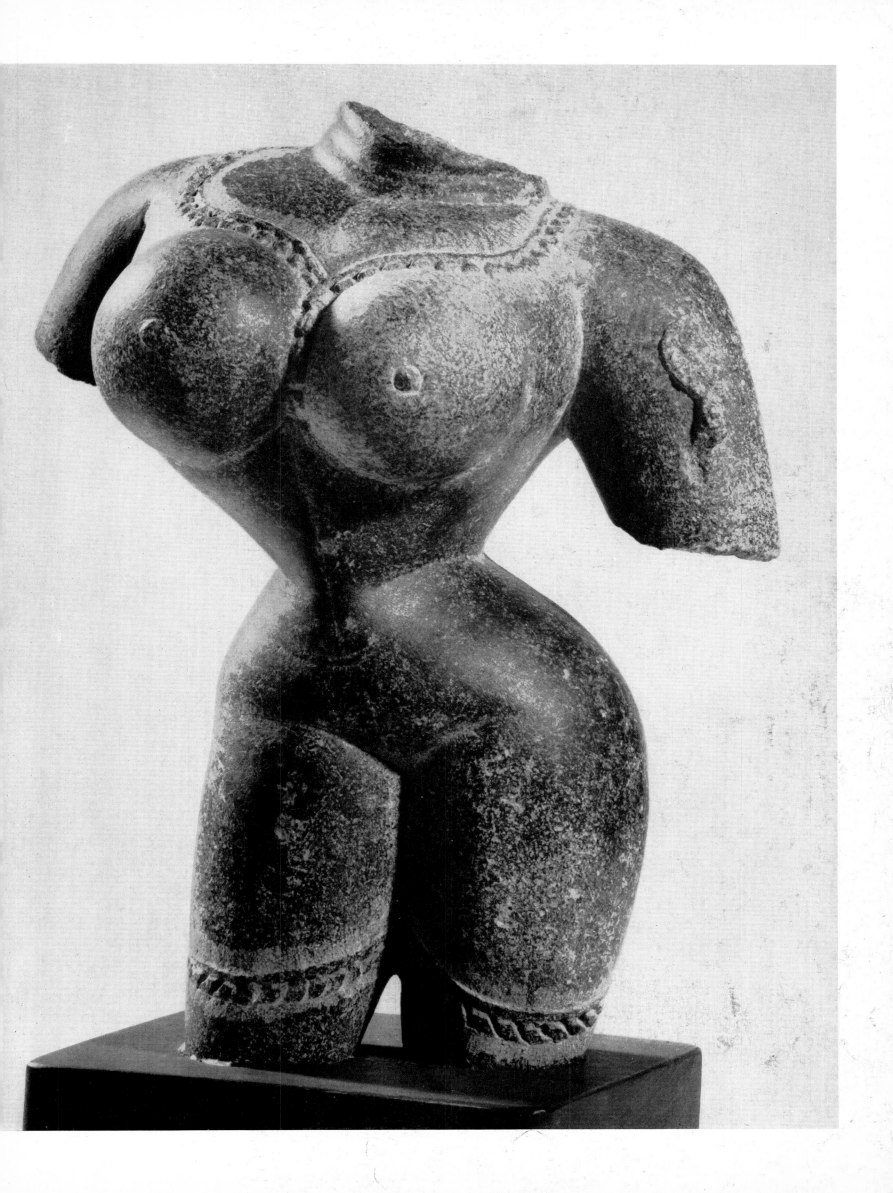

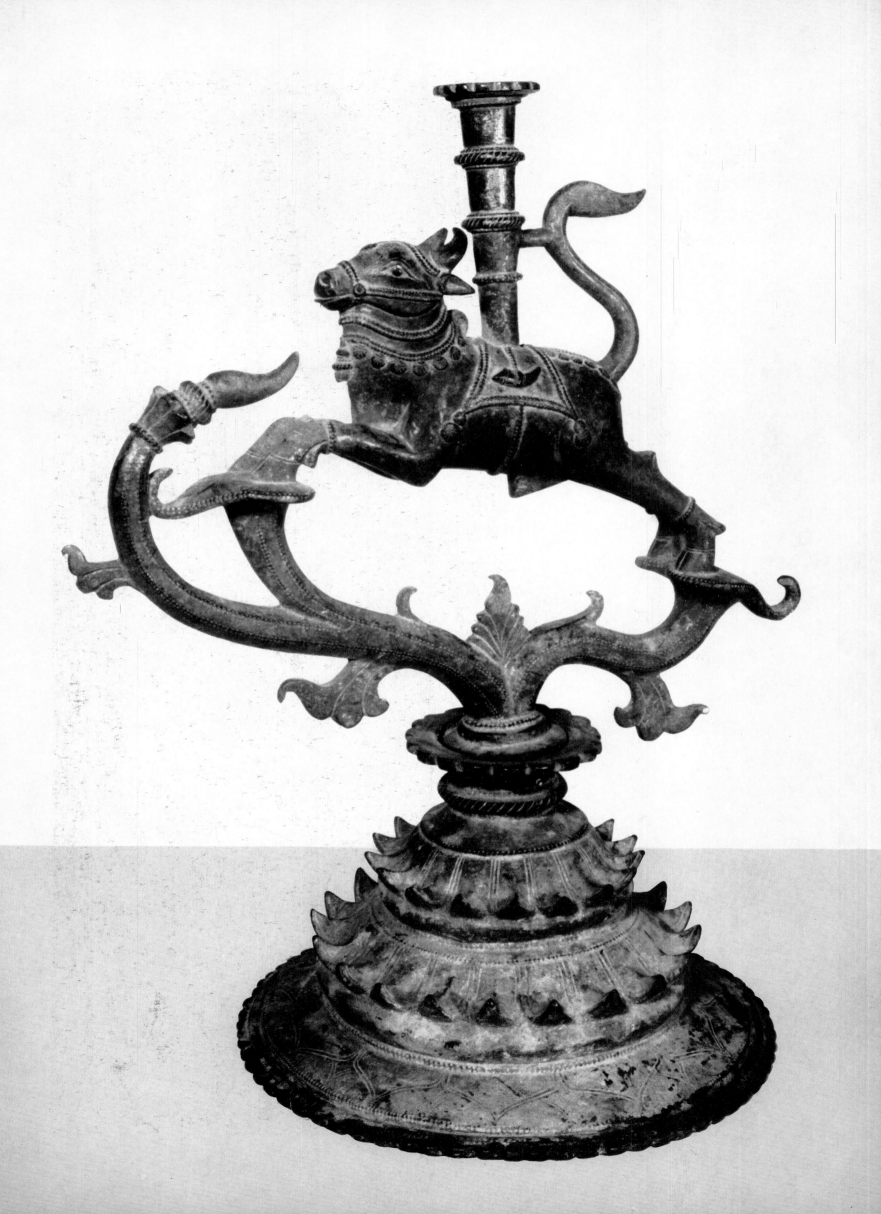

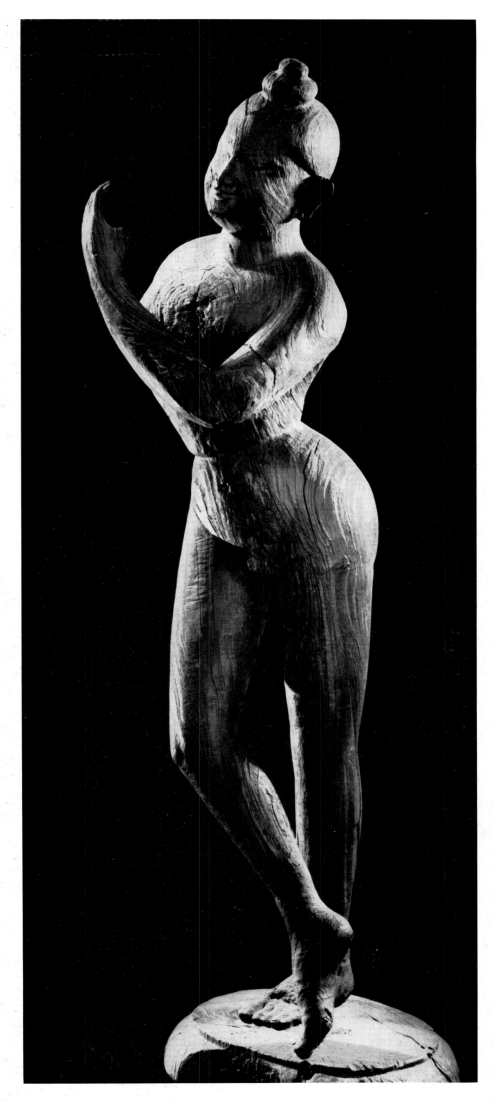

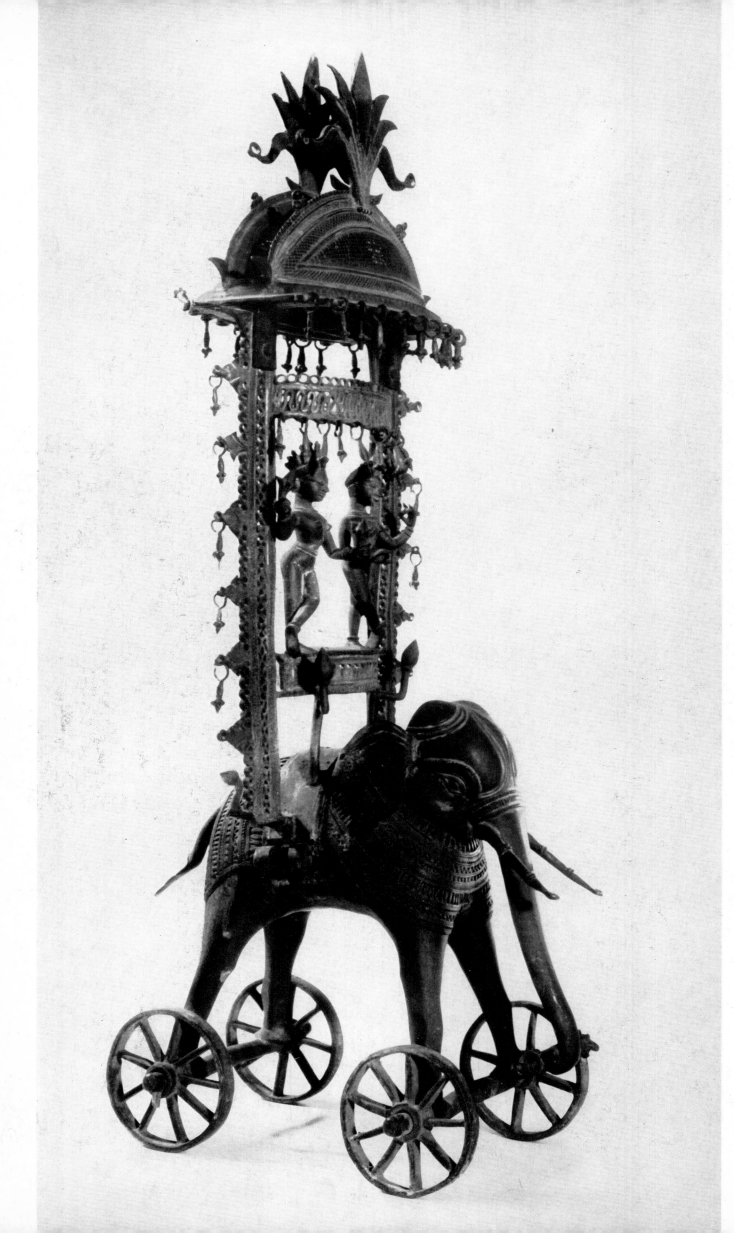

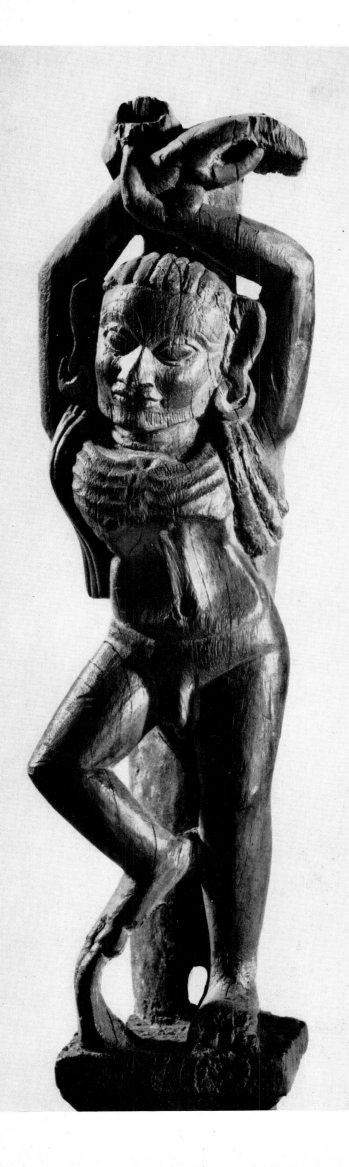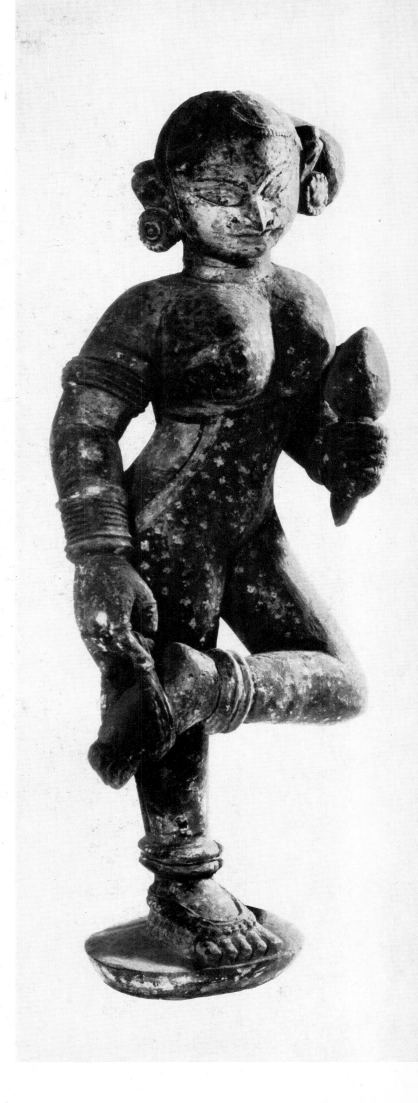

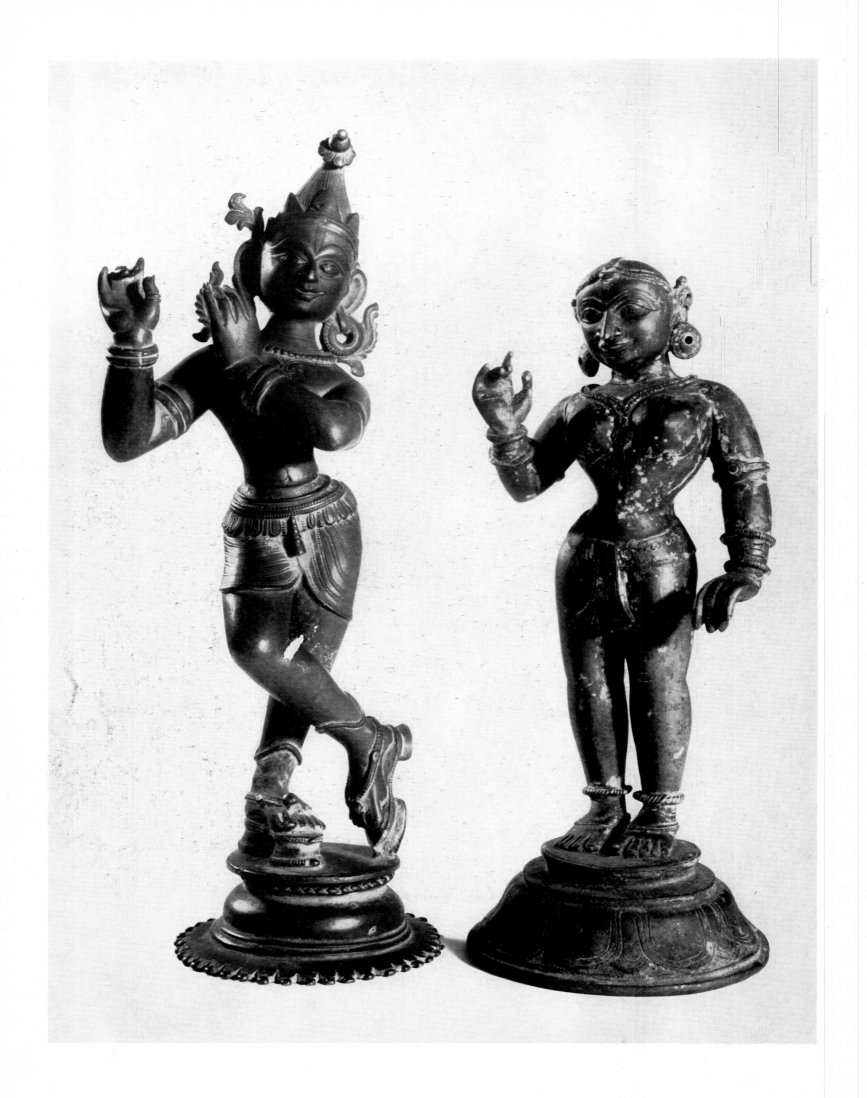

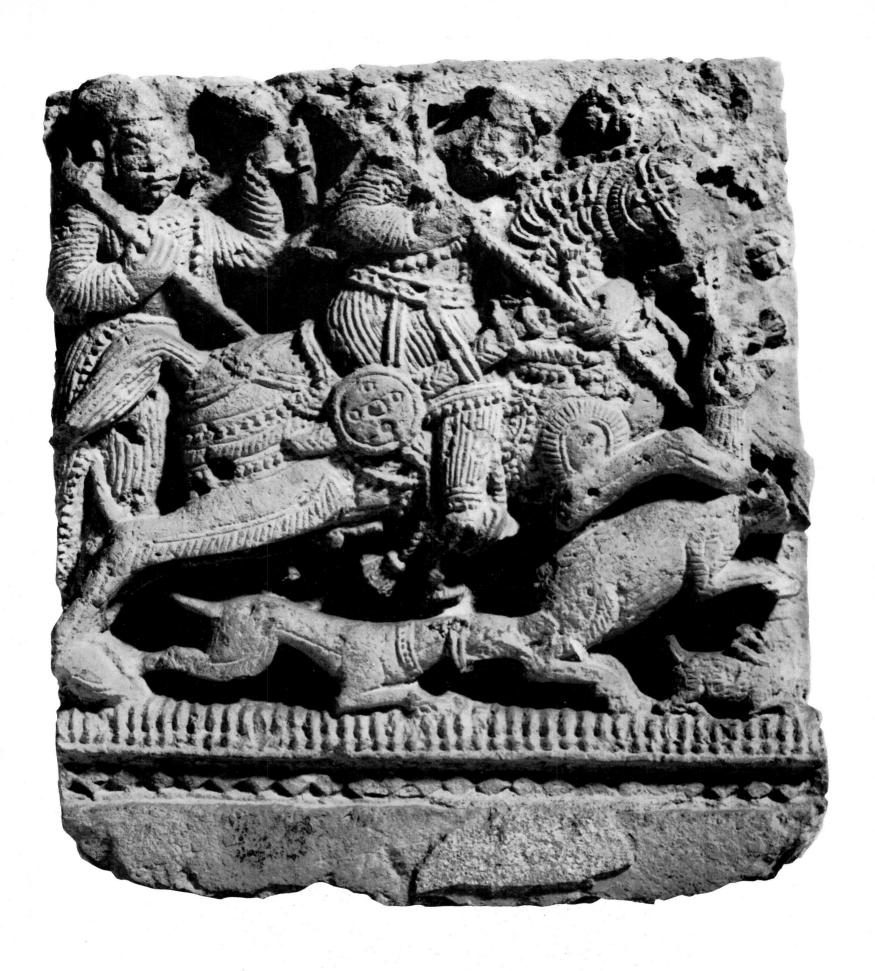

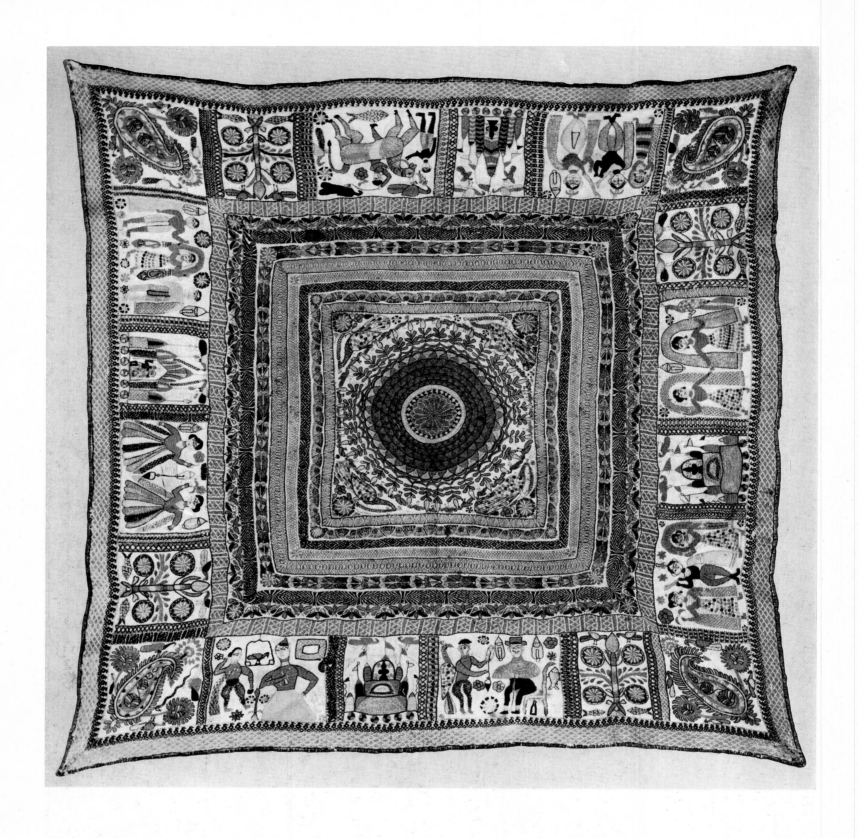

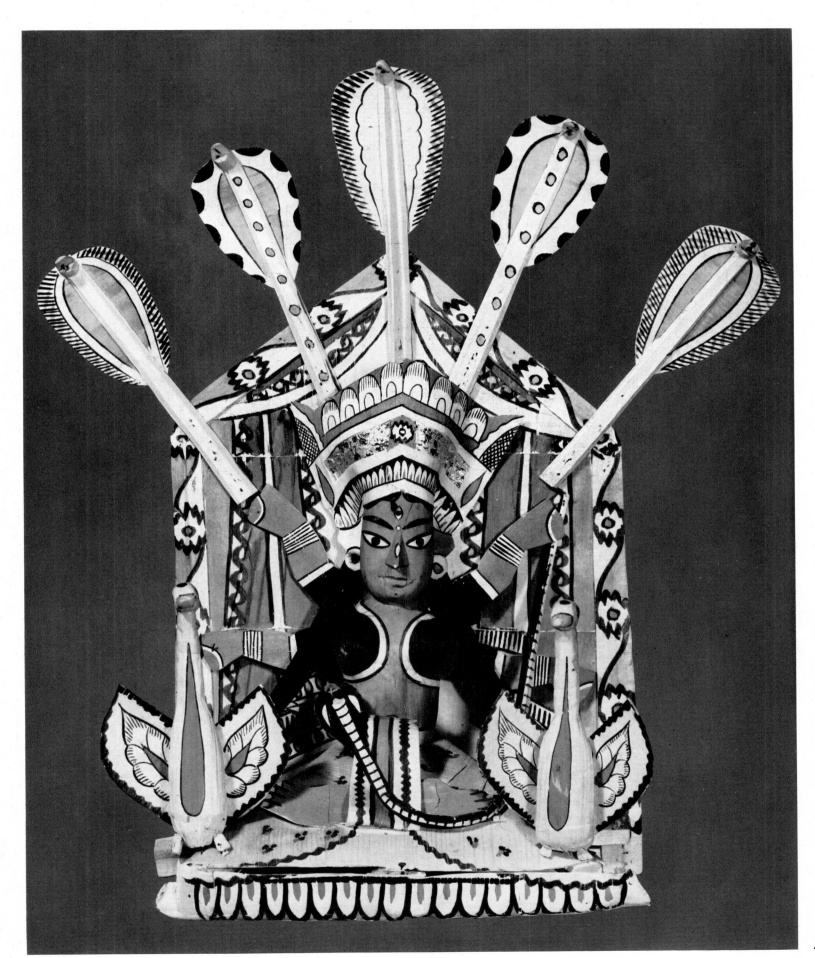

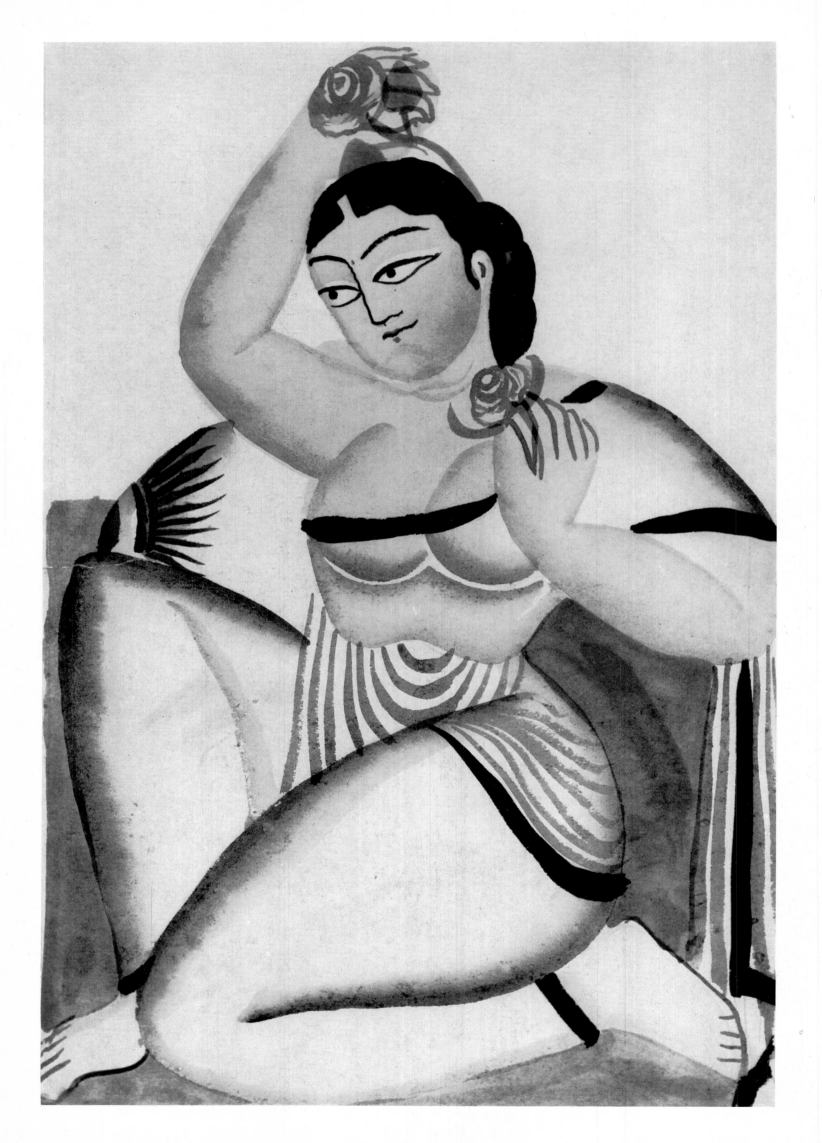

76

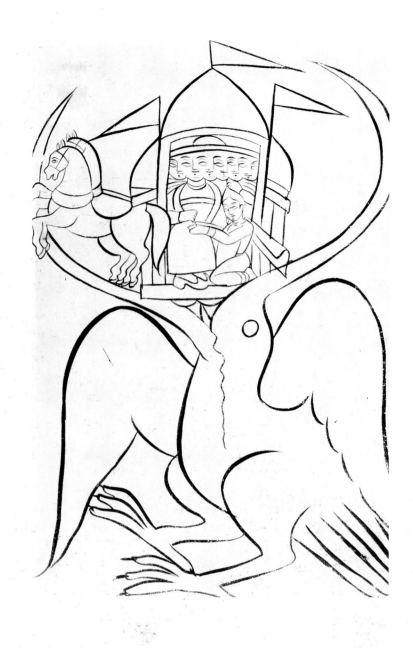

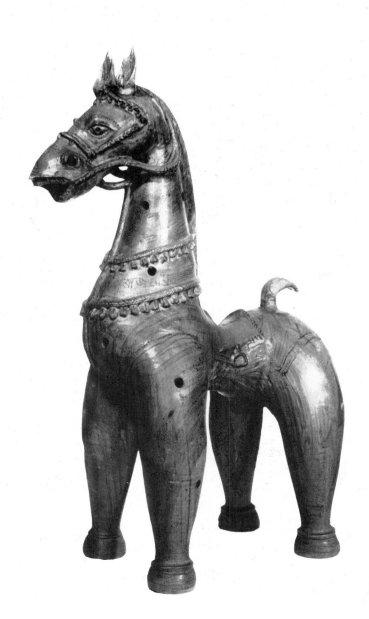

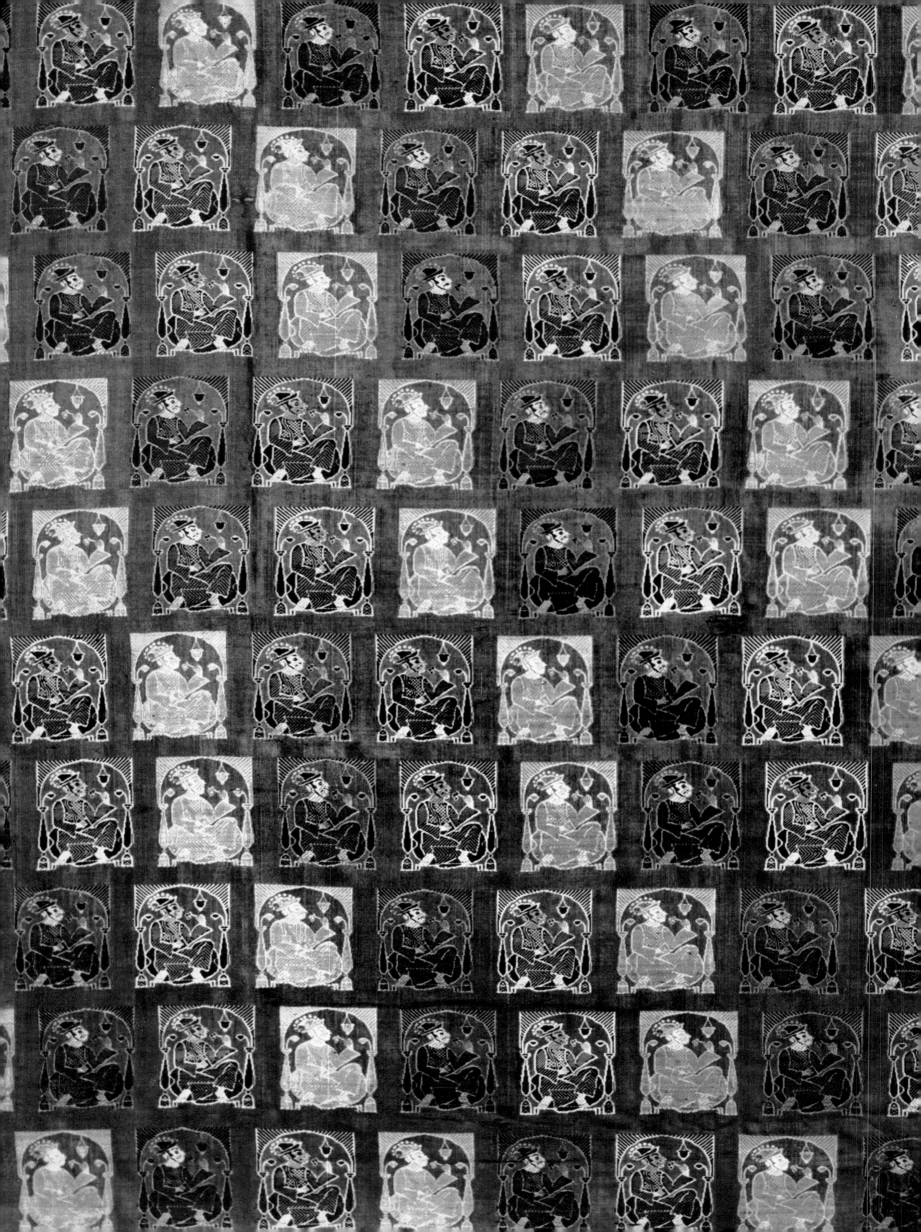

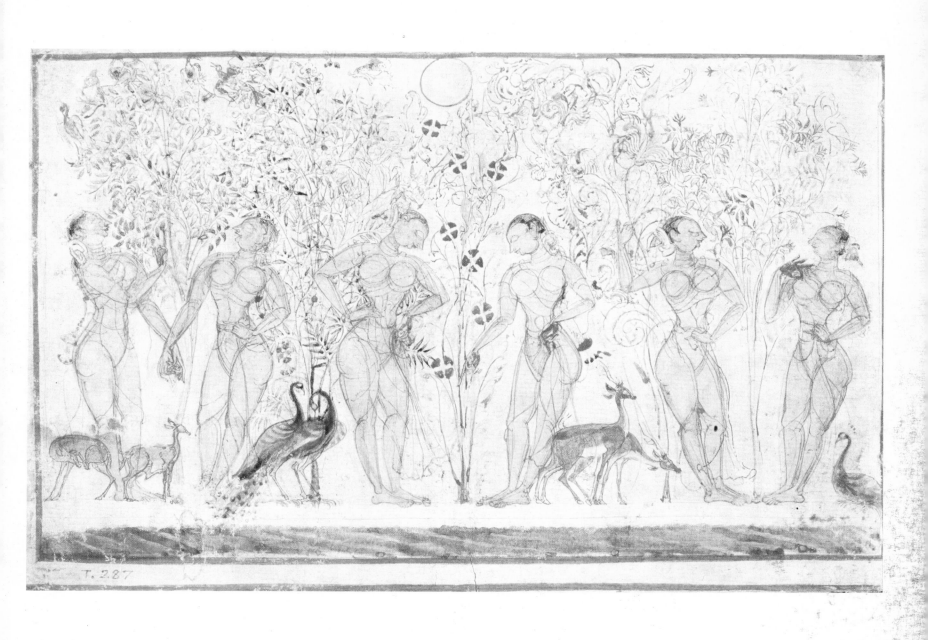

T. 287

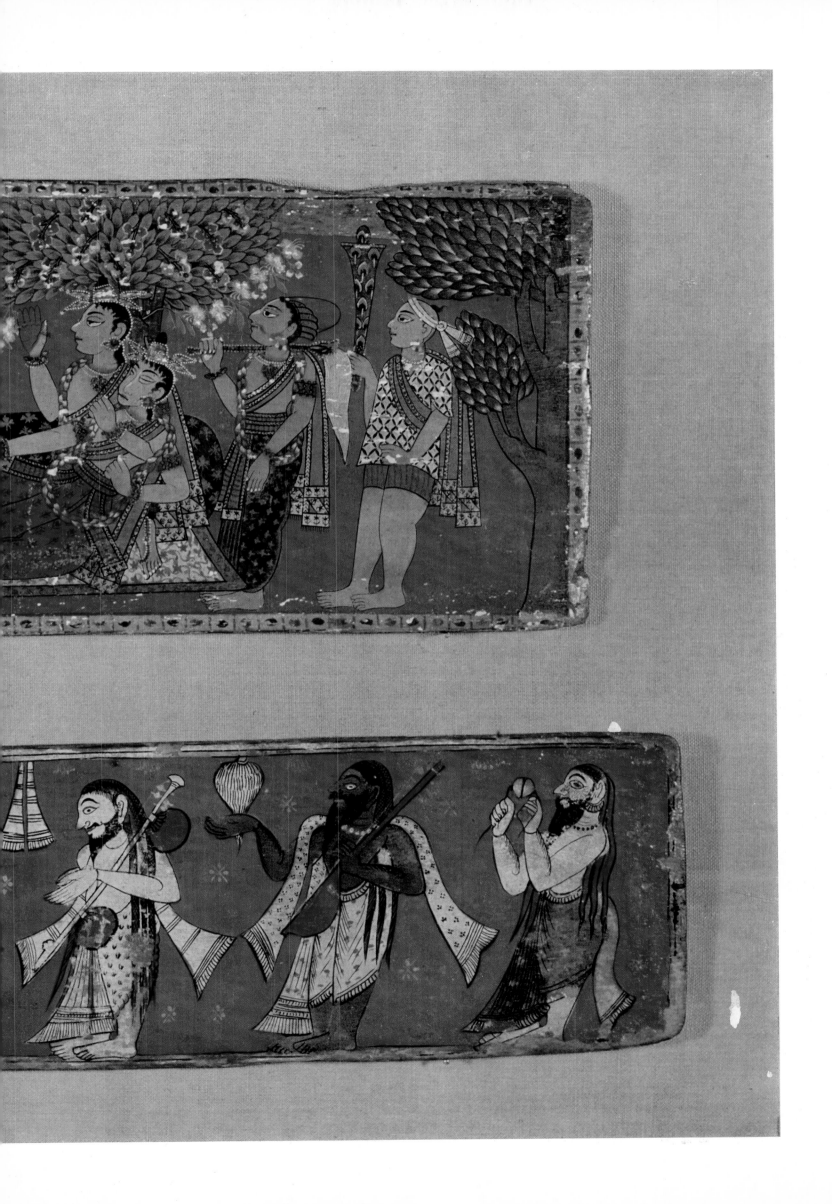

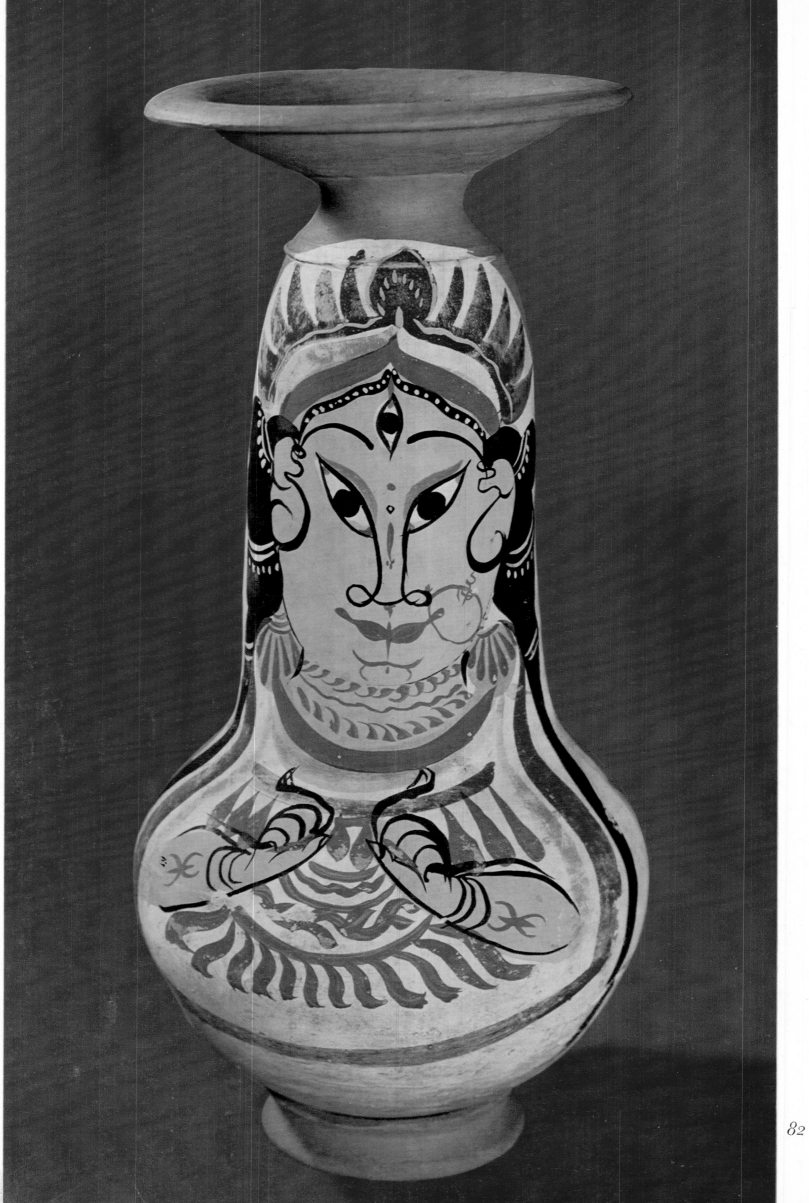

82

BIRLA ACADEMY OF ART
AND CULTURE

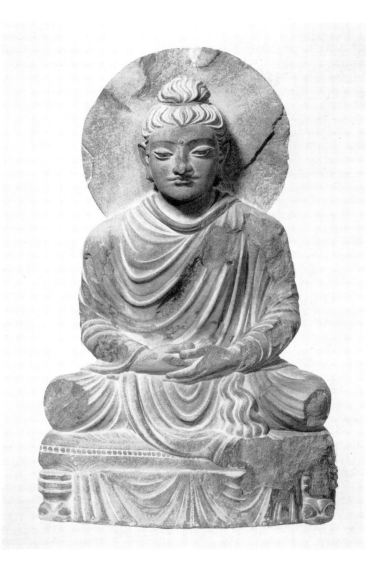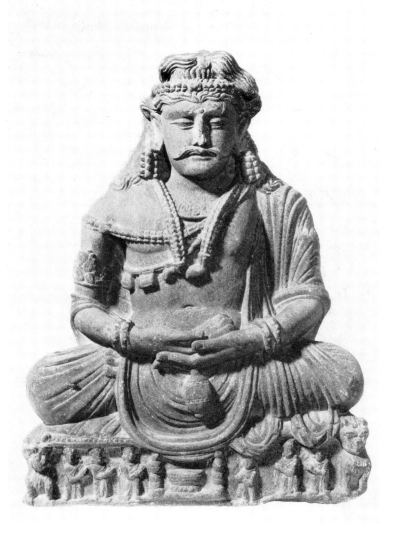

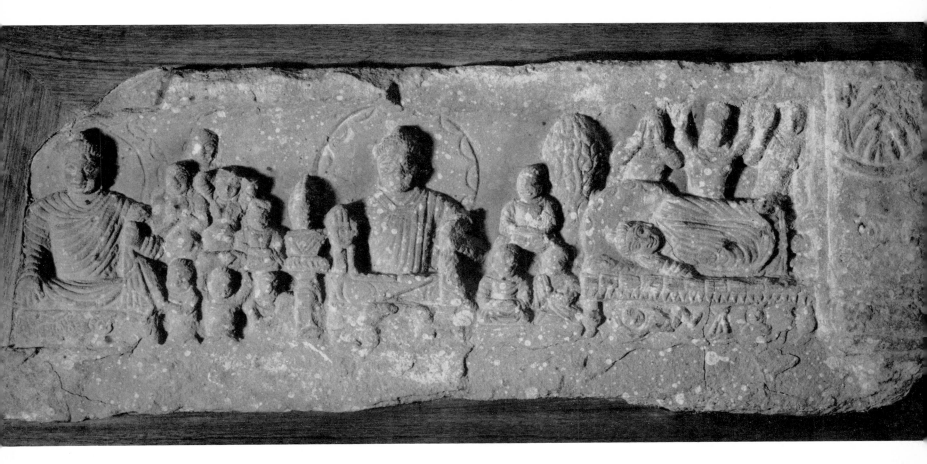

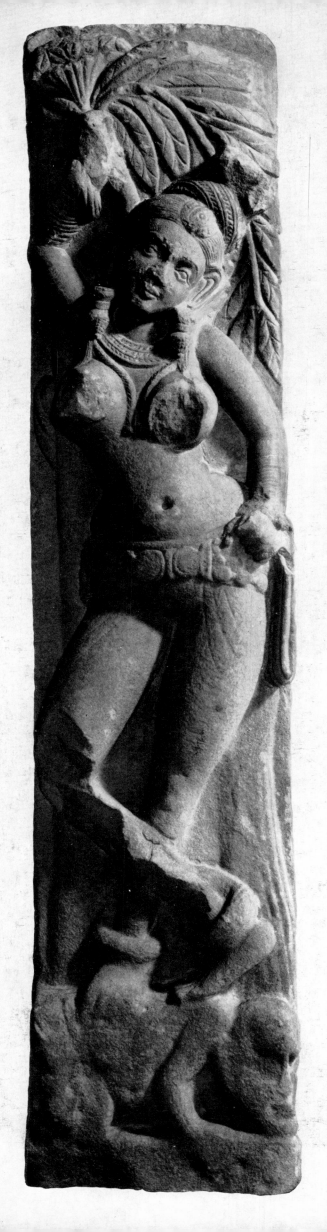

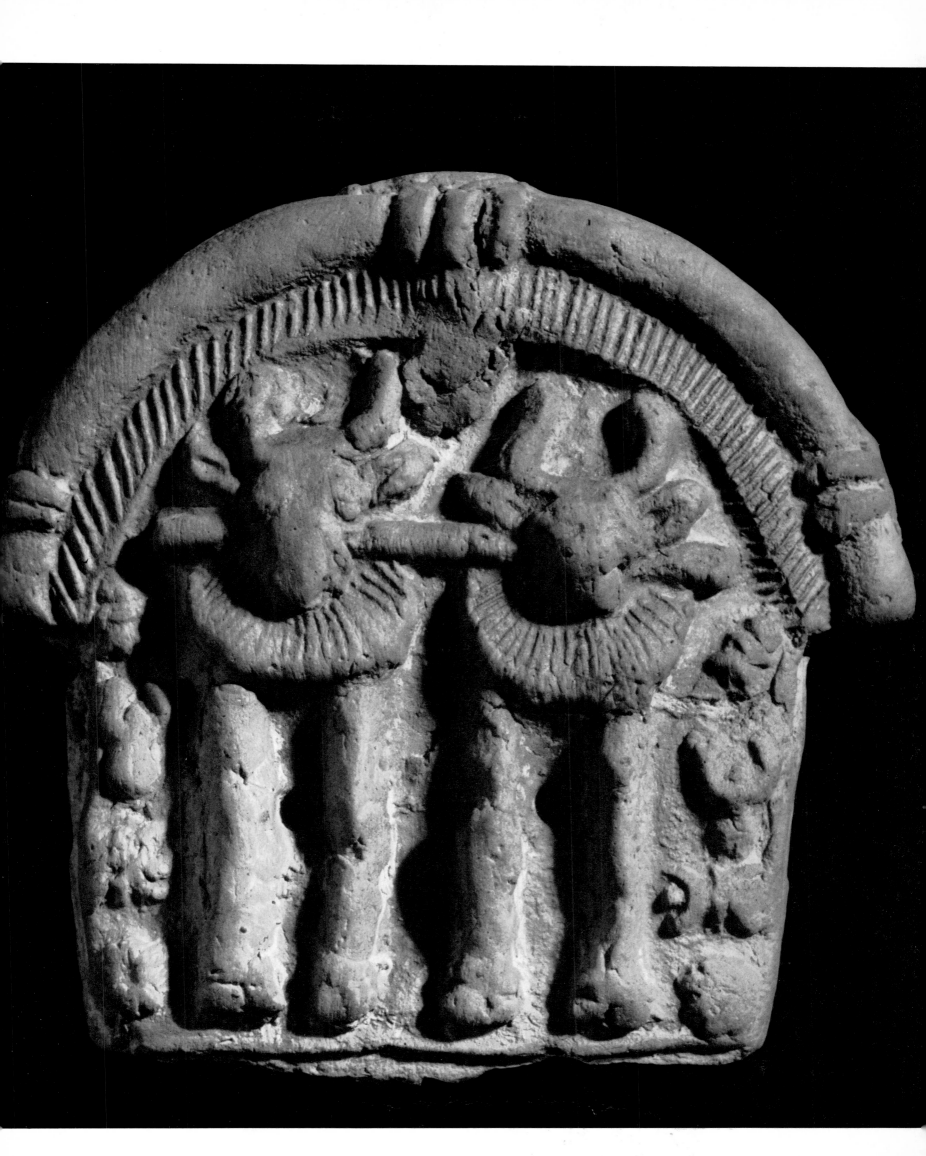

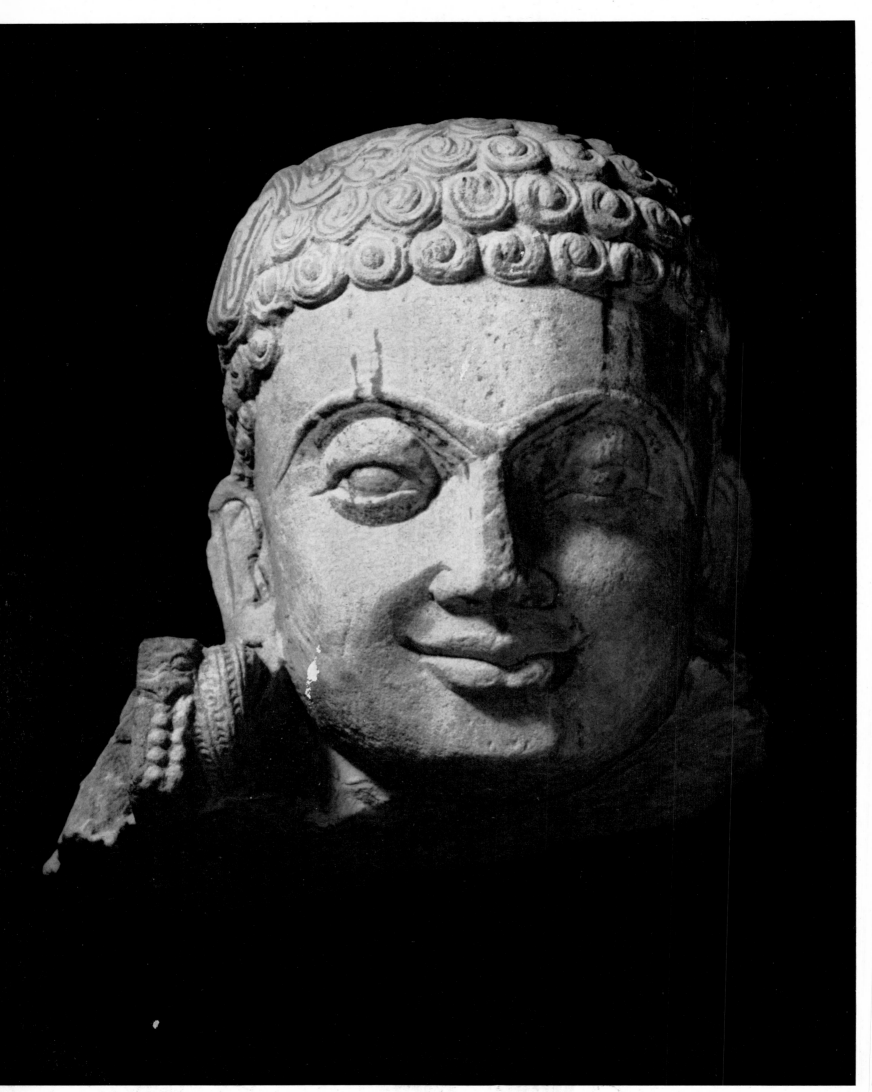

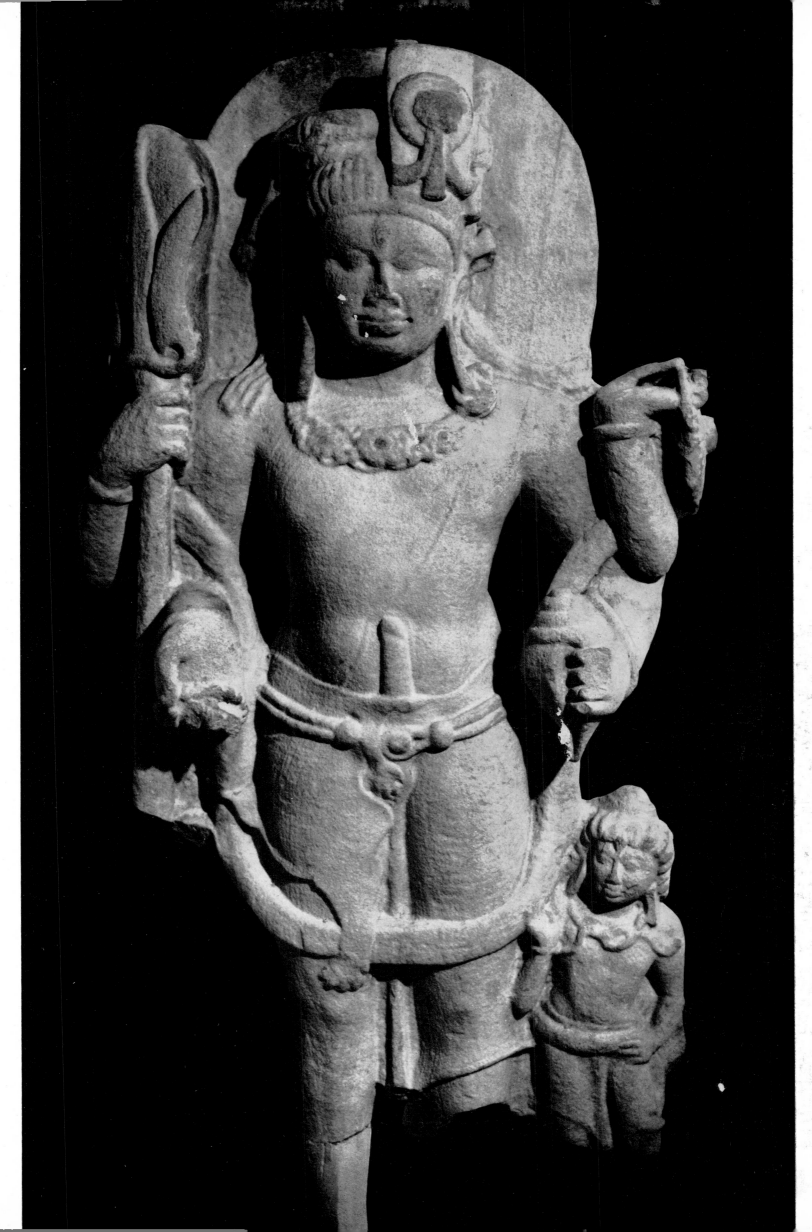

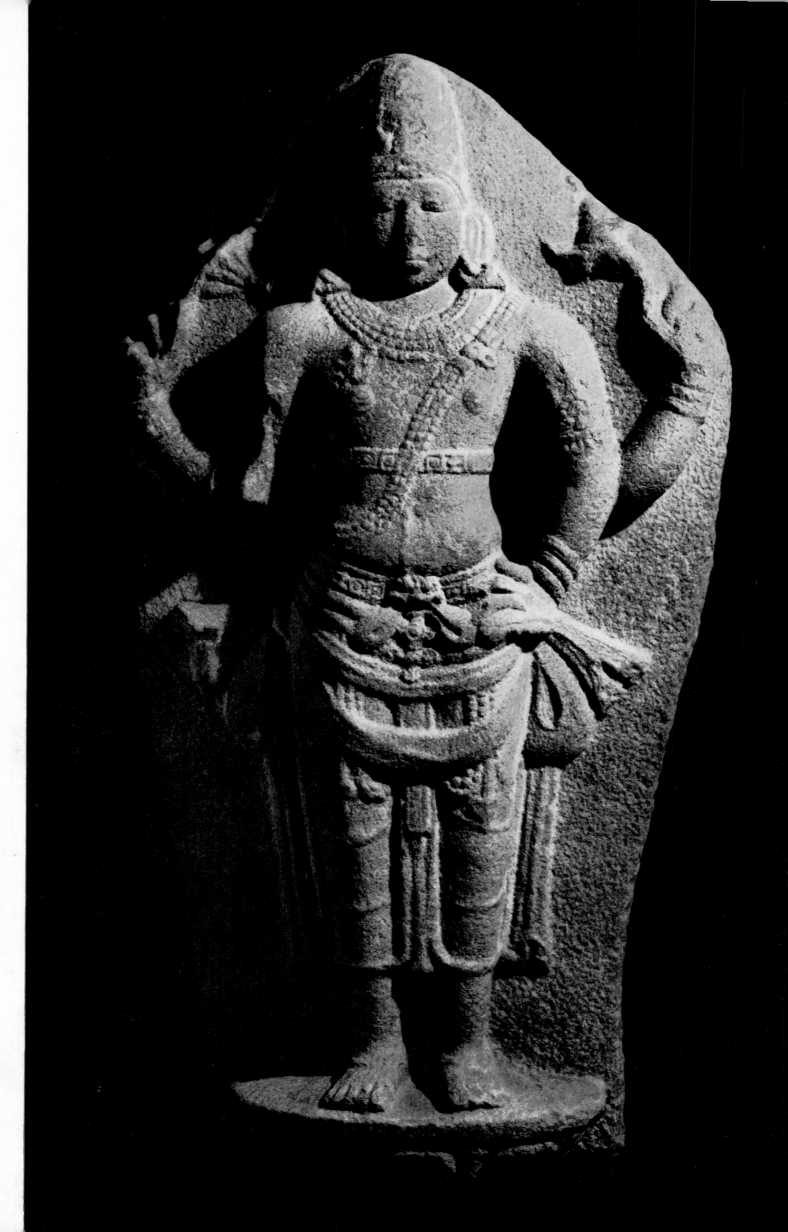

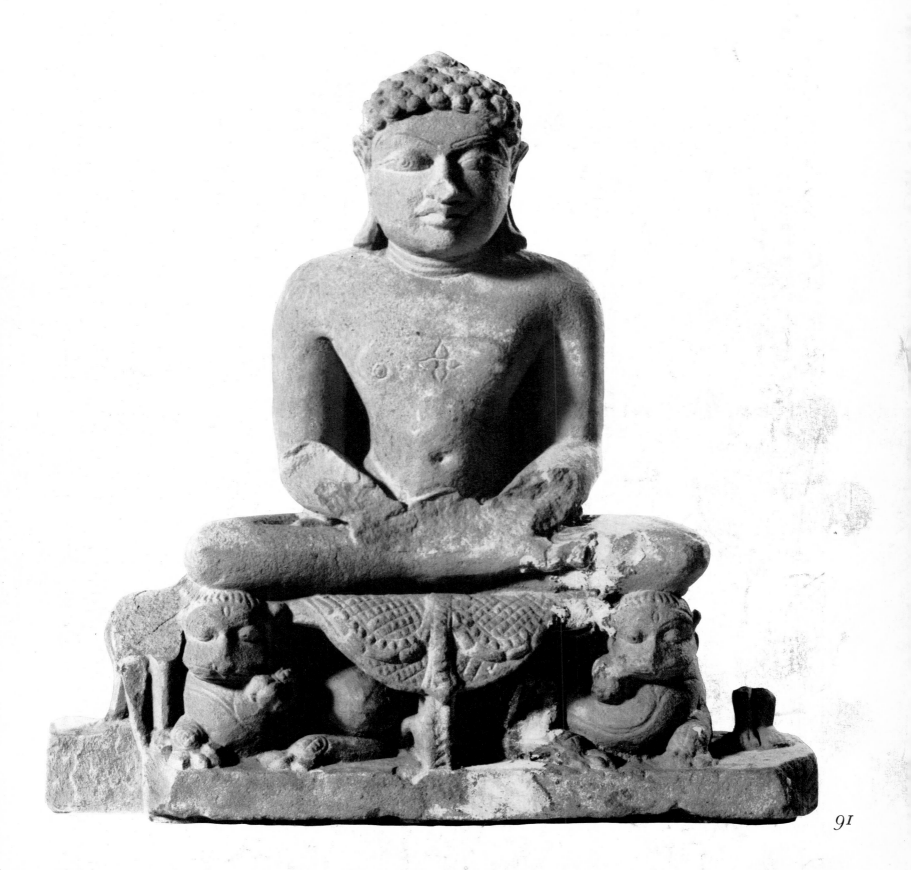

91

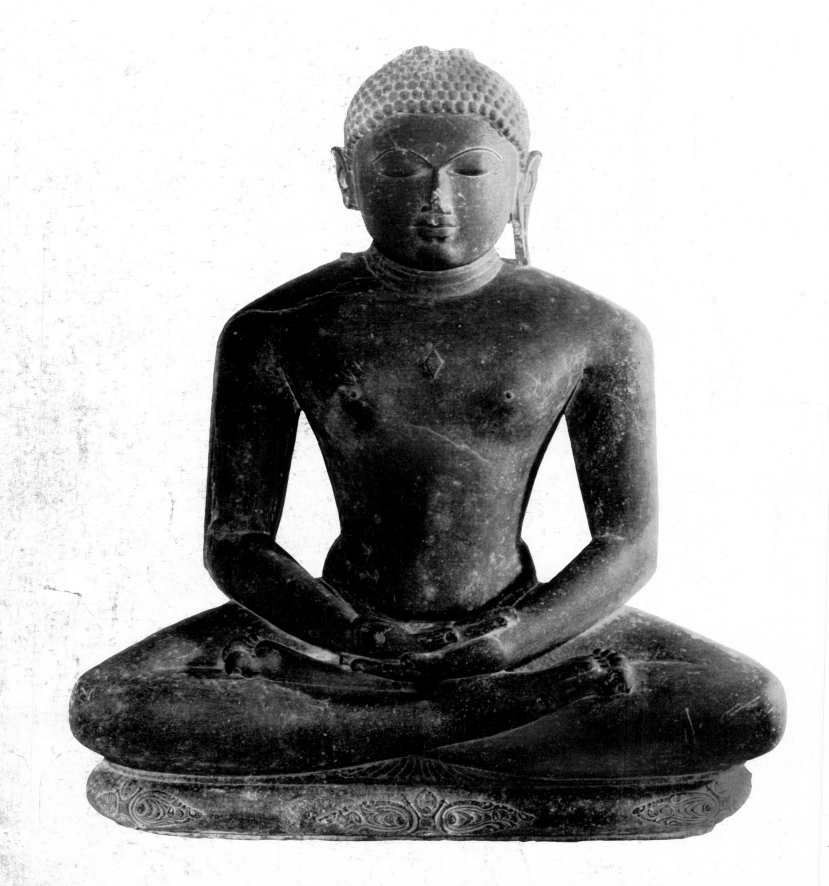

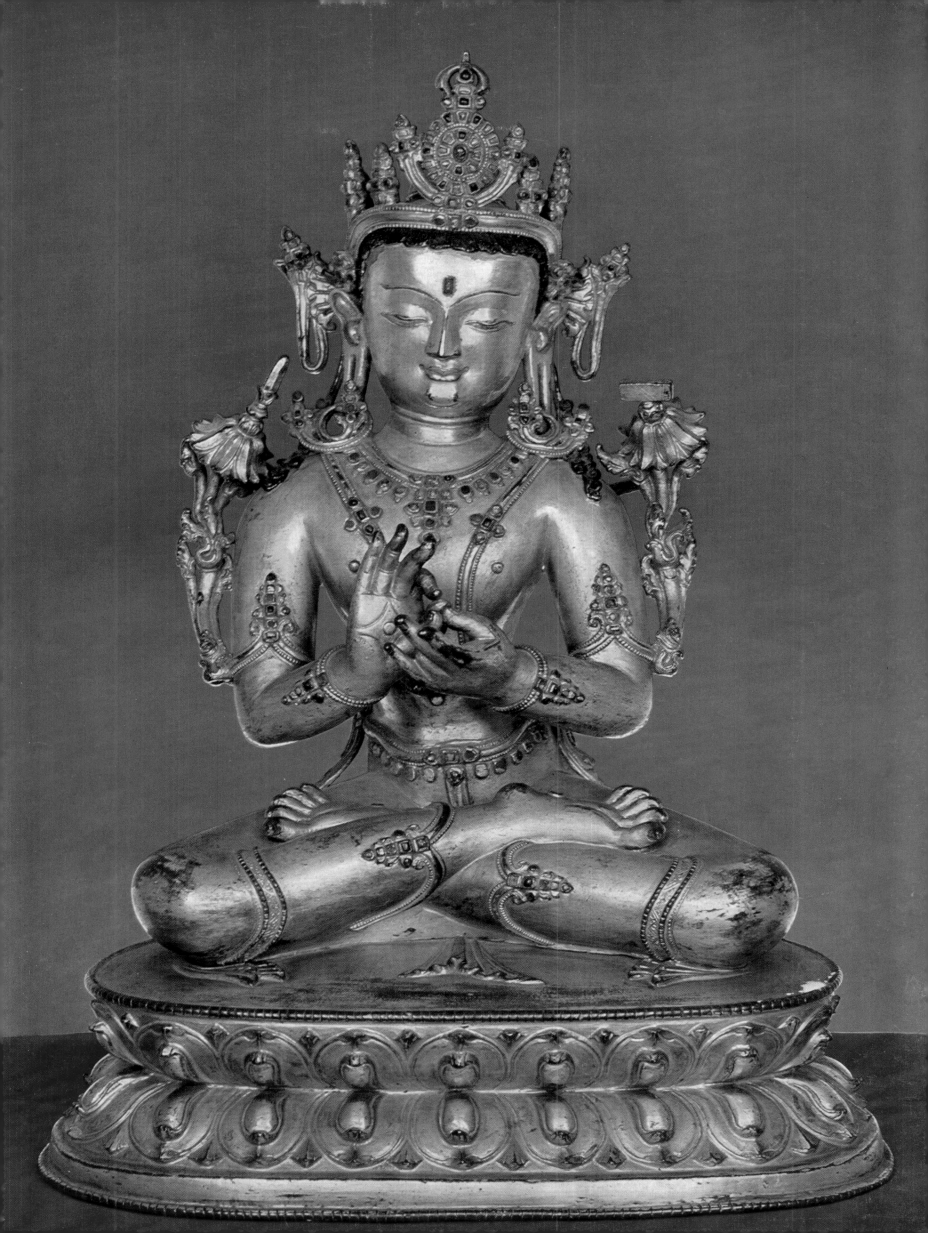

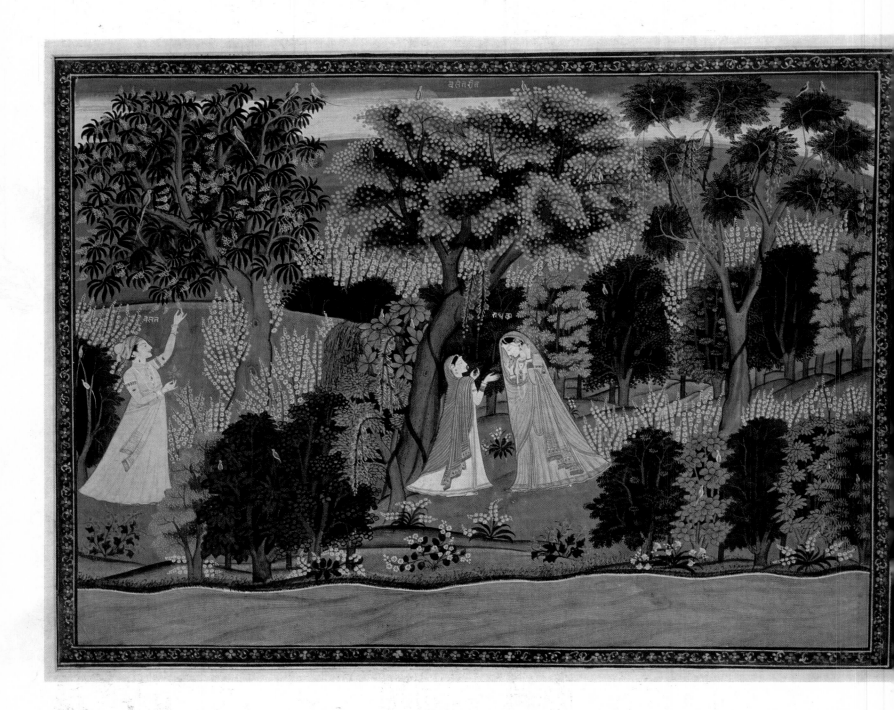

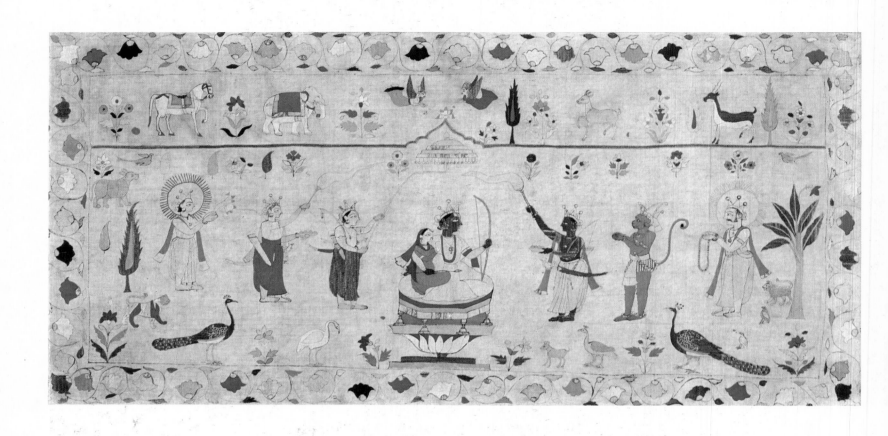

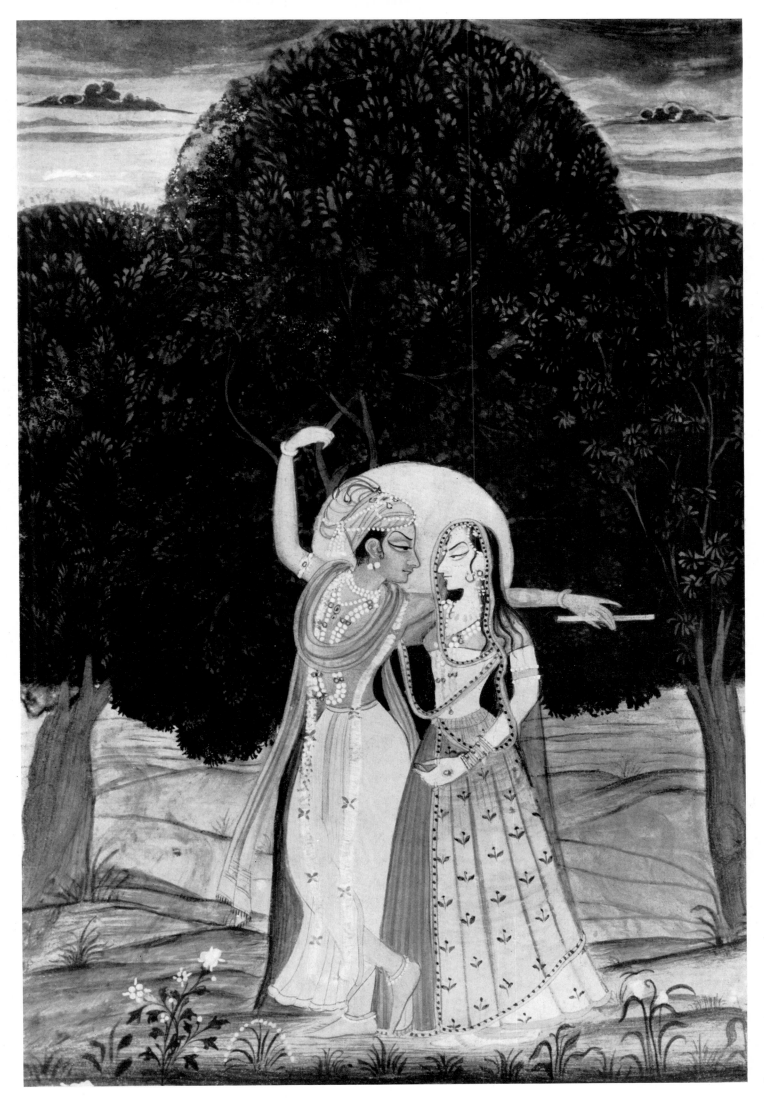

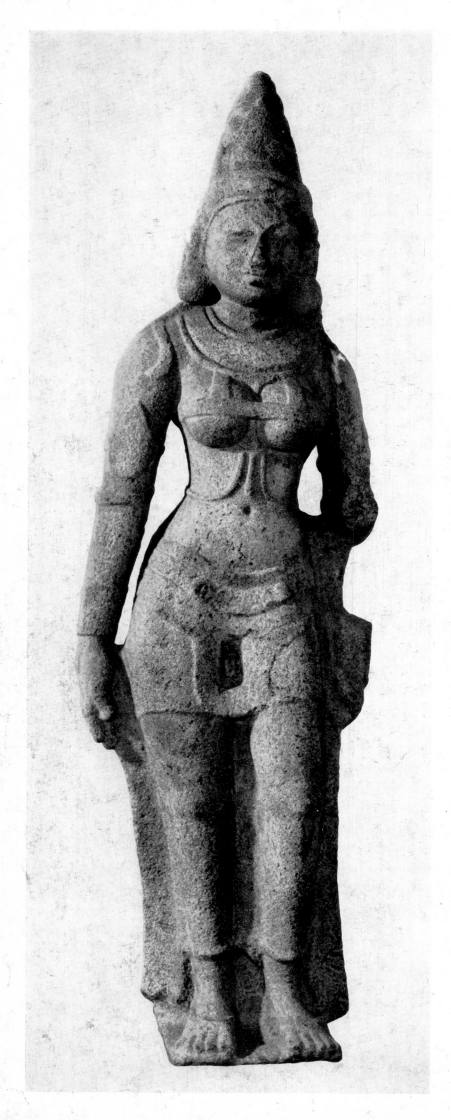

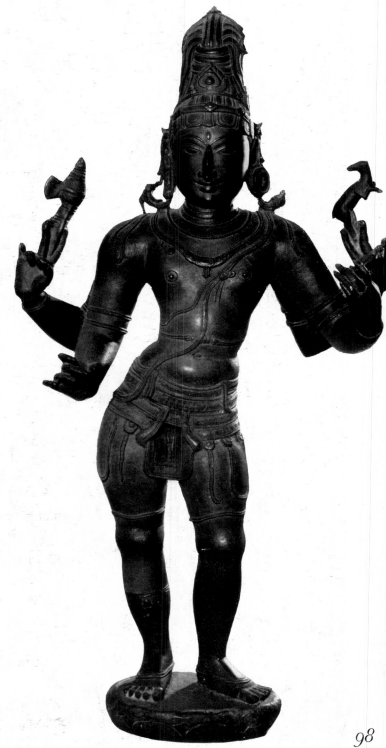

98

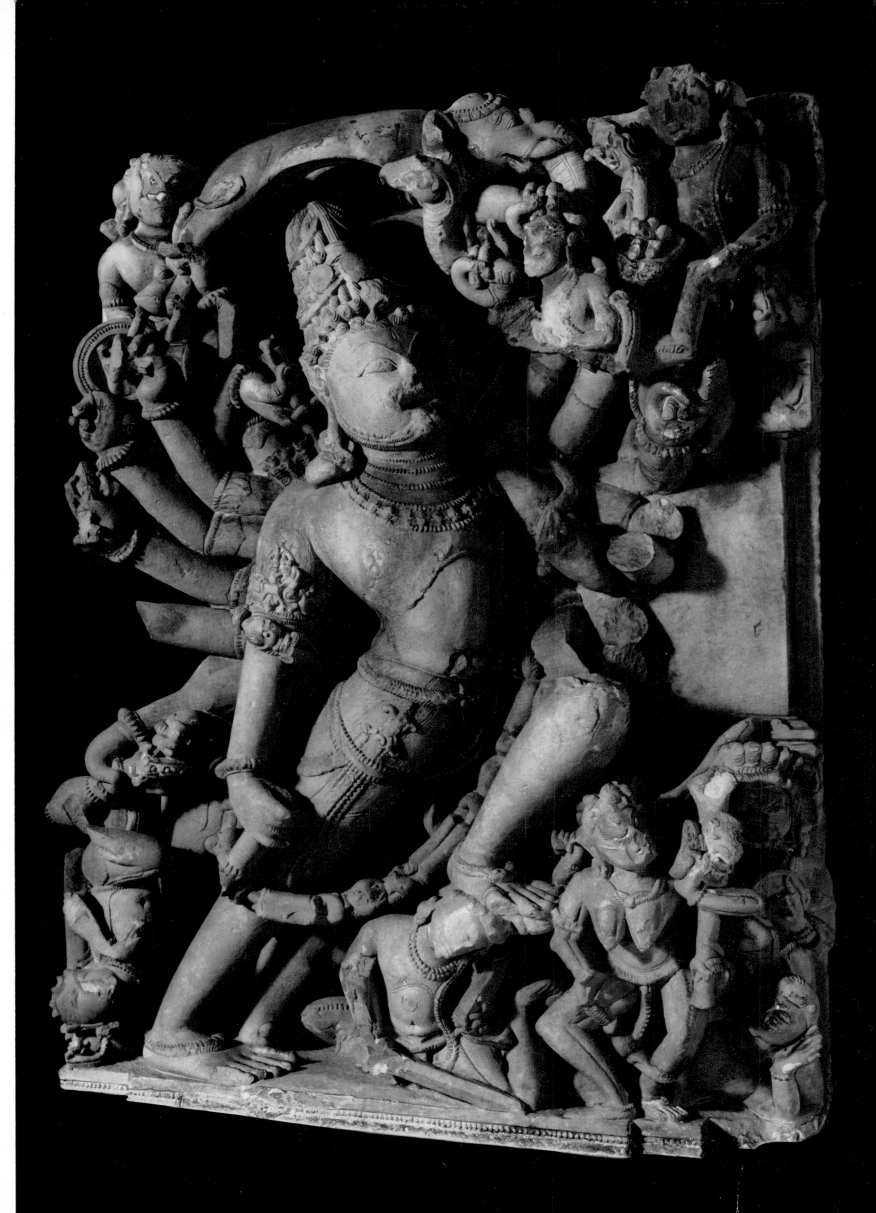

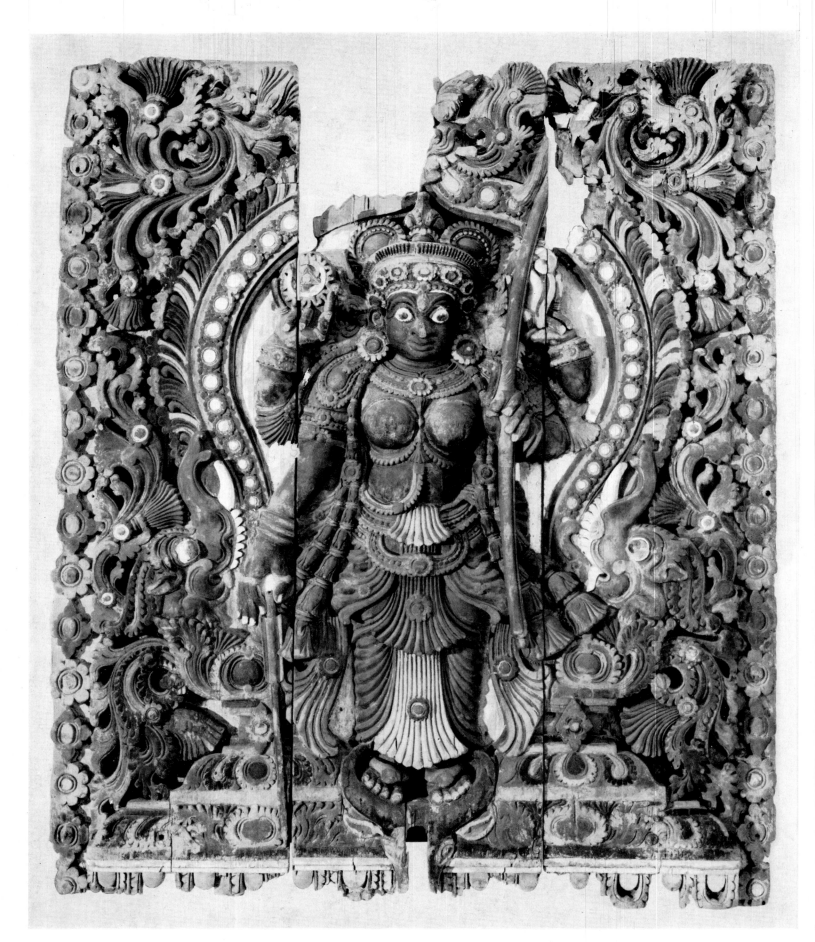

GURUSADAY MUSEUM
OF BENGAL FOLK ART

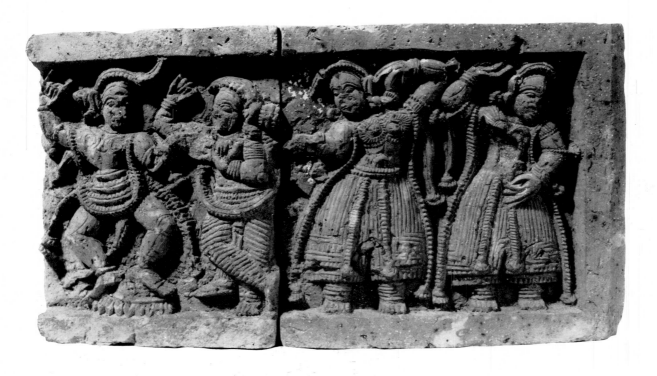

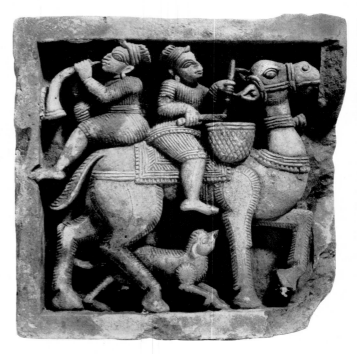

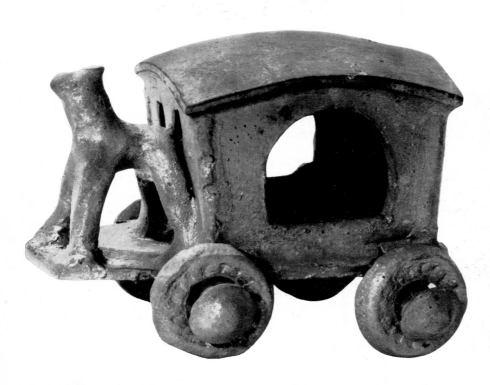

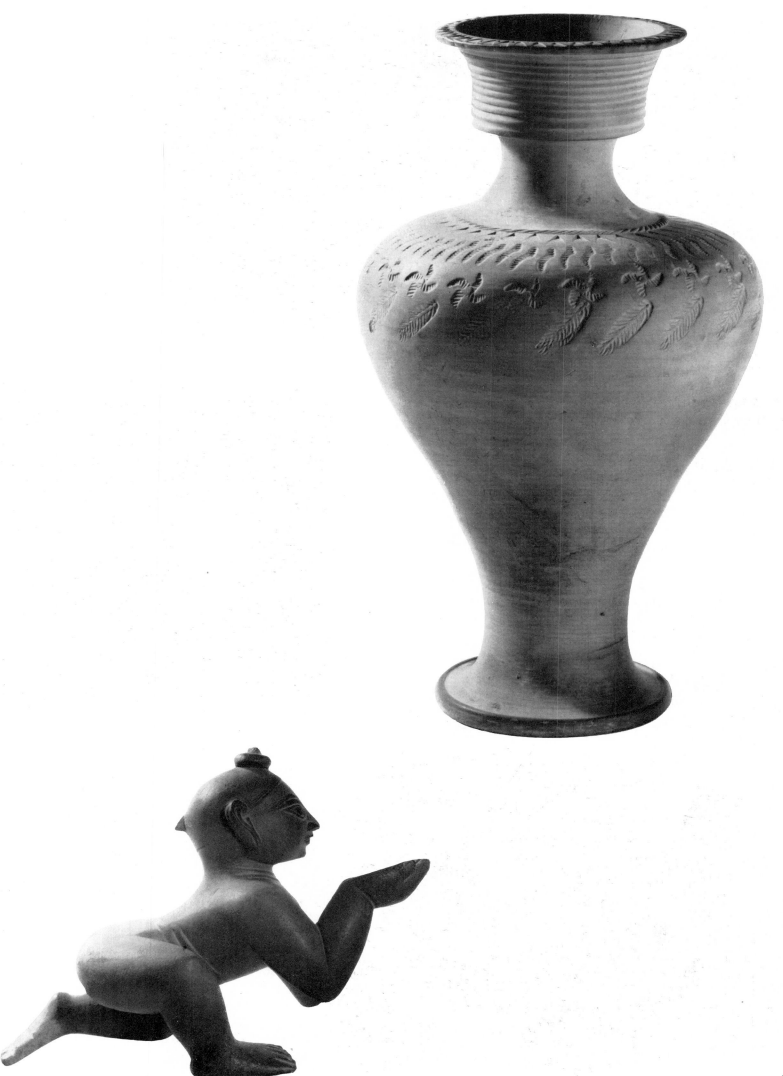

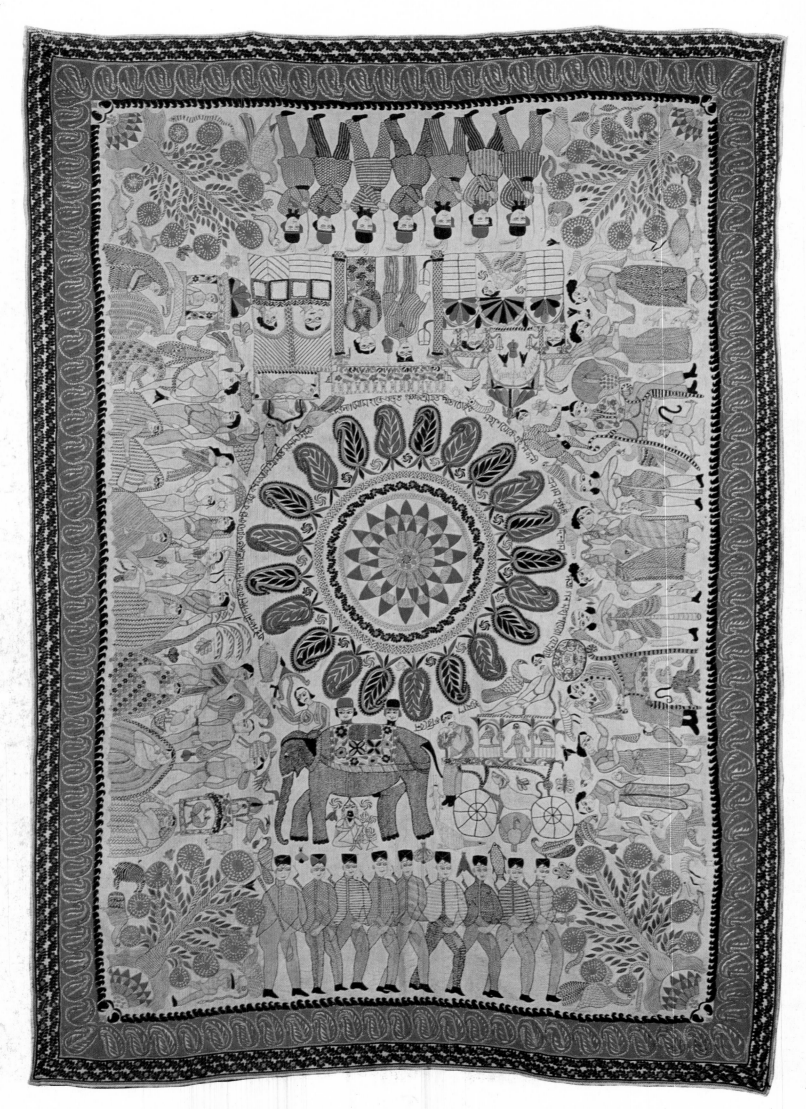

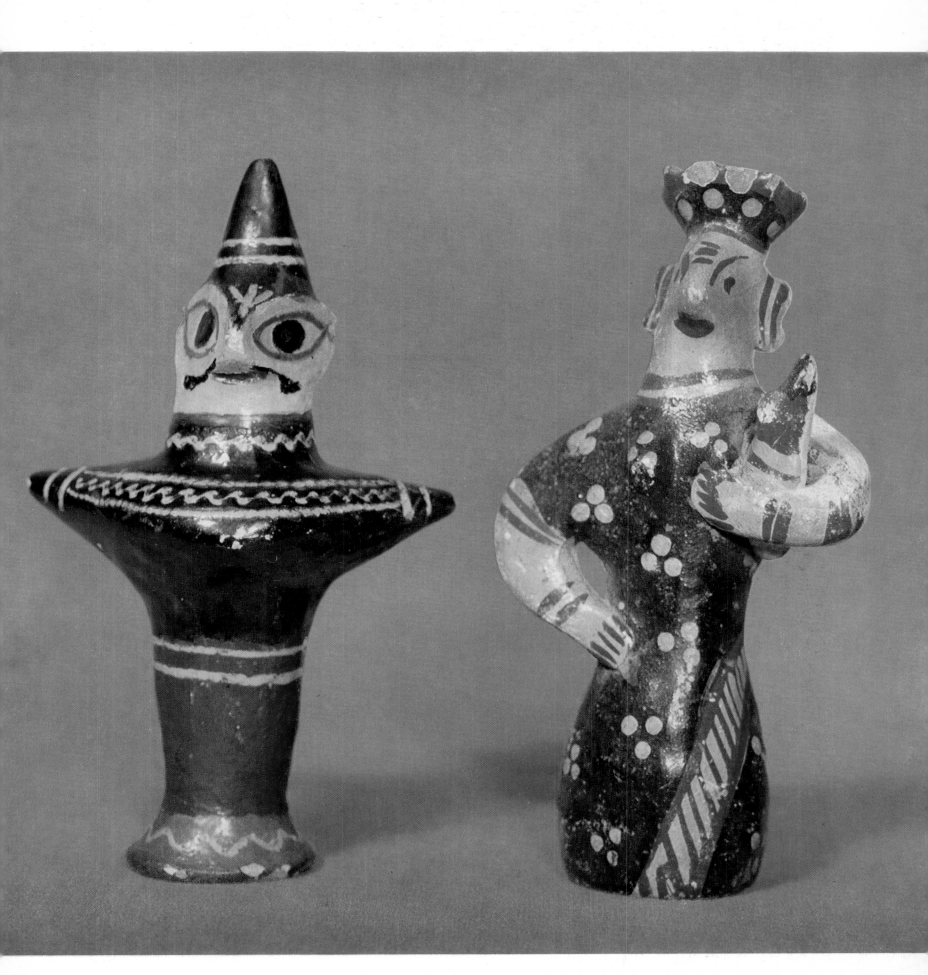

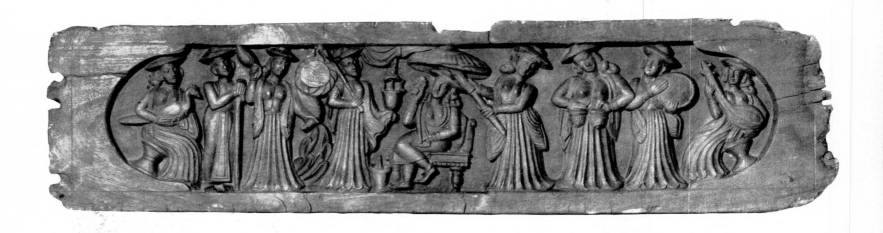

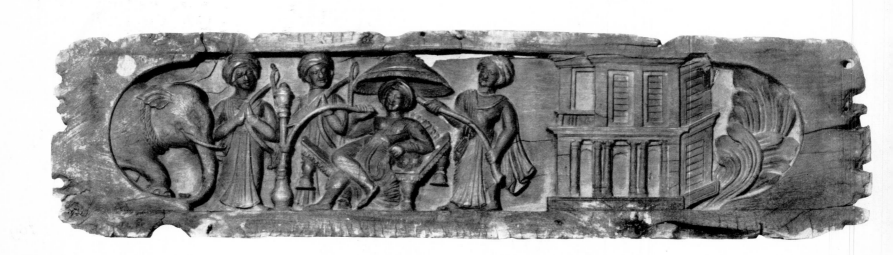

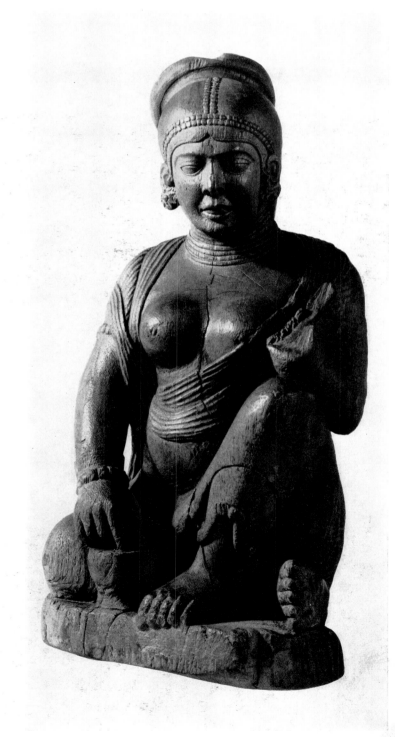

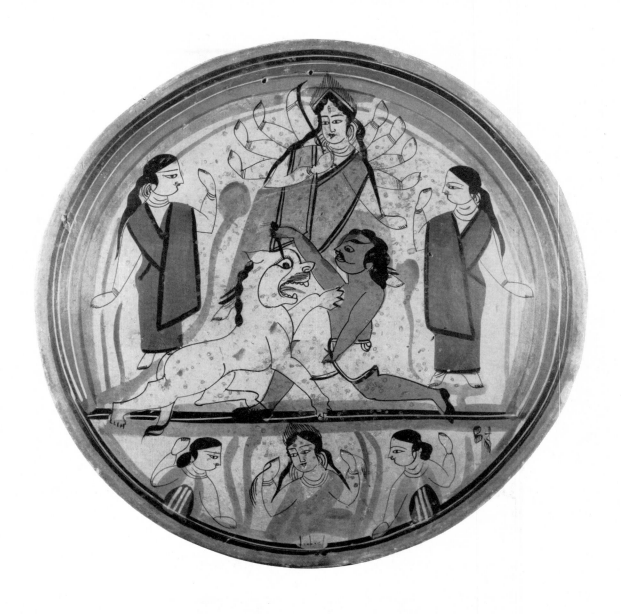

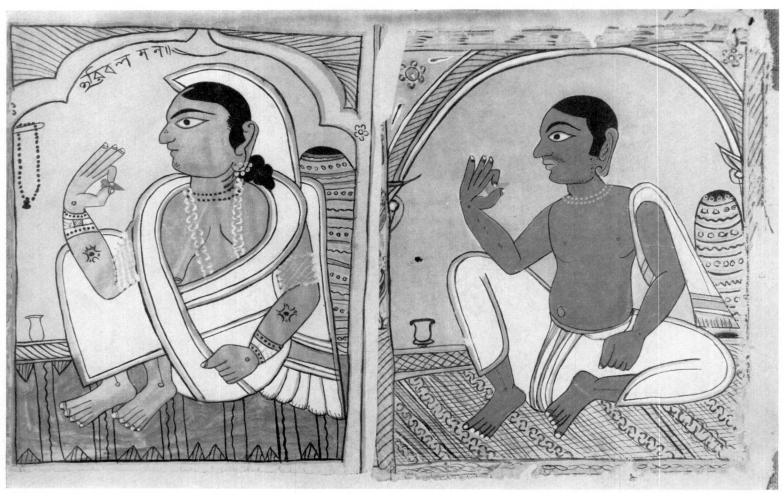

RABINDRA BHARATI MUSEUM

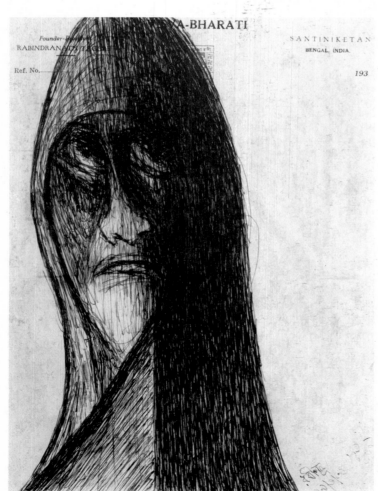

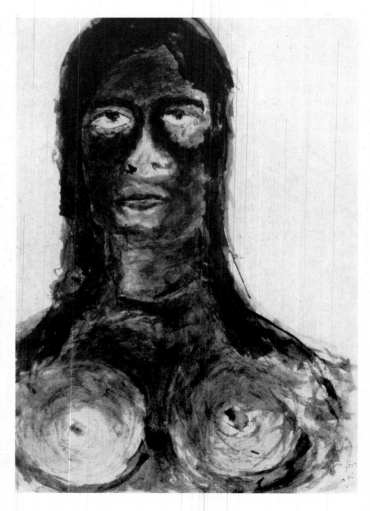

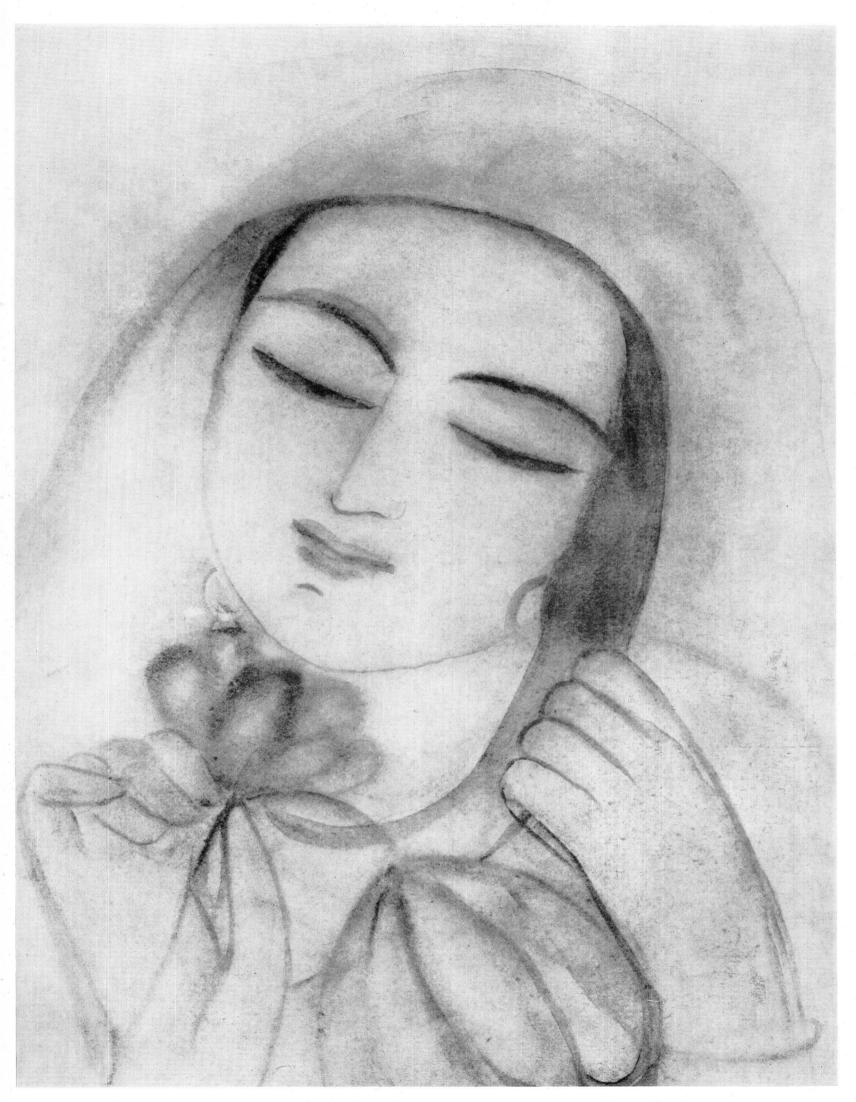

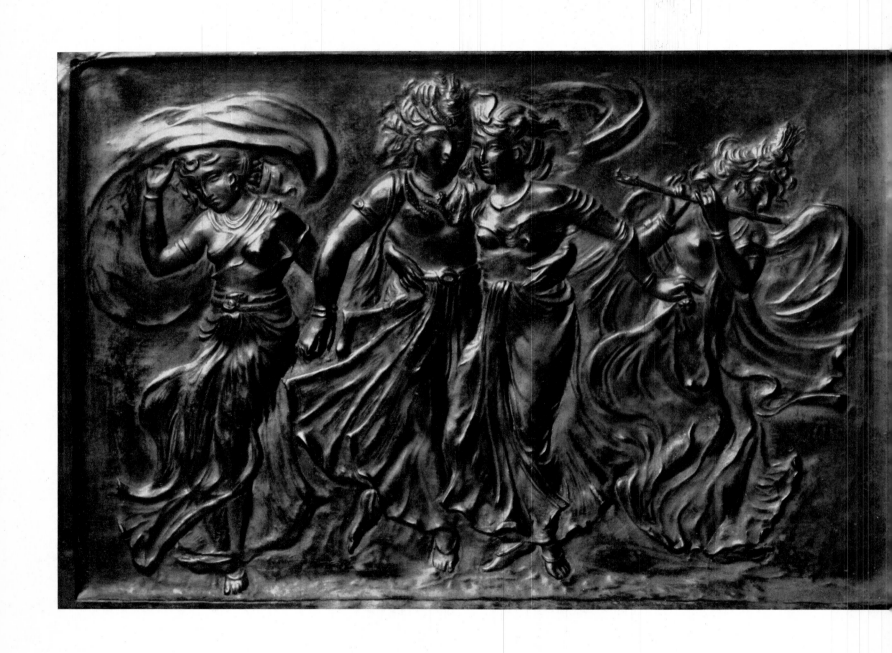

INDIAN INSTITUTE OF ART
IN INDUSTRY

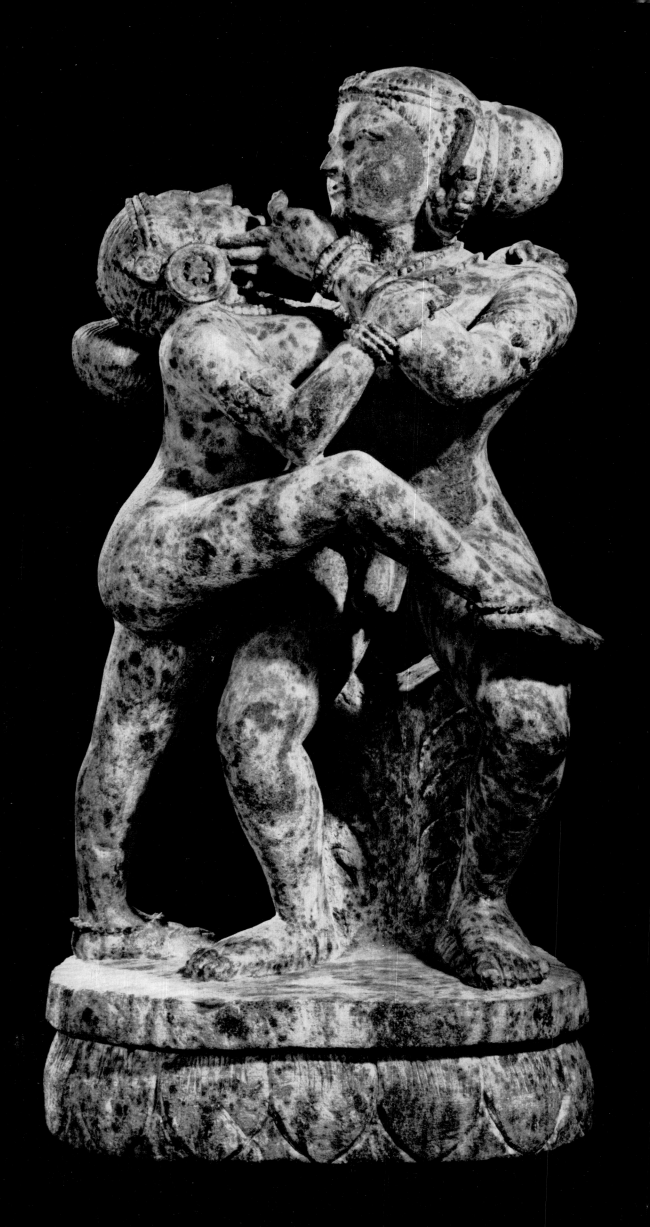

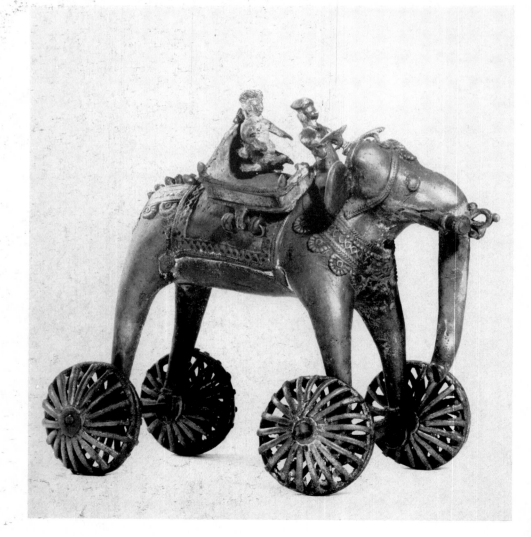

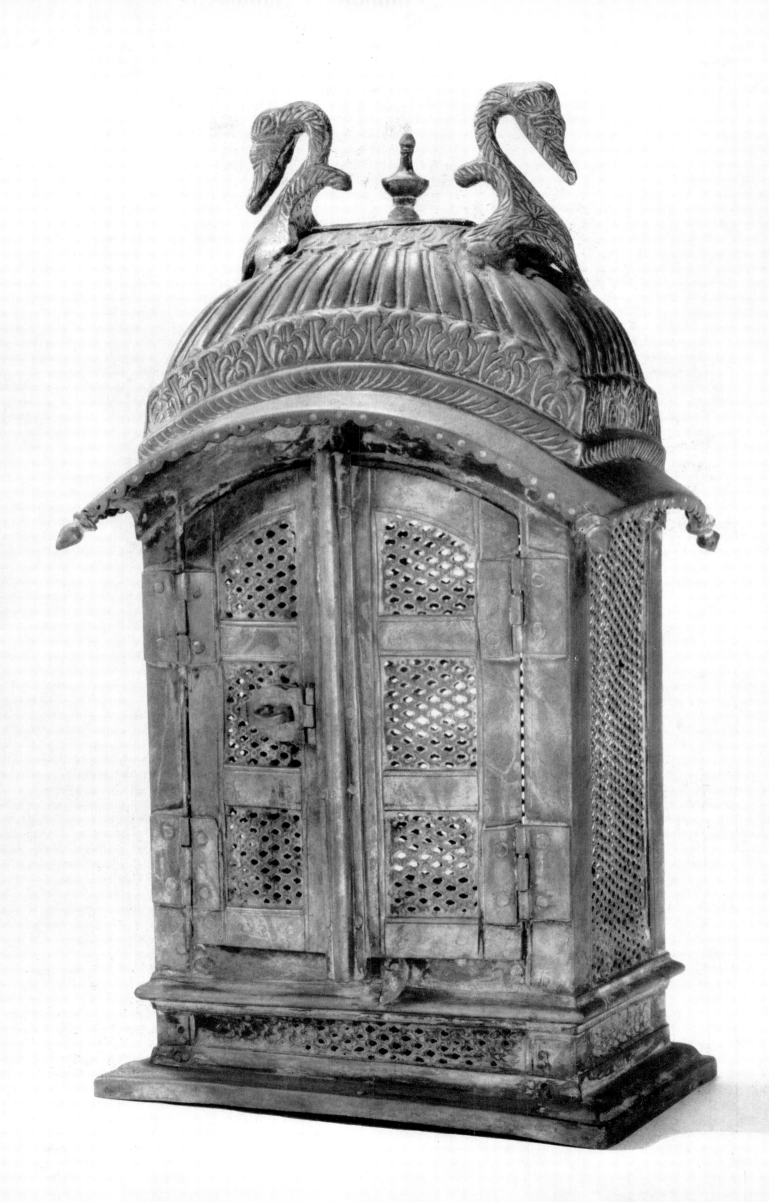

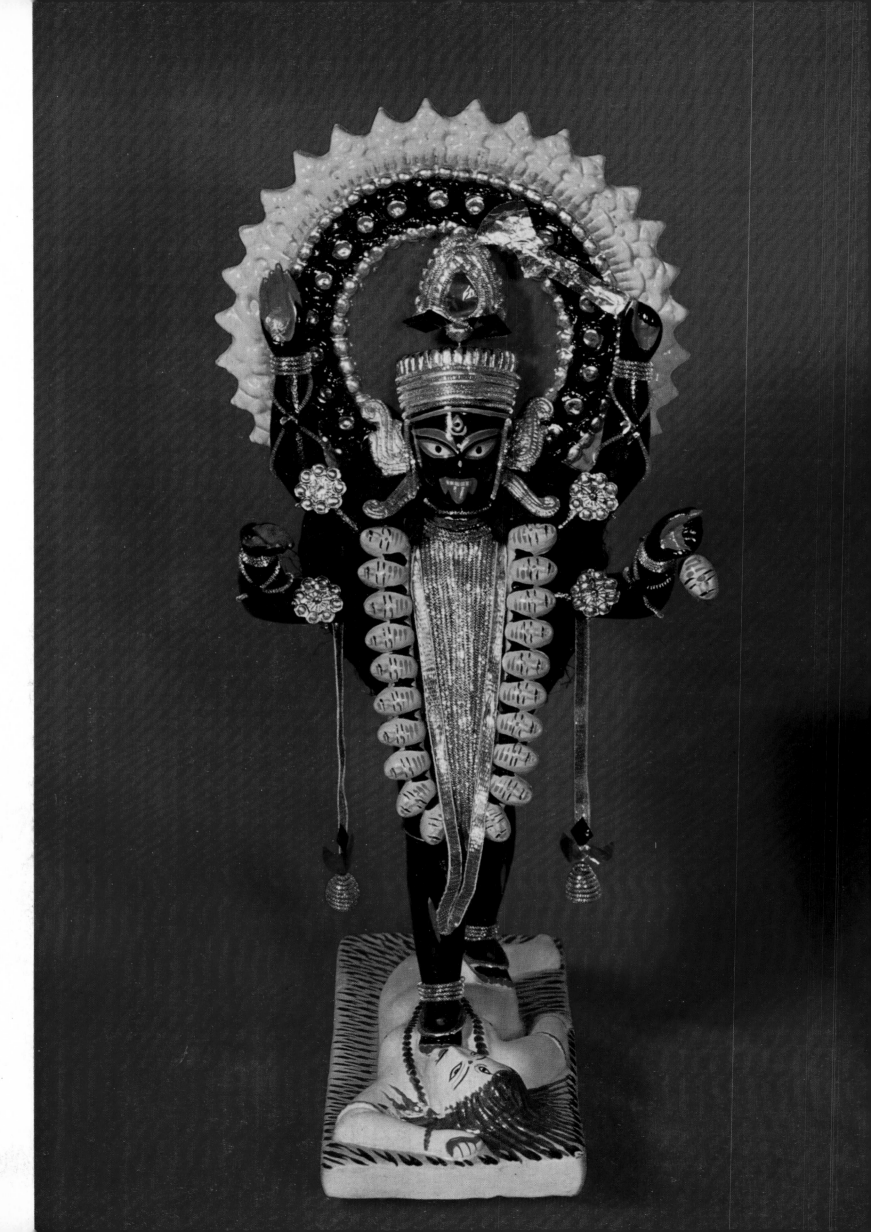

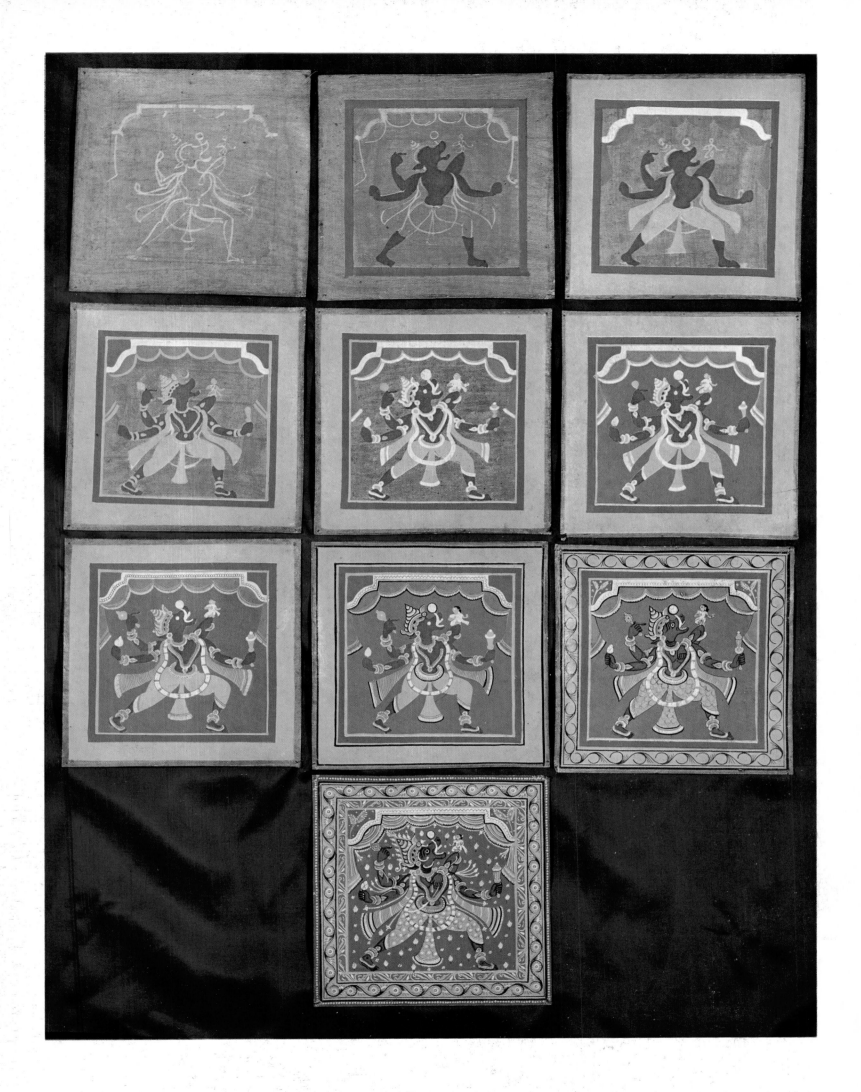

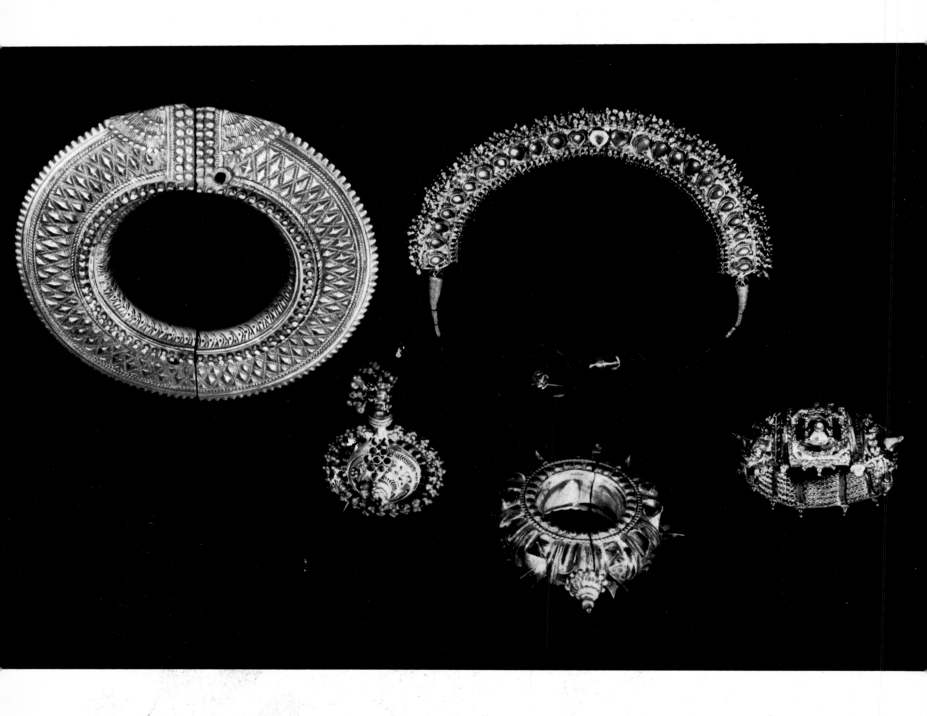

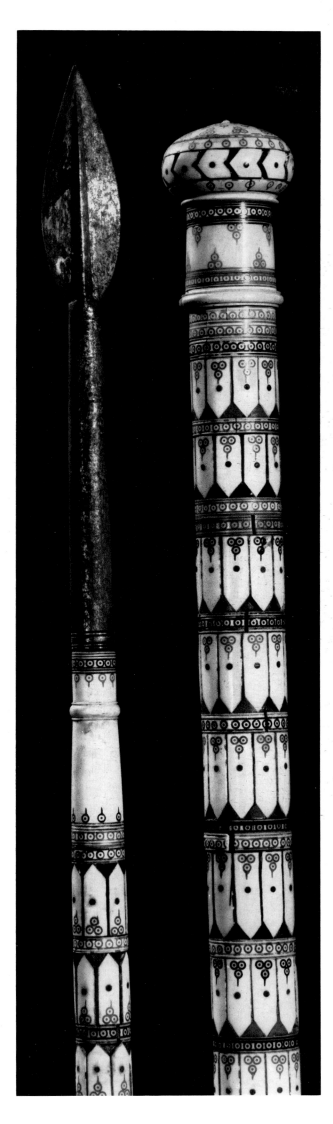

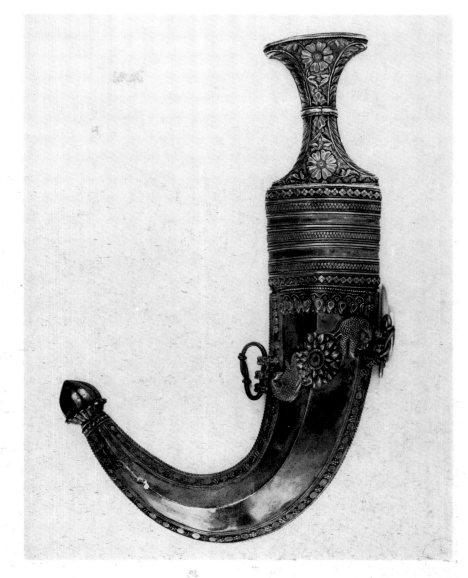

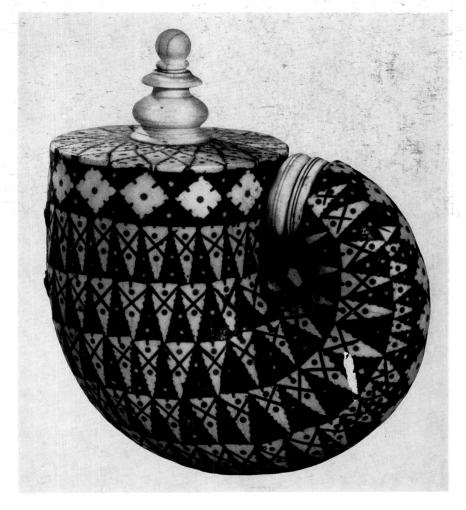

133

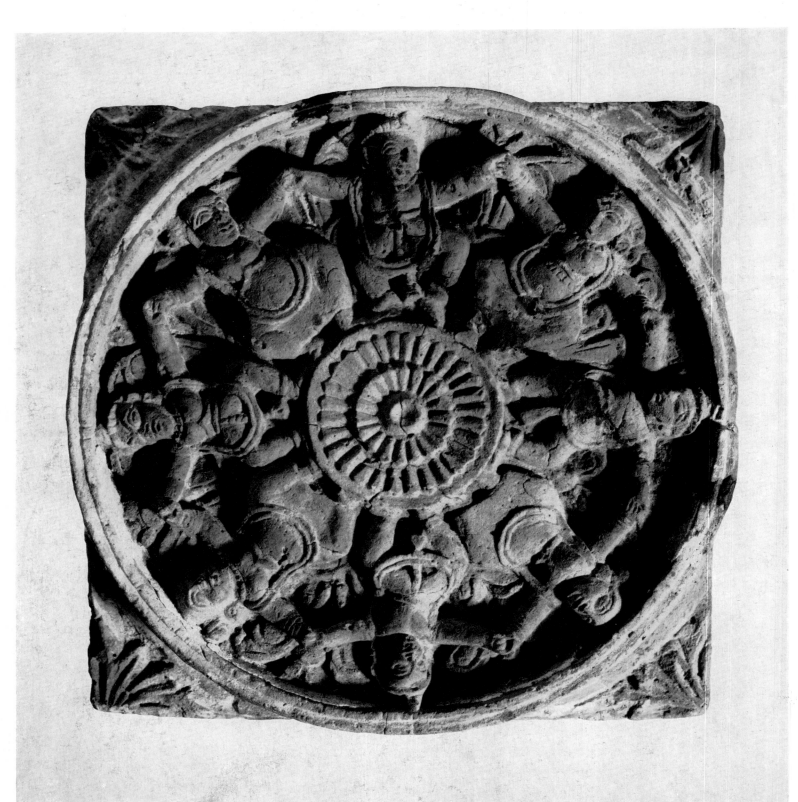

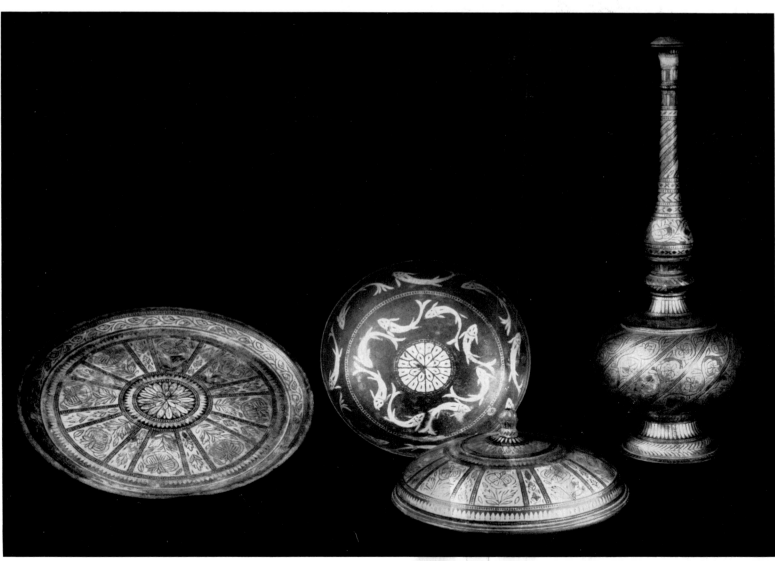

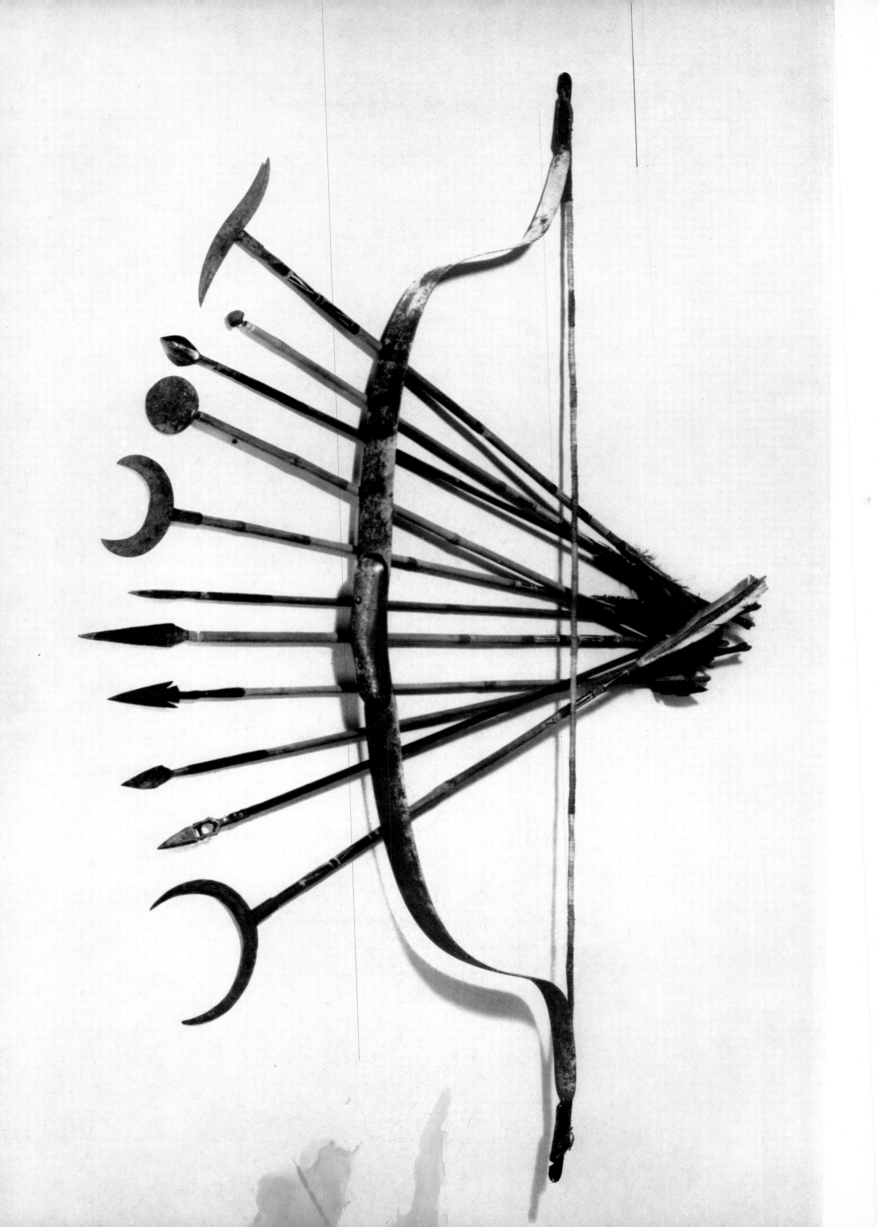

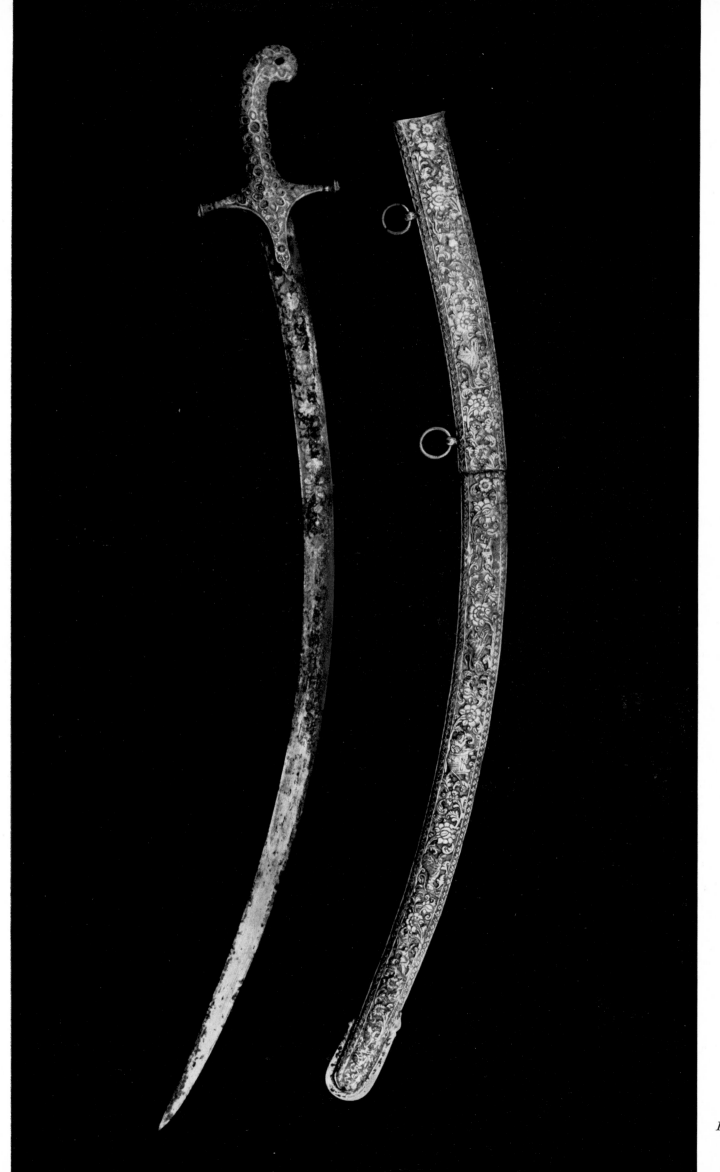

139

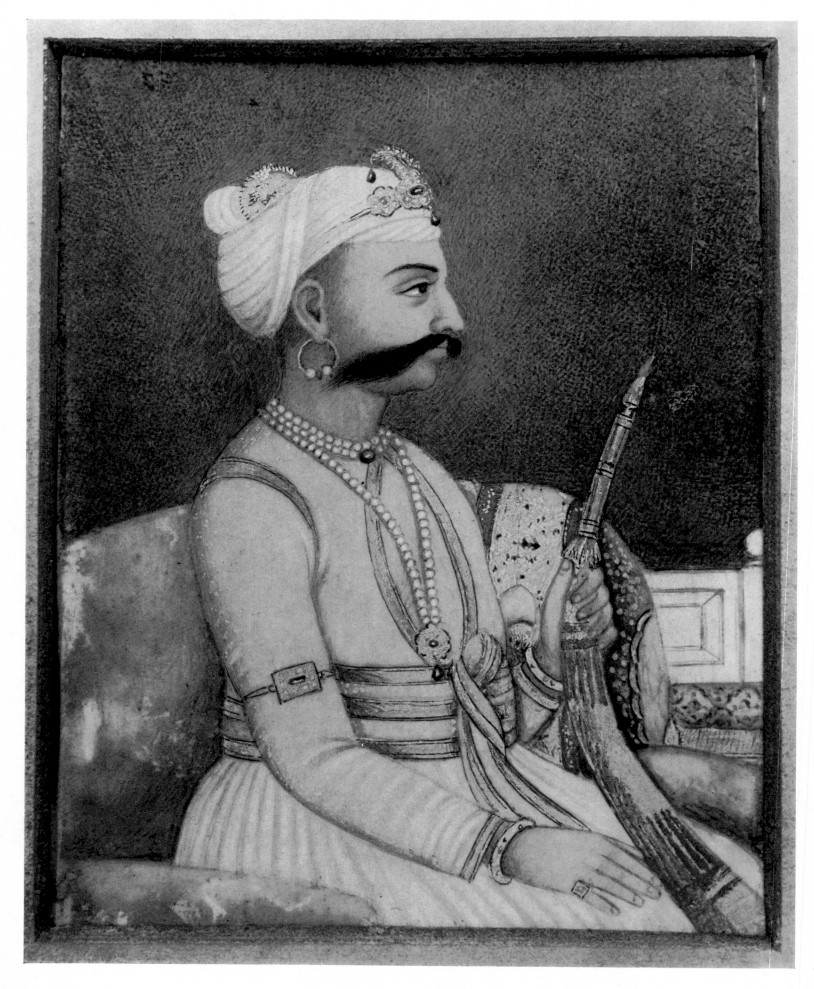

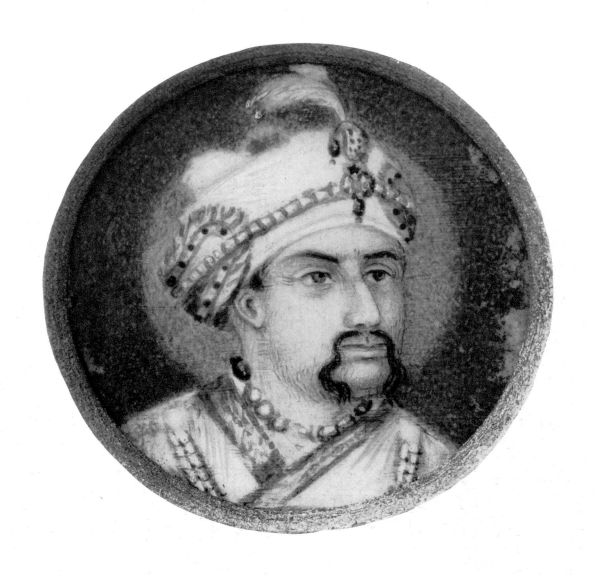

143

STATE ARCHAEOLOGICAL GALLERY
OF WEST BENGAL

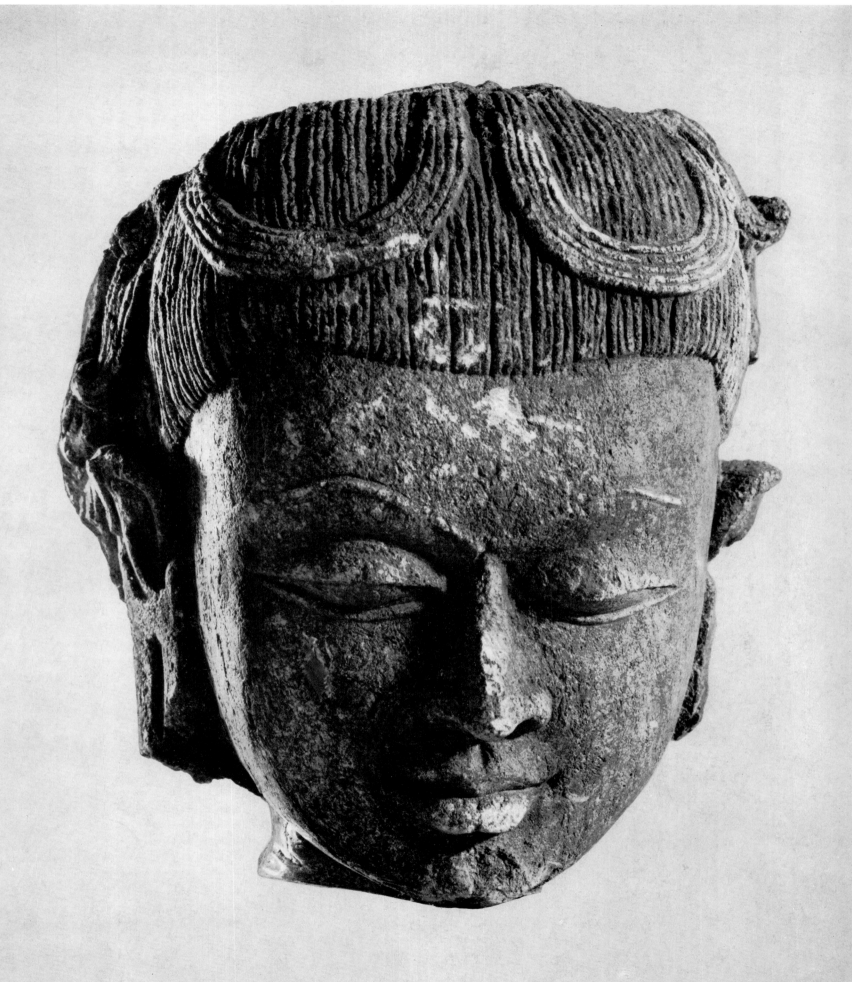

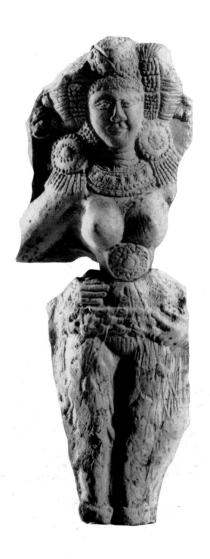

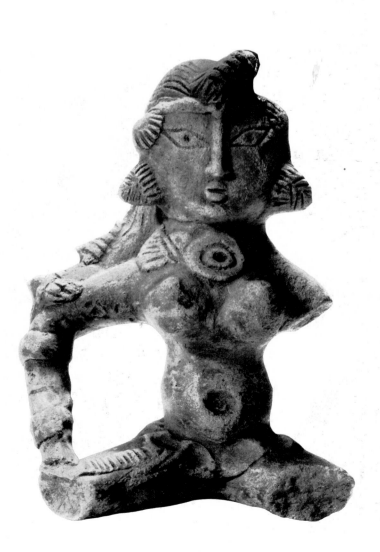

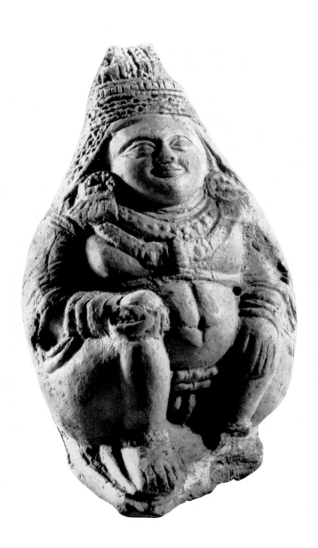

148

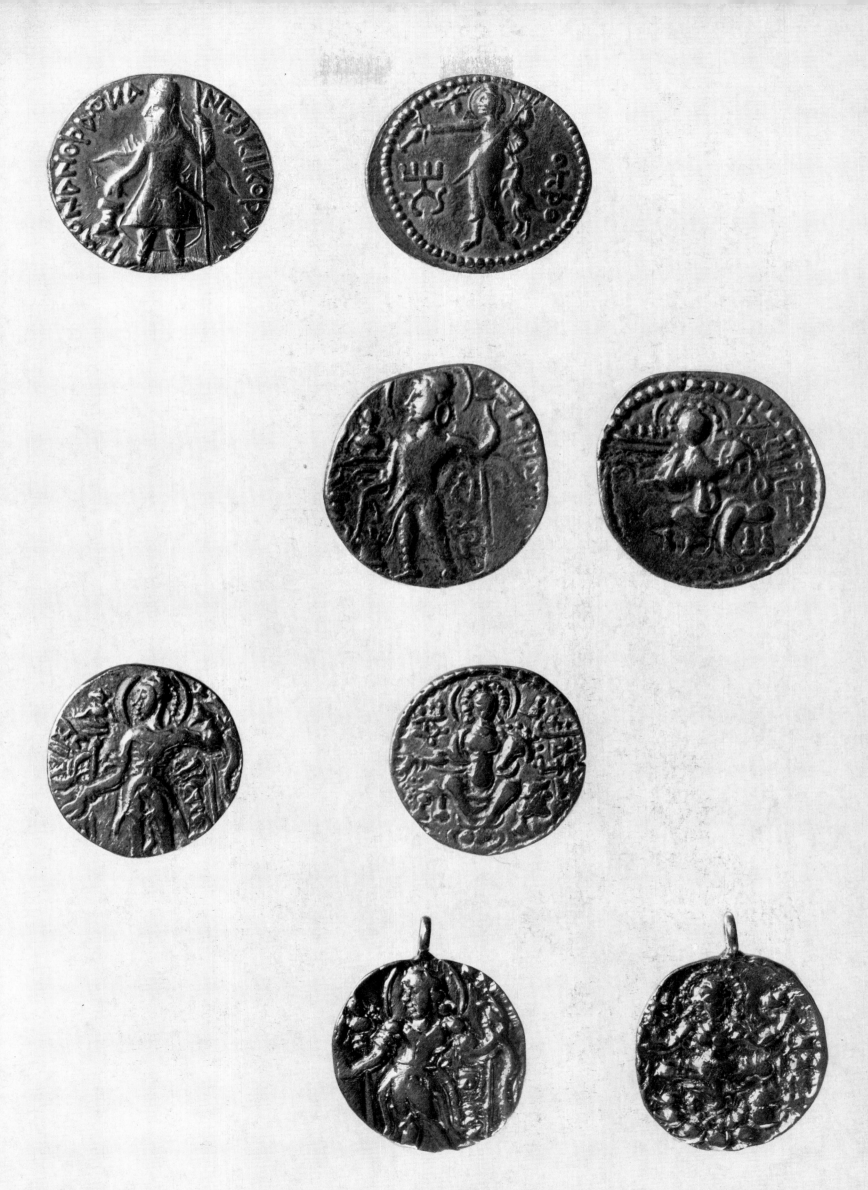

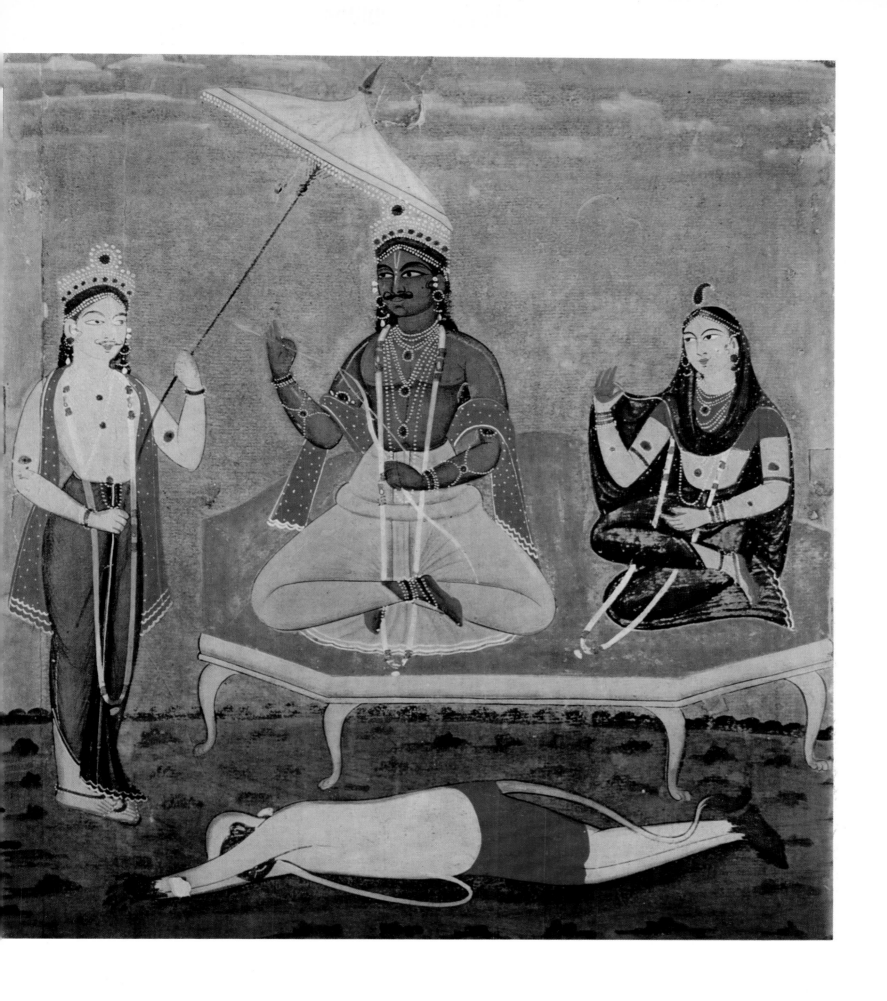

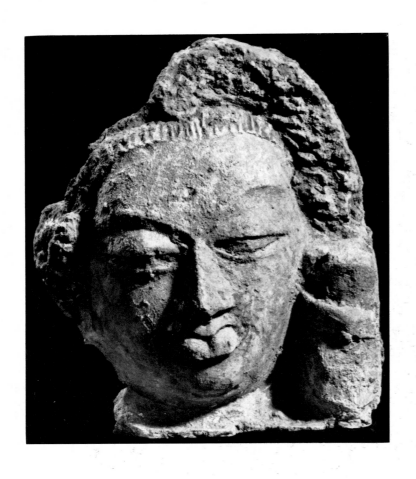

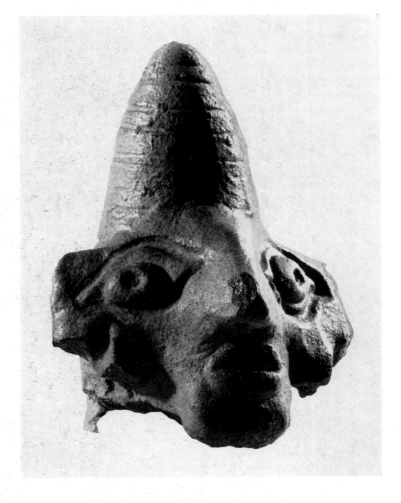

152

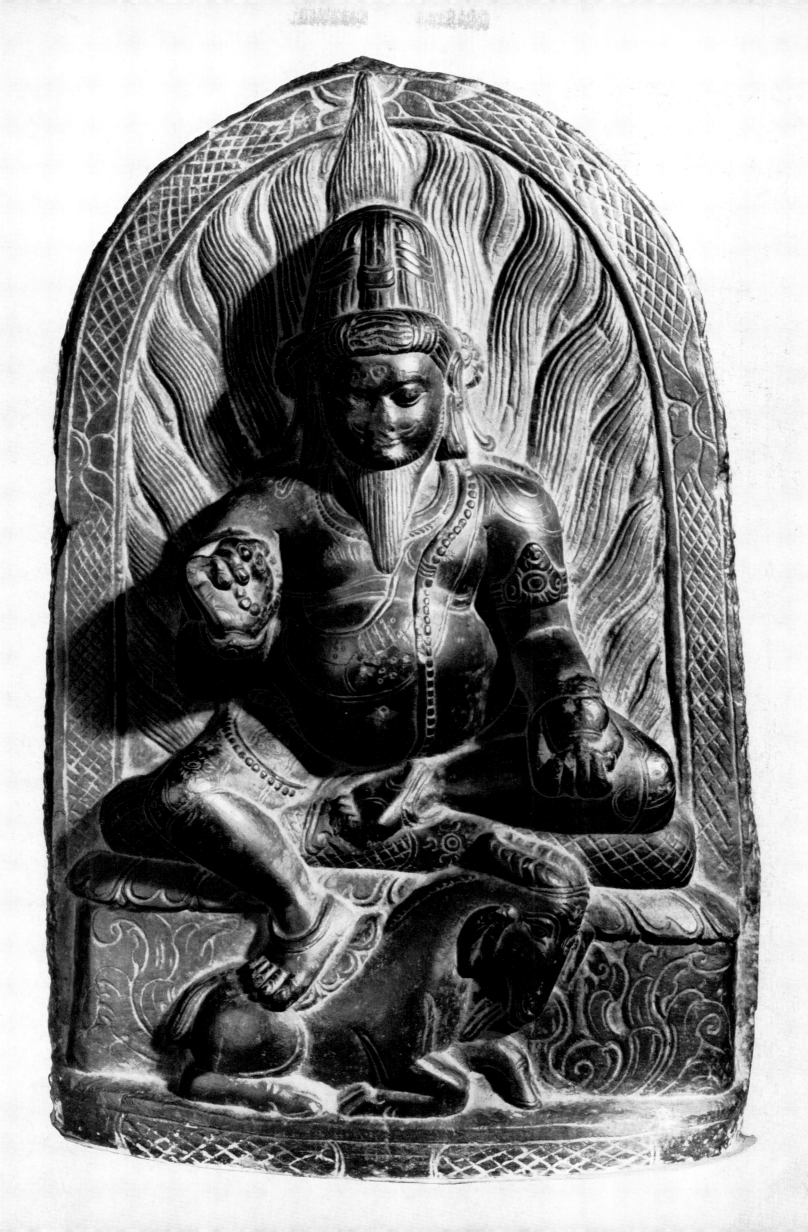

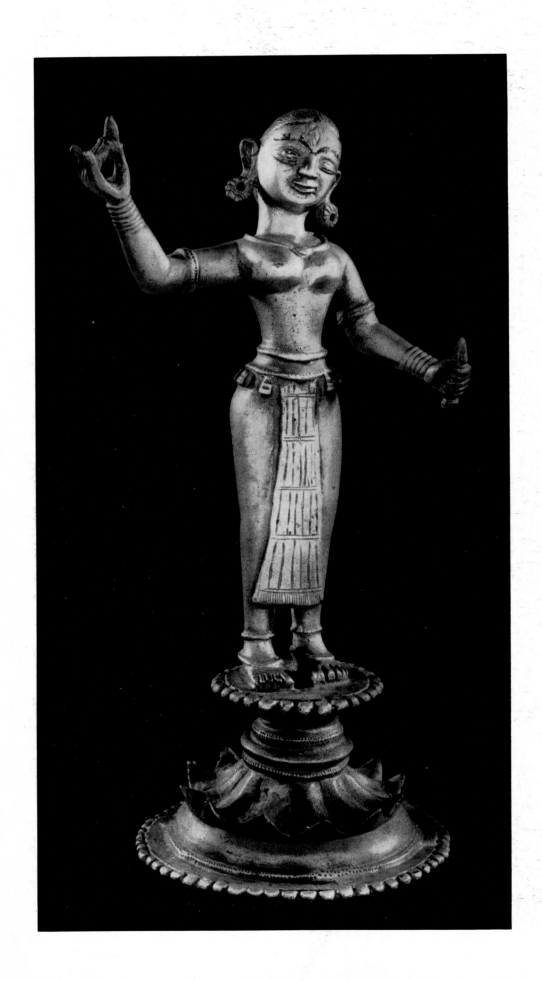

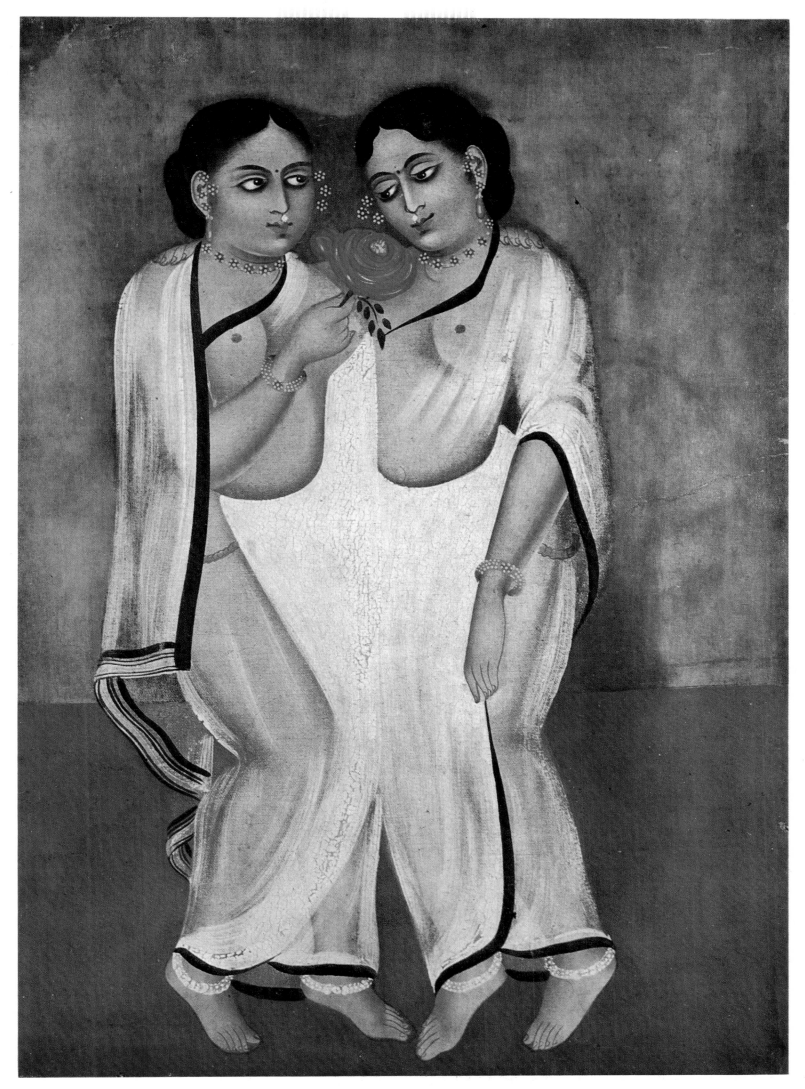

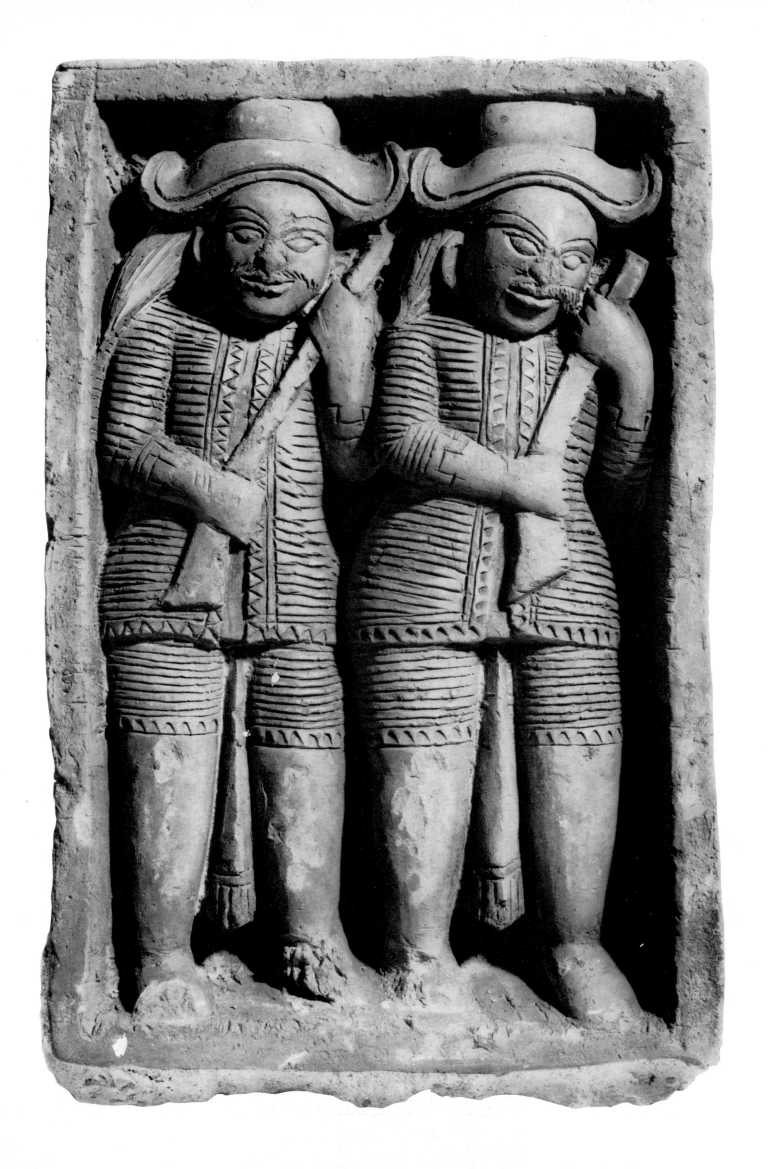

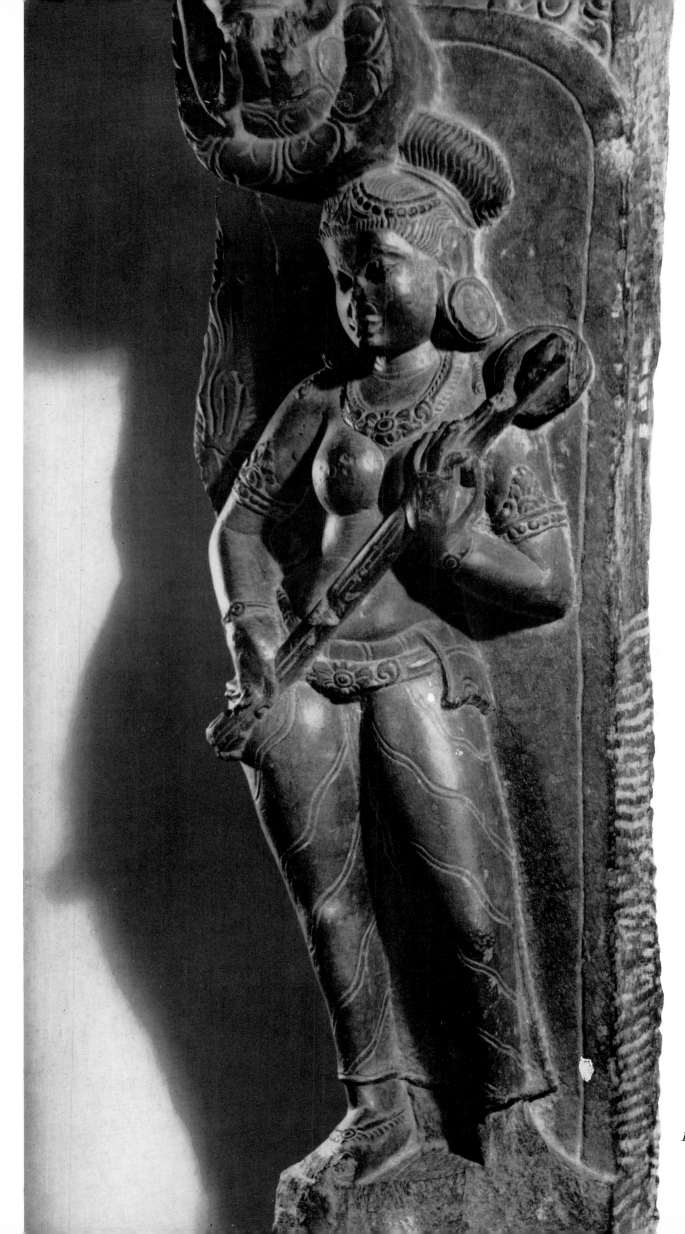

157

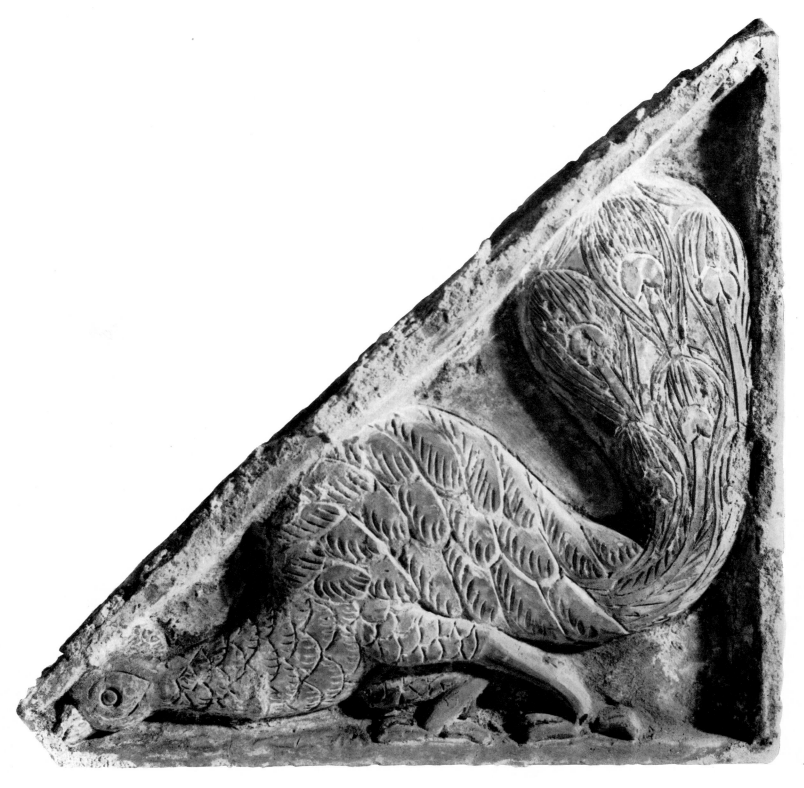

ACADEMY OF FINE ARTS

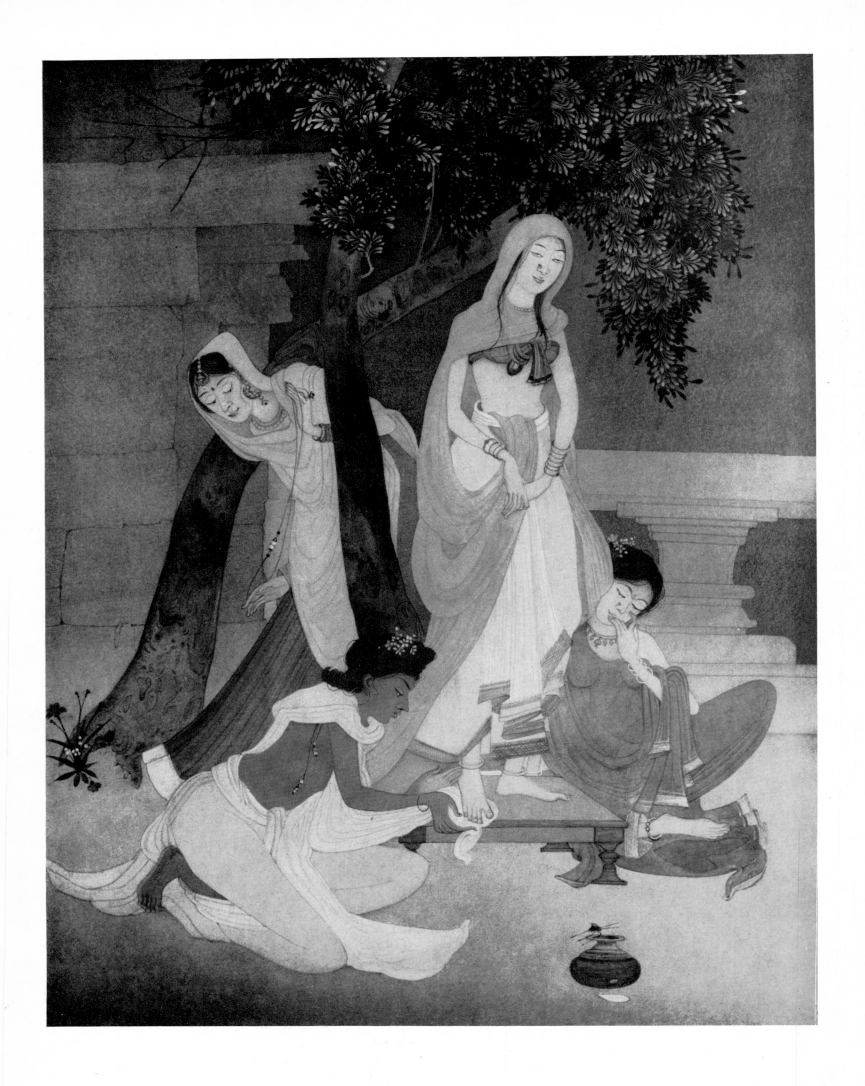

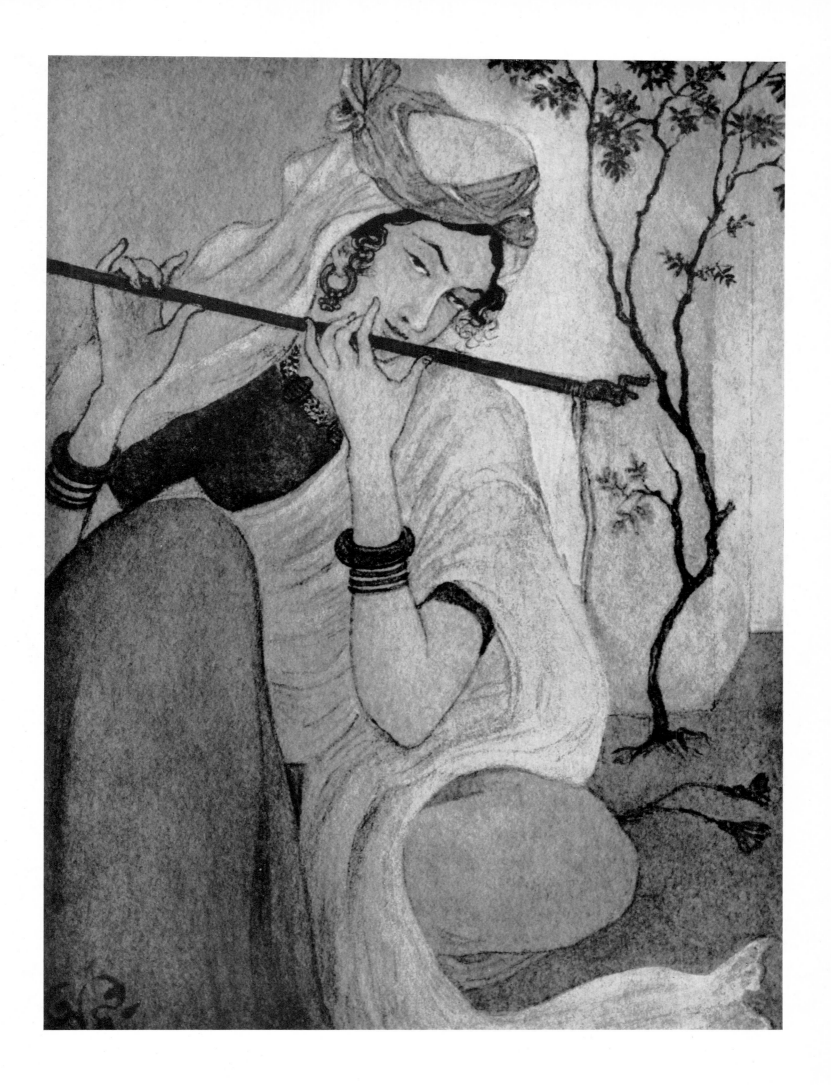

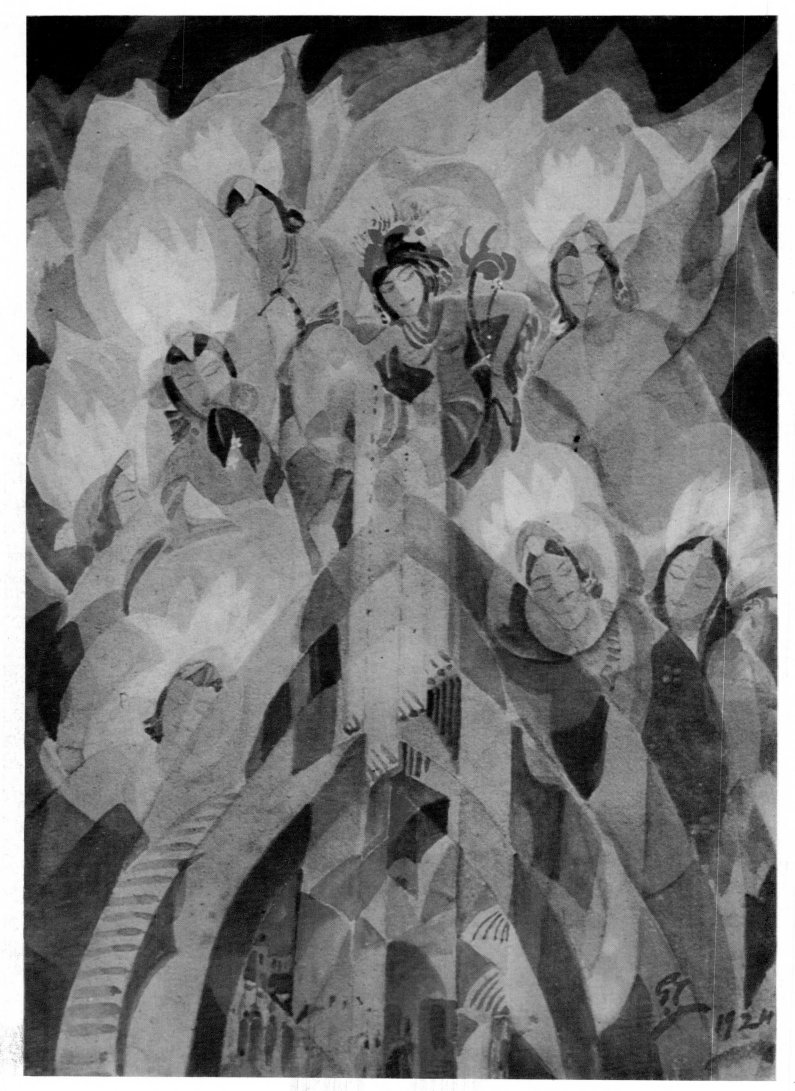

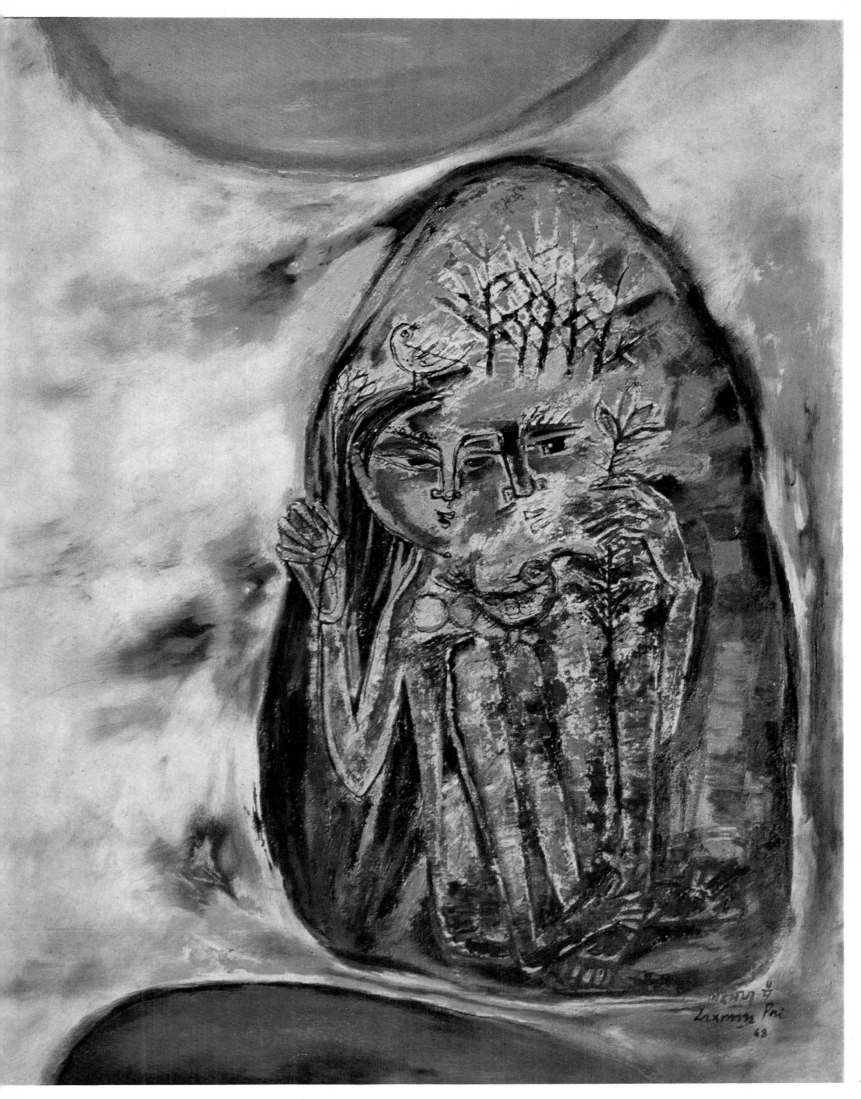

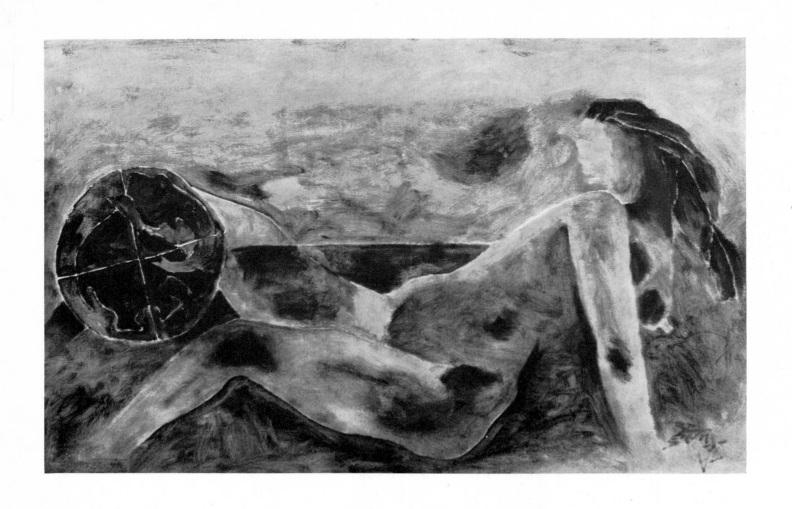

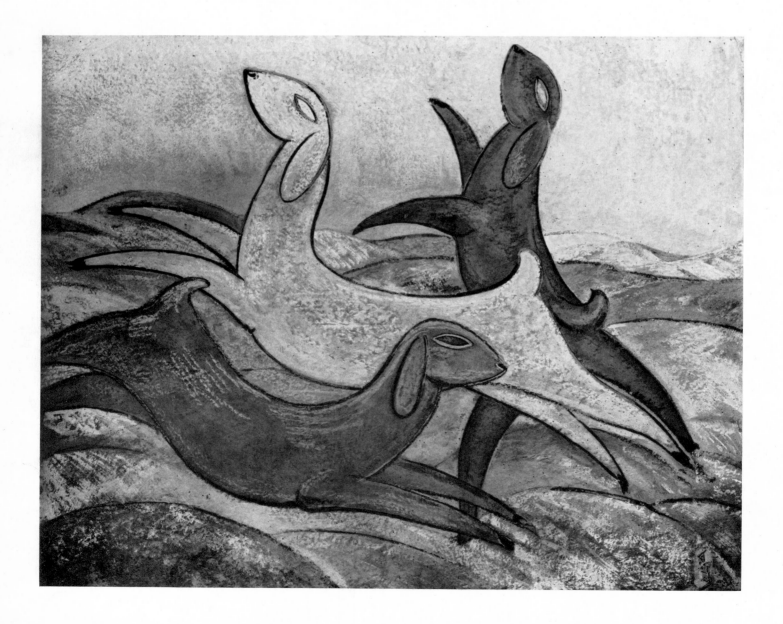

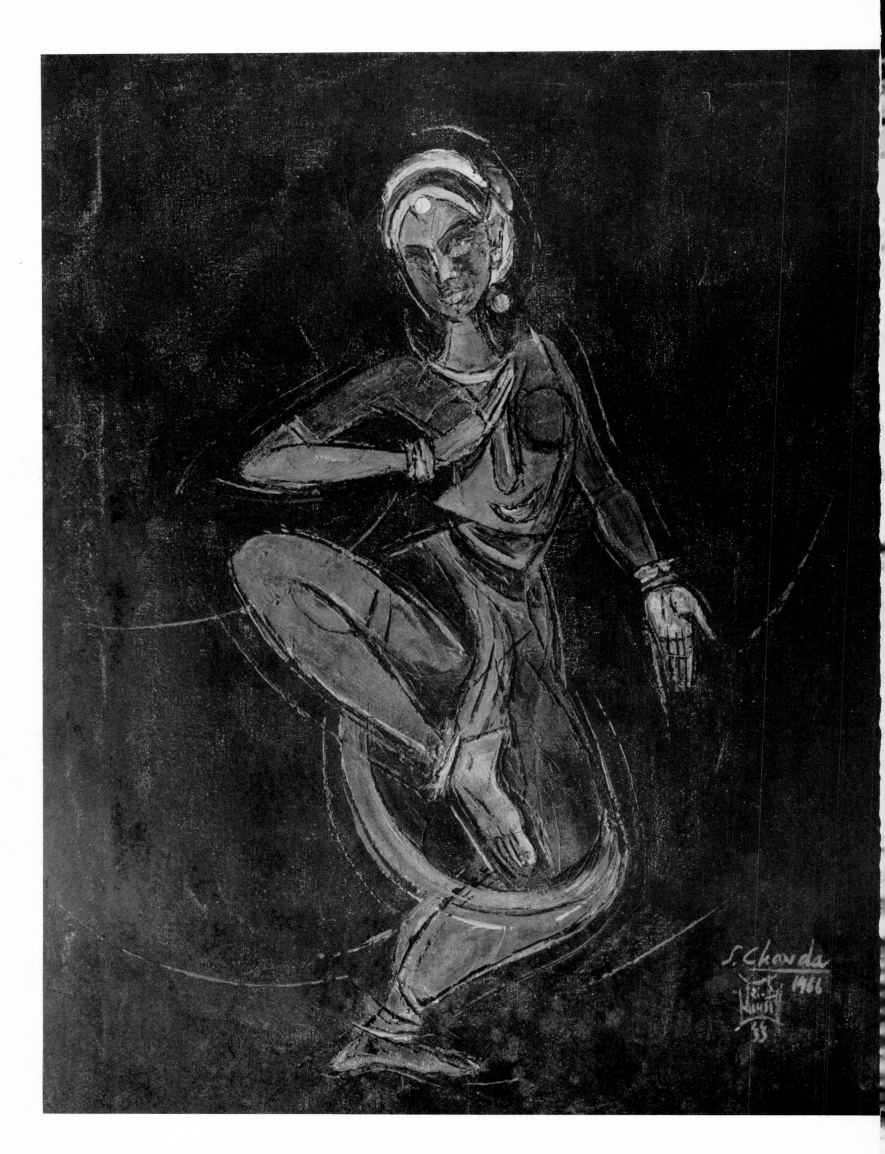

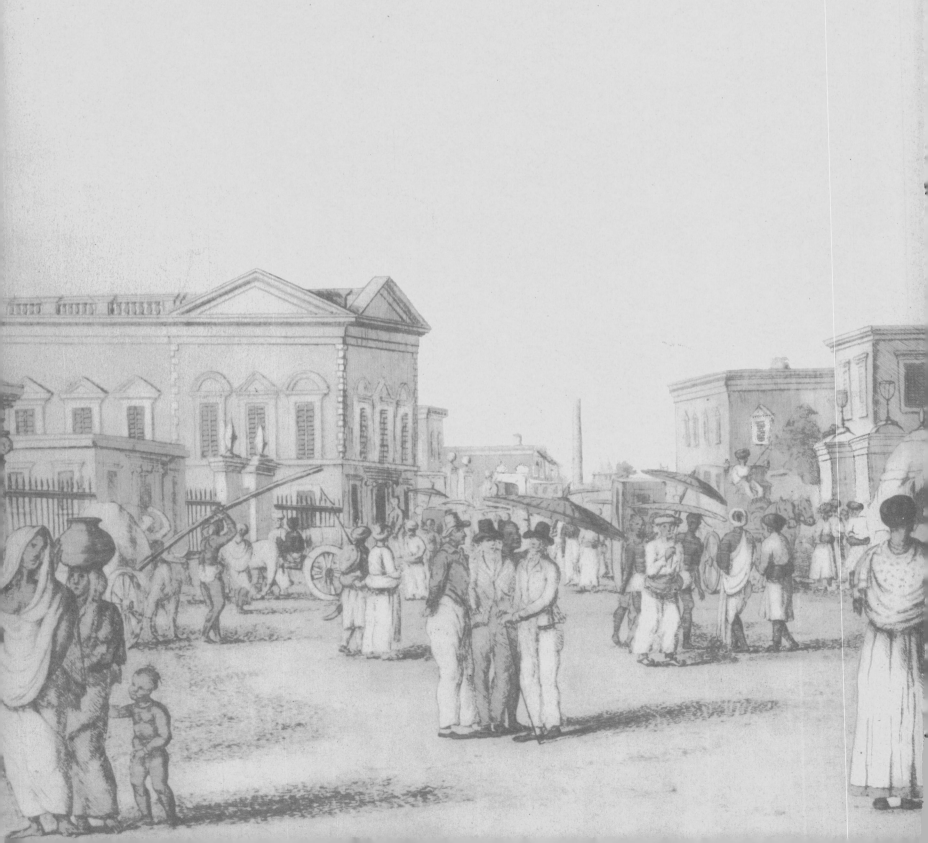